Sara&
Gerald

Sara&
Gerald

Villa America and After

by Honoria Murphy Donnelly

with

Richard N. Billings

Foreword by William M. Donnelly

Design by Francis Brennan

Times
BOOKS

For permission to reprint original and published materials, the follow-ing are gratefully acknowledged:

Letters of Ernest Hemingway, pages 86, 94-97, 153, 168, 170, 171, 175-76, 176, 176-77, 177, and 178, copyright © 1983 The Ernest Heming-way Foundation, Inc. All rights reserved, not to be reproduced in any form without the permission of the copyright owners.
Letters from Ernest Hemingway: Selected Letters, 1917–1961, on pages 93-94, 99, 156-57, 169, 171-72, 185, copyright © 1981 The Ernest Hemingway Foundation, Inc., copyright © 1981 Carlos Baker (New York: Charles Scribner's Sons, 1981), reprinted with the permission of Charles Scribner's Sons. Francis Scott Fitzgerald Smith, for correspondence of F. Scott and

The copyright page continues on page 243.

Published by TIMES BOOKS, a division of
The New York Times Book Co., Inc.
Three Park Avenue, New York, N.Y. 10016

Published simultaneously in Canada by
Fitzhenry & Whiteside, Ltd., Toronto

Library of Congress Cataloging in Publication Data

Donnelly, Honoria Murphy.
 Sara & Gerald: Villa America and after.

 Includes index.
 1. Murphy, Gerald, 1888–1964. 2. Painters—
United States—Biography. 3. Murphy, Sara.
4. Wives—United States—Biography. 5. Artists,
Expatriate—France—Biography. 6. Artists—United
States—Biography. I. Billings, Richard N.
II. Title
ND237.M895D66 1982 759.13 [B] 82-50037
ISBN 0-8129-1030-3

Manufactured in the United States of America
83 84 85 86 5 4 3 2

To
John, Sherman, Laura,
Sara and Gerald's "golden grandchildren"
*
And to Linda M. Billings

Acknowledgments

It is not possible to record here a complete list of that worthy legion of friends and relatives who, in some way or another, have helped bring this book into being. The varied strands of their separate memories have been woven into the fabric of the whole, and we trust that by the length, color, and texture of the threads, these willing and generous participants will have little difficulty in recognizing where each of their contributions appear in the grand design. We are deeply grateful to them.

There are several, however, whose conscientious devotion, not only to the creative ordeal of producing this work but also to the loving memory of Sara and Gerald themselves, must be singled out for special mention. They are: Edward T. Chase, Ann Buchwald, Susan N. Kane, Archibald and Ada MacLeish, Lillian Hellman, Frances Fitzgerald Smith, Fanny Myers Brennan, Alice Lee Myers, Calvin Tomkins, Ellen Barry, Noel Murphy, Elizabeth Dos Passos, Ernestine Leray, Henriette Géron, and Deborah Billings.

<div align="right">

HONORIA MURPHY DONNELLY

RICHARD N. BILLINGS
</div>

JULY, 1982

Contents

Foreword

BY WILLIAM M. DONNELLY

I had never heard of the Murphys when I first met Honoria in 1950 in California, but I had certainly heard of the Mark Cross store. As a matter of fact I had gone to war with one of their cigarette lighters. But as I came to be a family member, I gained vivid and lasting impressions.

Gerald was incapable of buying, owning, or even arranging anything other than in almost perfect—to most people—style or taste, or shape, or color. Evidence of this gift ranged from the purchase of a thirty-five cent blue pitcher (we still have it) from the five-and-ten, to finials, weathervanes, and the several houses he built or bought, renovated, "decorated," and landscaped. Always, always with Sara's help and comments. He could hang pictures, place furniture, display bric-a-brac and little objects, and, of course, paint beautifully. He wrote like a poet.

The Murphy life-style is well recorded, but what does an elegant couple do with the Jersey Turnpike, for God's sake? Well, pack a picnic with Sara's hors d'oeuvres, hot soup, cold chicken, salad, stuffed eggs, and a very adequate wine served on a collapsible table with folding chairs and a simple French checked tablecloth. And what does one do on arrival in San Francisco at 8 A.M. after a thirteen-hour flight on a DC-6 from New York? Head for the bar and have a double whisky sour and then proceed on the three-hour drive to Carmel to visit us. What does one do on the way back from Carmel for another boring drive to San Francisco

airport? Stop off with the Alfred Hitchcocks for drinks and lunch at their place overlooking the mountains in Santa Cruz.

Gerald Murphy could wear—with perfect aplomb—the strangest clothes you ever saw. (Sara had dash and was inclined to flowing purple with tan ribbons and panels.) When he swept into the Mark Cross store, usually wearing one of several capes he owned, his employees would affectionately call him "The Phantom of the Opera." He would walk through the toughest sections of New York in the most elegant, positively foppish outfits, consisting of spats, a homburg, cashmere jacket, river gambler's vest, Charvet tie, and silver-headed walking stick. His imperious manner must have intimidated the muggers; he was bothered only once by a youth who fled empty-handed. After that event his cane or umbrella usually concealed a sword. On one of his walks through the city, he heard the dreaded scurrying of footsteps behind him. Whirling around, he drew his sword like D'Artagnan, and a group of three changed their minds and scuttled.

The closeness of this family and their friends was unbelievable; my bride phoned her family every night of our honeymoon. They wrote and telegraphed and cabled and phoned. They visited during emergencies, they visited without emergencies. When someone really did get sick, it was devastating. They hugged and kissed, they traded recipes and travel tips; they talked about mutual prenuptial friends. They not only remembered, but celebrated their *dogs'* birthdays.

To my delighted surprise, the Murphys turned out to be liberal Democrats. (When my father died in January 1946, he was Democratic National Committeeman from Michigan.) Gerald was an eager veteran of World War I, and I of World War II. Sara was an avid reader, and our tastes coincided, in books, furniture, American antiques, and objets d'art. We all loved Adlai Stevenson, travel, seascapes, dogs, food, and wine. We all loved Honoria.

And then in 1950 there came a revelation. It so happened that at their house at Snedens Landing on the Hudson, called Cheer Hall, the guest room was on the ground floor; the middle floor was for living and dining rooms, and the family quarters were on the third level; and they all had magnificent views of the Hudson. In the ground-floor quarters hung several really astounding paintings, either four or five. They were so good that, not wanting to display my ignorance of an artist who *must* be famous, I kept silent. Finally, a

dinner guest remarked that I was lucky to be sleeping in the "Gerald Murphy Gallery." Not a word had ever been said about Gerald's painting, suggestive of the curious fact he'd stopped painting altogether after 1929, at the time it was confirmed his son Patrick Murphy had TB.

In addition to Gerald's taste must be added other talents: his very life-style with Sara—*Living Well Is the Best Revenge* by Calvin Tomkins was written about them, after all; his paintings, of course; his entertaining; and his ability to communicate with others. My brother John C. Donnelly (our eldest child is named after him), no stranger, as a lawyer, to eloquent language and friend of many prominent public speakers, said that Gerald Murphy had the most perfect command of the English language of anyone he ever met. The director of painting and sculpture at New York's Museum of Modern Art, William Rubin, stated at the opening of the one-man show of Murphy's works in 1974, ten years after his death, that he was one of the few really major American painters of the twentieth century; he toasted him as a "cerebral painter" at a dinner celebrating the opening of the exhibit. Matching Rubin's assessment of Murphy's role in art was Archibald MacLeish's comment that Gerald could have been—he implied that he *should* have been—a really first-rate writer.

Another remarkable thing about this couple was the devotion of their servants—and they had many. There are senior citizens of several nationalities scattered around the world who stop everything when the Murphy name is mentioned; old snapshots and letters that have been tucked away for many years are brought out, wine and biscuits are served, and the reminiscing begins, complete with tears and laughter. In addition to the Russian Captain Vladimir Orloff, there are several others I remember. One is that late and lovely Irish angel, Theresa Morgan, widow of "Dumb Dan" Morgan of prize-fighting renown; the immortal and very devoted friend, Mrs. Emil Wessberg, a superb cook and general manager who was with the family for over fifty years. There is that midget dynamo of so many years here and abroad, the feisty little (four feet eight inches) Ernestine Leray, now living in unaccustomed idleness in Brittany near Gaël, in a beautifully named retirement conclave, *Cité du 3eme Age,* or City of the Third Stage (in life). Also in France, down in the sunny Biarritz area, is the gentle Henriette Géron—the Murphy children's governess—always ready with a new anecdote.

Lastly, there was that lovely woman Lillie Nyberg, who was Honoria's baby nurse, and who came out of retirement in Pacific Palisades to nurse our own first-born, John, and then returned to a peaceful death.

As the years went on, we visited back and forth between Carmel, California, where we lived, and East Hampton, New York, where the Murphys had a summer "cottage" on the Atlantic Ocean. Some years we drove and some years we flew. One year we traveled by train in three first-class compartments with our three kids and our mongrel dog: great fun.

The Murphys were amazed and delighted by Carmel. Age, wealth, and "position" meant nothing there. We all went to parties where the guests would include everyone from tiny children to elderly couples, from rich to poor, and from construction workers to poets. They loved it. Gerald haunted the tiny artisans' shops in the village; he admired handmade objects, and Carmel abounded in them. He was particularly intrigued by a pocket-sized silver and leather store named Scott's, where everything for sale was designed and handcrafted by the two men who owned it. Gerald tried to place an order for Mark Cross for two hundred beautiful dog leashes of rolled leather with heavy sterling silver bands every few inches. The proprietors (who were shooting friends of mine) said that, well, they'd have to hire someone, fill out payroll and tax forms, etc. They were willing, however, to sell their entire inventory—three. Another Carmel "industry" that intrigued Gerald and Sara was the then-struggling, now-famous Robert Talbott Ties. The Talbotts had started the business in the guest room of their house next door to us. In their early years, they asked the head of Mark Cross about *directions* in business; whether to continue with the time-consuming and not very profitable hand-sewn method, or to make more money with less effort by changing to machines. Gerald advised them to keep their product at the very top in quality. He said that the trend in the United States, including Mark Cross, was toward obsolescence versus permanence, but there were always people out there willing to pay any price for the best. He added that it was more fun to direct your effort at the top five percent of the market than to the masses. Robert Talbott ties now sell for up to one hundred twenty-five dollars.

The Murphy family really did know how to live well. They planned bonfire picnics on the beach in front of their East Hampton

house to coincide with a full, or near-full, moon. On the Fourth of July, there were always plenty of displays in the area to make everyone "ooh!" and "ah!" The annual trek to the Village Fair (a very important fund-raising event to keep the village as charming as it is) involved *full* foppery, with the accompanying granddaughter, Laura, dressed to the Victorian nines in a lace-trimmed dress of her mother's. At one Fair, at dusk, our friend Jeffrey Potter happened to glance up at the almost deserted dance floor on the Fair grounds. The orchestra was playing by candlelight and kerosene lamps; most of the Fair-goers had moved on to other loudly ballyhooed events. There was Gerald Murphy dancing with his "golden granddaughter," alone, with a delight and pride in his expression that Jeffrey found very moving.

The Murphy cocktail hour was a unique production. As the hour approached, Sara would place on the bar small Steuben pitchers containing orange, lemon, and lime juice, always fresh. There would be mint, orange slices, lemon twists, onions, olives, and so on. Gerald would take the orders. This man didn't mix drinks, he performed an office. He looked like a chemist or magician, measuring, mixing, holding up to the light, garnishing, and, finally, serving with a flourish. He was absolutely delighted when someone ordered a complicated drink that called for several ingredients. His opinion of drinking was that he loved drinking but disliked drunks. He had mixed a batch of drinks one evening for our friend Max N. Edwards, then an assistant secretary of the interior. As they watched the sunset from a terrace, Gerald remarked that "this drink has gone right to my head, which is just what I intended it to do."

He could not pass a hardware store without stopping. Twenty years after his last visit, he is still fondly remembered in the better hardware stores of Carmel, of McLean, Virginia, and of East Hampton. He loved leather, as one should have who headed Mark Cross, but he also collected wooden tools. There is a display of European farming tools on the wall of the East Hampton property—shovels, pitchforks, rakes, and hoes—that looks like a museum display; not a nail or a piece of metal in sight: pure wood, espaliered with great patience, and hand-carved in Europe.

In seeming contrast to the old-fashioned wooden tools was his fascination with the very latest and most modern gadgets. He bought every new garden and kitchen doodad as soon as it came on the market: coffee-makers, egg poachers, seed-planting tools, weed

diggers—anything that was new. His collection of aprons to use with these tools in the garden or kitchen (he loved to cook) was simple: no "jokes," ever. Not only were there no "I am the chef!" aprons, the ones he wore were real, for working people. There were a horizontally striped porter's apron from Venice, a kitchen or butcher's apron from France, a carpenter's from Austria, and, finally, a blue denim number from Georgetown in Washington. Not from the boutiques, but from one of the older workers' supply stores that still exist there.

Long before it was popular, the Murphys were collecting American Primitive works. People from the Smithsonian have expressed jealous admiration for several items: "The finest collection of tinsel paintings in the country," said one. We have a cocktail table inlaid with a map of the United States in decorative woods shipped from the actual states. It is as smooth as the proverbial glass, and seems to be unique and absolutely mystifying to the occasional appraiser trying to place a value on it. Gerald bought it from a ferryboat skipper who assembled such tables in the winter when the boats were tied up; he paid thirty-five dollars for it.

He—I should say they—collected everything: furniture, rugs, dogs, friends, houses, recipes, walking sticks, books, you name it, *except,* for some inexplicable reason, paintings. Gerald could not have been jealous of other painters, because he told many listeners that he was not, and never would be, a first-rate painter. The fact that more and more people were beginning to disagree with him didn't impress him one bit. The missing painting *Bibliothèque* was discovered after he died, rolled up in a corner of the garage, unwrapped, stacked with broken rakes, rusted downspouts, and used brooms. When one remembers that Gerald mingled for years with some of the finest artists in the world, that he admired design and color and composition, how then is the lack of even one sketch by his friend Picasso to be explained? After Sara and Gerald died there were one large Léger, some watercolor quick sketches by the same artist, a modest Farny inherited from Sara's father, F. B. Wiborg, and practically nothing else. Even Gerald's own paintings are scattered and lost; of eleven or twelve or thirteen or fourteen (the total is in dispute) executed, only six can be found. When asked why the Dallas Museum had two, he answered that it had *asked* for them; it was that simple. Sara also had a fair amount of talent as an artist, as well as the ability to express herself, but there was no jealousy

whatsoever in their love affair. Indeed, they were a unit, and complemented each other in everything they did.

Our children had been born in Carmel. They were baptized at the font in the Basilica San Carlos Borromeo where Father Juniperro Sera had baptized thousands of Indians. They had been down the coast to Big Sur many times, one of the world's most famed spectacular drives. They were not, therefore, strangers to breath-taking scenery. But the first drive we took with our two sons, John and Sherman, on the Corniche from Monte Carlo to Antibes on a pilgrimage to Villa America, the Murphy dwelling, impressed them tremendously. They remarked that the California coast, while even more spectacular, was also colder—and much less crowded.

When we arrived at Antibes in our rented Peugeot, my wife's photographic memory worked as usual; we easily found the property where she grew up and drove directly to her old place, Villa America. Upon arriving at the gate and being greeted by the gardener, two impressions dominated: the surprisingly large size of the place, and the utter degradation of the house. The property had changed hands more than once in the years since Honoria had seen it, and was at that time owned by a Middle Eastern bank, which very kindly arranged our visit. Even though some of the original property had been parceled off and sold (at one point in the past, the only larger property in the area was the Aga Khan's), there were still about two and a half acres. Having a gardener live there meant that the huge *jardin exotique* was in pretty good shape, but the trees that the Murphys had planted so many years before had grown so that the once-spectacular view of the Mediterranean was almost obscured. The very large house itself was a shambles: falling plaster, mildew, a motorized lawn mower parked in a room that had known so much gaiety, and, would you believe, *goats* wandering through the ground-floor rooms! As we poked through the musty interior with sagging doors and broken windows, Honoria's spirits were obviously very low; ours were not much better. We took some snapshots, thanked Gerald, the caretaker, and left. (Yes, Gerald. He was the son of the original gardener, and had been named after Gerald Murphy. He was living in Gerald's studio.)

To cheer ourselves up, we went to the Hôtel du Cap at Antibes for a drink. The Murphys had lived there while the Villa America was being redone. We all had a drink, and Honoria showed the boys Eden Roc, where she had "bathed" years ago. We then piled into

our car and drove the short distance to the Garoupe, where Gerald had raked the seaweed every morning before the guests arrived for their swim. If we were amazed at the large size of Villa America, we were equally amazed at the size of this world-famous bathing beach —it was, and is, tiny. It was cool and deserted the day we were there in early June. We drove back to Monte Carlo in a very pensive mood.

When Sara's health started to fail in her late eighties, we took her and her nurses into our house. One day she started singing "Here Comes the Bride," and died two hours later. Adding further poignancy is an entry in Honoria's date book that day: "Mother died tonight. She is with Dow now." When Archibald MacLeish came down from New England to give the eulogy at Sara's funeral in East Hampton, Honoria told him of the singing. He called his beloved wife, Ada, over and asked Honoria to repeat what she had just said. When she did, they both smiled beatifically; they knew she was singing to Gerald.

Our children got to know and love their illustrious grandparents of the maternal side for many happy years. We still own the East Hampton property and some furniture and prints from the old days; nothing else of value is left. But we still have every letter, every snapshot, every recipe, timetable, shopping list.

Let me close by quoting Thomas Fuller: "But the reader will catch cold, by keeping him too long in the porch of the Preface, who now (the door being opened) may enter into the house itself."

Here it is.

Note to the Reader

As becomes readily apparent, the first-person voice is that of Sara and Gerald's daughter, Honoria, the witness, as it were, in this narrative of their lives.

Sara&
Gerald

Ripeness Is All.

King Lear, V, ii

(Inscription chosen by Archibald MacLeish
for the gravestone of Gerald Murphy
in South End Cemetery, East Hampton, New York)

I know now that what you said in **Tender Is the Night** *is true.*
Only the invented part of our life—
the unreal part—has had any scheme any beauty.

Gerald Murphy to F. Scott Fitzgerald
December 31, 1935

I. The Invented Part

In April 1974, at the Museum of Modern Art in New York City, there was an exhibition of the paintings of Gerald Murphy, who was described in the program by William Rubin, director of painting and sculpture at the museum, as a "major American artist." It was extraordinary recognition of a man who had painted for but seven years of his seventy-six-year life and who could be remembered for only six canvases that had been preserved, as well as photographs of three others, and a written description of one. Gerald Murphy's renouncement of his career as an artist had been irrevocable: it had even extended to a refusal to keep track of all the works he had completed, so there is a dispute as to their number. While ten have been established, Rubin, who did exhaustive research in preparation for the exhibition, is convinced there are—or were—fourteen.

Murphy, who died in 1964, was not altogether unknown. He and his wife, Sara, were that legendary couple who had sailed for France in the early 1920s and had become, as the poet Archibald MacLeish wrote about them, "the nexus" of the expatriate idyll. MacLeish and John Dos Passos were their dearest friends from among the American literary colony in Paris, but Ernest Hemingway was a confidant and sometime soulmate, and Scott Fitzgerald simply idol-

ized the Murphys, who were the inspiration for Nicole and Dick Diver, the protagonists of his flawed but ambitious novel *Tender Is the Night*. In 1962, the social aspect of the Murphys' life was the subject of an article in *The New Yorker* by Calvin Tomkins, which was adapted as a book, *Living Well Is the Best Revenge,* in 1971.

As might happen with people who travel in the company of creative writers, myths about the Murphys materialized over the years, and Gerald, who was committed to the belief that only the invented part of life "had any scheme any beauty," can be credited with perpetuating them. Their wealth, for example, was greatly exaggerated, in large part by their lavish habits. "People have always thought us richer than we are because we spent freely," Gerald wrote his daughter, Honoria, in September 1962, having just explained that "our funds cannot last indefinitely." The Sara legend is equally misleading. She was a devoted wife and mother in her mid-forties during the "era" of the twenties. Yet she has been portrayed as something of a femme fatale, who was the romantic object of the competing affections of Ernest Hemingway and Scott Fitzgerald. Most inaccurate, however, is the notion that the Murphys were the grand masters of the good life in which happiness abounded. They lived, in fact—and MacLeish described it well—"a deeply tragic life, a life which sometimes seemed intentionally tragic, as though an enemy had planned it." What that enemy visited upon the Murphys was the death, each within months of his sixteenth birthday, of two sons, Honoria Murphy Donnelly's brothers, Baoth and Patrick. In 1935, during their period of grief, the Murphys wrote separately to their friend Fitzgerald. "I don't think the world is a very nice place," said Sara, who would live for nearly ninety-two years. For his part, Gerald elaborated on his conviction that only that which is invented has any meaning: "Life itself has stepped in now and blundered, scarred and destroyed." He was alluding to the double tragedy, which began on the day in October 1929 when it was confirmed that Patrick had tuberculosis. It was the day that Murphy quit painting forever.

Misunderstanding the Murphys has been abetted in no small way by Gerald's inventive bent. He confused art historians considerably by telling one of them in 1955 that there had been a one-man show of his work at Bernheim Jeune in 1935, since extensive inquiries turned up no such exhibition at that or any other Paris gallery. In notes of the catalogue for the 1974 show at the Museum of Modern

Art, Rubin offers an answer: "Opinions among Murphy's friends differ as to how to explain this apparent mystery. Some feel it was Murphy's own sly spoof of himself. Others feel that [it was] Murphy's penchant for fantasy and invention." When it was later discovered that there had been an exhibition of Murphy paintings at Galerie Georges Bernheim in 1928, Carolyn Lanchner, a curator at the Museum of Modern Art, wrote Honoria Donnelly an apology. "I am remorseful that I didn't comb the 20s as I did the 30s for the 'Bernheim' show," she wrote. But the fact of Gerald Murphy's tendency to twist the truth remains. Lillian Hellman, the playwright, who met Sara and Gerald in Paris in 1937, was asked if Murphy, perhaps, exaggerated a bit. "I wish you'd stop using that word," she replied impatiently. "It's a meaningless word. We all exaggerate. Exaggeration is to say I have $5,000 when I only have $1,000. But to say I have $1,000 when I don't have anything is invention. Gerald Murphy invented."

An additional reason for the mystery surrounding the Murphys was the failure of art critics to recognize Gerald, who was not discovered until 1960, as a serious American painter. He did his best during his lifetime to stress the point that the move to France, rather than a merry lark, had been a serious effort to find "nourishment," as he put it, in the cultural capital of the world. He called Paris "the perfect incubator for that kind of activity," and he told Calvin Tomkins how he had been inspired by the painting of such modernists as Matisse, Braque, Juan Gris, and Picasso. He had studied under Natalia Goncharova, the Russian artist who designed the sets for the Diaghilev ballet, and he had been able, following a fire that destroyed the sets, to help repaint them under the guidance of Goncharova, Braque, and Picasso—an "invaluable experience." This having been said, it was not until later that Murphy did the work for which he could be remembered. None of the set designs for the ballet were done by him alone, nor were they signed by him. He did, however, paint the set design for *Within the Quota,* an early ballet by another Murphy friend, Cole Porter.

It was their insatiable appetite for the arts—the ballet, exhibitions, and concerts—that put the Murphys in touch with the American writers who chose Paris as a refuge in the 1920s. Fitzgerald had little enthusiasm for the arts per se, writing excepted, but he would show up at a performance or a showing of paintings if it served his literary interests. Hemingway, on the other hand, once told Murphy

he would prefer to be a painter and confided that he thought of his short stories as pictures, a writing approach amply demonstrated by Hemingway's ability to evoke visual imagery. Murphy enjoyed telling a story of an encounter with Hemingway in 1925 at the Salon des Indépendants at which 2,200 canvases, including Murphy's *Razor,* were exhibited. "He bought for the equivalent of two hundred dollars, part of which he had to borrow and the rest of which he had earned carrying vegetables, . . . *La Ferme* by Joan Miró, who was at the time unknown." Dos Passos, an accomplished amateur artist himself, considered Murphy far ahead of Stuart Davis as an American response to the modern school in Paris, but it was MacLeish, more than anyone, who championed the achievements of his long-time friend. "Even during the period of his irrelevant fame as a character in contemporary fiction," MacLeish wrote in 1974, "the canvases continued their labor of establishing Gerald Murphy as what he really was and always had been, a painter of his time."

In his own view, which is supported by the uniqueness of his work, Murphy was not so influenced by what the artists of Paris were painting as by what they believed. "I had no desire to paint like Matisse, Picasso, or the others," Murphy wrote late in life to Douglas McAgy, director of the Dallas Museum for Contemporary Arts, where two of his paintings had been placed permanently on display. "Like most painters who work independently and for themselves, I was not especially curious to know . . . what other painters were doing." Murphy's originality was attested to by no lesser a contemporary than his friend Picasso, with whom Murphy had a reunion on a return visit to Paris in the summer of 1938. They were discussing the work of modern painters, and Picasso suddenly said, "After all, Gerald, that is what you and I did."

Murphy got his inspiration from what his eye was drawn to, as he put it, "in the cafés, on the street, in the music halls, at the circuses . . . everywhere in the world of the people. . . . It was the era of the 'populo' in all the arts." Oddly, if Murphy's painting showed a similarity to the work of another artist of the period, it was that of Stuart Davis, which Murphy did not even see until he returned to the United States in 1932, three years after he stopped painting. Nevertheless, the influence of the Paris artists was there, as Murphy explained to McAgy: "One saw the café table with its glass and *Le Journal* through the eyes of Picasso, Braque's pears and

grapes in the market, Léger's railroad signals in the freight yards."
It was Picasso who made the greatest impression, due to the quality
of his work, his strength of character, and the fact that, with the
single exception of Fernand Léger, Picasso was the painter Murphy
came to know the best: "Companionship with Picasso nourished
and stimulated enormously one's personal view of the visible and
invisible world. Once, in Paris, he saw tacked on the wall a ma-
quette in watercolor of my design for the *pavillon particulier,* the
owner's flag, of our schooner, *Weatherbird.* It was an abstraction of
the human eye in black, white, and red on a yellow ground and had
been devised to appear to wink as it waved in the wind. . . . *'J'aime
beaucoup les choses que vous faites,'* he said. I still feel, undiminished, the
satisfaction I felt then."

The *Newsweek* reviewer of the one-man exhibition in 1974 put it
nicely: "Murphy tried as man and artist to rise above the bumptious
culture in which he lived. He failed, of course, in life. In art, he did
it, briefly, intensely, and completely."

* * *

My father is a recognized artist and better remembered now for it, but
to those who knew them, what was Gerald was also Sara, just as what was
Sara was also Gerald. They were regarded as a unit, "the Murphys," never
as Gerald or Sara individually. Betty Dos Passos, who met my parents
when she became Dos's second wife in 1949, was struck by the way they
complemented each other: "It seemed . . . as if they were two manifesta-
tions of a single personality." No one was more aware of this than my
mother, who drew an analogy from the Bible. "We are, I suppose, Mary
and Martha in a sense. Neither of us has much value without the other
. . . ," she wrote in 1918 to my father, who was in the Army, training for
combat in France. He was, as he put it, "at the gangplank" when the
armistice was signed. "Jerry dearest," my mother's letter continued, "let's
never separate again, for business or any reason. . . . Because without you
I am only existing—I am less than half of myself."

Except in those early letters, Mother never to my knowledge called my
father "Jerry." He was "Gerald," though she would often refer to him as
"Dow-Dow," which is the name I gave him at an early age, a name my
brothers and I—as well as a few intimate friends, such as Archie MacLeish
—always used. My father often called my mother "Sal."

My parents met in East Hampton, New York, in 1904. Mother was

originally from Cincinnati, Dow-Dow was born in Boston. Their families had moved to New York for business reasons. After an eleven-year courtship, they were married on December 30, 1915.

In another of the early letters, Mother alluded to her reliance on Dow-Dow in the raising of children, a girl in particular. Although I know she adored me, she was more comfortable with sons and believed "that if one or the other of us had to bring up Honoria alone, how much better it were you." From her, I would receive "a stern uprightness and a discriminating sense of . . . worth. . . . But what of the tender poetic expressions of herself that she would not be afraid to give out of her secret soul to you? . . . Perhaps I would be better for a boy. Do you think so?"

Mother was the more decisive of my parents, and Dow-Dow well realized how much he depended on her. He would dream of distant shores, which would prompt him to confide in Mother, as he did from Cambridge in 1919, when he was a graduate student at Harvard studying landscape architecture: " . . . possibly this is the period of our navigation between Scylla and Charybdis [a reference to some difficulty with their respective families], but we have seen the shore ahead and will reach it, if there be no loss of command."

It would be up to Mother, however, to exert that command. Fluent in French, German, and Italian, she had often traveled abroad. Her familiarity with the way of life in foreign capitals, London and Paris in particular, enabled my parents to initiate their European experience, sailing for England in June 1921 with three young children. I was three and a half, Baoth was two, and Patrick was eight months. In explaining it to Calvin Tomkins in January 1962, my father wrote: " . . . we elaborated on a technique [Sara] already knew. I organized, executed, and sometimes coloured it."

The reasons my parents went off to Europe, not as tourists but with their passports stamped "foreign residents," are quite complex: there is a surface level of explanation, and there are elusive answers, which are more meaningful. Unraveling them is not unlike understanding a poem by Robert Frost, which can be read for its descriptive beauty, as well as for the deeper implications that Frost intended.

As a landscape architect, my father wanted to see the renowned gardens of England, so we spent the summer in London and at Croyde Bay in Devonshire. But there had been a frightful drought that year, and the gardens were burned to a crisp. Actually, Dow-Dow's interest in landscape architecture was a fleeting one, and he soon tired of it. He had gone to Harvard to avoid making a career of the family business, Mark Cross, merchandisers of leather goods and other furnishings. "It is unsatisfactory

to perpetuate something that has been made by someone else," he later wrote. The "someone else" was his father, Patrick Francis Murphy, who had built the Mark Cross Company out of a small saddlery shop in Boston and moved it to New York.

In early September 1921, we were living at the Hôtel Beau-Site in Paris. Mother and Dow-Dow had joined a social group of Americans, which numbered several old friends. They included the only two who had remained on good terms with my father from his undergraduate days at Yale: Cole Porter, who was on the verge of achieving fame in the world of music; and Monty Woolley, the actor, who would become best known for his role in *The Man Who Came to Dinner* by George S. Kaufman and Moss Hart.

Dow-Dow had few fond memories of his days at New Haven, even though he had been voted "best dressed man" and "most thorough gentleman" of the class of 1912. He steadfastly refused to communicate with his class, even to answering inquiries as to his address, occupation, and so on. Archie MacLeish had also gone to Yale, but he and Dow-Dow were three years apart, and they did not know each other there. "The first time I laid eyes on your parents was when I was at the Harvard Law School," Archie told me. "I looked down a street in Cambridge one day—in 1919, I believe it was—and there was this couple. I thought to myself, 'I would like to know those people. They look so well-laundered.' "

* * *

MacLeish did not meet the Murphys until he had abandoned law and had himself gone to Paris, to pursue a career as a poet. Even then, there was a reluctance among mutual friends to introduce Archie and Gerald, as it was known that Gerald harbored animosity toward Yale men, in general, and members of his secret society, Skull and Bones, in particular. Whatever it was that had caused the bad feeling, it had involved the society or certain members of it. "I don't know what it was," Monty Woolley wrote Calvin Tomkins in 1961. "Of course, Skull and Bones is . . . a very secret organization. And so Gerald has never revealed just what took place. But it must have been something rather formidable." MacLeish also had been Skull and Bones, and that, it was feared, might have stirred Gerald's resentment. "We did meet, though," Archie remembered years later, "and we started to talk, and we became the greatest of friends from that moment on and never stopped talking." In their forty-year friendship, however, the subject of Skull and Bones was never brought up.

Always more important than the social life of Paris was the cultural nourishment that was provided, and the Murphys soon found themselves drawn together with other Americans, writers for the most part, "by the fact that they shared the same interests," as Gerald later explained to Tomkins. "They were struck by the music of Les Six [a group of outstanding French musicians, also named 'The New Young' by the composer Erik Satie, who was their mentor]; they went to the [Jean] Cocteau ballet, *Le Boeuf Sur le Toit,* which was performed by the Fratellinis [the famous family of circus acrobats] at the Cirque Medrano, with music by [Darius] Milhaud [the composer and a member of Les Six]; they went to all the premieres of the Russian ballet." And Arthur Rubinstein, not yet recognized as a great pianist, would play at the Murphy house for the small fee he could command.

Not all of the expatriates were writers, of course, and there were social, as well as cultural, events of note. There was, for example, Gerald Murphy's Yale classmate, William Bullitt, who became U.S. Ambassador to the Soviet Union and to France. In 1923, Bullitt was married in Paris to Louise Bryant, the widow of journalist John Reed, who had chronicled the Russian Revolution and had been buried in the Kremlin wall. Bullitt hardly knew Murphy, despite their Yale connection, but when he was the ambassador to France right before the second world war, he made the acquaintance of Sara's sister, Mary Hoyt Wiborg.

* * *

That my father lived and dressed the part he was playing in Paris was attested to by William Lord, who remembers much better than I do, as I was just four and a half in the summer of 1922. Bill Lord was class of 1922 at Yale, and he had come to Paris shortly after graduation. He was introduced to Dow-Dow by a friend one evening in July at the Café de la Paix. "I don't remember anything else but this striking picture of your father," he told me. "He was wearing a black broad-brimmed hat—I guess it was a Parisian artist's hat, . . . and he was sporting red sideburns."

My parents' chief reason for leaving the U.S. was to seek cultural nourishment, but there were other factors—negative factors, if you will. There was, for one, a restlessness, which was a reaction to American social and business customs. This was true especially of my father. Then, too, both my mother and my father had rather uncomfortable family situations.

Patrick Francis Murphy was a strict Spartan. He had little patience with

illness, especially if it was the least bit psychological. "Only you, Sara, could stand being married to Gerald," he would say, referring only half in jest to Dow-Dow's occasional black moods. He was also less than subtle in his disapproval of my father's disinclination to pursue a business career.

Dow-Dow was also affected by the oppressive influence of his mother, Anna Ryan Murphy, who was so devout in her Catholicism that she moved my father's birth date from March 26, 1888, to March 25, which marks the Feast of the Annunciation. (Before he died, my father set the record straight by seeing to it that his gravestone would be marked with the correct date of his birth.) Her fervor surely had a lot to do with Dow-Dow's decision to leave the church at an early age, although he attributed it to harsh treatment by nuns while attending a parochial boarding school.

My mother's family was, in her own terse way of summing up things, "powerful." Her father, Frank B. Wiborg, was a self-made millionaire, the co-founder of Ault & Wiborg, a very successful printing-ink company. By reason of many years of hard work, he tended to be a bit hard-boiled. Her possessive mother, Adeline Sherman Wiborg, demanded her constant attention and stubbornly opposed my parents' marriage. Mother also had a strong-willed sister, Mary Hoyt, who had a way of getting people to do her bidding, in my father's estimation, "by subjugation and domination."

There were three Wiborg girls, and my mother was much closer to her other sister, Olga. They had spent much of their early life at East Hampton, a Long Island summer resort. Frank Wiborg had come there in 1900 and started buying property. In 1910, he began building on his largest tract, which consisted of approximately eighty acres, bounded by the Atlantic Ocean on one side and Hook Pond, a tidal tributary, on the other. The house he built, which was torn down in 1941, was said by oldtimers to have been the largest in East Hampton.

The idea that my parents and others left the United States because of Prohibition—an interpretation that has been widely circulated—is an oversimplification, and it ought to be discounted. I can speak only for the Murphys, but their discontent had to do with an absence of cultural stimulation in America, a philistine attitude that was ably illustrated by the biographer of my parents' close friend Dorothy Parker. "During these years," John Keats wrote, "a French delegation asked President Coolidge whether the United States wished to be represented in an international art exhibition to take place in Paris. President Coolidge said, 'No,' explaining that there were no painters in the United States."

My parents always maintained that there was nothing anti-American about their expatriation. As my father later described the European experience, "What we lived was a contemporary American version. We were in close touch with the U.S.A. at all times. . . . You were made to feel proud of being an American. When Lindbergh made his flight, all our French friends at Antibes sent us sheaves of flowers with red-white-and-blue ribbons." On the day after Lindbergh landed in Paris in May 1927, Dow-Dow wrote to Ernest Hemingway from the Villa America, our house in Antibes: "Thank God that somebody like Lindbergh does something like what he's just done. . . . It tightens the main spring."

By going to France, my parents did not sever family ties entirely, nor was that their intention. They remained close to their parents and were joined in Paris by my father's brother, Fred, and his sister, Esther, and by my mother's sister Mary Hoyt. In fact, of the five family expatriates, Mother and Dow-Dow were the only ones ever to return permanently to America. Fred died in Paris in 1924 of medical complications, which were related to his wartime service as a tank officer with the American Expeditionary Force; his widow, Noel Haskins Murphy, was still living outside Paris when I visited her in June 1981. Esther, a literary scholar whose unrealized ambition was to write a definitive biography of Edith Wharton, died in Paris in 1962. Hoytie, as Mary Hoyt was called, had sailed for France in 1918 as a nurse attached to the French medical services. She received the Legion of Honor, which enabled her to live for the rest of her life, except during the German occupation, in a low-rent but luxurious apartment owned by the City of Paris. She died in Paris in 1964.

In the spring of 1924, Esther introduced Scott and Zelda Fitzgerald to my parents, who were attracted to them right away. They considered their legendary revels to be slightly amusing, at least at first. The Fitzgeralds would appear, for example, in the middle of the night at our house in Saint-Cloud, looking for an impromptu invitation. They would call up to the window and say they were sailing the next day on the *Lusitania,* which, of course, had been sunk in World War I. From the cool reception they got, Scott and Zelda soon realized that the Murphys were not impromptu party people.

We lived at the time in what had been the residence of Gounod, the composer. It was the setting for the poem by Archibald MacLeish, "Sketch for a Portrait of Mme. G—M—," in which he was able to capture Mother's exquisite talent for making a residence an embodiment of herself:

> *. . . old Gounod*
> *Who'd written Mireille in the room and played*
> *The airs from Baucis on the grand piano*
> *And wasn't, you would understand, a man*
> *To leave his mortal habitation empty*
> *No matter how the doors had closed on him.*
> *And yet you'd say, "Her room," as though you'd said*
> *Her voice, Her manner, meaning something else*
> *Than that she owned it; . . .*

My father maintained that the friendships with the American expatriate writers—Fitzgerald, Hemingway, MacLeish, Dos Passos, Robert Benchley, Dorothy Parker, Philip Barry, Donald Ogden Stewart, and others—just happened as a result of a common interest in cultural events. I suspect there was more to it than that, for nothing ever occurred by chance where my father was concerned. Any event in which he was involved was planned in detail, as if by the director of a play, which in effect Dow-Dow was, except that the plays were real-life episodes.

In Paris, the stage for many of those episodes was the Diaghilev ballet, to which my parents not only lent their skills as set designers but also made financial contributions when the company was in need. Further, they attended every premiere and every rehearsal, and they invited their American friends to come, many of whom did. It was not intended, however, as a casual gesture, and my father would never understand why E. E. Cummings, who had come to a rehearsal with John Dos Passos one day, rudely refused to be introduced to him and Sara. Dos was embarrassed, but he tried to make light of the incident by saying that he never liked to mix his friends.

* * *

Few, if any, of the Murphys' encounters with exponents of the arts were as unsettling as the one with the American poet E. E. Cummings. "[James] Joyce came with Ernest once," Gerald wrote Calvin Tomkins in 1962, obviously relishing the memory. "At the sight of the piano (as he came in the door), he walked over to it, sat down, and accompanied himself to what he called 'my Irish reper tory.' " Through their association with the Diaghilev ballet, especially, they were in contact with European masters: some, such as Picasso, were amiable companions, whose friendship would endure

for years; others, like Cocteau, endeared themselves by being ex-
tremely amusing. It was Cocteau, for example, who made a memo-
rable Murphy party to celebrate the premiere of Stravinsky's ballet
Les Noces—a dinner aboard a barge on the Seine—even more memo-
rable: he donned the captain's dress uniform and went from port-
hole to porthole, announcing, *"On coule!"* ("We're sinking!"). Still
other great artists were, not surprisingly, a bit distant. Sara and
Gerald were not affronted—on the contrary, they were honored just
to be invited each time a new Stravinsky piece was performed at the
apartment of the Princesse de Polignac, who was originally Wini-
fred Singer, an American. ("All those sewing machines," Gerald
liked to say.) Stravinsky, in fact, could be a bit intimidating. One
day, at a ballet rehearsal, he demanded that a heavy scarf be cut
from around the neck of the ballerina Nijinska, so she could hear
his commands. When Sara produced a pair of scissors from her
pocketbook, Stravinsky said gruffly, "Only Americans carry scis-
sors."

There was a story about Diaghilev and Picasso that Gerald Mur-
phy savored—it was, perhaps, his favorite reminiscence, for it was
a first-hand account of the influence of one artist on another. It had
to do with "the day Diaghilev said to Picasso, 'You are coming with
me to Rome. I am doing a ballet based on the music of Scarlatti.
. . . I shall douse you in the Commedia dell' Arte of which you know
nothing, since you never leave Paris. I will arrange what you are to
see there.' Three days before they left [Rome]," Gerald continued,
"Diaghilev told Picasso to spend the rest of his time looking at
nothing but Roman sculpture. . . . 'Something will come of it,' he
said. Well, it did: those great big girls, which Picasso did on the spot
in pastel, they with their huge cylindrical fingers, monolithic heads,
and thick eyelids, but running like gazelles down beaches on their
piano legs. What a boy, Diaghilev!"

* * *

Dow-Dow insisted there was nothing clannish about the circle of his
and Mother's friends. "It wasn't a clique, it wasn't a coterie." He deplored
the very idea of belonging—to his college class, to any association, society,
club, set, whatever. As for Mother, she feared out of genuine modesty that
any attention paid to the reputations of the Paris friends, most of which
were made *after* the era of the twenties, would reflect poorly on her and
Dow-Dow. " . . . we ourselves did nothing notable except enjoy ourselves,"

she wrote in 1959 to Dos Passos. She was seeking his advice on their being the subjects of Tomkins's *New Yorker* profile. "And now, at this late date, it would seem like loathsome name-dropping."

That did not appear to be the case when the article was published, but it tells you something about Mother: for a woman as gifted as she was, she was an unassuming person. She once wrote my father of her belief that worldliness was an "ill-fitting garment," even though she had traveled widely since early childhood. Her sister Hoytie, she said, was the worldly one.

Hoytie was also the socialite of the family. She preferred the company of European nobility to that of intellectuals and artists. An old friend of my parents, Hester Pickman, whom they had met in Boston when Dow-Dow was at Harvard, tells a marvelous story about Hoytie. Arriving at the opera house in Paris one day to find Mother and Dow-Dow chatting with Picasso and Goncharova, she demanded, "What are you all doing here, wasting your time?"

The Diaghilev ballet was not the only beneficiary of my parents' generosity. They had a comfortable income from Mother's inheritance (her mother had died in 1917, the year I was born, and her father had divided his substantial fortune among his three daughters and himself), and they were happy to share with their friends, many of whom were struggling. Hemingway was quite poor when they first met him in 1925, and he and Hadley, his first wife, were living in a modest flat over a sawmill, which MacLeish described in a poem, "Years of the Dog."

> . . . *the lad in the Rue de Notre Dame des Champs*
> *at the carpenter's loft on the left-hand side going down* . . .

The Hemingways' son, John, or Bumby, I was told, had to sleep in a dresser drawer. Dos Passos, who was ever on the go gathering material for his books, was often short of cash. "Tell me how many dollars you want," Dow-Dow wrote to Dos, who was touring Russia in 1928, "and the Guaranty Trust draws on our account."

From reading my parents' letters, I am reminded of how they resisted the idea of settling down. When first married and living in New York City, they talked of moving to a farm. Then there was Paris, then Antibes, where they established what Dow-Dow called "our real home," the Villa America. I never called any place "home," however—the word was not in my vocabulary. For even after we had bought the villa in Antibes, our travels

continued. There were a monthly trip to Paris, and periodic visits to the United States—quite a few of them, for as a child I sailed across the Atlantic sixteen times. My father did not like to be asked about his plans for the future. If he was, he would inevitably reply, "I don't know yet."

We spent the summer of 1922 at Houlgate, on the northwest coast of France, with Monty Woolley and our friends from Boston, the Pickmans. But Mother and Dow-Dow found the climate in Normandy a bit chilly, so they went for two weeks to visit Cole Porter, who, as my father once explained, "always had great originality about finding new places." The Porters had taken the Château de la Garoupe at Antibes, which was in itself original, for the season there had traditionally ended at the beginning of summer.

My parents were so impressed with the Riviera that Dow-Dow acted out of character and "set the stage for the future," as he confided to my brothers and me. He had persuaded the manager of the Hôtel du Cap, Antoine Sella, to permit us to spend the following summer at the hotel. Before that summer had ended, he and Mother had bought an old villa just below the Antibes lighthouse, which they would renovate and name the Villa America. My mother and father have since been credited with starting the summer season on the Riviera.

We stayed at the Hôtel des Reservoirs in Versailles over the winter of 1922–23 and went, as planned, to Antibes in June 1923, immediately following the premiere of Stravinsky's *Les Noces.* Then my father went to Venice for a month—Mother went for two weeks, leaving us with a nurse —to work as a set designer with Cole Porter on *Within the Quota,* which was performed in Paris in October 1923 by the Swedish ballet company.

For the following year and a half we were on the move, as family records indicate: winter of 1923–24, a return to Versailles; we took the Gounod house in Saint-Cloud in April 1924, and Dow-Dow rented a studio at 69 rue Froidevaux in Paris; another summer at the Hôtel du Cap in Antibes; a trip to America in the fall; a winter holiday at Château d'Oex in the French Alps; a visit to Antibes in March 1925 to see how the renovation of our villa was progressing. Finally, in the summer of 1925, we were able to move into the Villa America, and that fall my parents rented what would become their "Paris headquarters," an apartment at 23 quai des Grands-Augustins.

Dow-Dow also found time to develop an interest in ocean sailing. It had been stimulated by Vladimir Orloff, a young Russian and a cousin of Diaghilev, who was employed as a set designer for the ballet company when my parents volunteered their assistance. Orloff had become a marine

architect at seventeen, and later, as a naval cadet, he was wounded in an encounter with a German gunboat in the North Sea. He was at home in Moscow, convalescing, when two men, presumably Bolsheviks, came to the door, asking for his father, who had been the Czarina's banker. Before Vladimir's eyes, one of them shot and killed his father. He fled to Paris, having sent his mother, an accomplished pianist, to Kiev, her birthplace. He never saw her again, though he learned from letters that she had been forced to clean streets to survive.

Vladimir and my parents became very close. He was employed by them for nearly twenty years, but he was a friend, not a servant, although he occasionally would call Mother *Madame.* He shared their excitement for painting, music, and literature, and he was especially fond of Mark Twain. I remember him best, however, as our tutor and as a storyteller. There was one story about Mowgli, a boy who had been raised by wolves, which he told in lovely Victorian French. He would build suspense by telling segments of the story each night, just as they did on radio mysteries.

My father learned from Vladimir some basic painting techniques, such as the preparing and the mounting of a canvas, and he was also assisted by Vladimir, both at the studio on the rue Froidevaux in Paris and at my father's atelier at the Villa America in Antibes.

When we moved into the villa, Vladimir came to live in the village of Antibes, and the combination of living on the sea and Vladimir's influence made a sailing enthusiast of my father. They went to Marseilles, where they found an eight-meter racing sloop, which had been retired. Vladimir outfitted her with a new set of sails, cut from Egyptian cotton, reducing the sail area from what had been required for a racing rig. He rebuilt the interior of the small cabin, installing three bunks; and he painted the hull black. She was named *Picaflor,* for the seagulls in the port of Marseilles.

The first two cruises taken on *Picaflor* by Vladimir, Dow-Dow, and Archie MacLeish were far from successful. On the first, they were becalmed for an entire day and baked in the hot sun. Ten days later, when they went out again, the winds were so high and the seas so rough, they barely managed to put in for the night at St. Tropez. Exhausted and angry, my father said to Vladimir, "And that's what you call the pleasures of the sea. Do what you please with the boat. Sell it." The weather turned for the better, however, and a week later, Vladimir received a cable from Dow-Dow: "Keep the boat. I'm coming back." From then until the last of our three boats, *Weatherbird,* was sold in 1942, Vladimir was our captain.

* * *

In 1925, the value of the franc in American currency rose to 24.7 cents, nearly double what it had been in 1921, the year the Murphys sailed for Europe. The escalating rate of exchange sent many Americans home, but there is nothing to indicate that Sara and Gerald gave it a thought, any more than they were concerned about international affairs or about what was happening economically or politically at home. Much as Gerald sympathized with the plight of the White Russian family of his friend Vladimir Orloff, he reacted to the Bolshevik revolution with only mild curiosity. Certainly he was not one to engage in a passionate defense of the capitalist system, although it had enabled his father, and Sara's, to rise from humble origin to a place among the mighty of enterprise, as pioneers, respectively, in merchandising and manufacturing. In a letter to Dos Passos, who was touring Russia, he expressed surprise that Communism functioned as well as Dos had reported, asking if there was not much poverty and suffering. But he did not ask out of alarm: "Not much more than New York, I guess." This indifference would change in time, as the U.S. economy collapsed (with direct effect on the respective Murphy and Wiborg business enterprises), and as early signs of world conflict could be detected. While essentially American patriots, the Murphys were not predictable politically. They tended to be drawn to the causes of their literary friends: with Hemingway and Dos Passos, it was the Loyalist side in the Civil War in Spain; with Dorothy Parker and Donald Ogden Stewart, it was the merits of Marxism. For the moment, however, the Murphys' concerns consisted almost entirely of family pleasures, the company of close friends, and cultural enrichment. As of late 1925, the center of all this was the Villa America.

The Villa America was a fourteen-room house on seven verdant acres of gardens, the multicolored rows of which ran down a gentle slope toward the Mediterranean, the "burnished blue-steel" Mediterranean, as Gerald Murphy liked to call it. For two years, with methodical care, the Murphys renovated the house and configured the landscape in much the same way that Gerald created a painting —step by step, piece by piece. The result was captured by Philip Barry, the author of several plays, including *The Philadelphia Story.* He had visited the villa often, and he used it as inspiration in setting the scene for a play he wrote in 1933, *Hotel Universe.*

"The Terrace is like a spacious, out-door room," Barry wrote, "irregularly paved with flags of gray stone. The house itself forms

one wall on the left, a wall from which two screened doors open—the first from a hall, the second from a sitting-room. Down Left, against this wall a flight of outside stairs, guarded by a slender iron railing, mounts to a balcony.

"The other entrance is at Right, down from the garden by stone steps. A three-foot wall follows the back and left sides of the Terrace just to where the row of small cypresses, which screens the garden terrace, begins. Over and beyond the wall nothing is visible: sea meets sky without a line to mark the meeting. There, the angle of the Terrace is like a wedge into space."

It is probably significant that during the restoration of the villa the Murphys were in close contact with Picasso, who also had spent the summer of 1923 at the Hôtel du Cap, with his wife, Olga, a Diaghilev ballerina, his son, Paolo, and his mother, Señora Ruiz. Gerald was impressed with Picasso's "inexhaustible sense of . . . the grotesque in everything. . . . There was no formula for it. What he said had infinite variety and was unpredictable. . . . He was a powerful physical presence." What Sara and Gerald had to work with, rather than oils to be brushed on a canvas, was a seventy-year-old tropical garden in which there were "the finest examples of Mediterranean planting, including trees thirty feet high," as Gerald wrote when it came time to sell the villa, which he did in 1951. "Many of the rare plants and flowers were brought from the Near Eastern countries to which the former owner was the French military attaché. These include white Arabian maples, desert holly, persimmon, many varieties of mimosa, eucalyptus, palms of many kinds, genuine cedars of Lebanon, et cetera. The further part of the property contains an old *Provençal bastide,* or farmhouse, which is now an independent guest house, below which [are] the terraced vegetable gardens, fruit orchards of orange, lemon, and tangerine trees . . . olive trees . . . and nut trees." In addition, there were a number of other buildings—Gerald's studio, Honoria's playhouse, a gardener's cottage, chauffeur's quarters, donkey stable, shed, storehouse, wine depot, and, across the road at the bottom of the hill, a separate little farm named La Ferme des Orangers, which the Murphys had renovated after moving into the villa.

Actually, the Villa America was the farm Sara and Gerald had dreamed of when they were first married. There were two cows, whose milk they shared with the MacLeishes, who had rented a villa nearby; there were money crops—oil-producing olives and

bitter oranges, the buds of which are a perfume base; and there was Sara's garden, planted with a variety of herbs: sorrel, tarragon, thyme, rosemary, oregano, chives, basil, dill, parsley, shallots, and more.

To design the remodeled villa, Sara and Gerald hired two Americans, Hale Walker and Harold Heller, who would work on Murphy residential renovations for over twenty years to come, in East Hampton and in Snedens Landing, New York, on the Hudson River. It was Gerald, however, who directed the planning and design of the villa, drawing on his "intuitive sense of the future," as Ellen Barry, widow of Philip Barry, has described it. The roof was flat, sturdy enough to walk upon; thus it was probably the first sun deck to be seen on the Riviera. The downstairs floor was waxed black tile, the interior walls were painted white, and the fireplace was framed with mirror glass. The furniture, with not a period piece to be seen, was covered with black satin. Outside, the house was beige with yellow shutters, and the terrace, sheltered by a silver linden tree, was the scene of seated dinner parties on metal chairs painted silver with hot-water radiator finish. As work proceeded on the Villa America, the Murphys were involved in another renovation project in Paris, at 23 quai des Grands-Augustins. They had acquired two floors, one for themselves and one for their children, of the only remaining coachman's quarters dating to the reign of Francis I, 1515–47.

At the time they were moving into the Villa America, the Murphys were on intimate terms with both the Fitzgeralds and the Hemingways. For Gerald—although they tried his patience at times, and he would come to pity them for their emotional difficulties—the ties to Scott and Zelda were particularly close. "We four communicate by our presence," he wrote them in September 1925. "Scott will uncover for me values in Sara, just as Sara has known them in Zelda through her affection for Scott." Sara's love for Scott, on the other hand, was akin to that of a long-suffering mother for an outrageous child. "But you can't expect anyone to like or stand a continual feeling of analysis and subanalysis and criticism," she scolded in June 1926, having become annoyed by Scott's piercing scrutiny of her and Gerald. "If you don't know what people are like, it's your loss. . . . If you cannot take friends largely and without suspicion, then they are not friends at all." She signed the letter, "Your old and rather irritated friend." It is true, too, that Scott often

got drunk and misbehaved: his punishment for deliberately breaking three of Sara's favorite champagne glasses one evening—an act of wanton naughtiness that is best explained by Fitzgerald's need to be the center of attention—was banishment from the Villa America for three weeks.

Gerald Murphy and Ernest Hemingway were the antithesis of one another in many character traits, so they were not as close personally as Murphy was to Fitzgerald, but Gerald's admiration for the ability of the talented young writer from the Midwest (Hemingway was not yet twenty-six when he was introduced to the Murphys in Paris by John Dos Passos in 1925) was boundless. "We read it the other day and were blown out of the water alive," he said in a letter to Hadley Hemingway after reading an unfinished manuscript of *The Sun Also Rises.* And later, to Hemingway himself: "Those Goddamn stories of yours kept me rooted and goggle-eyed all the way to Germany the other day. I never even saw France. . . . 'A Canary for One' is made of incorruptible stuff, if you will. My God, but you've kept your promise with yourself." As for Sara, she adored Ernest and would not hear a disparaging word about him, even from other close friends, many of whom—Zelda Fitzgerald was one—had reservations about Hemingway. The Fitzgeralds and the Hemingways had themselves recently met at the time they were getting to know the Murphys. "She's crazy," Ernest had said of Zelda, shocking Scott with his brutal candor. Zelda got her revenge, though. Aware that Hemingway was extra-sensitive about his masculinity, she said to him one day, "Ernest, nobody is as male as all that." Gerald asked her once what she had against Hemingway, and Zelda replied, "He's bogus."

In March 1926, the Murphys, along with John Dos Passos, went to visit Ernest and Hadley at the Hemingway retreat in Schruns, in the Austrian Tyrol. "Skiing was just becoming popular then," Gerald later wrote, "and there was a hotel called the Madelena House that was one of the first ski resorts. We left the girls down in the valley, in Bludenz, and climbed up to the top. Dos has always had hugely powerful legs and a tremendous restless energy, and Ernest was an expert climber. I struggled along, trying to keep up with them, and felt terribly ashamed that I was holding them up. . . . I was determined to learn how to ski in the two days we were up there. Ernest always gave you the sense of being put to the test, and he was an absolutely superb skier. . . . I had spent two days doggedly

practicing and falling down and had learned the rudiments. . . . Dos didn't bother to learn, because his eyesight was so bad, he knew it was no use. When we started down, Dos just decided to go straight and sit down whenever he saw a tree. . . . I managed to get down the first part without falling. Then, in the second part, we had to go through a forest. I managed that pretty well too, falling only once or twice. Ernest would stop every twenty yards or so to make sure we were alright, and when we got to the bottom, about a half an hour later, he asked me if I'd been scared. I said, yes, I guess I had. He said then that he knew what courage was, it was grace under pressure. It was childish of me, but I felt absolutely elated." Gerald was endowed with more than his share of grace under pressure. Once, when swimming off the Lido in Venice, he was warned he was in danger by lifeguards, who cried, *"Pericoloso! Pericoloso!"* Gerald broke stroke just long enough to raise a forefinger and say in Italian, "So is love dangerous."

In June 1926, the Hemingways, the Fitzgeralds, and the Mac- Leishes all came to the Riviera. Ernest came on his way back from Spain in the beginning of the month. Hadley had been staying with the Murphys at the Villa America, but when their son, Bumby, was found to be suffering from whooping cough, she put him in quaran- tine in a villa that had been leased by the Fitzgeralds, who moved to another beach house nearby. Hemingway's arrival was the occa- sion for a small champagne-and-caviar party, hosted by the Mur- phys, at a nightclub in Juan-les-Pins, a resort near Antibes. Fitz- gerald behaved appallingly: he made disparaging remarks about the affectation, as he saw it, of serving champagne and caviar; he stared rudely at a pretty girl; and he lobbed ashtrays over to a nearby table. Gerald walked out in anger, and Sara sent Scott a scathing note the next day. "And last night you even said that you had never seen Gerald 'so silly and rude,'" she wrote. "It's hardly likely that I should explain Gerald—or Gerald me—to you. . . . And if Gerald was 'rude' in getting up and leaving a party that had gotten *quite bad,* then he was rude to the Hemingways and MacLeishes too. No, it is hardly likely that you would stick at a thing like *Manners*—it is more probably some theory that you have. . . . But you ought to know at your age that you Can't have Theories about friends. . . . We *Cannot* . . . at our age . . . *be bothered* with Sophomoric situations like last night."

She assured him that "we are *literally,* and *actually* fond of you both," but the Murphys' fondness for Scott was at a low ebb. Beyond his bad behavior, he shared no mutual interests with them —neither cultural nor even social ones. Scott had no taste for fine food, and he seldom joined the Murphys' bathing parties on La Garoupe at Antibes. This disturbed Sara and Gerald, who were admired for creative taste in all social endeavors, be they at the dinner table, on the beach, or in any setting. Scott, however, was no doubt more bothered, given his tender pride, by something else he must have sensed: the Murphys were not nearly so impressed with his writing as they were with Hemingway's. Fitzgerald treasured the Murphys' esteem, Sara's especially.

There is a unique reason the Murphys felt a special affinity for the Hemingways in the summer of 1926: compassionate people, they tended to gravitate toward friends in trouble, and they were just becoming aware that the Hemingway marriage was breaking up. The year before, Ernest and Hadley had met the Pfeiffer sisters, Pauline and Virginia, wealthy American women, who had come to Europe for the social advantages. Pauline, though, had been hired as an editor of the Paris edition of *Vogue,* and Ernest admired her for that. To the Murphys, who later became good friends of both Pauline and Jinny, the Pfeiffers were friends of Hadley, so they saw nothing out of order in Ernest's suggestion that they all go to Pamplona for the bullfight festival in July—the Murphys, the Hemingways, and Pauline Pfeiffer. It was not until later that the Murphys learned that Hadley, the previous spring, had confronted Ernest with her suspicions about his love for Pauline, and he had angrily admitted that her assessment was accurate.

Ernest had been to Pamplona twice before, absorbing the sights and sounds that inspired the splendid visual imagery of *The Sun Also Rises,* the manuscript of which he was still revising (with help from Fitzgerald before departing for Spain). Many years later, Gerald told of the trip with the same excitement, punctuated by moments of apprehension, he had felt at the time.

"We went to the Hotel Quintana . . . and we were across a narrow corridor from the rooms of the matadors and their *cuadrillas* [their retinue]. . . . We'd look in at these matadors lying on their beds . . . surrounded by flowers and candles and staring at statues of their saints. . . . Ernest knew all of them, and he talked to them in Spanish,

. . . and of course they were amazed at this American with such a passion for bullfighting." During the running of the young bulls through the streets of the city, Hemingway suggested that they stand, protected, in a doorway, but when they got to the arena, where young Spaniards were in the ring taunting the bulls and being tossed in the air in some instances, he proposed that they give it a try. "My heart sank," Gerald recounted, "but being with Ernest, I just could not say, 'I think I'll stay here.' So I got up and went down, and I had never been so scared in my life. I had a raincoat with me, as it had been drizzling. . . . Ernest was watching me out of the corner of his eye. He didn't want me to get thrown, but he did want to see how I was going to take it. . . . Then, I saw this bull coming straight at me, and I held up the raincoat, but unfortunately I held it in front of me. . . . Ernest yelled, 'Hold it to the side!' I moved it just in time, and the bull went right by me, and Ernest said something about a veronica. It was terrifying, those animals with their heads down, and they are going to cut an aisle right through you."

Sara did not feel a need for Ernest's approval, though she received it anyway, and she did not care if her revulsion at the spectacle in the bullring was apparent. On the first day of the *corrida,* bothered especially by the sight of the broken-down horses of the picadors being gored by the bulls, she stalked out of the arena in disgust, though she returned the next day and actually enjoyed herself. Gerald, on the other hand, was self-conscious and fearful of Hemingway's judgment of him, so much so, in fact, that he could remember thirty years later what he had chosen to wear on the trip to Pamplona and how Hemingway had reacted to his choice. "I did not want to go there in a Panama hat or a straw hat from Brooks," he explained, "so I decided on a cap, . . . an old cap of Father's, a kind of golfing cap, which I'd always been quite fond of. I was relieved, with Ernest being a figure there, when he said, 'That's just the right thing to wear.' Gerald had also worn a gabardine suit, which was unusually light in color, a pearl gray, and when he noticed some townspeople pointing at him, he asked Ernest what they were saying. "They call you 'the man in the silver suit,' " he answered. "Do they approve?" Gerald wanted to know. "Yes," said Ernest, "they think it's fine."

Hemingway had fun, in a good-natured way, at the Murphys' mild expense. On the night of the annual fiesta, having been put up to it by Ernest, the crowd began pointing at Sara and Gerald and

chanting, *"Dansa Charleston."* The entire Murphy family had learned
the popular dance just that year from an American vaudeville team,
which had been appearing at a nightclub in Cannes. "They made a
circle in the middle of this great big square, and there Sara and I
were," Gerald explained. "The band started playing jazz. . . . Sara
and I stood up and took hands, with these floodlights on us and all
these Spaniards yelling, and we danced the Charleston. They were
delighted."

The Hemingways went on to Madrid from Pamplona, Pauline
returned to Paris, and Sara and Gerald rejoined the children in
Antibes. They immediately sent a note to Hadley and Ernest, ex-
pressing their feelings about the trip. "Sadie said," Gerald wrote,
" 'Isn't it a relief not to know why we feel as we do about Pam-
plona.' But it didn't prevent us from talking far beyond Toulouse
of what we thought we felt. It's the finest thing we've ever ex-
perienced."

On a visit to the Villa America in August, the Hemingways an-
nounced they were splitting up. Sara was privately critical of Had-
ley for having told Ernest she believed he was in love with Pauline,
because, Sara believed, it put the idea in his head and made him feel
guilty at the same time. While Sara preferred Pauline's company to
Hadley's, she was less concerned for the individuals involved than
for the institution at stake, the marriage. Of her own marriage, Sara
once wrote in a letter to Gerald: ". . . it should not be kept in a casket,
as other rarest jewels are, but shown, held high, so that its light may
be seen." Nevertheless, she and Gerald were sincerely sympathetic,
aware of how tormented Ernest was over the breakup of his mar-
riage. Shortly after seeing him in Paris in September, Gerald notified
Hemingway that he had put four hundred dollars in his bank ac-
count. "We couldn't leave, . . ." he wrote, "without acting on the
hunch that when life gets bumpy, you get through to the truth
sooner if you are not hand-tied by the lack of a little money. I
preferred not to ask you, so Sara said, 'Deposit it, and talk about it
after.' " He also offered the use of the studio at 69 rue Froidevaux,
and it was from there, in November, that Ernest attached a touching
note to a published copy of his short story, "Today Is Friday." He
was, he said, "about as happy as the average empty tomato can.
. . . However, I love you both very much and like to think about
you and will be shall we say *pleased* to see you."

The Murphys returned the sentiment. "My dear boy," Gerald wrote, when Ernest was living in the studio. "We said to each other last night and we say to you now that: we love you, we believe in you in all your parts, we believe in what you're doing. . . . Anything we've got is yours: somehow we are your father and mother, by what we feel for you." In a separate note, Sara added: "In the end, you will probably save us all—by refusing—to accept any second-rate things. Bless you, and don't ever budge."

Hemingway more than returned Sara's affection—his admiration for her was absolute. "I think he liked Sara so much, because he thought she was tough," Gerald once wrote. "He liked her briskness and her frankness."

Fitzgerald was equally fond of Sara. "Scott was in love with her," Gerald told Calvin Tomkins. "She fascinated him. Her directness and frankness were something he'd never run into before in a woman. . . . He was quite open about it, . . . but she knew how to handle his infatuation." Sara, in her modesty, said simply that Scott was in love with all women.

<p style="text-align:center">* * *</p>

It was always fun when the Fitzgeralds came for dinner. One particular evening, Scott said he had an exciting plan for the three of us, and he took two lead soldiers from his pocket. He told us there was to be a party for Scottie, the Fitzgeralds' four-year-old daughter, at which one of the soldiers, who was secretly a prince, would attempt to rescue a princess he intended to marry. The princess, he explained, was being held prisoner by a wicked witch in a castle, which was guarded by a dragon. The other soldier was a member of the witch's army.

When we arrived at the villa the Fitzgeralds rented in Juan-les-Pins on the appointed afternoon, Scottie greeted us and took us immediately to an oval area in the garden, thirty by fifteen yards, which was surrounded by round stones. In the middle, there was a castle that Zelda had made of *papier-mâché,* though it appeared to be constructed of gray stone. It had turrets and a tower, and there was even a moat, in which toy ducks were "swimming." And *there* was the princess, with long blond hair and wearing a white satin dress, standing at a window in the tower. Her arms were raised, as if to signal her distress.

On a field outside the castle, there were two armies of lead soldiers opposing each other in combat lines. They were dressed in uniforms of different colors: one was red and gray, the other was dark blue and black.

The prince stood at the head of the red and gray army. The toy soldiers were, we later learned, part of a collection Scott had had since boyhood.

After we had enjoyed lemonade and French cakes, excitedly mapping battle strategies all the while, Scott outlined the situation. The princess had been held for years by the witch, who was somewhere inside the castle. In addition to her army, the blue and black force, there was the dragon to contend with. Scott then pointed to a wooden cage, which was in front of the castle gate. In it was a hanneton, a type of beetle, which would play the part of the dragon.

We positioned ourselves around the battlefield, and Scott said, "Let's start." He deftly manipulated the soldiers from point to point, narrating as the action progressed, and we could see that the prince and his men were gradually gaining the advantage. Now and then, Scott would ask one of us to shift the position of a soldier or to remove a casualty. When the blue and black army had been sufficiently reduced in strength, the prince and his men surged to the dragon's cage.

Suddenly there was a loud crack, as a defending soldier cut the lock of the cage with his sword. Actually, Scott had snapped his fingers while holding the blue and black soldier and opening the gate. As the beetle came toward the prince, Scott said, "We will just turn him over on his back, which makes beetles helpless, you know." The "dragon" lay on his back, his legs wiggling, just long enough for the prince to get to the moat. Then Scott gently—and I will never forget how gently he did this—turned the beetle back on its legs and let it run off into the garden.

We all helped get the prince and his soldiers across the moat and into the castle. As the witch was captured and the princess was rescued, we could hear screaming and crying—it was Zelda, who was imitating the voices of the witch, the princess, and her lady-in-waiting. Zelda had spent weeks making their dresses. The princess had thrown down a rope, which the prince climbed. He reached her and carried her down the rope to a drawbridge across the moat. They ran hand-in-hand out the castle gate, and we cheered happily. It had been a beautiful day there, in Scott and Zelda's make-believe world.

"He certainly did arrange nice things," Zelda wrote my parents after Scott died in 1940. "That he won't be there to arrange nice things is . . . grievous."

The Fitzgeralds were going through difficult times in the summer of 1926. My parents had worried for some time about Scott's drinking. Dow-Dow would remark in dismay that just two drinks would make Scott very

drunk, or that perhaps there was always a residue of alcohol in his system. And Zelda, at twenty-six, had just decided to study ballet under Madame Egarova of the Diaghilev school in Paris, who had also been my teacher. "Honoria," said my father, who had arranged for Egarova to train Zelda, "in Russia they learn ballet at the age of seven. Zelda is determined to be as good as a Russian ballerina, and she is killing herself."

From the villa the Fitzgeralds rented at Juan-les-Pins, Scottie could see the lighthouse out on the *cap,* and she was fascinated. She would stare at it night after night and wonder what it was that made the light go round and round. I was just as baffled by the light as she was, though not as willing to admit it, for I was four years older than Scottie.

Scottie finally asked my father about the lighthouse, and he told her it was inhabited by fairies, who turned on the light at night to guide ships into port. He then invited her to go with him one evening to see if they could see the fairies. They planned the event for months, and Zelda made Scottie a filmy pink dress, so she would look like a fairy princess.

When the big night came, Dow-Dow got very dressed up—in a coat and tie, white Panama hat, and spats—to drive to Juan-les-Pins and pick up Scottie. We were all very excited. I, in fact, was a bit jealous and wondered if Dow-Dow loved Scottie more than he loved me. Scottie was to become —and still is—one of my best friends.

It was just before sundown when they returned, and Scottie's eyes were as big as saucers. She had become quite frightened as they approached the lighthouse, so they did not go inside. "The fairies might be busy," my father had said to her, "so we'll watch from close by."

I was ten years old in the summer of 1928, old enough to remember it vividly, and it was a summer well worth remembering, perhaps the happiest of my childhood. For the earlier years in Antibes, I am left only with impressions, because I was so young. Some are very strong, however, such as that of Picasso, in a black bathing suit and black Stetson, taking pictures of people on the beach. There is one of my parents that is particularly evocative, because you can see Picasso's hat on the sand next to them. I also recall that Picasso had a very long nail on the little finger of his right hand, and I asked him why. He said he used it to mix his paints.

Picasso, along with Olga and Paolo, were with us at the Hôtel du Cap in 1923, and at my parents' suggestion they took a villa at Juan-les-Pins for the following summer. Something very odd happened, however, in 1924. On their way from Paris to Juan-les-Pins, the train stopped for a half hour at Marseilles, so they got off and sat in the station. Picasso had a way

of becoming attached to a place, any place, in no time at all, and he said, "Let's stay here." So they spent the summer in Marseilles, and they never again, at least while we were there, came to Antibes.

Pauline and Ernest Hemingway, who had been married in 1927, were not in Antibes either in the summer of 1928—they were not even in France. Their first son, Patrick, was born in June, and Pauline, like Hadley with Bumby, had chosen to give birth in America. When my father learned they had named him Patrick, he wrote to John Dos Passos: "Ireland is doomed if *that* name is going to take on literary values and go the way of Michael, Shane, Moira, etc. I thought it was foolproof."

I was told that Patrick Hemingway had been named after Patrick Murphy, which made my parents quite proud. There was, however, a bit of bad feeling between Dow-Dow and Ernest over children's names. It extended even to nicknames, mine in particular. "I had always called Honoria 'daughter,' " Dow-Dow wrote Calvin Tomkins in 1962. "Ernest started using the term—except, I noticed, when I was present. He had been the first to call himself 'Papa,' and, I felt, considered that he had a better right to calling women 'Daughter.' "

Several other old friends were on the Riviera that year. There was Monty Woolley, for one, who had a full red beard and a booming voice. He and Dow-Dow would don formal attire, including top hats, and ride to town on a motorcycle, which caused quite a stir among local residents. Or they would play "stomach touch," which was a parody of two Yale alumni who had run into one another at a bar, and who would proceed to engage in a hail-fellow-well-met dialogue, which was full of collegiate clichés. As they conversed, they would physically address each other with protruding stomachs.

Bob Benchley, the humorist who went to Hollywood as a script writer and became a well-known actor, was also at Antibes. He and Gertrude and their boys, Nat and Bobby, who were roughly the same age as my brothers and I, stayed at the Ferme des Orangers, which Bob insisted on calling La Ferme Dérangée. There were Phil and Ellen Barry and their boys. There was Dorothy Parker, and John Dos Passos would stop by, though he was always on the run.

A typical day at the Villa America in that summer of 1928 would begin with the loud shouting, in Italian, of our farmer, Amilcar. *"Basta,* Violetta,"
he would cry, scolding the cow for kicking him at milking time. It was our signal to get out of bed, and Baoth, Patrick, and I would get dressed in our playsuits and troop to a table under the linden tree on the terrace for a

breakfast of hot cereal, bread and butter with jam, milk, and fruit. Then our tutor, Yvonne Roussel, would arrive by bicycle, and we would spend the morning on our lessons—arithmetic, English and French grammar, history. I was not all that keen on studying at first, and after Mademoiselle Roussel first came to be interviewed by Mother, I found her calling card and tore it up.

It was a special treat on certain days to be invited to watch our father paint. We would go to his atelier, or studio, where he and Vladimir Orloff were at work, and Dow-Dow would explain in minute detail what he was doing. Once, for example, he showed us a paintbrush with only two hairs. He had used it to recreate, in enlarged form, his own thumbprint for a painting he called *Portrait*. Dow-Dow gave *Portrait* to Vladimir, and it was subsequently lost, although the circumstances of its disappearance remain a mystery.

Every ten days, Monsieur Trasse, the barber, would come, carrying in the basket of his bicycle scissors, hair lotion, and towels. Dow-Dow was quite concerned about his hair, which had thinned considerably by age forty. He would always wear a hat while out in the sun, and, in time, he brushed it forward and had it cut in an oval shape, to give the appearance of fuller growth. He also wanted to offset the chubby look of his cheeks, his "Irish moon face," as he called it, which partially explains his preference for noticeable hats and for wide, loosely buttoned collars. My father was not fat; in fact, he was lean and athletic looking from swimming and doing exercises with my brothers and me on the beach.

Mother was not as conscious of the clothes she wore as Dow-Dow was, but she was extremely meticulous about her appearance. She kept abreast of the Paris fashions and dressed accordingly. Her brown hair, which was gold-flecked by the sun, was worn short in those days. She cut my brothers' hair, and throughout my early childhood she insisted that mine be kept in a short bob. Finally, when I was about ten, she allowed me to let it grow, to my great relief.

Just before noon, our father would announce, "All right, children, we're going to the beach." It was a delightful daily ceremony. We would get our string bags, filled with toys and clothing, climb into our yellow Renault, an open touring car, and head happily for La Garoupe. Once there, our nurse—Henriette Géron, but always Mamzelle to us—would lay out big blankets, and Dow-Dow would put up beach umbrellas. We were encouraged to sunbathe naked, but after our swim we would be rubbed with coco cream, bundled up, and given floppy sun hats to wear. Usually we returned to the villa for lunch, and then naps on folding cots somewhere

in the garden. The nap was a ritual, for one hour, and if for any reason we were being punished, it was extended to two.

There was lots to do at the villa, although we did not have as many playmates as most children. We had our pets to take care of—dogs, rabbits, turtles, pigeons, and guinea pigs—and our small vegetable gardens to tend. We did sketches and paintings, which were exhibited periodically on the terrace—*les salons de jeunesse,* as Mother and Dow-Dow called them. Also, I had my playhouse, equipped with a miniature wood stove, on which Ada MacLeish taught me how to make delicious baking-powder biscuits. And on special occasions we would watch American movies, silent films from Hollywood, which Dow-Dow projected on a sheet pinned to the wall of his studio. I still remember one of them—it was *The Black Pirate* starring Douglas Fairbanks.

Late in the afternoon, we would go to Eden Roc for swimming and diving lessons and to watch Archie MacLeish do beautiful swan dives off the highest rock. I was afraid of swimming when I could not see the bottom, but sometimes I would go with Dow-Dow to the very deep part and feel ecstatic when he praised me. Then, back to the villa again, where we would get into wrappers and have supper, while Mother and Dow-Dow had cocktails, at times alone, but more often with six or eight friends. My father was, as in everything, very precise as he prepared his Villa America special, consisting of brandy, a liqueur, and lemon juice, which he poured from a silver shaker into long-stemmed glasses, the rims of which had been rubbed with lemon and dipped in coarse sugar. "Gerald, you look as though you're saying Mass," Philip Barry said to him one evening. Another time Dow-Dow was asked by someone what it was he put in the drinks, and he replied, "Just the juices of a few flowers." Phil Barry used the line in a play, *Holiday.*

After cocktails, there were seated dinners, usually quite formal, meaning the men wore coats and ties, and the ladies wore sparkling long dresses. At one point, probably during cocktails, my brothers and I would be summoned to kiss the guests good night. We called them all by their first names, at their request, and we were asked occasionally to give a short performance. We would sing a song, or dance, say, the Charleston. I would practice it for hours in my bedroom, accompanied by a jazz record I loved. I cannot recall the name of the song, but the record had been sent to Dow-Dow from America by the drummer in the band that accompanied Jimmy Durante's act.

My parents enjoyed all sorts of music—the classics, songs from Broadway musicals, and American jazz, which they literally introduced to their

friends in France. They were great fans of Louis Armstrong, who was just becoming known in the 1920s. One number Armstrong did called "Weatherbird" was written in 1923 by the famous trumpet player Joe "King" Oliver. Mother and Dow-Dow later named a sailing yacht for the song.

We were, I suppose, relatively well behaved for children of ten, nine, and seven. What punishment our parents did inflict consisted of the extra hour of nap, an occasional spanking, possibly confinement to our rooms. I do recall one time in Antibes, however, when Dow-Dow got absolutely furious with Baoth for something and started to shake him by the shoulders. "You're going to choke him," I screamed. Usually, though, the discipline was more subtle. "In order to educate children, you must keep them confused," my father would say. It was not said entirely in jest, as he believed it was good for us to be kept on our toes, constantly questioning.

If there is anything about our upbringing that might be faulted, it is that we were overprotected. Mother felt, rightly, that our health depended on nutritious food and regular hours, but she was excessively afraid of germs, and she went to extremes to protect us from them. Accordingly, we were made to wear white gloves when we traveled, our coins were washed, and bed sheets, which had been dipped in disinfectant, were pinned to the walls of our berths when we went by train. My father supported my mother in such precautions, but there were those who suggested that they were a factor in our susceptibility to germs when we got older, a comment that Mother did not take lightly after my brothers died.

Nevertheless, I would have to admit that we had a sheltered childhood. I think of my father in those early days as the keeper of our world—my brothers' and mine. It was he who exposed us to the outside world, and our view was influenced by his particular tastes for such disparate diversions as the music of Les Six, the *Three-Penny Opera,* dancing the Charleston, showings of movies sent from America, boating trips, an assortment of pets, and—best of all—the adventures my Mother and Father invented for us.

It was unlike my father to lose his temper, as he did that time with Baoth. Once, however, he had a towering row with the *huissier,* the chief law officer of Antibes, who had impounded the Benchleys' car while Gertrude and Nat and Bobby were shopping. Dow-Dow called the *huissier* a *sale voleur,* a dirty thief. Realizing he was in the wrong, he quickly apologized.

More often, when he was angered, Dow-Dow would become icy cold, and he had a caustic way of upbraiding anyone who offended him, though he seldom exercised it within the family. As for Mother, she might become cross if we interrupted her when, for example, she was paying bills. She

tended, as did my father, to be quite nervous. "Gerald, you're making my hands tremble," she once said, when he urged her to hurry and get ready to leave on a trip. Her mild rebuke was often repeated as a family joke.

There were a number of family sayings, as Mother was fond of coining them. "Dinner-Flowers-Gala" was one. It had been used to describe a captain's dinner on one of our Atlantic crossings, and thereafter it was applied to any special evening. "Parsley till the train leaves" signified good food nicely presented. It originated on a day we were getting ready to leave Antibes right after lunch. Ernestine Leray, our maid, brought in a meat platter, which had not been garnished with parsley, and Mother asked her why not. Ernestine said there had not been time for parsley, what with all the preparations to leave. "Parsley till the train leaves," Mother insisted.

We children were required to try all kinds of food and were allowed to dislike only one dish. Patrick chose boiled pea pods, and Baoth and I agreed, as they were very stringy. To this day, I like just about everything there is to eat.

I have very fond memories of my brothers in Antibes. Baoth was a comedian, a laughing child. He was very much like Mother, which is why she loved him so. He even looked like her, with his thick brown hair and turned-up nose, though he was all boy. Patrick, though towheaded, while Dow-Dow's hair was reddish brown, was "more Gerald than Gerald," friends used to say. He was a very wise and talented little boy. The boys were not alike: Baoth was built like an ox and athletic; Patrick, even before he became ill, was a bit delicate.

I realized, even as a child, that the male principal—the son—was cherished in our family, especially on my mother's side. I did not mind particularly, because our parents lavished so much love on all three of us. But I lived with the knowledge that after I was born and Grandfather Wiborg was told I was a girl, he was heard to comment, "Oh, pshaw." Mother told me this, explaining she had cried when she first heard about her father's attitude. But later, she said, she had come to regard it as a joke, and she hoped that I would, too.

It was not a joke. Grandfather Wiborg had had only daughters, and he felt sorely deprived of an heir to carry the Wiborg name. For that reason, in 1926, my brother Baoth's name was legally changed to F. Baoth Wiborg. It was a gesture to my grandfather in which my mother and father concurred.

Mother and Dow-Dow did everything together to the extent that it is difficult to separate their respective responsibilities. But Mother actually

ran the Villa America. She did not cook there herself, but she ran the kitchen and planned the meals. She had excellent taste in food, and she collected and devised her own recipes. She made long and detailed lists of groceries and other needs, and she did the shopping with rare imagination. Because she did not drive (she had tried to learn, at her parents' place in East Hampton, but she kept running into hedges and so gave up forever), she was driven to town by the chauffeur.

Mother loved to putter. She arranged the flowers that were brought to her daily by Joseph Revello, our gardener, and she did other chores about the house—endlessly. Once when Monty Woolley was visiting, she was swatting flies, and Monty said to her, insistently, "Sara, will you stop that infernal noise." She said she would not, so he asked her again, this time shouting, and she shouted back. I became alarmed and cried, "Oh, Mother and Monty, don't dispute yourselves." It was a direct translation from the French, my first language, but it sounded so funny that they laughed and ended their argument.

Mother also supervised the staff: Celestine, the cook, and Clement, the chauffeur; Mamzelle, our nurse, and Ernestine, who returned with us to the United States; Joseph, who employed two other gardeners, Italians like himself, his wife, Baptistine, and their son Gerald, who was named for my father. For all her obligations, however, Mother was never too busy to pay attention to her children. We came first, absolutely.

We were aware that Dow-Dow had occasional gloomy moods—the Black Service, as he would call them. Grandfather Murphy once said there was an "Irish gift of felicitous melancholy" in the family, but there was little sign of it in Antibes. We could tell when Dow-Dow was feeling especially cheerful, really ready for the day ahead, when he uttered a sort of yelp. It sounded like a hiccup, and it usually meant he was planning something exciting for us to do. He also had a wonderful way of expressing esteem for someone: "He's a corker." It was his favorite accolade.

My father was ingenious in the way he planned and directed activities. He flew fishkites at Easter, for example, and he and Mother devised ideas for elaborate costumes for us to wear to parties. We would be harlequins, or clowns, or sailors, or pirates. The thought of pirates brings to mind the most memorable adventure of my childhood, a treasure hunt.

One day, in the summer of 1928, we were summoned to our parents' bedroom. Dow-Dow closed and locked the door and then said to us, almost in a whisper: "Children, we have just received something very mysterious in the mail. It is a letter with a diagram showing where a map is buried in our garden. From what I can gather, it will show us where we

will find treasure buried by pirates on the coast between Antibes and the Spanish border." We were not able to contain our excitement and begged to go to the garden immediately. "All right," said Dow-Dow. "We can go now, but we must not attract attention. You never know who might be watching."

We hurried off to a point in the garden designated in the diagram and started digging. Soon, beneath a stone, we found a small metal box, which from its rusted condition appeared to be very old. We opened it and found a parchment map, in faded ink, of the coast of France. Just above a cove, near St. Tropez, a cross had been drawn in what looked to us to be blood. Though difficult to decipher, it seemed to mark a hill overlooking the cove. "We must tell Vladimir," our father advised. "He will be able to navigate us to the right spot."

We all went right up to the villa with the little box, locked ourselves in our parents' bedroom, and carefully examined the map. Two days of frenzied preparation followed. Mother bought food for the trip, and Dow-Dow purchased two small tents, for we planned to camp on the beach while searching for the treasure. Anyone curious enough to ask was told simply that we were going on a pleasure cruise.

Finally, our departure day came. We piled into the car and drove to the port of Antibes. We had a new sailboat, a sixteen-meter sloop, the *Honoria*. I *was* quite honored, but there was no call for my brothers to be jealous. I was aware, as were they, that boats are routinely called "she," so a girl's name was more appropriate.

It was a beautiful sunny morning on the Mediterranean, as we sailed southwest, past the *calanques,* or cliffs, and houses painted a pale pastel, which had been shuttered for the summer. We dropped anchor at noon and went for a swim in the crystal-clear water. It was quite deep, and I felt a tinge of fear at the sight of brightly colored fish—there must have been thousands of them beneath us. Dow-Dow assured me the fish were more afraid of us than we of them.

After we had climbed back on board the *Honoria*, Mother laid out huge beach towels in the cockpit, and we wrapped ourselves in them. She then put a piece by Stravinsky on the crank-up gramophone, and we had a delicious lunch of gnocchi, salad, and fresh peaches with cream. We went below for naps, as the boat got under way. That night, we put into the port of St. Tropez and tied up at the municipal dock. We took a walk through the town, and when we returned a crowd had gathered. There were friendly cries, *"Ce sont des Américains."* Americans were still a rarity on the Riviera in 1928.

At dinner that evening, Dow-Dow announced, "Children, tomorrow we should reach the cove where we will drop anchor and set up camp on the beach." We climbed into our bunks, but I had trouble getting to sleep. I kept having visions of an open chest, filled to the top with sparkling red rubies.

We were all on deck early the next afternoon when Dow-Dow gestured toward shore and said, "Immediately around that point is the cove where the treasure should be—up in the hills above the beach." Everyone— Mother, Dow-Dow, Vladimir, but especially Baoth, Patrick, and I—was filled with excitement as we checked the map against the coastline. They matched perfectly. We dropped anchor, but our father, pointing to a man on a distant hill, said we would have to wait until the next morning to start our search. "We must be very careful not to alert anyone else to the treasure."

It was still warm and sunny when we rowed ashore in the "youyou," our dinghy, and ran up on the beach, where Vladimir and Henri, the mate, had pitched tents. Dow-Dow showed us a cave in which our equipment would be stored. He said the pirates had no doubt used the cave for shelter. That evening, Mother cooked on an open fire. Dow-Dow told pirate stories, and he even supplied spooky background music, having set up the gramophone in the cave. One piece I remember was *The Engulphed Cathedral* by Debussy.

It was hardly dawn the next morning when I heard someone stirring. It was Dow-Dow, searching for firewood. When the fire was going, Mother put on two large metal pots—one containing coffee, the other milk for our cocoa. Later, we ate bread, jam, and fruit.

After breakfast, we started walking up the hill, along a path, which was marked on our map. Suddenly Dow-Dow halted and said, "I believe this is the spot." Henri started to dig, but Dow-Dow stopped him, pointing to the top of the hill. The same man we had seen the day before was standing there, and he was looking at us. "We must pretend we are picking wild flowers," Dow-Dow said.

Finally, the man departed, and Vladimir resumed the digging. He struck something hard, and in another shovelful or two he uncovered a metal box, but it was small, too small to be a treasure chest. There was a key in the box, attached to a parchment tag with a skull and crossbones drawn on it, and more directions, also on parchment. They read, "If you walk two feet uphill from where this box was placed and five paces to the west, you will be standing directly on the spot where you should start digging again."

When we got there, Dow-Dow handed the shovel to Baoth, who soon

hit another hard object. He kept digging, and there it was—a pirate chest! Mother had been designated by Dow-Dow to unlock it. She bent down, put the key in the lock, and turned it. We helped her lift the lid. The chest contained jewels and beads of every color, sparkling in the bright sun. There were diamonds, emeralds, rubies, bloodstones, gold and silver bracelets and chains, earrings, cutlery, compasses, and heaps of coins. My eyes were fastened on a long "ruby" necklace. "It's for you, Honoria," said Mother. "Your favorite color, red."

It was years later that we learned the treasure hunt had been invented. Dow-Dow and Vladimir had searched all over Paris for parchment-like paper, and they had found the chest somewhere on the Left Bank. They then had drawn the map and made an advance trip to bury the chest. Mother, meanwhile, bought the treasure at flea markets and costume jewelry shops on the Rue de Rivoli in Paris. I still have the key, and I still wear the "ruby" necklace.

* * *

Scott Fitzgerald began writing *Tender Is the Night* in 1927, but he did not complete it until 1933. Gerald and Sara watched, as Scott destroyed the seventh draft. "He took it out in a rowboat," Gerald recalled, "and he tore it up, page by page, and scattered it over the Mediterranean. We were so afraid it would turn out to be the last draft, but it wasn't." In the book are accurate portrayals of the Murphys on the beach at Antibes. Fitzgerald pictured, for example, "a young woman . . . under a roof of umbrellas, making out a list of things from a book open on the sand. Her bathing suit was pulled off her shoulders and her back, a ruddy, orange brown, set off by a string of creamy pearls, shone in the sun. Her face was hard and lovely and pitiful. . . . Beyond her was a fine man in a jockey cap and red-striped tights." After describing others of the party, who, in reality, did gather each morning at La Garoupe, Fitzgerald returned to the man in the cap, which actually was a French sailor's cap that Gerald had purchased in St. Tropez. "[He] was giving a quiet little performance for this group; he moved gravely about with a rake, ostensibly removing gravel and meanwhile developing some esoteric burlesque held in suspension by his grave face. Its faintest ramification had become hilarious until whatever he said released a burst of laughter." The ritual of raking the beach was, in fact, a serious project for Gerald, since there had been a bed of seaweed four feet thick when he first began it in 1923. He did see the humor

of it, however, and he was particularly delighted one day when an elderly lady offered him a tip.

Sara's sister, Mary Hoyt Wiborg, also inspired a character in the novel, whom Fitzgerald depicted as "a compendium of all the discontented women who had loved Byron a hundred years before, . . . there was something wooden and onanistic about her." Hoytie had visited the Villa America and had loved Antibes, but the people were not "the right sort" for her, according to Gerald. "She wanted to bring over a lot of friends from Cannes, all English and titled, and Sara flatly refused." After an argument, which lasted an entire day, Hoytie stormed out, but it took hours to get her fourteen trunks to the train station, and she missed the train to Paris. So she returned to the villa, stayed three more days, "and never spoke a single word to Sara or me the whole time. She spoke to the children only."

Fitzgerald's use of the Murphys as models, as anyone who reads the book can tell, was simply his way of introducing Nicole and Dick Diver, who are really autobiographical protagonists. Nicole is mentally ill, as was Zelda; their marriage disintegrates; and by the final scene on that beach on the Riviera, Dick Diver no longer bears any likeness to Gerald. Sara Murphy, understandably, took exception to being used in this fashion. "I hated the book when I first read it," she said, "and even more on re-reading. I reject categorically any resemblance to ourselves or to anyone we know." Gerald reacted differently. He had confided to Scott his belief that the realities of life—birth, sickness, death—must be accepted, but they are not really important. "You see, Sara and I are different in this. Sara is in love with life, and skeptical of people; I'm the other way. I believe you have to do things to life to make it tolerable. . . . The *invented* part, for me, is what has meaning." Thus, Gerald could explain, or rationalize, Scott's treatment of him and Sara. "It was the invented things we did," he wrote, "the picturesque part of our life, that Scott used in the book."

Nevertheless, Gerald had second thoughts about *Tender Is the Night*. He revealed them in a letter to John O'Hara, the novelist, in 1962. "It wasn't because of Scott's handling of us that we had reservations . . . ," he wrote. "His approach . . . was so painful for all concerned. . . . Most certainly it has some of his greatest writing in it." Gerald was speaking for himself when he praised Fitzgerald's writing; the observation about his approach was more a reflection of Sara's objection to Scott's scrutiny of them.

O'Hara had written to Gerald his opinion: "Scott did what all your writing friends wanted to do, which was to write about Gerald and Sara and their life. But Scott didn't have my method to guide him, with the result that Dick and Nicole were never you and Sara. . . . Scott wrote about the life, but not the lives. . . . Sooner or later his characters always came back to being Fitzgerald characters in a Fitzgerald world." O'Hara's insight was perceptive, his conceit notwithstanding. He was indeed a methodical writer, who developed the lives of his characters with precision and consistency. He was not concerned, as was Fitzgerald, with writing about life; he was concerned with telling a story, which he often did very well.

<p style="text-align:center">* * *</p>

"Bravo! We are going on the *Saturnia* on the 23rd of October," it says in my diary for 1928. Our destination was California, following a brief stay in New York to see our grandparents. My father had been asked by King Vidor, the movie producer, to come to Hollywood as a music consultant for *Hallelujah,* a film set in the nineteenth-century South with an all-black cast. Vidor had met Dow-Dow through Scott Fitzgerald, and he had visited us at the Villa America. He had admired Dow-Dow's painting, and he had learned he was an expert on early American Negro music.

While he was studying landscape architecture at Harvard, Dow-Dow became acquainted with John Singer Sargent, who was lecturing at the Boston Museum of Fine Art. Sargent had an avid interest in the Negro spiritual, which my father shared, and they sang them together. Inspired by this experience, my father did research at the Boston Public Library, where he found the manuscripts of a member of the Higginson family of Boston, who, as a drummer boy in the Civil War, had become interested in spirituals and had made a lifetime avocation of preserving them. My mother and father often sang spirituals for friends in Boston and later in Paris. "Oh, Graveyard" was one they particularly liked, as was "Sometimes I Feel Like a Motherless Child," which Paul Robeson, who became a friend of my parents in the late 1930s, sang in concert.

There was great excitement when we learned we were going to the place in America where they made the Douglas Fairbanks and Charlie Chaplin movies we had watched on the makeshift screen in Dow-Dow's studio. And my brothers and I would, for the first time, enjoy some uniquely American experiences. On the train across the country, for example, we saw cowboys and Indians, having been assured by Mother that they no longer fought one another. Dow-Dow told us, however, that the Indians

had not been treated fairly and had been confined to reservations. And we learned to roller-skate not long after we moved into our rented house in Beverly Hills.

There was something else about coming to the United States that was not so much fun. It was my first encounter with fear. There had been brief scares in Antibes—once an octopus grabbed Patrick's arm as he reached into the sea from a rock, and a passing fisherman had to rescue him. We had, however, never known constant fear—the fear of being kidnapped, for example. In Hollywood, shortly before we arrived there, there had been several incidents, and Mother cautioned us never to talk to strangers. So, if we were outside playing and a car came by, we would run for the house, terrified.

Our happiest day in Hollywood was the one on which we were taken to meet Charlie Chaplin, or Charlot, as the French called him. The occasion was a party at the mansion William Randolph Hearst had bought for Marion Davies at Malibu, and Charlot had come early, just to meet us. He did not look at all as he had in the movies—his hair was gray, and the little black mustache was missing. He spoke to us briefly. He was especially charmed by Patrick, whom he patted on the top of the head, admiring his blond hair. On another day, we visited a set where a war movie was being made. Eleanor Boardman, King Vidor's wife, had the lead role. She talked to us in between takes of a death scene, all the while chewing away on a piece of gum. When it came time to resume shooting, she pushed the gum to the corner of her mouth with her tongue and proceeded to "die." We were amazed.

On balance, though, the trip to California was not a pleasant one. First of all, our governess, Henriette Géron, was infatuated with Vladimir Orloff, who had come to assist Dow-Dow on the film. Vladimir, who had been uncomfortable in California anyway, used this as an excuse to leave. My father was also displeased. He was offended by the superficiality of Hollywood, and he did not approve of the demeaning treatment of the American Negro in the making of *Hallelujah*.

* * *

"My God, what a place this is," Gerald wrote John Dos Passos from California. "The kitchen utensils have enamelled handles in pastel shades. Bootblacks and barbers wear indigo and jade-green smocks at their toil. The milkman has a blue-and-white-striped livery with the name of the firm embroidered in red across his back, cap to match. Waitresses are costumed as Watteau shepher-

desses, matadors, Holland maidens (with wooden shoes), sailors (the effect somewhat marred by make-up and plucked eyebrows). . . . One cannot bear to eat unless it be in Mammy's Shack, The Dutch Mill, the Money Farm, or Ye Bull Pen Inn, . . . each one built in loving imitation of the spot chosen. And don't think they're fantastic or gay or even crowded, they're not. There is a monstrous Brown Derby, where you 'eat in a hat,' and very badly, I suppose. . . . Oh, God, the need to be quaint with it all. You dine at the Sip and Bite, the Goodie Fountain, the Hippedy-Hop Cake Shop, the Optimist Doughnut, the Naughty Waffle Sandwich, the Buddy Squirrel's Nut Shop, the Miracle Cafeteria, the Lovers' Delight Sandwich. . . . It would be all right if they weren't so smug —that combined with their ignorance, their ignorance combined with their prosperity. The wealth of it all takes the heart out of you. Vladimir lasted only six weeks. . . . Lost weight, tormented by nightmares, he got the miseries, and we didn't have the heart to ask him to stay. He crossed the continent all alone, and sailed away. . . . I've been officiating for six weeks at a picture that should have been sure-fire stuff: eighty Negroes combed from the southern states. But in two weeks, they had it so full of scenes around the cabin door with talk of chitlins and cornpone and banjoes-a-strummin'. . . . When they got Lionel Barrymore to coach these Negroes in the use of dialect, I resigned."

* * *

We did not know it at the time, but something occurred in California that would alter drastically the course of our lives. It was the first step of the ultimate tragedy, or so it seemed to my parents, of two sons dying young, within less than two years of one another. The awful irony is that each of my brothers succumbed to a disease that could have been successfully treated by antibiotic drugs, which were developed just a few years later.

My father was still working on the movie when Patrick, Baoth, and I had tonsillectomies, which had been recommended by our doctor in California as preventive medicine—another irony. When we got home from the hospital, Patrick was carried from the car by a chauffeur who, my parents learned, was later diagnosed as being tubercular. That apparently is when Patrick was exposed to TB.

I have always associated our trip to California with misfortune, mostly because of what happened to Patrick, but also because of a ghastly experi-

ence of my own soon after returning from the hospital. I was a bleeder—
that is, my blood did not coagulate normally, and about a week after the
operation, I began to hemorrhage. I complained to the nurse that I was
swallowing blood, but she said it was nothing and I should go to sleep. I
called for Mother, who came to my room, sensed that something was
wrong, and summoned the doctor. "Ten more minutes," he said, "and this
child would have been dead." The nurse, of course, was promptly dis-
missed.

One bright spot of our stay in California, which ended in early 1929, was
a visit to the Fish ranch in Carmel. The younger of my mother's sisters,
Olga, was married to Sidney Fish, who had moved to California in 1926
to recuperate from pneumonia. He had been a lawyer in New York, but
he made some successful oil investments and decided to buy the ranch, the
Palo Corona. They had one son, Stuyvesant, or Stuyvie, who was less than
a year younger than Patrick, and we had a wonderful time, riding horses
and going on picnics.

We were back at the Villa America in May 1929, when Patrick became
ill. It was diagnosed as stomach trouble by a doctor in Paris, who pre-
scribed a non-fat diet, just what is *not* recommended for TB patients, who
need nourishment. It was an active summer. The Benchleys and Dorothy
Parker came to visit, and the Barrys were at their villa in Cannes. In July,
we went to St. Tropez on the *Honoria* and camped on the beach. Patrick did
his best to keep up, but he was obviously getting no better. He was pale
and thin, and he would tire easily.

Mother took Patrick for three weeks in September to Villard-de-Lans in
the hill country of southern France. At the suggestion of Ernestine Leray,
he had been examined by a doctor in Juan-les-Pins, and we had learned
he was suffering from a grave infection, though we still did not know its
exact nature.

"He progresses very slowly," my father, who was at Antibes with Baoth
and me, wrote Aunt Hoytie on September 7. "The doctor says that it will
take two-and-a-half months. The real benefit is not felt until after the first
month. Clement [the chauffeur] and the Chrysler went along [to Villard-
de-Lans]. The place is at an altitude of 1,050 metres and surrounded with
glaciers. The food is not very good, but Sara is able to scout through the
country with the car and forage for milk, cream, fruits, etc. It apparently
calls for endless patience and care. . . . The country is very wild, Sara says.
They go trout fishing, and conditions are everything they should be for his
recovery."

Patrick did not show any sign of improvement by October, however, and Dow-Dow took him to Paris to see yet another physician, Armand De Lille, a specialist in children's lung ailments. De Lille "immediately recognized that one lung was badly affected and the other menaced," as Dow-Dow explained in another letter to Hoytie. "He started that very night the injections of gas, regardless of Patrick's depleted condition. . . . De Lille's idea was to get us out of Paris to an altitude as soon as possible. We at once had . . . all the surrounding household, including ourselves, radiographed —all negative. Sara brought Honoria, who had had bronchitis, to Paris to see if she had been infected, but she and Baoth are immune." I do not know what persuaded Dow-Dow that we were immune, but at least the test was negative.

I remember well the day my mother heard the worst. She and my father were in their bedroom, and Baoth and I could hear her crying from the next room. "Your father has just told your mother that Patrick has *la tuberculose,*" Ernestine told us. We did not fully understand what it was, nor did Ernestine, who said it was an infection of the glands in the chest. We did sense it was extremely serious, however. "The only hope is to take him to the mountains," Dow-Dow explained. "He has to have fresh air, so we are making preparations to take him to Switzerland."

In November 1929, Mother wrote to Mamzelle, who had not accompanied us to Switzerland: "If only we had had the good sense to have telephoned Dr. Armand De Lille in May." My father expressed his feelings to Hoytie: "His case indicates that the fever he had last May and diagnosed by the great Paris specialist as intestinal infection was, in reality, an ugly pleurisy and the beginning of what he has now. I feel as if the clock of life had been turned back eighteen whole months. Fortunately Patrick doesn't at all realize what goes on. He's quiet, ruminative, and lurks within himself."

* * *

In notes appended to the 1951 edition of *Tender Is the Night,* Malcolm Cowley, the literary critic, wrote, "The book is dedicated to Gerald and Sara Murphy, wealthy friends of the Fitzgeralds who entertained them at Cap d'Antibes in 1925." Looking back in later life, Gerald wrote that "for two cents Scott would have thought of us as the idle rich. He never did really understand our life." Gerald then elaborated: "Scott was always baffled by the question of how much money we had. He couldn't really make us as out-and-out wealthy. Sara wasn't even a lesser heiress." She did have, Gerald

allowed, the income from one-fourth of her father's estate. "I said I would have nothing to do with the money, although Sara's father wanted me to manage her share. We put it with an old Boston investment firm [Loomis-Sayles], in the hands of Mr. Copley Amory, a distinguished man who became a great friend. Whenever we wanted money—to build the *Weatherbird,* or renovate the villa, . . . and this was always Sara's decision—we simply wrote a letter to Mr. Amory and asked him to sell the necessary securities. We spent everything, you see. Scott never understood this. He kept asking me what my income was, and when I'd say that I didn't know, he'd say, 'Oh, it's as big as that.' I'd try to tell him, 'We don't live on an income. We're not income people.' We had 3½ percent on a fund of less than $200,000 (Sara's estate), and my father sometimes made gifts to us."

There is evidence that Sara's father did not approve of the Murphys' free-spending ways. "It seems to me you are going ahead in a very extravagant way about your purchases," he wrote on November 7, 1919, Sara's thirty-sixth birthday, "and while I have no business to criticize any more than I have already done, I think you should cut your cloth according to the extent of the material you have to do it with." For all his wealth, Frank Wiborg believed in frugality. "I have always had to deny myself and save, in order to get ahead," he told Sara in the same letter. Yet, he was generous to his daughters, and he decided a few years later to share everything he had, including the East Hampton acreage, with them. As a result, Sara's annual income from her trust fund, which had been just a little more than $5,000 in 1919, was increased to $40,000-plus in 1922.

It was a considerable sum—$217,000 in 1982 dollars—especially if you take into account the additional advantage of the inexpensive living in France. "Antibes was dirt cheap when we came there," Murphy later explained, "and the exchange gave our dollars a purchasing power far in excess of what they would have been worth at home. . . . The MacLeishes came to Europe with $25,000, and they lived on it for five years." After two summers at the Hôtel du Cap in Antibes, the Murphys, aware of the rising popularity of the summer season, decided to buy the villa. "And the whole thing didn't cost us more than $15,000," said Gerald. "Scott and Zelda spent lavishly, of course, far more than we ever dreamed of spending."

It was in the very October of the Murphys' personal tragedy, the discovery of Patrick's tuberculosis, that Wall Street collapsed. It

would appear that Sara and Gerald were not affected by the Depression that followed, judging from the way they continued to live—in Switzerland, in a rented mansion in Austria for a summer, and cruising on the *Weatherbird,* while still maintaining the villa at Antibes. They were, in truth, living quite expensively—more so than, say, the Fitzgeralds, notwithstanding Gerald's latter-day estimation. It might even be said that they were living recklessly, given the fact that they depended entirely on Sara's income from securities, which of course was affected by the ups and downs of the stock market. There were warnings, but they went unheeded. Sara's father had written on May 30, 1929: "The income from this money I have given you is *the* important thing. No one can attend to the income on your own affairs as well as you could right on the ground. That is why I am asking you to return to America and take up the thread here, so that you can look after your own interests. If you do not, your income will not only be much reduced, but your stocks and bonds may depreciate so that you will be very great sufferers thereby. I am not an alarmist. I only know that in my own experience, I have had to attend to my own business, my own matters, in order to have any kind of protection, to say nothing of progress."

By the time Sara and Gerald did return to America to stay, in 1932, they were close to financial disaster, relatively speaking, though they may not have been fully aware of their predicament. The management of money, Gerald acknowledged in the 1950s in a letter to his sister Esther, "has always been one of the . . . irrealities of life." F. B. Wiborg was worth three or four million dollars when he died in May 1930, but by the time his estate was settled, that figure had been reduced to seven or eight hundred thousand, leaving Sara with her real estate holdings, which consisted of some twenty-seven acres in East Hampton, and about two hundred thousand dollars after taxes. Gerald inherited even less when P. F. Murphy died in November 1931. "He left a company [Mark Cross], not an estate," he wrote later of his father's will.

Life itself has stepped in now and blundered, scarred and destroyed.

Gerald Murphy to F. Scott Fitzgerald
December 31, 1935

II. Life Itself

Patrick Murphy turned nine on October 18, 1929, the day his father took him by train to Montana-Vermala in the Swiss Alps. Six days later, thirteen million shares of stock changed hands on Wall Street, but Gerald and Sara Murphy were too remotely positioned and too preoccupied to pay attention to the Panic, the effect of which they would not realize until the Great Depression had entered its third year. The Murphys, meanwhile, spent their money as if it were milk from a miraculous pitcher. The move to Montana-Vermala itself was an enormous expense, for it entailed the transfer from one country to another of an entire family with their servants —Ernestine, the maid, and Clement, the chauffeur, who drove the Chrysler to Switzerland—an assortment of pets, and any friends who happened to be staying at the Villa America at the time. Honoria, whose own prognosis was still uncertain, followed right behind Gerald and Patrick, accompanied by Jinny Pfeiffer, the sister of Pauline Hemingway; Sara then brought Baoth; and Dorothy Parker, as she would explain in a highly amusing letter to Robert Benchley, escorted several pets and the last of the baggage.

* * *

I have never liked mountains, for I associate them with sad times. I still find them depressing, and I am happiest when living by the sea, as we did

at Antibes, or as I still do in the summers at East Hampton. Even if it is the American shore of the Atlantic, I feel I can fly at a moment's notice to France, the country of my fondest childhood memories.

Montana-Vermala was especially gloomy. Many tuberculosis patients came there, not so much to be cured as to be better able to manage. In those days, being told you had TB was as horrifying as discovering you had cancer. Cold, mountain air and a rich diet were prescribed to prolong Patrick's life, not to rid him of the disease, although we always had hope he would get over it.

We stayed for the first seven months at the Palace Hotel, which actually was a sanatorium. It was huge and dark and dull-looking, with plain wooden furniture, but it was quite comfortable. We had a six-room suite on the first floor along a wide balcony, where Patrick, all bundled up, spent the days. There was a magnificent view of the mountains from the balcony, but it did little to improve Patrick's spirits. "Melancholy skenery," he would say, and I would agree. At night, he slept in an unheated room, on doctors' orders.

Mother and Dow-Dow were determined to bolster our morale under trying circumstances. They had allowed us, for one thing, to bring our pets from Antibes, including my many canaries and our four dogs. We even added others to the menagerie after arriving in Montana-Vermala. A parrot named Coquotte was a present from Dorothy Parker, who had come to stay with us, and we had acquired an ill-behaved monkey named Mistigris. There was also the fun of friends coming to visit. In addition to Dorothy Parker, who was our guest for nearly a year, Katy and John Dos Passos came, as did Ada and Archie MacLeish.

Scott Fitzgerald visited frequently after tragedy had brought him, too, to Switzerland. In October 1929, the Fitzgeralds had returned to Paris from the Riviera. Zelda had suffered a serious mental breakdown the following April, and Scott had placed her in a psychiatric clinic in Prangins, near Geneva. Ernest Hemingway was also on hand. He came for Christmas in 1929 and brought a goose he had shot for Christmas dinner, which was cooked in the kitchen of the Palace Hotel. It was an American holiday feast with flourish, for Mother was doing all she could to create a cheerful mood, although she and Dow-Dow were not very cheerful themselves. We had mashed chestnuts the color of cocoa and a flaming pudding, which had been soaked in brandy. It had been decorated with a sprig of holly, and I watched as the leaves burst into flame, curled, and turned black.

Ernest took us skiing during his visit. Baoth and I had taken lessons on the beginners' hill, and we were eager to go on an outing. The Palace Hotel provided lunches—a ham sandwich, an orange, and a thick square

of milk chocolate. Mother protested that we were not permitted choco-
late, but Ernest overruled her, insisting that sugar was an important en-
ergy food. He told of a man who had gotten lost in the Alps a few weeks
before. He had survived, Ernest said, only because he had lumps of sugar
with him.

There were no ski-lifts in those days. Ernest showed us how to wrap our
skis in sealskin for traction, and how to climb. First he taught us the
side-step, then the herringbone. I was good and scared when we first got
to the top, but Ernest showed us how to do the stem-stop and the chris-
tiana. His patience cured my fright.

* * *

Gerald Murphy wrote a letter to Pauline and Ernest Hemingway
on October 12, 1929, six days before leaving Paris for Montana-
Vermala. He enclosed a copy of a passport picture of Patrick, which
had been taken the day before, a picture Murphy treasured for the
rest of his life. "Please keep it and hunch for luck," he scribbled on
the back. He described the painful pneumothorax treatments Pat-
rick was getting: "He's taking the injections of gas like a brick. He
gets 300 cubic centimetres of it each time through a thick needle
under the arm between the ribs. It surrounds and collapses the lung,
immobilizes it, stops the spread. He's living on the good lung. They
hope to keep it good. Altitude and sun-treatment will help." The
gas injections may have arrested the disease temporarily, but they
were no more effective as a cure than the cold mountain air and
dairy-food diet, which doctors prescribed in those days. It was only
after antibiotic medicines had been put to use—in the 1940s—that
tuberculosis was curable.

As an avid reader of Thomas Mann, Hemingway was possibly
well aware of the likelihood that the stay at the sanatorium in
Switzerland would not save Patrick and perhaps would have a nega-
tive effect. In 1927, Mann had published his monumental novel *The
Magic Mountain,* the setting for which was a sanatorium very similar
to the Palace Hotel. "In the year 1912," Mann wrote in a postpubli-
cation explanatory note, "my wife was suffering from a lung com-
plaint, fortunately not a very serious one; yet it was necessary for
her to spend six months at a high altitude, in a sanatorium at Davos,
Switzerland." While Mann was visiting her, he was examined for
a bronchial cold. "The head-doctor . . . thumped me about and
straightaway discovered a so-called moist spot in my lung. . . . The

physician assured me that I should be acting wisely to remain there for six months and take the cure. If I had followed his advice, who knows, I might still be there! I wrote *The Magic Mountain* instead. In *it* I made use of the impressions gathered during my three weeks' stay. They were enough to convince me of the dangers of such a milieu for young people—tuberculosis is a disease of the young. You will have got from my book an idea of the narrowness of this charmed circle of isolation and individualism. It is a sort of substitute existence, and it can, in a relatively short time, wholly wean a young person from actual and active life.

"Such institutions," Thomas Mann maintained, "were . . . only possible in a capitalistic economy that was still functioning well and normally. Only under such a system," he argued further, "was it possible for patients to remain there year after year at the family's expense. *The Magic Mountain* became the swan song of that form of existence. Perhaps it is a general rule that epics descriptive of some particular phase of life tend to appear as it nears its end. The treatment of tuberculosis has entered upon a different phase today; and most of the Swiss sanatoria have become sports hotels."

Donald Ogden Stewart visited the Murphys at Montana-Vermala and wrote about it in 1960 to Calvin Tomkins: ". . . they were living in a Magic Mountain village in a desperate attempt to save Patrick's life. The memory of a night with the gay Murphys of Paris and Antibes in that rarefied cold silence of 'and here's to the next one to go' atmosphere of death is one of the most terrifying of my life. But [it is] also one of the Murphys at their most brave, most lovable, most heroic."

Dorothy Parker was in New York and feeling depressed herself in 1929, owing to romantic troubles, so she accepted the Murphys' invitation to come to see them in Europe. She had gone first to Antibes and then had followed by train to Montana-Vermala, ". . . with three dogs, two of them in high heat, and the baggage the Murphys left behind, which consisted of eleven trunks and seventeen handpieces." Her description of the visit was contained in a remarkable letter to Robert Benchley, whom she called Fred, for reasons known only to her and to Benchley.

"Well, Fred, if you had told me last year that this November I should be in a sanatorium . . . in Switzerland, . . . I should have said, 'That's great,' because last November I was in Hollywood, and any

change would have been for the better. And NEXT November, Fred, I do hope that you are going to be able to find time to come visit me up at the Death House in Sing-Sing. Because Palace Hotel, my eye, Fred—they are all called hotels, and all Palaces, Splendids, Royales, Grands, Magnifiques, and Collosales, at that. But they are all sanatoriums for the tubercular, and jolly no end, no end whatever. The halls are full of doctors dressed in butchers' coats, . . . and everyone walks on tiptoe and speaks in whispers.

"I have put off talking about the Murphys until now, because truly, Mr. Benchley, it would break your heart. Ah, why in hell did this have to happen to them, of all people? Patrick's treatment will take two years, they say. Gerald has absolutely isolated himself with him—does every single thing for him, and takes his meals with him. I didn't see anything at all of him the first few days I was here; and then I caught a glimpse of him, hurrying along the balcony, with a pot-de-chambre in one hand and a thermometer in the other, and he was dressed in Swiss peasant costume, . . . and it was the most touching thing I have ever seen. They are so damn brave, and they are trying so hard to get a little gaiety into this, that it just kills you, Fred. And now the doctors have found that Honoria—well, there are no positive germs, but she has a constant fever and her lungs are spotted. . . . It's too much, isn't it? The doctors have traced the incubation of Patrick's illness back to last February—when they were in Hollywood. Sara thinks it was probably that nice . . . chauffeur. . . . They recall now, as people always do, that he had a frightful cough.

"Sara and Baoth and I dine in their little salon—the rooms are regular hospital rooms, but Sara, of course, has made it all different, and Gerald, of course, has insisted that there be . . . regular ham-Swiss decorations. I remember having some idea that I would always wear little chiffon pretties for dinner on account of morale—the Englishman-in-the-jungle school of thing. Yes. So what you wear for dinner is a tweed suit, a coat over it, a woolen muffler tied tight around your neck, a knitted cap, and galoshes. When you go outdoors, you take off either the coat or the muffler . . . it is much colder inside, with no sun. They have to have it that way on account of the sicks.

"There is no real drinking—I believe stiff liquor is supposed to kick the tripe out of you at this altitude, . . . but every night we have a solemn glass of gluhwein [a spiked claret, served hot] . . . before

we go to bed at nine. Poor Gerald (and those lights are out at the Hippodrome, Mr. Benchley, when you think of Gerald Murphy as 'poor' Gerald) has tried to recapture the old spirit and he has fixed up a table as a little bar—it has on it just a bottle of wine and a bag of cinnamon and some lemons and a spirit lamp. He is also making the room into a gluhwein parlor, with mangy white fur rugs on the floor, and all the horrid Swiss decorations he can get. I gave him a cuckoo clock and a parrot—an awful beast. Gerald is scared to hell of her, and carries her on his shoulder, with his neck bent forward at a hitherto undiscovered joint, saying in a quavering voice, 'Ah, de sweetheart. Ah, de goose-girl,' and then the goose-girl bites a wedge out of his ear. I got her because she was just the right smell for a gluhwein parlor.

"So we sit there, Fred, for about twenty minutes after Patrick is settled for the night, in that freezing room, all done up in mufflers, and talking in whispers, of course, because Patrick is on one side and someone strange and older and sicker is on the other, and poor Gerald importantly makes gluhwein, and we talk about you. 'Ah, old Boogles Benchley. Ah, old imaginary good lucks. Let's cable the old fool to come over.' Ah, gee, Fred, last night we were sitting there and Gerald suddenly got up and raised his heavy hospital tumbler, and said—of course in a whisper—'To Tiggy Martin, the Wickedest Woman in London,' and this is the kind of thing you couldn't stand. I can keep from crying much longer if people aren't brave.

"Today was Sara's birthday, and we had a little party. . . . We had a cake, and Honoria was carried into Patrick's room for the event, and a very nice nurse and the housekeeper and one of the doctors came. . . . And we had champagne, and when Sara's health was drunk, Gerald kissed her, and they twined their arms around—you know—and drank that way. Jesus, Fred, I can't stop crying. Christ, think of all the shits in the world, and then this happens to the Murphys. There aren't any people, Mr. Benchley, except you and the Murphys. I know that now. Ernest is pretty damn good, but he isn't it. There are only you and Gerald and Sara. Nobody else. Sara is a great woman. I didn't know women could be like that. And Gerald is a great man. And you are a great man

"I don't know how long Gerald can stand it, Fred. I don't know what goes on in his head. I don't in the least minimize his devotion to Patrick, truly I don't, but there is something else in this absolute immolation, for after all, a nurse could do as well and better all the

routine things. . . . I think there is something of his denial of illness in it. . . . '[They] say it will take two years, do they? Why I'll show them this child is not sick—I'll have him up and about in a couple of months.' And there is something else—that morbid, turned-in thing that began with his giving up his painting and . . . turning back from that cruise. . . . It wasn't a broken mast, Fred; Vladimir told me. Every time they touched a port there would be telegrams from Sara telling him it was his duty to come back and be with his children. . . . He looks like hell; all the points of his face have gone sharp and turned up. . . . He works every minute—all the energy that used to go into compounding drinks and devising costumes and sweeping out bath-houses and sifting the sand on the *plage* has been put into inventing and running complicated . . . sick-room appliances, and he is simply pouring his vitality into Patrick, in the effort to make him not sick. He is already cracking; he goes into real tantrums of irritation when the child's fever doesn't go down or he doesn't gain weight, although the doctors have told him these things aren't expected for a long time. But he was so sure he could lick them, it drives him crazy that he can't."

Parker was at her best when she was being a bit sarcastic. "Their families, of course, have been of enormous assistance," she wrote Benchley. "Mrs. Murphy writes that all they have to do is to act and to think as if Patrick was twice as ill as he really is, and then everything will be all right with God's help. (Gerald got that letter just as he was about to stagger out of the room with four laden trays piled one on another. 'With God's help,' he kept saying. . . . 'With God's help. Oh, my *GOD!* With God's help.') Mr. Wiborg points out that this doubtless would never have occurred if the children had not been brought up like little Frenchmen. And Hoytie, good old Hoytie, cabled: 'Don't be forlorn. I will be over after Christmas.' When he heard that one, Dow-Dow's face lit up just like the Mammoth Cave."

Hoytie was being an angel—for Hoytie, at any rate. "Is Dottie Parker still with you, and will she be able to stay on there indefinitely?" she asked in a letter to the Murphys from New York on December 6, 1929. "I do hope so, as it would be company for Sara and otherwise be a comfort. . . . I saw the Ted Pickmans, and I have seen the Barrys and the MacLeishes, and all your friends want news of you." She tried to emphasize the hopeful side of the situation,

although she expressed it awkwardly. "The main thing . . . is to get the other children full of health and yourselves and just to take this as something Fate has provided to get you out of the Riviera atmosphere, perhaps a blessing in disguise." In the meantime, Hoytie was having difficulties of her own, though she was not saying how serious they were. "I lost my shirt in the stock market but am getting it back, I hope, in small driblets during the next twenty years," she wrote.

On December 8, 1929, Gerald sent his mother a year-end situation report. "Patrick is working through his second slight relapse," he wrote. "Between them he has had about ten days of healing and progress. These setbacks will last for several months and are characteristic of the disease. His temperature on the whole is better, except during the several days in which the infection gets the upper hand. In spite of all, he is slowly gaining weight. He is weighed about every five days. Sara cooks his meat, a vegetable, soup, and compotes and sends them in. I have an assortment of about 20 cereals, which I cook him for breakfast—I get good cream and milk. By dint of this, he is for the present gaining, though confined to bed constantly. In a few months, when he is well enough to get up, . . . things will be better. He takes his injections of gas in the lung cavity every ten days. . . . These he withstands with a stoicism . . . the doctors marvel at. It is his unflagging will to get well and his infinite patience and refusal to complain that will cure him in the end. I've never known such quiet determination." Gerald related to his mother the latest on the condition of the other children. "A thorough examination of Honoria and Baoth on their arrival showed that they had both been exposed," he wrote. "Baoth had resisted infection but is left with 'adherences' in his lung. Honoria was still resisting the infection. The doctors put her to bed as she had as much temperature as Patrick and was coughing. She is now getting up and is almost recovered." As for Sara, she was "somewhat better," Gerald reported, considering Patrick's condition. "Naturally, there will be no release until he is well."

* * *

On May 10, 1930, we moved to a rented chalet, La Bruyère. It was only a mile or so from the Palace Hotel, but what a relief to get out of that place! There was a road winding down the mountain, passing both behind and in front of the house, and the village children skied down it, past banks

of plowed snow that at times reached the top of our wall. It was snowing on the day we moved.

Dorothy Parker was still with us at La Bruyère. She struck me as being very unhappy. She had a sad face to begin with, and she had a habit of staring into the distance for long periods. She smoked a great deal, and she had a throaty laugh to accompany her naughty wit, but she would suddenly exude warmth. She might say, for no particular reason, "Mrs. Murphy, I just love you." Mother used to say she was a very easy guest, and it was comforting to have her around.

Dorothy could be very funny, though her humor often had a sharp edge to it. She had a thing about sugary-sounding women and would say, "Beware of girls with 'Betty-Boop' voices." She drank quite a bit, and when she did her speech would become slurred, and her eyes would lose their sparkle. Once, while quite tipsy, she insisted on helping me clean my bird cages. When I handed her one, she dropped it. I was afraid all my canaries would escape, but they just fluttered a bit. She apologized, and that was that.

* * *

Gerald was visiting his parents in the United States in the summer of 1930 when he got a note from Patrick. "We are all very well," the boy wrote from La Bruyère, "and the animals too. The rabbit is getting much more used to Misti [the monkey, Mistigris] and begins licking him. . . . Dorothy now calls Mee Mee, Angel Mee Mee, because she doesn't go around wanting the other dogs' dinner, and all the others do that. Chang snaps at Robinson, Johnny doesn't fight with our neighbor's dog, and Judy is just the same as she was. I hope grandmother and grandfather are well too." He signed it, "love from Patrick" and added a P.S.: "I wrote this with Dorothy's typewriter."

* * *

Dorothy and my father had a terrible row one day over a spanking Dow-Dow had given Baoth. She said he had acted too harshly, and he said it was none of her business. They kept fighting until finally Dorothy said, "Well, I guess I had better leave." Dow-Dow agreed, and Dorothy promptly departed for Paris. She returned a short time later, however, and all was well.

As in the case of the roughing up Dow-Dow had given Baoth in Antibes, the spanking resulted from an outburst of temper, which my father regretted afterwards. More often he devised creative methods of punishment. When Baoth denied he had stolen a small sum of money from Ernestine,

while we were living at La Bruyère, Dow-Dow took him before a Protestant clergyman. It was a form of confession, though not Catholic. Baoth did confess he had taken the money, and he paid it back out of his allowance.

Two days after we moved into La Bruyère, Grandfather Wiborg died suddenly in New York City, and Mother took Baoth to America for the funeral, which was held in East Hampton. The death of their father and the property he left would ultimately be factors in a bitter dispute between Mother and Aunt Hoytie, but relations were still reasonably friendly in the summer of 1930 when Hoytie, along with Aunt Mame, the wife of my grandfather's brother, Harry P. Wiborg, came to visit. Hoytie always did, of course, exasperate my parents, among others. She was terribly self-centered and had been all her life. Mother used to tell a story of when they were little girls living in Clifton, Ohio, a small town outside Cincinnati. They were out in the garden playing one day when it started to rain, and Hoytie went running into the house, purple with rage and screaming, "It rained on *me.*" In later life, Mother's benign aggravation turned to bitterness. "[W]e have *always,* since childhood, been so far apart," she wrote, "in our character, tastes, and aims in life, so deeply alien."

Since their troubles were not yet financial in 1930, my parents sought diversion in fairly expensive ways. They bought a house, for example, in Montana-Vermala and turned it into a bar, which they decorated with red stars and mirrors. They called it Harry's, after Harry's American Bar in Paris. It was a going business, with paying customers and a dance band to entertain them, though I doubt that it turned a profit.

They also decided to build the *Weatherbird.* Mother decided, actually. It was her decision to make, as it was paid for with her money. The *Weatherbird* would be, as Dow-Dow explained in a letter to Archie MacLeish in January 1931, "a spacious *goélette*—not very long, twenty-seven metres on deck, . . . nice and deep with head-room below. We're taking as model those schooners that come from the Balearic Islands. . . . But of course she'll have a regular New England deck-house, and big awnings. She will be a composite of all that Sara found the *Honoria* not to be. She will be undersailed: jibs that come over automatically, a fixed stay-sail on the front mast, and on the main mast both Marconi and regular rigging. . . . She'll be a regular sea-going schooner, very steady and domestic, and very comfortable."

As with nearly everything they did, my parents were building the *Weatherbird* with my brothers and me in mind. "Patrick will not be able to stay at sea level," Dow-Dow said in the letter to Archie, "but it seems a voyage

at sea is good from time to time. We shall use the *goélette* by way of educating the children, taking them along the coast of Spain, Africa, Italy, Greece, etc. When all this is to be, we are not sure, but we are building the *goélette*, by God."

The *Weatherbird* was named for the jazz song my parents liked so well, and a Louis Armstrong record of it was sealed in her keel. She was designed by Vladimir Orloff and Henri Rambaud, a naval architect in Antibes. Dow-Dow drew a chalk-powder outline of her hull, as it would be seen from the top of the mast, on the lawn at La Bruyère, so Patrick could see it from the window of his bedroom.

In the fall of 1930, Baoth entered a boarding school near Munich, where he quickly mastered the local German dialect and learned a complicated dance called the *schuplatler.* On October 5, Mother, who never enjoyed robust health from the day she learned of Patrick's illness, received a report of a physical examination from the American Hospital in Paris. She learned she was suffering from a gall bladder disorder. Dow-Dow sent the news, among other tidbits, to John and Katy Dos Passos, who were living in the United States. "There's a metre of snow already," he wrote. "We are high above Montana in an abandoned Belgian refugee consulate. At least Patrick and me. Sara, poor dear, ordered to Cannes for 'rest' and treatment." Apparently I was still suffering from some malady, for Dow-Dow added, "Not-well Honoria with her."

Dow-Dow was doing his best to sound cheerful, but it was he who was faring the worst, at least psychologically. In happier days, we would laugh when Bob Benchley called him "Mr. Gormerly," for being gloomy, but there was no joking about Dow-Dow's black moods in Switzerland. He had sought psychiatric help, but it appears he found relief more readily by going off by himself. At one point, he took a long hike to a monastery, where he stayed overnight. He had enjoyed the company of the monks, but they had told him a horrible story, which he related when he got back to La Bruyère. There were rescue dogs at the monastery, Saint Bernards, and one of them had turned on a lost traveler and killed him. Dow-Dow explained that such incidents sometimes occurred, though rarely, and he was very upset to have been a near-witness to one.

<center>* * *</center>

Monastic living would become in later life a form of therapy for Gerald Murphy. In the only house he and Sara ever built from the ground up, a small cottage on the Wiborg property in East Hamp-

ton, he fashioned his bedroom after a monk's cell. But that was the Gerald Murphy who had weathered the worst of life and who could look back philosophically and even feel, as he explained it in a letter to Calvin Tomkins, "a strange sense of satisfaction in the knowledge that one has really touched bottom." In January 1931, however, Murphy confided to MacLeish that he felt only despair.

"After all these years," he wrote, as he was approaching age forty-three, "I find myself pried away from life *it*self by the very things that went to make up *my* life. . . . I awaken to find that I have apparently never had one real relationship or one full experience. It would seem that all my time has been spent in bargaining with life or attempting to buy it off. . . . My terms with life have been simple: I have refused to meet it on the grounds of my own defects, for the reason that I have bitterly resented those defects since I was fifteen years of age. . . . You *know* . . . that Sara has given you what she was and is. You have never known that I have given you what I was not—am not. You have *felt* it. That I know. . . . In refuting this self-recrimination (as one is always tempted to do by instinct), do be honest in not confusing me and what you feel about me and Sara. But rather recall that she is incorruptibly modest, and has never accepted (much less taken) . . . for what she does, what we give out, and what she is. This rare alchemy of nature has distilled a deceptive elixir, for which I have always received and taken too much credit. The process has left me impoverished—spiritually—as it should."

Gerald had gone to America the summer before to visit his parents. "Before I left, . . . Sara said that I should cable you I was coming. Over an hour's argument I said that I didn't want to, didn't *feel* I had a right to, in fact couldn't, because I *knew* I couldn't follow it up. I tried in vain to state my reasons. Sara could not, naturally, understand them. At last she said: 'I think that you are *afraid* to have people *like* you.' And I knew that what she said was true, and that I couldn't see you or anyone whom I like or know or who likes or knows me. Dorothy Parker had cabled Bob Benchley I was coming. He met me at the pier unfortunately. It made my heart sink with guilt, somehow. I like him. . . . I saw no one else except rather fantastic strangers. . . . I was at Southampton most of the time and most certainly saw no one there. My God, what a race of people! The hopeless circumspection of their lives, the richness, the sure-

ness, the pompousness, the leaden dullness of it all. Desolation! Sacred staleness!"

What was Gerald getting at in his letter to Archie? Plainly, he was suffering the deepest of depression, the Black Service, and it appears that Patrick's illness had triggered old self-doubts that had remained with him even in the happy days of Paris and Antibes. He had, however, succeeded in keeping it to himself. Who would deny, though, that it was the *real* Gerald Murphy who emerged in the 1920s as a creator of life and art, only to reject both of his creations upon learning that a beloved son had a disease from which he probably would not recover?

What, it must be asked, were the defects that Gerald had resented in himself since the age of fifteen? They were serious enough, in his view, to prompt a brutally self-critical remark. "You," he said to Archie, his closest friend, "have never known that I have given you what I . . . am not." Twenty-five years later, Gerald would write Archie of his restored faith in human relationships. "I was for resigning from *all* of them in sheer desperation at my inadequacy," he wrote on June 11, 1956. "I even wrote you . . . a mistaken and churlish letter on the subject. Mercifully enough, I received a corrective one from you in return, for which I have ever since been grateful." (The "corrective" letter was not found in the Murphy collection of MacLeish correspondence.) Still, there had been character flaws, at least in Gerald's own estimation. What was their nature? Intellectual? Emotional? Social? As best we know, only Gerald perceived them, and he would have shared this perception with no one but Sara.

The letter concluded: "My God, what a race of people!" By "race," Gerald was referring to his own breed, the progeny of an age of plenty in America, "these rich," as Hemingway would describe the Murphys themselves in a bitter memoir, *A Moveable Feast*, published in 1964. Gerald disdained the breed, as it was symbolized by Southampton, the Long Island resort where his parents summered. He was troubled at being part of it, though he enjoyed to the hilt the advantages of wealth.

* * *

My father was indeed very depressed by Patrick's illness. More so than Mother, who refused to give in openly to her emotions and who stoutly refused to believe that anyone she loved was ever sick. She cried just that

one time in Antibes, on first learning Patrick had TB. We could tell she was desperately worried—about his poor appetite, as much as anything, and she kept a daily log of his food consumption.

On the other hand, both my parents were resilient optimists who would take great encouragement from any sign that Patrick was improving. They also looked for things that amused them, so they could laugh and show they were still the happy Murphys of better days. There was a postcard from Baoth with a picture of an elephant that pleased Mother in particular, for it was her favorite animal. "The elephant probably brushes his teeth better than me," Baoth wrote.

Fortunately, there were good friends still coming to visit. Vladimir Orloff stayed at La Bruyère for three weeks in January 1931. He built a cage for the monkey, Mistigris, who had gotten into an inkwell and "finger-painted" the walls and ceiling of one of the bedrooms. The MacLeishes returned in February, and their cheerful presence always helped immeasurably. Also, we went on trips, which provided relief from the dreary routine. In March 1931, Mother and Dow-Dow picked up Baoth at the school in Germany and took him and me to Venice, where we posed for a picture among the flocks of pigeons in the plaza. I could not, however, help but feel all the more sorry for Patrick, who had to stay at La Bruyère with his nurse, a Canadian named Helen Stewart, who had taken care of me as a baby.

As Patrick still was not allowed by the doctors to go to Antibes, my parents rented a house for the summer of 1931 at Bad Aussee, in the lake region of Austria, about two hours from Salzburg. There is a concise description of the summer in my diary. "On the first day of June," I wrote, "Mother, Maria (our maid), our monkey Misti, and I packed off to Austria. We got the house nicely fixed up. Then a few days afterwards, Patrick came with Dow-Dow, Miss Stewart, Ernestine, and the four dogs. . . . Baoth came for his summer holidays. . . . He came without a passport. (The director of the school had forgotten to give it to him.) He managed to get from Germany into Austria very well. Well! Here we are, the whole family!"

Ramgut, as the house had been named by its owners, was roomy, with a staff of servants to supplement the ones we brought along, so we were able to invite lots of houseguests, some of whose visits overlapped. Fernand Léger and Simone, his girlfriend, stayed from July 22 to August 11, according to Mother's records, which were kept on scraps of paper in pencil. Our Boston friends, the Pickmans, were there from July 27 to August 19; the Fitzgeralds—Scott, Zelda, and Scottie—stayed from August

5 to August 11; and Aunt Hoytie, from August 8 to August 17. It was, for the most part, a pleasant, uneventful summer. We rode bicycles, swam in the lake, and played croquet, and we had a family portrait taken in Tyrolean costume. The Fitzgeralds' visit ended sadly, however. Scott had considered Zelda well enough to leave the clinic in Prangins, but he was mistaken. Very early one morning, they left suddenly, leaving Scottie behind with a nurse, who had come with them.

We left Bad Aussee in August: "Baoth went back to his school, and we all went to Paris," as I noted in my diary. "On the way, we went in cars —Aunt Hoytie and I in her car, the rest in our car; Aunt Hoytie had an accident with some Jews." What I meant by that comment, written in childlike innocence, is that Hoytie's chauffeur-driven car, in which she and I were riding, was involved in a minor accident with another automobile. Hoytie was so outraged that her neck actually turned purple. She rolled down the window and yelled at the other driver, *"Jude! Jude!"* She was terribly anti-Semitic, and it was the worst name she could call him, in her bigoted way, whether he was Jewish or not. The man did take offense, and he rushed over and tried to strike Hoytie. She rolled up the window just in time.

When my parents heard what had happened, they were mortified. They said so, and they demanded that Hoytie apologize to the man, but she refused to do so. My mother muttered, though I am not sure Hoytie heard her, "This is typical, just typical." I was horrified. Ethnic slurs—or any kind, for that matter—just were never permitted in our house.

I must say this about Aunt Hoytie, however. She was my godmother, and in the early days—in the twenties, before the awful feud with Mother over the property in East Hampton—she was very nice to me. She took me once to Paris to see a show featuring a family of midgets. As we were leaving, I said, "I wish I could see them again." Aunt Hoytie replied, "In that case, we shall have them for tea." And we did.

We finally arrived in Paris, and we put Patrick, along with Miss Stewart, in the Park Hotel in Ville d'Avray, just outside the city. "Then Mother, Dow-Dow, and I," as I wrote in my diary, "(and Aunt Hoytie, as she was there) all went to America on a dashing trip!! When we arrived there, we went to the Savoy Plaza Hotel, and there Lillie Nyberg was waiting for us. We [had] asked her to come there to stay with me, . . . as Mother and Dow-Dow were *terribly* busy at their business affairs, and at night they went out with friends." Lillie Nyberg had been our nurse in Cambridge and in Europe, when we first arrived there.

I was thirteen in the summer of 1931, but my life had been restricted

to the family circle. My education, up to this point, had consisted entirely of private tutoring. Consequently, my parents thought me young for my age. Whether I really was or not, I cannot say, but it was an attitude they were guided by—my father more than my mother—throughout my teenage years. I was eighteen, in fact, when Dow-Dow wrote to Mother of my "process of mind," which he considered not very thorough. "This she gets from both of us: my lack of mathematical sense; your lack of mechanical or practical (in the material sense) aptness. I was a downright bad scholar. We are both irresponsible in the material sense. So is she."

<p style="text-align:center">* * *</p>

It is not clear whether Gerald, or Sara, fully understood how irresponsible they had been in depriving their children of a traditional education. It was patently selfish of them: they wanted the freedom to travel at will, and the private tutors afforded them that freedom. In this regard, Murphy's claim to MacLeish that building the *Weatherbird* would provide a floating history classroom clearly seems a rationalization. The disadvantages to the children of the tutoring were twofold: educational, as demonstrated by Honoria's having to drop back when she entered a private secondary school in the United States; and social, as shown by the long period of time it took Honoria to adjust to a community inhabited by contemporaries.

<p style="text-align:center">* * *</p>

In September 1931, still staying at the Savoy Plaza, we spent weekends at East Hampton. The Fishes were there, living in a house they had built on Aunt Olga's share of the Wiborg property. A house was being readied for us nearby, which indicates that my parents had decided to come home. It had been a farmer's cottage and was named Hook Pond, for the small body of tidal water the house overlooked. Just before returning to Europe that fall, we visited the MacLeishes in Conway, Massachusetts. In addition to Ken and Mimi, whom I had known at Antibes, they had a three-year-old son, William, who was my parents' godson.

Mother and I went to Paris and stayed until just before Christmas. She loved to shop and was doing her best to enjoy herself, going to Montmartre in the evenings with Bob Benchley. She looked stunning, especially in a long black dress, which made her look so slim. She often wore a pearl necklace and a black fox fur piece. She was very careful about the way she put on make-up, and she was able, by the sheer force of her beauty, to mask the anguish inside her.

My father had taken Patrick back to Montana-Vermala, but he was forced to return suddenly to the United States by news of the death of his father. Grandfather Murphy had gone to Rochester to visit his friend George Eastman, the founder of the Kodak film company. On the train trip back to New York City, he had become overheated and subsequently caught a chill, which had developed into pneumonia, and he died on November 23, 1931. "Dow-Dow had gone to America because his father died," my diary reads, "and shortly after we arrived in Switzerland, he came too. Then he went off to Germany to get Baoth from his school, and then we were all together. We had a lovely Xmas and a happy New Year. . . . All my adventures of 1932 are told in the other diary. Good-bye ladies and gentlemen."

<div align="center">* * *</div>

On January 8, 1932, Gerald wrote to Archie of the Murphys' immediate plans. They centered on the new yacht, the *Weatherbird,* which had been commissioned at Fécamp, on the coast of Normandy. "Poor Vladimir made the 2,000 miles from Fécamp to Gibraltar against head winds," Murphy wrote. "In coming up from Gibraltar they hit the hurricane. . . . They were driven back into Barcelona, then came out twice and were driven back each time into Las Palmas, a little port on the northeasterly Cap of Spain. Finally they got to Marseilles. Vladimir says that the *Weatherbird* is indestructible and that he has proof. . . . We are going down to Antibes in a week or so to try her out, and are planning a cruise for Easter vacation. Unfortunately the doctor won't let poor little Pook go to Antibes. We must keep him here until just before we sail the end of April. This cursed thing is the worst imprisonment for him; as he grows older, he chafes more and more under it. The other day he said: 'Oh, I wish I had another sickness!' Instead of less, unfortunately, he feels more and more the things that Baoth and Honoria can do, without thinking or asking. It is cruelly hard for him, and there remains no choice for us. We have, I'm afraid, become identified for him with constant, constant deprivation."

Gerald wrote again on February 4 to Archie, who had sent a message of condolence, having heard that Gerald's mother was dying. "I know of nothing that has happened to us that has shaken us as deeply as your cable," Gerald wrote. "Mother's mind failed before I could have got to her. . . . She has no lucid intervals at present. . . . She may live for weeks or months. It is sad that she

cannot die. She wanted to. But this life-death thing continues." (She did die, on April 25.) Gerald turned to other news. "Sara and Honoria have gone to Antibes. . . . Baoth in Germany. . . . Patrick and I here preparing for the home-stretch. . . . *Weatherbird* is a thing of great solid beauty says S. Antibes a paradise: mandarins, lemons, oranges, camellias. Of a sudden it's anemones, mimosa, and lunch on the terrasse."

* * *

Mother, Ernestine, and I, with Johnnie the dog, took the overnight train from Switzerland to Antibes, arriving on January 27. We had reopened the Villa America for a final stay before returning to America, although there would be summertime visits thereafter. Dow-Dow came on February 11, and Baoth arrived two weeks later.

The Nazis were on the march, and my parents had decided it was high time to take Baoth out of the boarding school in Germany. We had learned that he was being forced to stand in the snow at 5:30 in the morning, wearing only his underwear, to do "Heil Hitlers." Baoth had left his trunk behind, however, and he and I went with Mother and Dow-Dow to get it. While they were having an angry discussion with the headmaster, a Prussian-looking man who wore a monocle, I went with Baoth to help him pack. It was then that Baoth told me of the way he intended to get revenge for what had been done to him at the school. As the headmaster came strutting down the hallway after the meeting with our parents, Baoth and I sprang from around a corner and stuck our tongues out at him. "Rude Americans," he spluttered, as we ran for the car, delighted.

My first formal schooling was at Mademoiselle Fontaine's in Cannes from February to May 1932. I was a day student, and I also took piano lessons in the afternoon. On May 16, Miss Stewart and Patrick arrived, and all the lanterns were lit in the garden of the villa the night we welcomed them. It was wonderful to be back at Antibes, and we took trips on the *Weatherbird*, such as one from St. Tropez to the island of Port-Cros.

Alice Lee and Dick Myers were staying at the Ferme des Orangers. Alice Lee was my mother's most reliable "friend in need," and Dick was perhaps the most gregarious person I have ever met. He was a connoisseur of wine, and he made it his profession, as a buyer and seller for M. Lehmann Co. of New York. He also was a fine musician, a pianist, and a composer. The Myers's children were also there—Fanny, Dicky, and a baby, Boo, or Alice Lee, named for her mother. Fanny became—and has remained to this day —my best friend.

Excerpts from my diary show that life was carefree in Antibes for the short period in 1932 that we were there. "(May 17) Stayed on the beach with girls all afternoon; came home, played with Myers; Barrys came for supper. (May 19) On the way to Port-Cros Thursday. Everybody went—Miss Stewart, Patrick, Mother, Dow-Dow, Baoth, sailors, and I. After lunch we went in car to St. Tropez where we met the boat. . . . Had supper on boat, . . . did a little shopping after dinner. (May 20) From St. Tropez to island of Port-Cros Friday. We brought Misti along. Sailed all day, had lots of fun, delicious lunch in deck-house. Threw cigarettes to men on a beautiful *goélette*. Went on island to get worms. Before supper, Patrick went fishing. Henri caught one fish. (May 22) I felt the sea a little, was slightly ill Sunday. A *mistral* came up, so we sailed all morning—very rough. Had lunch at Cap Tayat, then sailed on and arrived in the afternoon at St. Tropez. Spent the night there. . . . (May 23) Stayed all morning Monday in St. Tropez. . . . We went in car to Antibes; on the way there a tire burst, and it was quite an affair. . . . (May 26) Fooled around in the morning; later went to beach with Fanny and Dicky; they had swimming lesson. . . . In afternoon, made scones with Fanny in playhouse. Pat went on boat with Mother and Dow-Dow and had a tea party. Invited Miss Stewart, Baoth, Dicky."

I also noted in my diary that Aunt Stella came for dinner on May 25, 1932. That would be Mrs. Patrick Campbell, the actress. I called her Aunt Stella, though she was not a relative. She was the only one of my parents' friends whom I did not address just by his or her first name. Perhaps it was because she was a good deal older than most of them and my parents, as well, or because she was a great lady of the English stage. George Bernard Shaw wrote *Pygmalion* for Stella Campbell, and her long romance with the renowned playwright had caused quite a stir in post-Victorian Great Britain.

On May 30, 1932, we went to Paris to see Patrick off for America. He was going to stay with Miss Stewart in Canada and then join us in East Hampton. We went on two more cruises on the *Weatherbird,* and in July we closed up the villa again and went to Paris. We saw Fernand Léger and his wife, Jeanne, to whom Mother gave the misbehaving monkey, Mistigris. This time we were really going home, though there would be vacations abroad. We sailed on the *Aquitania,* arriving in New York on July 16. At the dock to meet us were Archie MacLeish, Dorothy Parker, and Aunt Hoytie.

*　　　*　　　*

Mary Hoyt Wiborg was an uncommon woman, no one would ever dispute that. Strong-willed and haughty, brash and bigoted, she induced definite reactions from relatives and acquaintances, most of them negative. There were, however, attributes of Hoytie's character that did not always receive a full measure of recognition from people—including Sara and Gerald and all their Paris friends —who had been put off by her authoritarian manner. She had, for one thing, a very well-developed artistic talent: she was an accomplished musician, who played the guitar and sang beautifully; and she was adept enough at writing drama to have a play about voodoo practices in Louisiana produced in New York in 1922. She also collaborated with Stella Campbell in the production of a play in London in the 1920s. The failure of the play caused a confrontation between Mrs. Campbell and Frank B. Wiborg. "Dear Mrs. Campbell," he wrote on July 23, 1926, "I have reached London and am surprised to learn of the feeling and recrimination you seem to harbor against my daughter, Mary Hoyt. . . . The production turned out unprofitably for you both, but instead of accepting your end of the contract, and subsequent loss, you have persistently dunned Mary Hoyt for the amount of your salary, with the idea that you would ultimately force her to pay you. . . . I, or my children, are not in the habit of contracting debts which we do not pay, and I have trained them to respect the force and value of a contract."

Mary Hoyt was, in addition, intelligent. There was the time in 1928 when she had been charged with bringing undeclared purchases into the United States. She pre-empted her lawyer and argued her case "so effectively," according to the *New York Daily Mirror*, "that an intended Government levy of $3,500 . . . was postponed." And she was courageous, "a very strong person," in the words of a nephew. "She was headstrong and demanding," he explained, "and she thought she *was* one of the world's anointed . . . but there was a lot about her to admire."

<p style="text-align:center">* * *</p>

I did not realize it until later, but the trouble between Hoytie and my parents began that day in July 1932, when she was at the dock to meet us as we arrived in New York on the *Aquitania*. For the time being, Hoytie and I got along famously. We were together a lot in East Hampton, where she taught me to drive, and she took me to a newsreel and to lunch when I went to New York to have a tooth pulled.

"At last the family all together in America," I wrote in my diary on July 20. We spent the rest of the month and all of August at Hook Pond, our house in East Hampton, although Mother and Dow-Dow made frequent trips to New York. Aunt Olga was also there, with Uncle Sidney and Stuyvie, and Aunt Hoytie came down on weekends. It is the only time in my memory that the three sisters were together at the estate that Grandfather Wiborg had left them. This, as I was to learn, is because the disagreement between Mother and Hoytie centered on the share of the property that had been left to Hoytie, which she sold to my mother and then demanded back. It was a dispute that would ultimately have to be settled in court.

In late August 1932, my mother and father and Baoth and I spent three weeks at a dude ranch in Montana, the L Bar T, having been invited by Pauline and Ernest Hemingway. Patrick was not well enough to go, so he stayed in East Hampton with Miss Stewart.

We were in mountain country. The ranch lay in a valley between two peaks, called "Pilot" and "Index." I still was not fond of mountains, but the Rockies did not seem as awesome as the Alps, and the atmosphere was friendlier by far than it had been at Montana-Vermala. The real reason for my change of attitude, of course, was that we had been encouraged to believe that Patrick was recovering from TB.

Every day at the ranch was a delight. Baoth and I would go with the cowboys at five in the morning to round up the horses. One cowboy was named Hal. He had a weatherbeaten face, which made him look mean, but he really was very kind. He taught Baoth and me every word of "Red River Valley," which was the first song of the American West I had ever heard.

Everyone was assigned a horse. I became very attached to mine, a gelding, and I felt sorry for him, because his mane was matted. I combed it for three days, until it was as smooth as a girl's hair, and then I braided it. This amused the cowboys no end.

We lived in cabins, and after the grownups had had their evening cocktails, we would go to the main house for supper. The food was different from what we were used to—lots of steak and fish fried in batter. I was famished at every meal and enjoyed it, but I could tell that my parents were not too pleased with ranch cuisine. Mother made fun of her appetizer one evening—canned fruit salad on iceberg lettuce with mayonnaise topped with a maraschino cherry. "Now, Sara, it's good for you," Ernest chided.

The highlight of the visit was a pack trip to a remote mountain lake in which, Ernest promised, the trout would be plentiful. We set out early one

morning on sure-footed horses. Ernest said they had a sense of their own girth that enabled them to judge if they could squeeze between two trees on a narrow trail, even taking into account the space required for a rider's legs. I was not so sure, as we climbed through clumps of small pines, and Ernest, who had been keeping an eye on me, said calmly, "Don't be afraid, daughter. You can do it."

We reached our campsite on a quiet, lovely lake in mid-afternoon, and the cowboys unpacked the horses, pitched our tents, and cooked steaks and potatoes over an open fire. After supper, we listened as Ernest told stories of his adventures as a hunter. As the air became cool and still, I felt a bit of fear. I asked Ernest if grizzly bears might come into our camp, and he assured me there were none around—only raccoons and rockchucks. I believed him and was no longer afraid.

The next morning we went out on the lake, two fishermen to a small boat. I had never fished, and Ernest said he would teach me, which meant I would be his companion, and that pleased me. We went to the middle of the lake, where Ernest shut off the outboard motor and showed me how to bait my hook. He then started the motor up again, and we moved to a part of the lake where he must have expected to find fish. Again he stopped, and he began to row very gently, while I trolled my line behind the boat.

Suddenly, I felt a tug, and I knew I had a bite. As Ernest encouraged and guided me, I managed to pull a large trout into the boat. It was flopping around, and I was wondering in my excitement what to do next when Ernest said quietly, "Watch while I take the hook out of his mouth." I was amazed at the way he held the fish so gently in his large hands and deftly removed the hook.

He then said he would show me how to clean the trout, and I started to wave my arms wildly and shriek, as I was not about to touch a dead fish, let alone cut it up and clean it. "Now, daughter," said Ernest, "let's grow calm while I explain to you the beauty of this creature from the water." He then proceeded with an enchanting explanation of the design and function of the fish. "First of all, they have a rough skin protection, called scales, and we are going to scrape them off. Now, notice how the fish is shaped—it is narrow at the tail, so it can glide through the water. Fish are clean, because they only eat things that live in the water. Can you see how the inside of its gills looks like pink coral? And can you appreciate its beauty? Look at the silver shine of its underbelly and the fine feathery lines of its fins. Don't they look like lace?"

The trout was lifeless, its skin scraped smooth, and Ernest placed his

knife in my hand and guided it as I slit open the stomach. He repeated his point about the cleanness of the fish, since it lived in clear water and ate only bugs and plants. Then he explained the arrangement of the trout's internal organs. "See here, daughter, the lungs look like deep pink sponges, don't they? They're right inside the gill slits, where they are protected. The fish breathes by opening and closing those gill slits, letting the water in and out, just as we breathe air."

As we cleaned the trout together, I no longer felt squeamish, and I was glad I had performed well for Ernest. He caught quite a few fish that morning, while I landed only one more, though my first one was the largest in our boat. Mother and Dow-Dow and Baoth and Pauline brought back a good many trout as well, and we ate them for dinner that night, cooked over the fire. I had never tasted fish like that—they were sweet, like nectar.

The grownups drank whisky before dinner, and it put them in a happy mood. My father loved to entertain people, and he could be quite a comedian. As we were settling into our tent for the night, Baoth and I could hear him singing as he strolled off into the woods to get some air: "There's a cabin in the cotton, far away but not forgotten." He heard us laughing and came back to serenade us until we fell asleep.

* * *

When Hoytie wrote the Murphys in December 1929 that she had lost her shirt in the stock market, "but am getting it back . . . in small driblets . . . ," she was understating or had not yet fully realized, or both, the extent of her predicament. It was not the stock market crash, however, that led to her ultimate financial ruin. It was her heavy investing in New York City real estate. Her misadventure began in 1928, when she conceived a plan to build an apartment house at Park Avenue and Seventy-second Street in Manhattan. She had already become the owner of three pieces of property—754 Park, 756 Park, and 56 East Seventy-second. To proceed with the project, however, she needed to purchase the house at 54 East Seventy-second, which was owned by Oscar M. Manrara and his family.

In spite of her stock losses, and over the vigorous objections of Nicholas E. Betjeman, the Wiborg family lawyer, Hoytie went ahead with the transaction. That was in 1930, and what happened is explained by Betjeman in a letter to Sidney Fish, dated May 3, 1933. "When Miss Wiborg purchased the inside 72nd Street house from Manrara, she gave back a mortgage of about $200,000, besides

paying about $130,000 in cash," Betjeman wrote. When Hoytie proceeded to default on the payments, "the deal fell through, and Manrara foreclosed on his mortgage. . . . Manrara has obtained a deficiency judgment against Mary Hoyt Wiborg for $204,876.90. Said big judgment was entered against Miss Wiborg on March 31, 1933."

Hoytie herself summed up her problem and indicated how she intended to handle it in a letter written June 15, 1932, to Sara Sherman, a cousin who was married to W. Ledyard Mitchell, an executive of the Chrysler Corporation. "I am still on the bond of the fourth house belonging to these . . . Manraras," she wrote, and she supplied the details of the foreclosure judgment. "So," she warned, "unless they make a radical reduction in this figure, they will have to be left out in the cold. In order to do this, I may have to declare bankruptcy."

Hoytie was aware that in order to declare herself bankrupt, she would have to dispose of her share of the Wiborg property in East Hampton, which consisted of her father's mansion, called Dunes, and about twenty-seven oceanfront acres on which it was located. On October 26, 1931, as a temporary measure, she had sold the property for one dollar to Mary C. Wiborg of Cincinnati, her eighty-year-old aunt. Aunt Mame, as Mrs. Wiborg was called by her three nieces, in turn had deeded the property on May 21, 1932, to Trex, Inc., a New York corporation. Trex had been formed by Hoytie as an instrument in the transaction she was ready to propose to the Murphys, as they arrived home from Europe in July 1932 on the *Aquitania*.

Hoytie's plan was also outlined to Olga and Sidney Fish, who received a letter dated July 14, 1932, from Nicholas Betjeman, at their California ranch. "In order to place her . . . property interests in other hands," the letter read, "Miss Wiborg would like to sell the same to other members of her family for a cash consideration, which might be about $25,000 each from Mrs. Murphy and Mrs. Fish. I understand that Miss Wiborg expects the right to repurchase the property some time in the future for the same amount of considera-tion. It is difficult to set forth the details of the transaction, but at least Miss Wiborg would like to know whether the proposition would be entertained in any event."

A reply from Sidney Fish was dated July 16: "In regard to Miss Wiborg's proposal, which I do not quite understand, Mrs. Fish and

I think we had better not go into any such agreement as it would probably result in complications and do no good to anybody." It was a prophetic statement, as the Murphys would discover. Sara Sherman Mitchell and her husband, Ledyard, were asked by Hoytie if they would be interested, and Ledyard replied to her on July 21: "I cannot tell you how dreadfully Sara and I feel about your present difficulty, and particularly as we cannot do what you ask, . . . but we simply haven't got $25,000." He did have a suggestion, however. "If Gerald can purchase half of your holdings for $25,000, would it not be logical with money as scarce as it is . . . to have him buy for the $25,000 your entire holdings? In other words: Price your holdings down to the point where $25,000 will cover them, and, while a distressing price, . . . it would be a sale and might answer the purpose." It was Sara Murphy, not Gerald, who made the purchase, as Betjeman reported to Fish on September 12. "The main house at East Hampton is *not* owned by Miss Wiborg and has not been since August 2, 1932. On that date, Mrs. Sara W. Murphy purchased the premises for good and valuable consideration and is now the owner thereof."

It is apparent from the correspondence that Betjeman, out of patience with Hoytie for her persistence in going through with the Manrara transaction, did not resolve the question that had perplexed Sidney Fish: What did she have in mind in her expectation of a repurchase right? There is no evidence that Sara and Gerald even knew of any such expectation. It was not long, however, before they realized that a fight was in the making. "She wants cash and threatens all sorts of things," Olga Fish wrote Sara in April 1935, making it clear that Hoytie's threats were directed at Sara and Gerald. "She is quite capable of a lawsuit."

Sara and Gerald staunchly took the position that there had been no strings attached to the purchase, which they believed had been made for the good of the family. Sara explained in a letter in July 1935 to her attorney that it had been a responsibility she had undertaken "solely to assure the family a little as to Hoytie's future." She went on to explain. "So—returning from Europe three years ago—I was confronted (almost at the gangplank) with Hoytie's desperate plight. A huge judgment was out against her. Everything was, or [was] going to be, seized. Everyone had been approached about help. Everyone had refused or was unable. I was *absolutely* the last resort."

There was never any indication of how Hoytie intended to repurchase the property. She herself insisted for the rest of her life that she was virtually destitute, although sympathy for her penurious condition was held in check by evidence that she never abandoned the high life. She had the luxurious apartment in Paris, for example, which she retained until her death. When Hoytie finally did file suit, in July 1942, she maintained that the money paid to her by Sara had been a loan and that she had deeded the property to Sara as security. The terms of the 1932 agreement between Sara and Hoytie would be the subject of a simmering, bitter feud, which would not be resolved until the suit came to trial in 1944.

* * *

As I had written in my diary in July 1932, we were back in America for good. There would be occasional trips abroad—Mother and Dow-Dow sailed for France that October, as a matter of fact. We continued to spend summers cruising the Mediterranean on the *Weatherbird* and staying at the Villa America. The yacht and the villa were the last vestiges of "the era," as Mother called it. They would not be sold until later, when it was clear that she and Dow-Dow no longer had an inclination to relive it.

We did not exactly settle down. We lived at Hook Pond in East Hampton. We had a house in Bedford Village, New York, called Duncraggon. And, beginning in 1933, we took the first of several apartments in Manhattan, at 1 Beekman Place. Even though they were as restless as ever, my parents had decided that it would be prudent to establish an American base. Patrick's illness had a lot to do with it, as did Baoth's and my education. In addition, my father's business, the Mark Cross Company, badly needed his attention.

There was one other important reason for our return to America. My parents were, at heart, American people. Years later, my father wrote to someone who had inquired about the period we had lived in Europe: "Although it took place in France, it was all somehow an essentially American experience. We were, none of us, professional expatriates."

Archie MacLeish sensed this, and he wrote a poem, "American Letter," which really was a plea to my father to come home. Archie sent Dow-Dow a draft of the poem, written in pencil on foolscap. It was to "Dear Gerald," still in France, from "Archie," back in America. It reads, in part:

> *The tossing of*
> *Pines is the low sound. In the wind's running*

> *The wild carrots smell of the burning sun.*
> *Why should I think of the dolphins at Capo di Mele?*
> *Why should I see in my mind the taut sail*
> *And the hill over St. Tropez and your hand on the tiller? . . .*
> *This is my own land, my sky, my mountain:*
> *This—not the humming pines and the surf and the sound*
> *At the Ferme Blanche, nor Port Cros in the dusk and the harbor*
> *Floating the motionless ship and the sea-drowned star.*

I spent the academic year of 1932–33 at the Convent of the Sacred Heart in Noroton, Connecticut. I loved it there, though I at first felt a bit out of place. I did not know, since I had not been raised as a Catholic, when to genuflect, but the Pickman girls, Jane and Daisy, were there, and they advised and guided me. Also, the nuns were very sweet and understanding. We attended mass every morning at six, and pretty soon I had calluses on my knees from praying. It was a very strict school, and I believe it was a good school. I have fond memories of being there.

While I was at the Convent of the Sacred Heart, I became deeply committed to the Catholic faith, which is one reason my parents allowed me to go there for just one year. They were fearful that I would become a nun, and their fears were well grounded, I will admit, for I was giving it some thought. I do not know which of my parents was more disturbed by the idea: my father, who had rejected the faith, which had been imposed on him by a dogmatic mother; or my mother, who had allowed my brothers and me to be baptized as Catholics, but who had refused to let us be brought up in the church.

There was another reason I changed schools, and it was the same with Baoth, who started in the fall of 1932 at the Fountain Valley School in Colorado, transferred the same year to the Harvey School in Hawthorne, New York, and was sent, in 1934, to St. George's in Middletown, Rhode Island, which is near Newport. My parents—my father, in particular—believed in variety and change in all aspects of life. Years later, after I had married and was raising children of my own, Dow-Dow cautioned me about becoming too immersed in domestic life, which I was inclined to do. He pleaded with me to get out to museums, to meet with friends, and to keep abreast of current events. It took some doing, but I valued his advice and tried to abide by it.

We took a delightful trip at the end of 1932 to Conway, Massachusetts, to visit the MacLeishes. My father had anticipated the occasion in a splendid letter he wrote to Archie from the dude ranch in Montana in Septem-

ber. "At Christmas vacation, we are going to open your house at Conway, and Sara and Ada are going to cook a goose with its accessories, and I am bringing the choicest wines and liqueurs, . . . which I have inherited from Father. . . . Enough of these herds of cattle. . . . I want to hear Ada ask the sweet potatoes whether they prefer to be cooked with pineapple or a marshmallow crust. I want to see Sara make a giblet sauce out of the parts that are condemned out here."

Patrick was continuing to get better, but he was not able to go with us to Europe in the summer of 1933, so he returned to Canada with Miss Stewart instead. The rest of us—Mother and Dow-Dow, Baoth and I, as well as Katy and John Dos Passos—went on a cruise down the coast of Spain, having spent a couple of weeks at the Villa America.

We left Antibes on June 28, 1933, and went by train from Marseilles to Port-Vendres, on the Spanish-French frontier, where we were met by Vladimir, who had sailed down ahead of us. We set out on the morning of July 1 at nine o'clock, and we sailed all day in beautiful weather. We spent the nights anchored at small ports, which we would visit early the next morning. There was much gaiety aboard *Weatherbird* in the evening, as Dow-Dow entertained us with tunes on an old upright piano. Although self-taught, he was quite accomplished at playing it.

The *Weatherbird* was an ideal boat for long cruises, for it had been built and outfitted for comfort. It had, to begin with, a spacious deckhouse with windows on all sides, a long table, which could be folded down when not in use, and a cushioned bench with navy blue covering. It was extremely pleasant to be able to eat above deck when the weather was bad—for me especially, as I tended to suffer from *mal de mer*.

The living quarters were connected to the deckhouse by a companion-way, and when one descended and walked toward the bow, the first cabin on the left was mine, which may have been apparent, as the curtains and bedspread were a girlish pink. My parents' cabin was across the way, done in green, which was Mother's favorite color. A bit farther along, at about midships, there was a main salon, which I called the living room. It was furnished with a long table, comfortable chairs, the upright piano, which was white, and sleeping berths for four guests. There was another cabin on the starboard side, forward of the living room, which was for more guests or for my brothers when they were aboard. The galley was on the port side. Still farther forward were Vladimir's cabin and quarters for the crew.

On July 3, we reached Palamós, and I shall quote from my diary to

explain what it was like to be fifteen on the Fourth of July in a strange Spanish port. "The next morning, we went to the market of Palamós. . . . Women old and young were sitting on stools, in a row along the sidewalk, with big wicker baskets full of fruits and vegetables. . . . One woman had picked all the best mushrooms out of her basket and had put them in her lap so as to tempt people. We were tempted and bought them. As it was the Fourth of July, the sailors (on *Weatherbird*) had dressed the boat with little signal flags. Dow-Dow played marches on the victrola all through . . . breakfast. Baoth put on Mother's nighty and danced around. He looked too funny."

Our cruise ended, following visits to Barcelona, Tarragona, Castellón de la Plana, and Valencia, with a very rough twenty-hour run to Palma on the Balearic island of Mallorca. We did not enjoy Palma, as I noted in my diary, because it was crowded with English and German tourists. We then took a ship back to Barcelona, except for Baoth, who stayed with Vladimir and the crew of the *Weatherbird* for the trip home.

The Dos Passoses went to Madrid, which reminds me of something about Dos. He never, in all the years that I knew him, was able to say "good-bye." He simply could not bear to say it, so he would just leave. Mother, Dow-Dow, and I took a train to the Spanish-French frontier, then switched to another train for Antibes. It stopped for two hours in Narbonne, giving us time to see a funny movie. I wrote the title in my diary. It was *"Theodore est fatigué"* ("Theodore Is Tired").

In the fall of 1933, I went to Rosemary Hall, a boarding school in Greenwich, Connecticut. I did a two-year stint there, and it was not a very happy experience. At first, it was partly homesickness. I had lived away from home at the Convent of the Sacred Heart, but the nuns were so gentle that they relieved much of the agony of being away from my family. There was more to my misery, however, than missing Mother and Dow-Dow and my brothers. Rosemary Hall was fashioned after a preparatory school in England. It was very strict. This was a time when I was beginning to be a bit rebellious anyway, and I bridled at the rules, many of which I considered silly. We were required, for example, to show our school spirit by attending athletic events. A friend and I would routinely wash our hair on Saturday afternoon and use that as an excuse to skip the game.

I enjoyed athletics, but I resented being ordered about. "Murphy, get in there and play guard," the basketball coach would yell. I also did not like contact sports, so when I saw the ball coming, I would run the other way. I was delighted when I broke the little finger on my right hand playing

basketball, for I then was excused from all sports. You see, I had never before taken sports in school, and I had never been exposed to competitive games. In my childhood, I had learned to swim and to ride, and that was it. I loved horses, and there was a riding stable near the school, which I patronized regularly. I also learned that I loved to run, so I went out for track and did quite well at it.

Just before I left Rosemary Hall, I was called in for a session with the headmistress, a dour woman who wore a pocket comb in her frizzy hair and often toyed with it as she addressed the students. "Murphy," she said, "the trouble with you is that I never know what you are thinking." Feeling quite satisfied, I thought to myself, "I've got her. She can't get into my brain."

In February 1934, Mother went to Key West, Florida, to visit Pauline and Ernest Hemingway. "Patrick has been in fine form," my father wrote from New York on February 15. "His appetite has held up well. . . . His face is very full. . . . He got about twenty valentines, which seemed to please him."

Dow-Dow had remained in New York because of a crisis at Mark Cross. The survival of the company depended on the renewal of a lease on a building that the store occupied at Fifth Avenue and Thirty-seventh Street in Manhattan. The landlord was Robert W. Goelet, an eminent entrepreneur who had made a fortune in New York real estate. He had not endeared himself to my father, who told my mother in his February 15 letter: "He has used every underground means to bring advantage . . . to himself."

My father never really enjoyed his business career. He would refer to himself as "the merchant prince," which I always took to be said with humor—a self-spoof, so to speak. Not so, Archie MacLeish informed me many years later. He said my father meant it very seriously. "Yes, and with such bitterness," Archie declared.

* * *

The Mark Cross Company, according to a one-hundredth anniversary booklet written by Gerald Murphy, was founded in Boston in 1845 by Henry W. Cross, an Irish saddler, who had served an apprenticeship in London, and his son, Mark W. Cross. Harnesses and trunks, "built of fine materials and workmanship" and sold at a small brickfront shop on Summer Street, comprised a thriving business in Boston, the mid-nineteenth-century hub of transportation and commerce in the United States.

In 1892, not long after he had taken over the company, Patrick Francis Murphy moved it to New York City, in order to serve a more dashing clientele, which was known as the carriage trade. The wealthy set, which gravitated to New York because it was the financial capital of the country, couldn't have cared less about harnesses and trunks. Its interests leaned to expensive goods of fine leather—pigskin saddles and luggage made of pin-seal skin—which P. F. Murphy introduced in America. In the one-hundredth anniversary booklet, Gerald Murphy epitomized the clientele with a description of Lillian Russell, the actress and singer, riding each day at noon down Fifth Avenue in her black and yellow tally-ho, pulled by four black horses with pigskin harness and white doeskin reins, both Mark Cross products.

Patrick Murphy had joined Mark Cross in 1875 at the age of seventeen, as a salesman. When Mark W. Cross died without an heir, Murphy gained control of the company, purchasing it for $6,000, which he had borrowed from his father at six percent interest and later repaid. An innovator with foresight, Murphy took account of the automotive age and realized that the carriage trade, as defined by its tastes and its ability to satisfy them, would outlive the mode of transportation for which it was named. Accordingly, he went to Europe each year and brought back hundreds of items never before seen on the American market—a thermos bottle, a hot-water bottle, cocktail sets, decanters, Minton china, English crystal, Sheffield cutlery, Scottish golf clubs, and many more.

Mr. Murphy was a uniquely inventive merchandiser. When told during World War I by a British Army officer that his pocket watch was too cumbersome to carry in the field, he designed a timepiece that could be worn on the wrist and had it made at his factory in England. He then brought the timepiece home and put it on the market, thereby introducing the wristwatch in America. P. F. Murphy was also a noted after-dinner speaker, one of the best in the days when such orators were in demand at "bankers' dinners" of up to 1,500 guests. Although it was never evident in the inspired wit that flowed from the rostrum, he had a rigid set of rules for his talks: he insisted on being the last speaker of the evening; he timed his talks to seven minutes, though with interruptions they lasted about fifteen; he never smiled and kept his hands clasped firmly behind his back; he spoke to an imaginary lady, elderly and slightly deaf, seated in an upper box of the ball-

room; he spoke after the demi-tasse had been served; and no waiters were allowed on the floor.

Gerald's brother, Fred Murphy, a Yale graduate in 1908, went to work for Mark Cross, but he and his father had a falling-out over Fred's demands that the company be enlarged, while P. F. Murphy was satisfied with a steady $75,000-a-year profit. By the time of his death in 1924, Fred had left the company, having joined its London branch for a short period at the end of World War I. As for Gerald, he joined Mark Cross fresh from Yale in 1912 and stayed with it until he joined the Army in March 1918, having been made a director and vice president-secretary.

When he was first with the company, Gerald was involved in a project to develop a cheap safety razor. The design that resulted was, as he put it in a later explanation of his early frustration, "stolen" by a competing manufacturer. Although he did not return to Mark Cross after the war, he continued to be a director and the third vice president. He held these positions even while living in France, though he had nothing to do with the day-to-day operations of the company. A reason for going to Europe in the first place was to escape the sort of mercantile materialism that Gerald detested. Ironically, though, his first familiarity with the old-world continent was brought about by his father's annual buying trips abroad. "Our father who art in Europe," Gerald was fond of saying, to describe his early impressions—a mixture of envy, awe, and scorn —of the patriarch.

When P. F. Murphy died in November 1931, he left control of the Mark Cross Company to his secretary, Lillian E. Ramsgate, whom Gerald would later characterize as "villainous." The assets, with an estimated value at the time of $2,000,000, were left to Gerald and his sister, Esther, but Miss Ramsgate, as president, was free to dissipate capital holdings. This, according to Gerald, is what she did, to an extent that by 1934 the situation was critical. The American economy was in the depth of the Depression; the other tenants of the building at Thirty-seventh and Fifth had defaulted, leaving Mark Cross with an obligation to pay $100,000 annually through 1941; and the company coffers were empty. In December, Miss Ramsgate called a meeting for the purpose of liquidating the company, informing Gerald that if he did not attend, she would resign.

Gerald, who had stepped down as a vice president when Miss Ramsgate was named president but who had remained a director, did not attend the meeting, and Miss Ramsgate did resign. Looking back many years later, Gerald explained his next move: "I came down and told the people in the store that I didn't know one thing about the business, but that it was all my sister and I had to live on, and so I would have to make a go of it. I said that I needed their help." He became president of Mark Cross on December 19, 1934.

Gerald turned to Goelet, the landlord, whom he considered an "honest pirate." As collateral on his sizeable loan, Goelet took fifty percent of the company, but Gerald was able to break the lease and move to a building at Fifty-second Street and Fifth Avenue, and he proceeded with a concerted recovery program. Making no pretense of understanding business management, he solicited guidance from others. For financial assistance, he relied on Ward Cheney, a fellow-graduate of Yale, although they had not known each other there, as Cheney was thirteen years younger than Murphy. Cheney would, in time, become a close friend and a member of the board of directors of Mark Cross. For his part, Gerald applied his skills as an artist to redesigning the store and its line of products. He had some innate qualities in his favor: his intimate knowledge of European customs and preferences, for one; his exquisite taste, for another.

Murphy made buying trips abroad, as his father had—to England, France, Germany, and to other countries. He also walked the streets of Manhattan, looking for five and dime items that could be refashioned in expensive leather. He spotted a linoleum key case at Woolworth's once, for example, and he had it copied. The Mark Cross name had been preserved, but the store still was not a financial success. "I found I could remember Father's taste well," Gerald explained, "or else that I shared it so that the store took and became about what it had been before." But, he said, "the costs were so much higher that it did not prosper." Gerald's own annual salary, which was $6,000 a year in 1934, never exceeded $35,000. He did manage, however, to pay off the loan to Goelet following the death of his "partner." He did so for only $25,000, because Goelet's heirs wished to reduce their inheritance taxes. On February 8, 1943, Gerald wrote Archibald MacLeish of being able "to release myself from the staggering burden, which was Mr. Robert Walton Goelet. His death alone made it possible for me to buy myself off from his estate (he paid the eleventh greatest inheritance and income tax in the

U.S.A.). It has whittled things pretty fine to do it, but at least the company is free. . . ."

* * *

My father had not yet become president of Mark Cross in the summer of 1934, which we spent in Europe—from June 9, when we sailed for Europe on the *Conte di Savoia.* There was high excitement as we packed and got ready to board ship, more than there had been in the immediately previous years, because Patrick had been pronounced by his doctors well enough to go along. The Myerses were joining us as well, which meant I would have the company of my good friend Fanny.

There were, of course, the usual good-byes, including a typically zany, yet warm and wonderful, telegram from Dottie Parker: "This is to report arrival in Newcastle (Pennsylvania) of first Bedlington terriers to cross continent in open Ford. Many natives note resemblances to sheep. Couldn't say good-bye and can't now, but good luck darling Murphys and please hurry back and all love."

The next day, as we were about to sail, there was another telegram, which was not of the usual sort. It was from Aunt Hoytie: "You will not have lucky journey for what you have done in breaking father's plans for us. All his reproaches will be with you."

The telegram was signed with just the letter "H." Hoytie's message cast a pall over the entire trip, and in light of what was to happen in the next few years, it was *never* forgotten. In fact, there was a legend, which gained credence over the years in my parents' circle of friends. It was that Hoytie had put a curse on my family and had actually wished for the deaths of my brothers.

When we reached Gibraltar, I went with Fanny Myers and her mother, Alice Lee, to Florence to visit the family of Frederick Schiller Faust, who wrote stories of the American West under the name of Max Brand. We then took a train to Antibes, where we rejoined my parents and the boys, who had sailed up on the *Weatherbird,* which had been brought to Gibraltar by Vladimir. They had been accompanied by Fernand Léger, who had illustrated the cruise with a marvelous set of watercolors, one of which was signed, *"A Gerald, à Sara, leur mousse tres dévoué."* He had called himself a very devoted cabin boy.

* * *

The most durable link to their European past, once the Murphys had returned to the United States, was their friendship with Fernand Léger, which lasted until Léger's death in 1955. Sara and

Gerald had known Léger since their early days in Paris: he had been a regular guest at the Villa America; he had visited them in Switzerland and in Austria; and he had made his first trip to the United States, in 1931, as their guest. It is clear that Léger—more the man than the painter—influenced Murphy, who once referred to him as "an apostle, a mentor, a teacher." There is evidence as well that Léger was similarly affected by Gerald. George L. K. Morris, the abstract painter, wrote in 1931 that Léger was fascinated with the detail of American life, the sort of detail that was a hallmark of a Gerald Murphy painting. "The true miracles of modern times for Léger are the Ford, the padlock, and the safety pin," Morris wrote. "He cannot even be enthralled by tales of the American skyscraper; during his projected visit to New York, he looks forward only to studying the shop windows."

In the reminiscences he wrote in 1960 to Douglas McAgy, director of the Dallas Museum for Contemporary Arts, Gerald gave his detailed impressions of Léger. "His lectures to certain pupil-painters at his studio were models of French ratiocination," Gerald wrote. "He had strict precepts and was a disciplinarian even in relation to himself and his work. . . . His visible reaction was startling. Once he went into our cubicle of a dining room on the quai des Grands-Augustins, stopped short, and exclaimed in astonishment, '*Oh! La valeur de* ça!' He pointed to a single rose in a vase against a white plaster wall. A rose appeared in a series of his paintings afterwards."

Gerald then told McAgy of two visits by Léger to the United States, the one in 1931 and another in 1935. "It is remarkable how, with no knowledge of English, he was able to fend for himself in vast, sprawling New York City. . . . Times Square delighted him. Broadway, he called 'Broderie.' He insisted on living on the lower middle east side, on the edge of what was then the slaughterhouse district. His father had raised cattle for market in Normandy, and he was more comfortable in their company, he said."

Gerald considered Léger an intellect with a splendid sense of the absurd, and he savored the memories of his humorous escapades. "Once," as Murphy explained it to McAgy, "he wished to prove to Blaise Cendrars [the French author] that the French either have no visual life or prefer not to appear astounded at anything they see. He and Cendrars walked the length of the boulevards at a crowded hour, both dressed normally except for an enormous scarlet ostrich feather in their hats. Léger swore they went completely unnoticed."

There is some evidence that Gerald did not always applaud Léger's artistic ability. "Where does one put a Léger?" he asked in a letter to Sara in 1936. He answered the question himself: "Where one puts a garage or an ice plant, I suppose." He and Sara were, however, always ready to help him. When Léger brought his paintings to exhibit in the United States in 1935, they advanced him money for the tour; they asked Robert Benchley to be his host in Hollywood, noting that Léger was "smitten by Disney's animated cartoons"; and they advised Léger to price his canvases at $2,000 on the U.S. market. (It was a decent price in 1935, though by 1982 a Léger would bring $100,000 or more.)

It was the warmth of his personality that endeared Léger to Sara and Gerald. He was especially kind to Patrick during his illness. In 1930, after the Murphys had moved to Switzerland, Léger sent Patrick a postcard, which the artist had illustrated with a sketch the boy had done. It was addressed to an *artiste peintre,* and there was a caption, which had been professionally printed: *"Un Tableau de Patrick Murphy. Collecion de Fernand Léger."* Léger also sent postcards to Patrick while he was touring the U.S. in the fall of 1935. One from Chicago was illustrated by a color photograph of the Field Building on which Léger had drawn the figure of a man in a derby hat, who is saying, "How do you do, Mr. Patrick." The same figure, drawn on a picture of the Cathedral of Learning at the University of Pittsburgh, is saying, "Good-bye, Mr. Patrick."

The telegram from Mary Hoyt Wiborg to the *Conte di Savoia,* in which she vowed that the reproaches of their late father would bring Sara misfortune, would be—inevitably, in light of what subsequently happened to the Murphys—referred to as the "Hoytie curse." There never again would be civil communication between the two sisters, though they kept tabs on one another through intermediaries. When Hoytie complained that she was penniless, as she often did, it was proposed, in a letter from Sidney Fish to Ledyard Mitchell, that the family establish a fund for her benefit, which it did.

There were indications over the years that Hoytie suffered from guilt for the telegram and the implication that she had wished for —and, therefore, was responsible for—the deaths of Baoth and Patrick. To cite a specific expression of this guilt, she prevailed upon Noel Murphy, Fred Murphy's widow, to have a doctor affirm that

her husband had died of tuberculosis, in an effort to show that the disease ran in the family. (Fred died of a stomach ailment he had had for years.) "She wanted to establish that she had not cursed her sister, that she had not cursed the boys," Noel Murphy said in 1981. "Well, she did curse the boys . . . and she meant to curse them."

Gerald was not subtle in his denunciation of his sister-in-law. "She's a crook and always has been," he wrote from Antibes in August 1934 to Harold Heller, the designer who had done the interior of the Villa America. "But she's clever enough to do it to people who, she knows, cannot or would not use the same weapons against her. Since her birth, she has never had to pay for one single one of the injustices and dishonesties she has perpetrated. She'll never pay. All she wants is power and money." Hoytie had written to Sara from Paris that summer of 1934, to say she had tried to invite the Murphys to tea when they were in town, but they had not answered. "Can you beat it for nerve?" Gerald asked in the letter to Heller. "[She is] robbing us with one hand and pouring our tea with the other." Hoytie had called that very day—from Cannes, on her way to Venice. "Sara told her (in all too quavering voice)," Gerald wrote, "that she didn't want to have anything to do with her."

There was good news to tell Heller about Patrick's health. "The boys are off on a five-day fishing trip to the islands off Hyères," Gerald wrote. "Patrick giving three hundred words of advice and orders to everyone per minute. He seems to have stood the change very well, although he is thinner. The summer has been mercifully very cool, and he's very sensible about not bathing too much. He is very anxious to go to Harvey, so we are going to try it. He begins the 24th September. Baoth at St. George's the 18th. . . . Honoria is . . . ravishing. . . . We have to fight to keep the young Latins off her. . . . The children are in a state about getting back to Hook Pond. Apparently they love it. It is amusing to listen to them deciding 'the first thing I'm going to do.'"

* * *

Despite the unpleasantness with Aunt Hoytie, we had a delightful time at Antibes in the summer of 1934. We did not know it then, of course, but it was to be our last visit to the Villa America, which is perhaps why my memories of it are so fond. They are distinct from the memories of my childhood, when every waking hour was spent playing with Baoth and

Patrick. My friend, Fanny Myers, was there. While we still went to the beach and played tennis and made fudge in my playhouse, there were also more grown-up things to do. We went to St. Tropez, to Madame Vachon's, which later became a rather famous boutique. Dow-Dow was in charge of the shopping trips, and it was his generosity and his taste that made them great occasions. He never bought just one of anything that caught his eye, such as a pair of crocheted sandals. He would buy them by the dozen, to give as presents.

We also went with Mother and Dow-Dow to the nightclub at Juan-les-Pins—the French call it a casino, and they actually do gamble there. We went to dance, however. "Keep your hand light on my shoulder," urged Dow-Dow, who was a beautiful dancer. "Keep your whole body light, as though you are treading water."

We returned from France, arriving in New York on September 7, 1934, on the *Aquitania.* We went to East Hampton, where the weather was still ideal for swimming—actually, September is about the nicest month of the year there. I was getting ready to return to Rosemary Hall, the thought of which did not please me much, and doing the things a sixteen-year-old girl does on vacation—goofing off, for the most part. One day, Dow-Dow came to where Baoth and I were relaxing on the beach. "Children, I have some bad news for you," he said. "Patrick has had a *rechute* [a relapse]."

I recall that out of the grief came a strange sense
of satisfaction in the knowledge that one has really touched bottom.

Gerald Murphy to Calvin Tomkins
November 9, 1960

III. Touching Bottom

Patrick was approaching his fourteenth birthday in September 1934—prep school age—but instead of entering the Harvey School, as he had wished, he was placed in a room in Doctors Hospital in New York City. His second bout with tuberculosis was more serious than the first, for the right lung, the other lung, had been affected. "He's living on the good lung," Gerald had written the Hemingways in October 1929, but in 1934 there was no longer a good lung. Patrick's symptoms were discouraging: he had no appetite; he had trouble breathing; and he ran a constant fever. There was beginning to be an awareness that it would be a losing battle, although Sara would not give up hope until the very end. Among the other aspects of the tragedy, the cost of Patrick's illness was mounting, and Sara and Gerald added to their burden, in October 1934, by taking an apartment at 439 East Fifty-first Street, on Manhattan's stylish East Side.

* * *

I was back at Rosemary Hall in 1934. I liked the school a little better, as I had gotten used to the regimen. Fortunately, though, New York was only about thirty miles away, and I went home at every opportunity.

Baoth was at St. George's, as robust and light-hearted as ever at age fifteen. "I just love the school," he wrote Mother the day after Dow-Dow had installed him there. "It's 'jus wunnerful.' " There were, however, some disturbing signs with regard to *his* health. "I just got out of the infirmary with a cold," he notified our parents on October 7. "I'm awfully sorry, but I was sailing in the bay and the boat capsized and I came home on the handlebars of my bicycle, another boy pedaling."

Baoth was naturally quite concerned about Patrick, and he asked about him in his letters home. "Say hello to Patrick for me. In fact I'll say it myself. 'Hello, Patrick. How are you?' 'Fine,' answers Patrick, I hope. I certainly hope he is better. Is he?"

Mother and Dow-Dow drove up to visit Baoth in late October, and the three of them sent Patrick a postcard, which pictured the Newport mansion of Mrs. Stuyvesant Fish, Uncle Sidney's mother. And in another postcard a couple of weeks later, Baoth passed along "the worst pun I ever heard," in an effort to boost Patrick's spirits. "At a football game, I was standing in front of the bench on the sidelines, evidently obstructing someone's view, because he said, 'I know you're a pain (pane), but you're not a window.' "

Baoth enjoyed the life at St. George's. Perhaps he relished the extracurricular part a bit too much, for he was having a difficult time with his studies. "I'm sorry about my grades," he wrote Mother and Dow-Dow on November 24, "but it's hard to settle down. . . . I'll try to keep my head. I'm having a very nice time. I take wrestling and swimming since football has stopped. I shall now turn over a new leaf."

He reported in early December, however, that his marks were "not satisfactory." His average was seventy-two percent, " 'wousy,' as Ernest would say." (Ernest Hemingway had a habit of pronouncing the letter *l* as though it were a *w.*) Baoth tried to be reassuring. "The average will not be the same next week after Dow-Dow has given me a 'pep talk,' " he wrote. Dow-Dow did visit the school and "gave me a great time," Baoth wrote, but the "pep talk" did not improve his grade average. It dropped a point to seventy-one, which does not seem all that bad in itself, but he had failing grades in history and math.

My parents' apartment overlooked the East River. When Baoth came home for Christmas vacation, he and several of his schoolmates took the Fall River Line boat from Newport. As they came down the river, there was a sheet hanging from a window of the apartment, which Mother had lettered: "Welcome home, Baoth."

Patrick's room at Doctors Hospital also faced the East River, so he had
a fine view of the boats. It was about as cheerful there as any such setting
could be. He had his hobbies to work on—wood carving, painting, and
stamp collecting are the ones I recall. I would visit him on weekends home
from school. I was struck by how white and frail he looked. He was
engulfed in pillows in a huge hospital bed, which he hardly ever left. He
was allowed now and then to sit up, but the doctors did not want him to
exert himself by walking.

* * *

As word of Patrick's relapse reached them, the friends sent their
sympathies. "It's a damned shame," Hemingway wrote the Mur-
phys on September 30, 1934, from Havana, "that poor old Patrick
should have to go through all of that with another lung. We feel
awfully. . . . At least, though, you and he have been through it once,
know how it is and how it turns out. So there isn't the desperation
of something unknown. But it is such a damned brutal thing to have
it all to go through again. Fortunately no one in the world is better
about it than you two—and no one has more sense, more patience
and more acceptance of things than Patrick." Hemingway had re-
turned from an African hunting expedition with trophies and
wanted Patrick to have one—"either a giant gazelle or an impala,
whichever he'd like. . . . The impala is the most beautiful, I think,
and have a record one he would like. . . . Tell Patrick they are the
ones that float in the air when they jump and jump over each other's
backs." Patrick did choose the impala head, and Hemingway wrote
on December 14 that he was pleased it was such a hit. "Give Patrick
my love and best regards," he added.

Archibald MacLeish also thought of Patrick after an encounter
with an animal, though not as a hunter. He told him about it directly
in a letter to the hospital from his farm in Conway, Massachusetts,
on October 26, 1934. "Last night it was dark coming up from the
pond," MacLeish wrote. "I always work there as long in the after-
noon as I can see to dig. There had been hunters in the woods
beyond and the chipmunks driving the dogs crazy and the sun
coming in sideways under the leaves the way it does only in au-
tumn. . . . I was tired coming up and not paying attention and when
there was a little rustling in the leaves in the woods I hardly looked.
Something like a toad was moving through them—something al-
most the same color as the elm leaves. It barely ran. When I caught

up with it I thought at first it was a field mouse but too big—a head the size of a rat. Then I saw its tail, broad and flat and grey with a fine grey fur. . . . I picked it up by the tail's end and it ran a little with its feet, its forefeet wide apart, its hind legs smaller and close together. I thought as I carried it that it was very hot in my hand but then I thought too that small animals always feel hot to us. When I came to the kitchen under the bright light over the sink I saw what it was. I saw the web of delicate skin running back from the front legs to the hips, white underneath and grey on top. It was a young flying squirrel, sick or hurt or for some reason unable to move. I sent the dogs in and went back into the woods and put it in the bole of a great maple covered with leaves. It lay still there. All night in the brilliant moon I thought of it there and wondered about it. Somehow it had fallen and been hurt or perhaps some partridge hunter had hit it. Its fur was softer than any squirrel. My love to you."

Stella Campbell, the British actress, who was trying late in life to adapt her talent to a Hollywood movie set, wrote Sara from Beverly Hills on November 26, 1934. "I am sure the doctors must be bitterly disappointed and so are reserved now," she noted. "I don't think I ever realized the cruelty of the disease before. I had an idea it was so much a matter of sufficient care. Now one knows and one's heart stands still. If we were allowed to give our health to another and mine were worth giving, I would gladly give it to Patrick. Bless his . . . courageous heart." Katy Dos Passos wrote from Key West on February 4, 1935, to "my dear Mrs. Puss," as she often called Sara. "I want that Patrick to be well," she said. "I wonder about him every day. Is he able to eat any more? How is he feeling? And when I think about the weather, I think about the winter in Patrick's room and how he's seeing the river. I wish we could visit him. I found I missed seeing him so much after I left—he was so sweet and so entertaining and funny and brave as an Indian chief. . . . I know how hard it must be for him to eat, not feeling hungry ever. I should think for that it would be important to keep his morale, and he is so good and courageous that he does a lot of it himself, but it can't do any harm to write him, and if he likes it we will write him a lot and send small gadgets. . . . Ernest is delighted that his impala had such a success—he and Pauline were in quite a state, because your letter came before we did, and they saw the envelope, and the first thing they said was, 'Go right home and read Sara's letter—it's been here for days.' "

* * *

Baoth was back in the St. George's infirmary in January 1935, but his letter to our parents on the 29th was reassuring, not just for what he had to report, but because of his jocular tone as well. "My ills are over," he wrote. "A slight cold mixed with a dash of hydrophobia made up my ailment." He was spoofing—Baoth loved to swim and had no fear of the water whatsoever. "I was let out of the infirmary on Saturday evening at six o'clock. The delay in the writing of this missive was caused by grievous arrears in Latin prose. . . . I can see Dow-Dow saying, 'He offers the worst excuses. . . . ' I *am* sorry, though." He tried to encourage Mother and Dow-Dow about his studies: "I think my grades are forging their way up. If their altitude is not sufficient, believe me, the pressure will be increased."

He spoke fondly of his Christmas vacation in New York. Mother and Dow-Dow always saw to it that the quality of our entertainment was of the best sort, and it often included Shakespeare plays. Back at school, Baoth boasted, "I'm a walking encyclopedia on *Hamlet* and *Romeo and Juliet.*" He obviously enjoyed being a clown, and he did a written imitation of a hillbilly accent. "Ah ain't fergettin' me pleasures daown thar in Noo Yawk." He signed the letter, "The leaning tower of Baoth."

Baoth had been in the St. George's infirmary on two occasions during the school year, but he had assured Mother and Dow-Dow that his colds were nothing to worry about. This is one reason why they—and I, as well —were unprepared for what then occurred.

The infirmary report, dated February 15, 1935, 5 P.M., was written in pencil on a small manila card. "Name: Baoth Wiborg. Illness: measles with ear complications. Temperature: 99.4. Respiration: 24. Pulse: 84. Remarks: Left ear draining an occasional drop. Nauseated at intervals between 9:30 and 12:30. . . . No vomiting since this time. Slept between 2 and 4 P.M. Feeling better upon awakening. Has taken four ounces of orange juice and retained it."

On the back of the report, was a message from Baoth, which the attending physician had written down and relayed to Dow-Dow. "Much pleased that Mother got away for a much earned rest. There isn't anything I want. Much love to everybody."

Mother was in Key West visiting Pauline and Ernest Hemingway and Katy and John Dos Passos. As he had the year before, my father stayed behind, and he was taking care of Patrick. Dow-Dow was also tending to the Mark Cross situation, which "marks time," he wrote Mother on February 18.

In that letter, my father finally admitted that he was worried about

family finances, especially in light of the burden of mounting medical expenses. "Our bills remain big," he wrote Mother. "I find you have expensive housekeeping tastes. . . . I can't get ahead of that Doctors Hospital, nurses, doctors, etc. Not that they're not reasonable, but so steady." It was, however, a generally optimistic letter. "Everything's fine here," he assured Mother.

My father had shown some apprehension over word from St. George's that Baoth had come down with the measles, but by February 20 the news was promising, and Dow-Dow relayed it by telegram to Mother, who was still in Key West. "Baoth is mending," he wired.

The *New York Herald Tribune* was delivered daily to my mailbox at Rosemary Hall, but on a certain day that February there was no newspaper. As it turned out, my roommates had hidden it, for it carried an account of my mother's sudden trip to Boston to be at Baoth's bedside.

I had heard that Baoth had measles, but it was not until I too got to Boston that I learned of a double mastoid infection. An ear operation had been performed as a result of which bacteria had entered the spinal fluid, and meningitis had developed. Baoth had been rushed by ambulance to Massachusetts General Hospital in Boston. The headmaster of St. George's made the decision so urgently that he did not have time to notify my parents beforehand, but they did not fault him for acting with dispatch. In fact, they were grateful.

For the first time in my life, I fully understood the feeling of panic. I had finally learned that my mother was in Boston, when my roommates, realizing I ought to be told, showed me the newspaper item. I tried to call my father at his office in New York City. He too was in Boston, but he called me later that day. He said he had arranged for me to be excused from school, and Harold Heller was coming to escort me to Boston. I'll never forget my friends' glum faces as Harold and I left in a taxi for the Greenwich railroad station.

We were in Boston a good ten days that March of 1935, first at the Ritz and then in a special set of rooms in the wing of the hospital where Baoth was being treated. We retained the hotel suite, though, as there were many family members and friends coming to be with us and to help, if possible. Aunt Sara Mitchell, Mother's cousin, was designated to take care of me. I was seventeen years old, but my parents still did not believe I could fend for myself. Under the circumstances, however, I can certainly understand their being overprotective of me.

Our friends the Pickmans—Hester and Edward and their many children

—lived in Boston, so we were able to find comfort at their roomy old house on Beacon Street. One day, after we had received a favorable report on Baoth's chances of recovery, there was a joyful spaghetti and salad lunch at the Pickmans'. The good news was momentary, however, and the next time I saw Baoth, he was in very bad shape. He was unable to focus his eyes, he was nauseated, and he had a terrible headache. He was barely able to utter a few words, and I remember the doctor saying, "This does not look good."

When Baoth's condition became critical, there was a twenty-four-hour vigil at the hospital. Mother and Dow-Dow and I were there, of course, as were close family friends, such as Hester Pickman and Alice Lee Myers. Patrick obviously could not leave his room at Doctors Hospital in New York, and although he knew that Baoth was ill, he had not been told how serious it was. Dow-Dow called him every day, and on March 17 had to tell him that Baoth had died.

Mother was completely devastated. She just would not accept the fact of Baoth's death, even after he stopped breathing. She kept pleading with him: "Breathe, Baoth, please breathe." The doctor, however, pronounced him dead, and he gave Mother a shot, a sedative, right then and there. My father had turned to me and said sternly, but gently, "Honoria, you watch out for your mother. Do not leave her side. Sit by her bed, because when she wakes up and has to face what has happened, it is going to be rough." It was. She slept for an hour or so, and then she cried and cried. Alice Lee came in and helped me try to calm her, but it was no use. I cried too, but not a lot, because I was to take care of Mother. One reason Dow-Dow gave me the responsibility was to take my mind off the loss of my brother.

* * *

"Baoth's ashes stand on the altar in St. Bartholomew's until Sunday," Sara and Gerald wired the Hemingways and the Dos Passoses from New York City on March 21, 1935, "when they will be laid beside his grandfather at East Hampton. Oh, this is so unlike him and all of us. We try to be like what you want us to be. Keep thinking of us, please. We love you." A telegraphed reply from Key West on March 26 was signed "Dos Katy Ernest Pauline," and it read: "We wish we were there with you or you were here with us. We must all hold together. We are your faithful friends, and you are part of our lives. Your way is our way." And there was another telegram from the Hemingways and the Dos Passoses on March 29: "We will come single or in swarm at any time to wherever you go."

*　　　*　　　*

My father, as far as I know, only broke down once following Baoth's death. It was in a taxicab on the way to the funeral service at St. Bartholomew's in New York City. He had remembered and was so sorry for the times he had lost his temper and severely scolded Baoth. He also noted the date of Baoth's death—March 17, 1935—and he never again celebrated St. Patrick's Day.

Bereaved as he was, my father was a good deal more concerned about my mother's grief than his own, and he committed himself to doing what he could to try to ease her loss. Mother *was* inconsolable, as Dow-Dow realized. After the service at St. Bartholomew's, she rushed out of the church and stalked up Park Avenue. Archie MacLeish followed, and as he caught up with her, she looked up in the sky and cursed God. No, she never really recovered. "I don't think the world is a very nice place," she wrote Scott Fitzgerald the following August, and I believe she meant it.

Baoth was cremated, and his ashes were buried in the family plot in East Hampton. On a Sunday in May 1935, there was a memorial service at St. George's. An apple tree was planted and Archie MacLeish read a poem he had written, "Words to Be Spoken."

> O shallow ground
> That over ledges
> Shoulders the gentle year,
>
> Tender O shallow
> Ground your grass is
> Sisterly touching us:
>
> Your trees are still:
> They stand at our side in the
> Night lantern.
>
> Sister O shallow
> Ground you inherit
> Death as we do.
>
> Your year also—
> The young face,
> The voice—vanishes.

Sister O shallow
Ground
> *let the silence of*
Green be between us
And the green sound.

* * *

"Twice I have tried to write Archie of what it meant to Sara and me—and to Baoth—for him to have done and felt as he did last Sunday," Gerald wrote Ada MacLeish, following the service at St. George's, "but I cannot. It's all too incommunicable. . . . I cannot blast it out of my heart, try as I do. . . . I tried to speak of it, but my words sounded like pebbles falling. I *heard* them. But I must *write* you. For beauty, for grace, and for strength of thought, I shall never see human creature equal Archie that day."

Many friends and relatives wrote, as would be expected—it was the depth of their feeling that was extraordinary. Yvonne Roussel, who had tutored the Murphy children in Antibes, called Baoth's death an "abomination," and posed an interesting philosophical question: might nature be "dealing more terribly with some privileged individuals and giving them life to the full and taking them away before they have had time to suffer all the disillusions and sufferings which most of us know?" Stella Campbell said to Sara, "I am almost afraid to write you." She had spoken with Ellen Barry, who shared her fears: ". . . we are all so stunned we are almost afraid to speak to each other of what you and Gerald are suffering. . . . Protect yourself—you are so wise and so brave."

"How our hearts shrank with dreadful pain when we heard yesterday," said Katy Dos Passos. "I think of Baoth—so handsome and sweet, so valuable, and it's too cruel." And from Dos: "You've been so brave through this terrible time that it is hard to write that you must go on and be brave. We admire and love you and wish so there was something we could do to make you feel just a little better. . . . Perhaps it can be a slight, too slight, consolation to feel that you have friends who feel what you feel, even if dimly and far away." Pauline Hemingway talked of Baoth's vitality, "so strong and handsome and fitted for life," and Ada MacLeish commented on the Murphys' strength in the face of adversity. "There is so much nobility in the way you are carrying the loss," she wrote.

Archie MacLeish spoke as the poet he was. "For some things in this world," he wrote on March 29, 1935, "one must give words to

his admiration for courage and grace and nobility such as yours. It is hard that people must suffer so to raise these memorials to the greatness of the human spirit. It is hard: but also just. Because the human spirit is not often great; because the greatness of the human spirit is the only enduring beauty; because it would not be fitting to achieve greatness without pain. All this is of no comfort to you. You did not wish for the cruel marble tearing the palms of your hands. You wished for your son. But for the rest of us, who have not suffered as you have suffered, a new justification of *all* suffering, a new explanation of the eternal mystery of pain, has been created. It is the heart of the irony of our lives that this justification—this explanation—should be apparent not to you who need it, but to us. For the symbol of the irony of our lives is the phoenix, which must die to live. No one can give you comfort—only time, whose comfort (until, like unwanted sleep, it is given) we reject. Those who love you can only ask you to believe that you have not suffered in vain. It is true. I love you both."

Ernest Hemingway had been closer than any of the friends to the Murphy children—he genuinely felt a fatherly devotion to them. "He had known [Baoth] since the days of Bumby's whooping cough on the Riviera," Carlos Baker wrote in his biography of Hemingway. In 1929, after Patrick had become ill, Ernest invited Baoth to stay with him and Pauline in Paris. "My mother wants me to stay with her this winter," Baoth wrote Ernest from Switzerland in November, "but I'd like very much if you invite me some other time for she says that that time I shall go with you to America. Thank you very much for asking me."

On March 19, 1935, Ernest wrote Sara and Gerald from Key West. "You know," he began, "there is nothing we can ever say or write. If Bumby died we know how you would feel and there would be nothing you could say. Dos and I came in from the gulf Sunday and sent a wire. Yesterday I tried to write you and I couldn't. It is not as bad for Baoth because he had a fine time, always, and he has only done something now that we all must do. He has just gotten it over with. It was terrible that it had to go on for such a long time but if they could keep him from suffering sometimes it is merciful to get very tired before you die when you want to live very much. About him having to die so young. Remember that he had a very fine time and having it a thousand times makes it no better, and he is spared from learning what sort of place the world is. It is *your* loss more

than it is his so it is something that you can, legitimately, be brave about. But I can't be brave about it and in all my heart I am sick for you both. . . . You see now we have all come to the part of our lives when we start to lose people of our own age. Baoth was our own age. Very few people ever really are alive and those that are never die, no matter if they are gone. No one you love is ever dead. We must live it, now, a day at a time and be very careful not to hurt each other. It seems as though we were all on a boat now together, a good boat still, that we have made but that we know now will never reach port."

* * *

More than ever after Baoth's death, Patrick heard from family friends. It was as if they sensed that more agony was in store for my parents, and they were trying to offset it by making Patrick happy. Irvin S. Cobb, the humorist, who had met my parents in Hollywood in 1928, was working on a movie, *Steamboat 'Round the Bend.* There was a letter to Patrick, dated May 30, 1935, from Cobb and the director, John Ford, and the cast, which included Will Rogers. (Two and a half months later, Will Rogers died in an airplane accident.)

Alexander Woollcott, the *New Yorker* writer and a regular member of the Algonquin Round Table, was doing a radio show in 1935 called *Town Crier.* He phoned one day to ask Patrick what his favorite song was, and the reply was "Country Gardens." Mother, Dow-Dow, and I gathered in Patrick's room on the night the show was dedicated to Patrick, and after an orchestra had played "Country Gardens," Woollcott said, "Good night, Patrick. I hope you're feeling better."

* * *

Ernest Hemingway wrote Patrick from Key West on April 5, 1935, just before leaving on a fishing trip to the Bahamas on his boat, the *Pilar.* It is a remarkable letter for its thoughtfulness, shown by the extent of descriptive detail, which Ernest obviously was eager to share with Patrick, whom he considered a fellow fisherman.

"I was awfully glad to get your letter today and am writing right away because tomorrow we will be packing to leave on a trip. And if I don't write now I will spend several weeks intending to write you—and won't do it. You know how hard it is to write on a boat.

"We have been trying to make you a movie of sailfishing—but the minute I took the camera on board the sailfish refused to bite

and we haven't seen one since. But we are now going from here up along the coast for about a hundred and fifty miles and then cut across the gulf stream to Gun Cay and Bimini in the Bahama islands to see what it is like for fishing this next May and June.

"We plan to go well out in the current of the stream and troll up for two days, putting in inside the reef to anchor at night. Then cut across early in the morning of the third day taking a bearing from Carysfort Lighthouse (you can find that on the chart) and steering east north east for Gun Cay.

"I have gotten my camera that I had in Africa cleaned up for taking movies and we are going to take the film your mother brought down and try to get you some good exciting pictures of marlin and tuna fishing. I will send the films from Miami with your address on them. So you will be the first to see them. Then we can get copies from them later. Will try to get some very good shots.

"If your father will order the chart showing Florida and the Bahamas you can tell just where we are and where the places are that I will refer to.

"Dos is going on the trip and so is Mike Strater [Henry Strater, the artist]. He is the President of the Maine Tuna Club and we kid him about this a good deal and always refer to him as The President. When he hooks a big fish we plan to put 'I Don't Want to Be President' on the phonograph. He takes his fishing very seriously. But he is a good fellow and a good clown too. The other people on the trip will be Old Bread, who is engineer on the boat. Your mother can tell you about him. He is fat and a good man with engines and also a good sailor. His real name is Albert Pinder. For cook we are carrying a man named Hamilton Adams, who is very tall and thin and is a good friend of Bread's. He is known in Key West as Saca Ham. Here everybody has goofy nicknames, which they get as kids and then have all their lives. I don't know what kind of cook Saca is. If he isn't good on this trip we will get somebody else for the next one.

"This way you will know who is who in the pictures. Saca is tall and thin with a lean face. Mike has a wide grin and very wide shoulders and looks a little like Abraham Lincoln as a young man if he had gone to Princeton. You know what the great Portuguese Mariner and line breaker Honest Jack Dos Passos looks like. I look much the same as always except a little bloated. Will hope to get thinner.

"We are going to try to catch wahoo, tuna, marlin, and sailfish. We plan to take two weeks for this first trip to look things over. The giant tuna aren't due until the middle of May. Nobody has been able to catch one yet. They run off all the line and break it at the reel. I have gotten a new reel to hold 1,000 yards of 39 thread line and have another ordered to hold 1,500 yards. . . .

"Because nobody has been able to catch one of those huge (2,000-pound) tunas yet I have rigged up one of our regular fishing chairs in my 13-foot Lyman Sea Skiff that I plan to tow behind the *Pilar.* When we hook a big tuna we are going to get into the little sea skiff and shut down on the drag and see if they can really go sixty miles an hour the way they say they can. The President has said that this is madness and that the tuna will tow us up to Nova Scotia. But between ourselves I think the President is slightly goofy and that the tuna will tow himself to death in a short time. Anyway I hope we can get you some movies of it. With a chair to brace in I can give the tuna or the marlin the devil pulling.

"The difficulty will be to get Dos to take the movies with the camera pointed away from him and toward the tuna instead of away from the tuna and toward him. But he is full of confidence and already thinks of himself as a big camera man and is starting to wear his cap with the visor on backwards. But if you get any closeups of Dos's eye instead of the tuna don't say I didn't warn you.

"The skiff is clinker built, very light and beautifully seaworthy. She is about half as broad as she is long and I hope we can get her to go faster with a big fish than a racing outboard ever pushed her.

"I have been feeling very gloomy with too many visitors and having to take the treatment for my amoebic dysentery that makes me over three quarters goofy. But now am cured, I think, and want to wash myself out clean with the gulf stream and the best soap I know—which is excitement or whatever you call it. Anyway we will try to can some of it on the films and send it up to you. Really good jumping fish pictures are swell and I hope we can get some.

"Will you give my love to your mother and your father and tell them the reason I don't write is because I can't write. But that I would like to see them. If they would like to fish, come to Bimini. You can fly it in less than an hour from Miami. If you go to the country this summer we will come up to see you wherever you go.

We are putting an outrigger on the boat to make a big bait skip. Will let you know how it comes out. We never found them necessary off Cuba but they say they are good. Mike Strater is giving it to the boat for a present.

"Well, Bo, if there is anything you want to know about the trip write me to Bimini and ask. The address will be On Board Yacht *Pilar,* Bimini, Bahama Islands, B.W.I. Dos and I will write you from there. . . .

"Well, so long, Old Timer. Write me to Bimini, will you?

"With best love from us all. Our Patrick caught a big barracuda yesterday without any help . . . of about twenty-eight pounds. Hooked him in the channel and thought he was a small tarpon. He was jumping in the sun. Jumped eight times. By the third jump we could see he was a barracuda. He made a fine fight."

It was signed in longhand, "Your friend, Ernest."

"Just back from Bimini where I left Ernest struggling with the gigantic furies," Dos Passos wrote Sara and Gerald on April 30, 1935, from Key West. Dos had done his stint as cameraman and advised, "I am sending a couple more reels of film to Patrick tomorrow." Baoth had been dead for just a little over six weeks, so Dos was anxious as to how the Murphys were faring. "Don't bother to write," he said, "but if somebody should happen to feel like it, I'd certainly be pleased to get a word. I'm wondering just how good no news is."

* * *

Understandably, there was no trip to Europe in 1935, which was the first full year in America for my family since we went off to France in 1921. Further communication with the Continent had virtually ceased, as was evidenced by the stated concern of Fernand Léger in July. It had been, he wrote, a year since he had seen my parents, ". . . and we are without news of all of you." Not having heard of Baoth's death, he speculated that the silence was due to worries about Patrick. Exhibitions of Léger's work were being arranged, he advised—in New York City, Chicago, and San Francisco —and he asked his "protective angels" to advance him $1,500 for his trip to the United States in the fall, which they did.

When my parents went to his exhibition at the Museum of Modern Art in New York, Léger told them that one of the paintings was for them, provided they could pick it out. It would seem an impossible feat, as there

were over two hundred canvases on display. There was just one, however, in which the dominant color was brown, my father's favorite, yet a color Léger rarely used, and that was the one they picked. He had inscribed on the back of the frame, *"Pour Sara et Gérald."* The painting was titled, *Composition à un Profil.* My husband and I were forced by estate taxes to sell it after Mother died in 1975. At auction at Sotheby Parke Bernet in New York in May 1976, it brought $92,500.

That same July, Mother took Patrick to Saranac Lake, New York, so he could have the dual benefits of the mountain climate and the excellent medical care of the TB clinic there. She rented a lakeside cluster of cottages —Steel Camp, it was called—for the summer, and, come fall, she moved to a house in town, at 29 Church Street. Mother was making the best of a dreary situation, as she indicated in a letter to the Hemingways in September.

"We have had a sort of Adirondack summer. Boats, bathing, quite some rain, friends to visit—a great many of them." And she was optimistic, as usual. "I do feel that my Patrick is on the mend, definitely. Of course, he's thin and doesn't eat too well and still has a temperature, but the last two x-rays show that the [lung] cavity is closing and pulse and respiration, etc. are all better, and the doctor is pleased. Patrick is pleased too. He continually asks for news of you, because in an unguarded moment I told him you might be coming north."

It was also clear from my mother's letter to Ernest and Pauline that there was an added strain in our family due to her forced separation from my father, which she made light of, as was her way. "The Merchant Prince comes *tous les 15 jours* [every fifteen days]," she wrote. "He is as busy as a bird dog and is doing awfully well, and it is good that he had it to do this summer." She was referring, of course, to Dow-Dow's obligations to the Mark Cross Company, which, she suspected, would last for years. "So we have taken a small non-housekeeping apartment for him (and me when I go down) in New York City."

I was attending the Spence School in New York that year, as a boarder. Mother, who had also gone to Spence (class of 1904), proudly wrote the Hemingways that I was following in her path. She also said she was longing for company. "I've taken a house up here for the winter—big enough, good lord, for lots of guests who want to help me out . . . and hope to have lots of nice clean snow to offer. We'll be in this camp, however, until 15 October unless frozen out. Is there any chance of your coming up to these parts? Really? Because I am pining to see you. I have such a good wine cellar and a good cook and lots of new music." By "new" music, Mother probably meant popular songs—Broadway show tunes, and so

forth. She was, however, a jazz enthusiast as well. She was particularly fond of the piano music of Fats Waller.

Mother wanted the Hemingways to bring their sons along to Saranac Lake, but she was aware there might be some fear on the part of Pauline and Ernest, since Patrick's TB was extremely contagious. "Our guests are in a guest house apart," she wrote, "and all Patrick's dishes, silver, laundry, etc. are separate. . . . We sleep under piles of blankets and have a roaring wood fire most of the time, and we love you very much." I gather from notes Mother kept that the Hemingways did visit the camp at Saranac Lake, but I do not recall it. I only remember that Ernest came twice to our winter house in town shortly before Patrick died.

It is not that Mother was all by herself in Saranac. Dow-Dow and I had been there often that summer, and both Dos and Archie had come to visit. She was, however, desperately in need of friends at this point in her life. My father knew better than anyone. "She needs nourishment—from adults—from those who are fond of her," he wrote Scott Fitzgerald in August 1935. Dow-Dow had discovered "something infinitely sad" about Mother, and he revealed his discovery to Scott. "Life begins to mark her for . . . tragedy, I sometimes think. Surely only those who have been as honest and trusting with life as she has really suffer. What irony!"

* * *

Hemingway had written to Sara in July 1935 from Bimini, where he was vacationing with Pauline and the boys, John (Bumby), Patrick, and Gregory. The second son of Pauline and Ernest, Gregory had been born in 1931. The return address on the letter was, simply, "E. Hemingway, Capt., *Pilar,* Bimini, B.W.I." The letter was intentionally cheerful. "You would love this place, Sara," Ernest wrote. "It's in the middle of the gulf stream and every breeze is a cool one. The water is so clear that you think you will strike bottom when you have ten fathoms of water under your keel. There is every kind of fish, although the big marlin seemed to have passed. There is a pretty good hotel and we have a room there now because there have been rain squalls at night lately and so I can't sleep on the roof of the boat. That's not a very nautical term but a fine cool place to sleep. Dos and Katy will tell you about it."

Katy Dos Passos wrote to Sara often, and her letters were warm and comforting. There was one—in August 1935, from Provincetown, Massachusetts—in which Katy told of a sailboat she and Dos had just acquired. "Seagoing Sadie is greatly missed on board," she said. "The herb woman is missed in the garden. We miss Madame

Murphy, the talented decorator, all over the house, and, oh, if we only had Sara the cook in the kitchen."

The Murphys' letters to most of their friends during this ill-starred period did not reflect their full feeling about their tragedy, for that was something they generally shared only with each other. There was, however, one exception. For reasons that were rooted in the relationship, as it had been formed in the halcyon days—and perhaps because there was a sharing of adversity—Sara and Gerald could be very candid with Scott Fitzgerald. The letter in which Sara found the world not to be a very nice place was sent to Scott on August 20, 1935, from Saranac Lake. "And all there seems to be left to do," she continued, "is to make the best of it while we are here, and be very, very grateful for one's friends, because they are the best there is, and make up for many another thing that is lacking." As for Gerald, he explained why Scott was his only confidant in his soul-searing letter of December 31, 1935, when he was at Saranac Lake with the family for the holidays. "Of all our friends," he declared, "it seems to me that you alone knew how we felt these days. . . . You are the only person to whom I can ever tell the bleak truth of what I feel. Sara's courage and the amazing job which she is doing for Patrick make unbearably poignant the tragedy of what has happened—what life has tried to do to her. I know now that what you said in *Tender Is the Night* is true. Only the invented part of our life—the unreal part—has had any scheme any beauty. Life itself has stepped in now and blundered, scarred and destroyed. In my heart I dreaded the moment when our youth and invention would be attacked in our only vulnerable spot—the children, their growth, their health, their future. How ugly and blasting it can be, and how idly ruthless."

Scott's reply did not come until the following April, from Baltimore. It was to: "Dear Sara (and Gerald too, if he's not in London)." Gerald had been abroad—on a Mark Cross buying tour of England, France, Belgium, Germany, Austria, and Czechoslovakia—but he had returned to New York. Scott revealed to Sara that he had suffered a severe bout of depression the previous autumn, "a sort of 'dark night of the soul,' " as he described it, "and again and again my thoughts reverted to you and Gerald, and I reminded myself that nothing had happened to me with the awful suddenness of your tragedy of a year ago, nothing so utterly conclusive and irrepara-

ble." Zelda was no better, he reported, "though the suicidal cloud has lifted." Sara had turned briefly to Christian Science for comfort, and she had suggested that Scott might do likewise. He had tried, he said, "but the practitioner I hit on wanted to begin with 'absent treatments' [prayers said by the practitioner in the absence of the patient], which seemed about as effectual to me as the candles my mother keeps constantly burning to bring me back to Holy Church —so I abandoned it."

Sara replied to Scott immediately, reporting that Gerald had returned from his six-week trip to Europe, "is back in harness" at Mark Cross, and "looks awfully nice. . . . A little too thin perhaps, but he says I always say that. We here on the Magic Mountain are . . . doing better too. I am *really encouraged* about Patrick. . . . He is still in bed (a year and a half!) and still has temperature. . . . And though he has his ups and downs, . . . he looks and acts . . . better. . . . I am sure, Scott, he is going to be alright and will yet have a good life, quiet perhaps, without violence, yet maybe better than any of ours."

<p style="text-align:center">* * *</p>

Dow-Dow, on his trip to Europe in 1936, had devised a novel way to report to Patrick his daily activities. "Instead of leaving the pages of my desk-engagement calendar unused," he explained, "I decided to write you each day on these said pages. . . . Certain days I shall pass you nothing more than the momentous news that I have waked, eaten, gone to (wherever), and slept. The main thing is that I shall be thinking of you and Mother and Honoria very much." Of course, he did more than record his everyday doings, for Dow-Dow was a thoughtful observer with a fine sense of humor. His log deserves excerpting.

Saturday, February 1 (aboard the German liner, *Europa*)
I am now convinced of something I suspected for years at Antibes: that apricots have twice the taste that peaches do and never get half the credit. Hence we say unthinkingly, "She's a peach," but never, "She's an apricot."

A few years ago Bob Benchley came down to see someone off and sailed in what he had on! On this boat! There are 160 passengers aboard and room for 600. What waste of space.

Sunday, February 2 (*Europa*)
The woman at the next table to me is from Boston. Every night she orders oysters and asks, "Are you **sure** *they're fresh?" And each time the waiter re-*

plies, *"They were taken on board yesterday."* I wonder who'll win by the time
they get to Bremen.

Monday, February 3 (*Europa*)

*I am obliged to wear a bandage and my black skull cap on account of electric-needle
treatments [for blotches on his scalp, caused by the sun]. My steward, who is the
soul of discretion, has all the German peasant's crafty suspicion of my identity and
is possibly trying to decide whether I'm an Irish-American rabbi (Rabbi Ben
Murphy, Dos calls me), or Mae West's brother disguised.*

Friday, February 7 (London)

*What have I noticed here? The same smell of soot (here soft coal is used), men
not minding the damp cold though they wear no hats, gloves, or overcoats—but
mufflers. Very little illumination in the street and shop windows. Flowers on sale
at almost every corner. Looking in the wrong direction for approaching traffic.
. . . A great number of women. . . . Every bit of merchandise a store owns stuffed
into the windows. Evidence of war-wounded men in the streets.*

Monday, February 10 (London)

*This business brings me to the strangest places, such as 45 A Shoe Street, 6 Love
Lane, 2 Valentine Place, 82 Mermaid Court, 19 Pickle Herring Stairs, . . . etc.,
etc. It's hard to believe I'm just looking for new kinds of leather. . . . Today I got balled
up in a tangle of above-named streets and asked my way. At once I was surrounded
and given directions from all sides. It was English they talked but I couldn't get a
word of it. Finally, they decided I was French. . . . The menace of European war is
in all their minds, but they act as if nothing were happening. I expressed my fears
to one in the bank this morning. "O I 'ope not, Sir, it would mess things up a bit,
wouldn't it, Sir." A great race.*

*P.S. This morning I saw a sign reading, "Purveyor of shellfish." For a moment
I was at a loss. It means oysters for sale.*

Tuesday, February 11 (London)

*All of the wholesale houses are in the old part of the city in old, old buildings.
One in which I was this A.M. seemed really almost too antiquated and I asked, "How
long has the firm of Mackerel and Mackerel been here in this building?" "Two
hundred and thirty years," was the reply.*

Thursday, February 13 (Walsall)

*Tonight I have come up from London to Walsall where our factories have been
where Father founded them fifty years ago. It was dark, so I couldn't see the coun-*

try, but the names of some of the towns were: Upper Sapey, Snittersfield, Quatt, Scriven, Kidderminster. . . . Wouldn't you think they could have avoided some *of these . . . ? They all sound like comic English butlers.*

Saturday, February 15 (London)

At 8 A.M. I looked out the window and couldn't see ten feet away. Such a fog. Every light everywhere lighted. As you look across the restaurant, fog is in the room. Taxis crawl, your eyes sting, you could be murdered and robbed, and no one would see you, including the murderer. I liked it. It had a false mystery about it.

Wednesday, February 19 (London)

Yesterday at the British Industrial Fair I had an "odd" experience. It was the day of the expected visit of Edward VIII, the new king. No hour was set, no place, as no demonstration was requested. There was a quiet tensity in the crowds, but no ganging up, no clamour, and no eager peering curiosity to be the first to see him when he came. No one knew from where or when he was to appear. I was on the platform of the Dent's Glove Display. The attendant salesman seemed to me distracted. I started rooting among samples on my own. He followed indifferently. All at once I darted into a curtained alcove to inspect something, talking all the while (as I thought) to the salesman. But no, I was alone, mumbling to myself. I pushed back the curtain of the alcove to give me more light, and was about to say . . . "Could you give me some information about this leather, pu-leeze?" when my eye hit on THE KING, four feet from me. Outside the display in the great aisle stood a silent crowd listening, orderly, attentive, to what questions he might be asking about the gloves, the leather, etc.

Thursday, February 20 (London)

I am collapsing this letter into one so that Mother will hear from me by the Bremen, which sails on the 26th, after I have left for Paris. I had thought of going by air as time is so pinched, but the heavens are full of whirring machines, so air-mindedness is being discouraged. The Crown is requesting that we remain on terra firma these days. I've enjoyed the Britishers: they seem simpler than we do and more easily pleased. . . . American slang is the latest fad, and you should hear them misuse it and mix it with theirs, thus diluting the effect. . . . The U.S.A. seems a growing influence, . . . and one sees for the first time in London shop-windows goods announced as "direct from New York."

Monday, February 24 (Paris)

If you can believe it, the honking and blatting of the motor horns is unpleasant after the village quiet of N.Y.C. Viva Fiorello La Guardia! Frankly Paris is gloomy

—and the French in a bad mood. They are inclined to blame all foreigners for something, they don't know what.

Wednesday, February 26 (Paris)

I was telling you that Paris seemed changed to me. I must qualify that opinion in the light of subsequent thought. Paris seemed more like itself than ever, but the French (or rather the Parisians) seemed changed. France lives so independently of other countries and peoples that when troubles menace them from without (as now) the sight or presence of a foreigner irritates them. They are in a difficult position with Germany restless and aggressive. I must say they show it.

Saturday, February 29 (Paris)

Vladimir has but one wish and that is that the moment that you are well enough to have someone pass an hour with you in the morning and one in the afternoon, that we send over for him and he will come at once. He longs to see you.

Monday, March 2 (Paris)

The trip to Leipzig, Germany, is so complicated by train and the trains so crowded with people going to the Leipzig Industrial Fair that I am going to fly. I must fly all the way from Paris to Berlin and then go two hours south to Leipzig. What would ordinarily take me eighteen hours will take me five. I am interested to see what my impressions of flying will be after having been up once over water in a hydroplane twenty years ago. Vladimir is very interested and is going to the field at Le Bourget (where Lindbergh landed) to see me off.

Tuesday, March 3 (Leipzig)

I enjoyed flying. The machine seemed to me ridiculously fragile when I got in with nine other passengers. . . . Naturally in taking off one has a certain emotion. . . . I didn't enjoy flying over the roofs of houses occupied by trusting and unsuspecting people, but over country it was better. Vladimir saw me off, and it all seemed matter of fact.

Friday, March 6 (Vienna)

Berlin seemed sullen and out of sorts as I passed through it. Also, my German was rusty and I had the feeling of being in an unfriendly city. I went to Leipzig by train as the plane comes down three times between those cities, and no time is gained. Leipzig is teeming with its great industrial fair. . . . I am in Wien (Vienna) to tackle the lines of twenty or thirty manufacturers, which were prepared for me in advance to see. The coffee in Germany was awful. Do you recall our wonderful cook at Ramgut, Bad Aussee? Her coffee I recall and tasted the equiva-

lent again today. . . . Tonight I go back to Berlin and dread the scene at the border during the night, during which you are made to feel like a counterfeiter or a blockade-runner or spy—or all three.

Monday, March 9 (Berlin)

Berlin is a-tremor, and I've taken a room overlooking the Unter den Linden. Hitler, after a few hours notice that he was going to send troops into the Rhineland in the face of the Locarno Treaty, has done so, and the nation is agog. There's a big meeting at noon of all the heads of Armies, Navies, Ministries, . . . etc., and he's going to tell the world what it's all about. Troops are marching through the Brandenburger Tor, their Arc de Triomphe, marines with bayoneted guns, truck-loads of infantry, officers' cars hurling along with beplumed admirals and bemedalled officers within. Public crowding the sidewalks. Young cadets saluting passing cars unceasingly. Bands. I asked the waiter what it means, and he says Hitler has to do something because the elections are coming, but that no man in the street wants it.

Tuesday, March 10 (Berlin)

It's strange to me that a city like Berlin, which is the capital of a country which may be hurling itself toward another war deliberately, does not show a sign of it in the streets and shops or on the people's faces. I expect taxi-drivers to refuse me as a passenger and say, "I'm sorry but things are too uncertain. I must stay near home in case I'm needed." But no, things go on unruffled.

Wednesday, March 11 (Bremen)

Bremen is up a river surrounded by flat country at water level with isolated trees and houses. The port is impressive with its forest of electric cranes and elevators up against the sky. It is strange to see the Europa *in such simple country as opposed to views of it at the end of New York streets. There are to be more people aboard this time, fortunately. I shan't forget that deserted forest look the boat had last time. There is fog in the channel, and we proceed slowly to Southampton first. Two steamers were sunk Sunday night, so we are crawling. I hope I won't be late in docking at N.Y.*

Thursday, March 12 (*Europa*)

We were six hours or more late getting away from Cherbourg and the fog continues. If the sea is good outside, we'll make up some time. . . . Everyone is worried about the situation created by Germany's Rhineland occupation, and newspapers are devoured as they come on at Southampton and Cherbourg. How strange it is: I am leaving a country (Germany), which defies France (at which I touch) and whom England (where I touch) is bound to resist, should she persist as

a menace, as I proceed to a country far off, which is determined to remain neutral, in spite of everything.

Friday, March 13 (*Europa*)

Today has been roughish, but the wind following and we're making good time, 675–680 miles a day, and gaining some of the time we lost. People on board are remarking that it's Friday the thirteenth. I, on the other hand, have word that you are well, which means gaining a little too, I hope.

Saturday, March 14 (*Europa*)

A wireless from Mother says that she's waiting in N.Y. I wish we were all together. It looks as if we'd dock on Monday in the late afternoon. I pray so. Not a cloud in the sky today. I'm going to mail this the moment I get off the pier, and doubtless I'll be seeing you very shortly thereafter.

Monday, March 16 (*Europa*)

Last night after dinner, 8 P.M. on board, I decided I must talk with Mother. I went to the radio station and asked what time it was in N.Y. I was told seven o'clock. I gave the number. . . . The operator said please wait five minutes. I went into a booth and sat down. In five minutes the call came through, and I talked perfectly to Mother and Honoria: across the water to a continent without any visible means. I hope you turn out to be a scientist. It seems to me a wonderful future, constantly new. We are approaching Fire Island through a fog; soon we get our pilot; it's safer then, as we are on the Broadway and 42nd Street of the Atlantic. . . . Love, Pook. I've been away forty-five days.

The picture on the postcard sent to me from London on February 26, 1936, was a portrait of Edward VIII. "Mother or Patrick will describe to you my contretemps with this sad-faced young monarch," Dow-Dow wrote, referring, of course, to the incident a week earlier at the industrial fair. "He is most beloved, and the public's attitude toward him is very moving."

<p style="text-align:center">* * *</p>

Later in the year 1936, Edward VIII was forced by the furor over his intention to marry a divorced American woman, Wallis Warfield Simpson, to abdicate his throne. Gerald Murphy's sympathies evidently were with the couple, although he had never met the king or his bride. When he heard, shortly before the Windsors married in 1937, that Mrs. Simpson was staying in Cannes, at the villa of a

mutual friend, Herman Rogers, Gerald offered the use of the Villa America. "Your offer came at a moment when we badly needed a helping hand," Rogers wrote Murphy on January 27, 1937. It was not accepted, however, for Mrs. Simpson had been trying to escape public attention, as Rogers explained. "Even though we could not move out of this crowded little house—the siege was too tight— your friendly gesture was a great help." Gerald learned later that the Windsors spent their honeymoon at the Hôtel du Cap in Antibes.

The Murphys had recently marked the twentieth anniversary of their marriage—on December 30, 1935. There had been little to celebrate in Saranac Lake, as Gerald had indicated in the bleak letter he wrote to Fitzgerald the following day. They were at a turning point. "The chemistry of our life was radically altered," Gerald wrote in 1960 to Calvin Tomkins. ". . . a life, which had been so fortunate and was coming into its rhythm, was suddenly robbed of its future. The ship foundered, was refloated, set sail again, but not on the same course, nor for the same port." He was even able, in a letter to Tomkins a few months later, to recall that "strange sense of satisfaction in the knowledge that one has really touched bot- tom." This, of course, was said with the help of temporal distance. The experience of a son's dying young was such an agony that neither Gerald nor Sara ever fully recovered. It was a source of strain, as well, for the marriage, which, though founded on a rock, was vulnerable to the "ruthless blasting" that Gerald had alluded to in his letter to Fitzgerald. The long periods of separation were more than practical answers to their respective responsibilities— Gerald's to Mark Cross, Sara's to Patrick. It is evident from the correspondence that the Murphys found it necessary to withdraw from each other to take spiritual nourishment: Gerald, from the serenity of solitude (when he sailed for England in February 1936, he remained cloistered in his cabin, not even bothering to reserve a chair on deck); Sara, from the company of friends (the following May, for example, she was off to Havana to visit the Hemingways).

Sara had suggested that Gerald, too, would find comfort in Chris- tian Science, and he indicated in a letter from aboard the *Europa* on February 5 that she had been right: "I'm grateful, first, for real contact with the Bible, which Catholicism had neglected for me, but further I have the feeling of learning a new language with which I find myself sympathetic and vaguely familiar, tho' I've felt myself

not adapted to such by nature. I shall see to it that I was wrong."
Gerald was so taken with his experience that, once in London, he
went to a Christian Science reading room. The lessons had been "a
source of great satisfaction," he wrote Sara on February 11, "a little
upheaving at first, but nourishing." Gerald customarily plunged
into a new interest with total enthusiasm, and Christian Science was
no exception. "I find it a language I . . . always have known," he
continued in the letter to Sara, "and believe unhesitatingly in all its
claims. Life moves to another level. Something happens to perspec-
tive and vision. Horizons get larger."

It is only natural that Gerald would relate Christian Science to
illness in the family. "You are *bringing* to Patrick all that these
lessons *show* us in the Bible," he wrote Sara from London. "I see it
very clearly. You must *believe* that you are as strongly as I *feel* that
you are." It must be said, however, that Murphy was a faddist
whose zeal for a movement or a philosophy tended to be transient.
This would account for the fact that Honoria never was aware that
either her father or her mother had been interested in the Church
of Christ, Scientist.

Gerald returned to New York, where he had taken an apartment
at the Hotel Russell on Park Avenue. His thoughts were fixed on
his marriage and on the long separations from Sara, who still was
at Saranac Lake. He realized that differences had developed between
them, and he tried to explain them logically. "There is one thing that
has always surprised me," he wrote Sara on April 16, 1936, "and
that is one's tendency to feel that just because two people have been
married for twenty years, . . . they should need the same things of
life or of people. You are surprised anew periodically that 'warm
human relationship' should be so necessary to you and less to me.
Yet nothing is more natural under the circumstances. You believe
in it (as you do in life), you are capable of it, you command it. I am
less of a believer (I don't admire human animals as much), I am not
capable, I lack the confidence to command it. . . . Certainly feeling
exists in people or it doesn't. No two people show it in the same
degree or *manner.* Hence the inadequacy of most relationships, which
are supposed to be kept at *constant* emotional pressure. It is hard to
believe in the ultimate value of love if one has always questioned
the real value of life. . . . One must believe *fully.* You are luckier than
I am. I fear life. You don't."

Reflective, thoughtful, brutally self-critical—Gerald's analysis

enabled the Murphys to weather the crisis. The depth of his intro-
spection, painful as it must have been, was the basis of renewed
understanding and proof of the resilience of a carefully constructed
relationship. "I suppose it's downright tragic," he wrote on April 18,
"when one person who lives by communicated affection should
have chosen a mate who is . . . deficient. I have always had the
knowledge . . . that I lacked something that other people had,
emotionally. Whether this is due to the absence of degree and depth
of feeling, or the result of trained suppression of feelings, . . . I don't
know. Possibly both. I do recall my attitude toward feeling being
warped by Mother's influence. Suffice it to say that now whenever
I think to myself this is the moment that I should like to give my
feelings play, this is when I should be feeling something, . . . then
I feel a constriction at the source and a choked sensation. . . . Not
a day has ever passed that I haven't thought of how rotten it's been
for you. Especially as I have known you to be crediting my defi-
ciency to a *personal* lack of affection. You naturally *feel* it personally.
Why shouldn't you? I wonder if anyone who wants as much feeling
of life as you do ever really gets it. Very rarely from one person,
don't you think? You certainly have always given it to people.
People talk of you with emotional gratitude, as having been made
to feel something you gave them for which they're glad."

That Gerald would be deeply depressed thirteen months after
Baoth's death and with Patrick's prognosis all but hopeless is easily
understood; what is not so clear, however, is the basis for the sort
of self-pity he was expressing to Sara. With the exception of his
own tortured confession, there is no recorded indication that Gerald
was emotionally deficient. Quite the contrary, according to Hon-
oria, who can cite as substantiation her own memories of her father,
in addition to the fact that her parents' marriage lasted until her
father died more than twenty-eight years later.

If Sara sent a reply to Gerald's plaint of April 18, 1936, her letter
was not preserved, and while it might be inferred from her failure
to write that something was amiss, such an inference would be
highly speculative. Sara did write to Hemingway on May 21, fol-
lowing her return from Havana, but it was a letter for the most part
filled with small talk and thank-you's for "your hospitality and the
general healing and 'back to normalcy' effect, . . . so that there have
been many favorable comments on . . . my alleged improved appear-
ance." She spoke hopefully of her vigil and of motherly love: "Pat-

rick and I are awfully well together. Much better than we ever were before his illness. You can't imagine how glad I was to see him, and he seemed glad to see me too. And we had missed each other. I found him very well, you will be glad to hear. He had gained another pound (weight stationary at 83)." She asked, as always, if the Hemingways intended to visit, and she alluded in a general way to her feelings about people and relationships. "About being snooty," she protested to Ernest. "You don't really think I am snooty, do you? Please don't. It isn't snooty to choose. Choice and one's affections are about all there are. And I'm rather savage, like you, about first-best everything: best painting, best music, best friends. I'd rather spend a few hours a year with the friends I love than hundreds with indifferents." There was just one mention of Gerald in that letter to Ernest, as Sara noted that he and Honoria had joined her for a Sunday in East Hampton right after her return from Havana.

Sara was back with Patrick at Saranac Lake on June 26, 1936, when there was another soul-searching letter from Gerald. This time, though, he was expressing despair over the tragedy that had befallen them, and no one would question his right to do so. "I wonder if life *is* unlikely," he wrote. "What *is* likely? What happened to Baoth, to me, is so *unlike* what one would think of for him, for us. I find myself uncomprehending—and I may say chastened by one thing and another. It does not leave one defiant. I hope it isn't scorn I feel. There's no comfort *there."* The letter was, at the same time, typically affectionate: "Only one thing would be awful, and it is that you might not know that I love only you. We both know it's inadequate, . . . but it certainly is the best this poor fish can offer, and it's the realest thing I know."

* * *

Mother wrote to Pauline Hemingway in May 1936, as she had to Ernest, about the "beautiful week we had," a week that was marred only by Pauline's absence. "Your not being there was a huge mistake," Mother said, but she had enjoyed herself immensely anyway. "I *love* Havana!" she told Pauline, "and you know how much going out on the boat meant to me. . . . Out of eight days, . . . six were at sea and two of them busily catching marlin. I am going back [to Saranac Lake] with an entirely new line of conversation for Patrick (all about fish and boats and tackle and Cuban sailors and, most of all, his adored Ernest)—and a beaming new

face. . . . Will you tell the *Gros Patron* again how much I am in his debt, forever."

At the end of the 1936 academic year, I was a boarding student at Spence in New York City, with yet another year to go, even though I would turn nineteen the following December. I was a couple of years behind, owing to the late start of my formal education.

I liked Spence a lot, and my surrogate sister, Fanny Myers, was also there, but I still was homesick, if you can call it that. There was no home, really, to miss, but I worried constantly about Mother and Patrick. They were in Saranac Lake, moving from one residence to another: Steel Camp, over the summer of 1935; a house in town, at 29 Church Street, from October 1935 to June 1936; Camp Adeline, named for my maternal grandmother, at Paul Smith's, New York, for the summer of 1936; and another house in town, in a section called Glenwood Estates, beginning in the fall of 1936.

On weekends and during vacations, I would take the overnight train from New York to Saranac Lake, often accompanied by Fanny. On one such visit, I had become enamored of a boy who had taken me sailing. I had not done well at holding the tiller, however, and I told Patrick of my fears that I had not made a good impression. He thought a moment and said, "Honoria, I think you will have to learn to sail."

Patrick was a very wise little boy, which is often the case with children who are confined by illness to a life of limited activity. So I would often go to him for advice, although he was three years younger than I. He was fifteen and I was eighteen in the spring of 1936.

Patrick kept a diary, which, while the entries are occasional, provides interesting insight into the turn of his alert young mind. The year was 1936:

Sunday, March 22 (29 Church Street)

Dow-Dow just returned from Europe and came up to spend Sunday and Monday with me. His business tour lasted six weeks, in which time he visited England, France, Germany, Austria, and saw the great industrial fairs, where he bought merchandise for the Mark Cross Company. He also bought me several lovely presents: two English sporting ties, an English bathrobe, and a steam engine run by an alcohol lamp from Germany. . . . On the way back, the chef of the Europa *insisted on baking me two loaves of black German bread. When I was opening the package, I asked Dow-Dow if it was something to eat. "Either that," he answered, "or to build a garage [with]." They weighed about fifteen pounds each!*

Thursday, March 26 (29 Church Street)

Dow-Dow went back to New York Monday night and is coming back Saturday. He convinced Mother to go to Boston to see the flower show. So, Wednesday at noon, Mother took the car to Albany, planning to fly from there to Boston. The weather, however, was unfavorable, so she went the rest of the way by train. This morning I got weighed, and to our delight found that I had gained a pound and a half. The x-ray taken Wednesday morning showed improvement, so I seem to be coming along.

Monday, March 30 (29 Church Street)

Mother, Dow-Dow, and Honoria came back from New York yesterday morning. We celebrated Dow-Dow's birthday (which was Wednesday) last night, and had a beautiful cake. Dow-Dow had several presents. Honoria is staying until next Monday, as this is her Easter vacation. Dow-Dow has to go back tonight. I am preparing for the fishing season and have asked for some fishing tackle for Easter.

The move to Camp Adeline was made in June, as Patrick explained to Archie and Ada MacLeish in a postcard on June 1: "We are now in the throes of packing up to move to the summer camp. I have been told that if I am *very* good and eat a *great* deal, I may fish a little sometime soon." He described the new camp, which was on a remote lake in the Saranac vicinity, in his last diary entry of 1936.

Saturday, July 11 (Camp Adeline)

It is lovely, with about eight different cottages, including guest, servants', dining and cooking, main, playhouse, and another cottage for Honoria, my nurse, and myself. Also boathouse and dock, with a launch, rowboat and canoe. Miss Daniel [Patrick's nurse] got a wheelchair from one of her former patients, in which I can go all over the place, including the dock, where I can fish. Mother and Honoria are staying here, and Dow-Dow comes weekends. He is planning a vacation soon. Guests also come quite often.

Katy and Dos came to visit at Camp Adeline over the Fourth of July, and Dos reported to Ernest that Mother "had fixed up a new camp on a different lake." But then he made a succinct—and quite accurate, in my judgment—observation: "God, but it's gloomy on those Adirondack lakes." There is a hint, in a letter she wrote to the Hemingways on July 29, 1936, that Mother agreed. "This camp is a great success," she said. "The house is much nicer than last year—the lakes remain the same. Fortunately friends come to see us, and I hope you will on your way back from the West."

Ernest and Pauline and the boys were at the L Bar T in Montana, the ranch we had visited in 1932. Mother still sounded optimistic about Patrick, but the news was not good: "Still runs a temp. and eats badly. . . . He has had two transfusions for his rather bad anemia. . . . Lately, in an effort to improve his appetite, which seems to resist everything, we push him all around outdoors in a reclining wheelchair, even down to the dock where he holds a fishline. He is simply *ravished* as he catches bullheads, perch, and sometimes little trout. It has really made his life over. . . . He really loves the camp, which is such a comfort. . . . He is really a remarkable person, and it's a pleasure to know him."

* * *

It does not require a degree in psychology to see the significance of Sara's repeated use of the word "really"—she was determined to wish Patrick well, and that was that. In the meantime, there were other family ailments and troubles, which caused concern. "Gerald has been having such a lot of arthritis and other disagreeables," Sara confided to the Hemingways in her letter of July 29, 1936, "they thought the tonsils might be poisoning him." An operation had been called for. Gerald, who spent the month of August at the camp, recuperating from surgery, was, in turn, worried about Sara. "It is Sara who needs attention now," he had written Scott Fitzgerald on July 30. "I want to get her to Europe for a month. Her inconsolability—and her present anxiety over Patrick—begin to tell on her. She refuses to release her tense grip and is burning white. The same pride in not sparing herself that her mother had has come to her now. There is little one can do for her. . . . She is gay, energetic, but is not well." Sara was coping, however, and Gerald admired her, as always, for the way she managed their home. He described for Fitzgerald the main building at Camp Adeline, "a well-built one of Edith Wharton's era, which she has somehow transformed into something outside New Orleans—gay, light, colored rooms, white rugs, a small jungle of indoor exotic palms and plants. . . . Patrick likes it very much."

* * *

There was no trip to Europe in the summer of 1936, as Mother had hoped and as Dow-Dow had planned for her. "The *Weatherbird* was suddenly rented for July and August," she wrote the Hemingways at the ranch, "so I never got my sailing trip. . . . So I may go over to Paris in September. I want new clothes and new ideas (in order named) and Hell-

stern shoes and perfumery and trick hats and lingerie, not to mention THE evening dress, and to sit for hours with Léger and his friends in cafés and haunt the rue de la Boëtie and see every good new play."

The trip in September did not work out either, and by October Mother was feeling lonely again. She betrayed her mood in a letter to Pauline Hemingway on October 18, 1936, Patrick's sixteenth birthday. "Just a line to say that *any* time you and yours wish to come for hunting or even health reasons (sleep and nibble a biscuit) or any reasons *whatever,* there is a place in our house and heart—a candle in every window for you all."

She was as optimistic as ever about Patrick's health, and she described birthday festivities to Pauline. "We had the start of a two-day celebration today—telegrams, cards, some presents, and a small glass of champagne. Tomorrow, Dow-Dow and Honoria arrive, and there will be a lot more of the same, only more and bigger and better. He loves it, and he looks well. Doctor came today and seemed satisfied. Good-bye dears. I still miss you dreadfully." She evidently meant Ernest, as well.

The Hemingways were a great comfort to Mother. Ernest made two or three trips to Saranac Lake while we were living there. I remember one—in late 1936—very well. He arrived alone and simply said to Mother, "I'd like to see Patrick." She said, "Certainly, Ernest," and we walked down the hall, the three of us together. Patrick's bedroom was in a first-floor wing of the house in Glenwood Estates. It was late in the afternoon and getting dark, but I could see Ernest's face, and I had never seen him look so sad.

As we walked in, Patrick said cheerfully, "Hello, Ernest." "Hello, Patrick," said Ernest, "how are you? I hear you are doing well," which he knew was not so. They had a short conversation, as Ernest stood on the right side of the bed. Mother and I were at the foot, and I was watching Ernest's face. They talked about fishing, but it was soon obvious that Ernest was having difficulty controlling his emotions. It was terribly sad to see this big, robust man about to break down as he faced the fact that a young boy he loved was soon to die.

"I think I can come back later to say good night, Patrick," Ernest said, "but I don't want to tire you out." His voice started to break, and he turned and left the room quickly. We followed, and as we faced him out in the hall, it was clear that he was about to cry. "Goddamn it," he said, "why does that boy have to be so sick?" He turned to me: "Sorry, daughter." He was apologizing for swearing. "But I can't help it." Mother took him by the arm and reassured him: "He's going to be all right, Ernest. He's going to be all right." Ernest knew, as I did, that she was deceiving herself, and

he wept—openly. "He looks so sick," he said. "I can't stand seeing that boy look so sick."

We went into the living room, and Mother gave Ernest a drink. He stayed several days and took pains to visit with Patrick at some length. He, of course, never let my brother know, but his anger mixed with sorrow did not subside. "Goddamn it," he would say. And then, always, "Sorry, daughter."

* * *

"Am here now indefinitely," Gerald Murphy reported in a postcard to Ernest Hemingway from Saranac Lake on January 8, 1937, indicating he recognized, even if Sara refused to, that there was little time left for Patrick. In a letter to Pauline on January 22, however, he showed his ability to pretend that all was well. Pauline had written recently, and Ernest—along with Virginia Pfeiffer, Pauline's sister, and Sidney Franklin, the bullfighter—had been to Saranac for a visit. Gerald, alluding to Pauline's letter, was able to be his old amusing self. "In a moment of boastful expansion with Ernest," he wrote Pauline, "I referred to certain passages, . . . which were not uncomplimentary to me. Drunk with success, I gave it to him to read. It is now confiscate, so I must answer you at random. Jinny, Ernest, and Sidney motored up from New York a few days ago in the latter's pulsing motor. It *was* nice, you'll admit, of people to do *that.* We were delighted. It was mother's milk to Sara. . . . Ernest looked fine, I thought, and hardened down. . . . Jinny has stayed on until today. Sara has been so happy to have her. We *love* that girl. We talked so much of you, Pauline! We missed you. We said so often. There were no dissenting votes."

* * *

"I hear Ernest, Jinny, and Sidney Franklin are all up there," I wrote Patrick from New York on January 16, 1937. "Isn't that wonderful." I sent him "much, much love," as well as Fanny's, and said, "I shall see you very soon." There was no reply, but Patrick managed to make entries in his diary almost to the end.

January 1

New Year's Day was one of the dreariest that I ever spent. Muggy, cloudy, no snow to be seen anywhere in Saranac Lake! I woke up in a wretched mood, took hours for my nourishment, and I listened gloomily to the merrymaking of my family and their guests. During the afternoon, they were allowed to come in for a few minutes.

We pulled some gifts out of a paper Santa Claus. I am greatly inconvenienced by having to breathe out of an oxygen tank, due to breathlessness. I now await supper, after which I will try to have a more restful night than the last.

January 2

Another dull day. No appetite. Find illness most deplorable. Am in Saranac Lake on account of tuberculosis. Mother staying with me in rented house. Father in city three days a week on business. One sister, Honoria, in school in city, comes up weekends. Name of father, Gerald Murphy, called Dow-Dow by everyone. Mother's name, Sara Wiborg. My name, Patrick. Have been here almost two years and doing fine, but have been set back terribly last two months by toothache, not eating, and taking drugs. Thus don't feel well.

January 3

Same kind of day, not feeling especially well, appetite poor. Do not feel like seeing people or playing with gifts. Saranac Lake is in the Adirondack Mountains situated in the northern part of New York State. I have a day nurse and a night nurse, two doctors. My day nurse has been with me a year and is apparently devoted to me. The night nurse is quite new, and I do not know her so well. You will hear a great deal about the day nurse later. Respectively, they are named Miss Daniel, Miss Morris. The doctors are Dr. Brown and Dr. Hayes.

January 4

Had a better night, but took too long for breakfast. Dr. Hayes gave me a new hypo in the arm instead of the usual buttock. Was pleased to find that the new prescription did not hurt in the new place. Had iced tea for lunch. Miss Daniel was slightly disgruntled at this. Dr. Wilson, who is my nose and throat doctor, came in the afternoon and found my throat in such good condition that he may not have to cauterize it next week. I tried some etching and made a good etching, but the etching did not print well at first. Later prints will be better, however. I am now eating supper earlier than usual to please Miss D. And so to bed!

January 14

Feeling about the same, stronger. Think night nurse telephoned doctor. Wants a rest. Have a new nurse named Miss Papineau. I thought she was Indian until saw her and found out she was French descendant.

January 15

Had a good night with Miss Papineau and ate better as a result. Ernestine arrived this morning and had several little gifts for me. I still do not feel much like doing

much and have not made much with my program. Mrs. Nelson came on tonight as my permanent night nurse.

January 16

Had a grunid night with Mrs. Nelson [Patrick had a way of making up expressive words]. Nothing new happened during the day. Ernest Hemingway, Jinny Pfeiffer, and Sidney Franklin, noted and only American bullfighter, arrived. Ernest came in to see me for a few minutes before I went to bed. He is giving me a bear-cub skin for a Christmas present, but it is not ready yet.

January 23

Had swell night but feel pretty sleepy and don't get started eating till late in the day. Dow-Dow does a lot of walking in the snow with Ada. I have taken up etching again and made a new one but have not printed it yet.

January 24

Had a hard time eating today and did not do well. Dow-Dow tried skiing for the first time in years. He found it very tame, however, on the road near the house with only a few inches of snow. Did some more etching this aft, but have not printed yet.

In New York, one day late in January—the 22nd or 23rd—Dow-Dow took me to lunch at the St. Regis. He was leaving for Saranac Lake by train that night, and I could clearly sense from the expression on his face that he had something urgent to tell me. He spoke in a matter-of-fact manner, which was his way of hiding the pain. He said that I should know that Patrick was not going to recover. He had taken a turn for the worse. The doctor held out very little hope. I had known, of course, that my brother was seriously ill, but the prospect of his imminent death came as a shock. I asked how Mother was doing. "Your mother will not believe it," said Dow-Dow. "The doctor has told her, but she will not face the reality that Patrick will not get well."

I did not cry during lunch. I was trying to be brave in front of my father. But when I got back to Spence and told Fanny, I cried and cried. She did too, although she tried to comfort me. Fanny Myers was more than a sister to me, she was a sister to my brothers, and she was a daughter to my parents.

When I had calmed down, I called Mother and said that I wanted to come to Saranac right away. She sensed that I was upset and asked why. "Everything is fine up here," she assured me. I was somewhat relieved, but not much. For a fleeting moment, I did not know what to believe, but

then I remembered my father telling me that my mother would not accept it.

I went to study hall but kept weeping and could not concentrate, and the girl next to me suggested I go and talk to the headmistress. I did, but not until the next morning. Fanny and I had talked it over, and I had decided to sleep on it. The headmistress, a Mrs. Osborne, called my parents. "Your daughter is extremely upset," she told them, "and she wants to come to Saranac Lake." Mother and Dow-Dow agreed it would be a good idea, and Mrs. Osborne said she was giving both Fanny and me permission to leave school. We took the overnight train.

Dow-Dow met us at the station, and when we got to the house, we were greeted by a contingent of family loyalists. Ernestine, who had been our maid in Antibes, was there. Ada MacLeish. Alice Lee Myers, Fanny's mother. The first thing I wanted to do was to see Patrick, and Fanny and I went down the hall to his room. I was not prepared for it. He looked much worse than he had a month earlier, when I was home for the holidays. He was very short of breath, and he was the color of his white bedsheets. He had had up and down days for some time, but by now they were all down. It was difficult for him to speak, but he greeted us as best he could.

The household was run as routinely as possible. Mother, naturally, was nervous and distraught, but fortunately she had Ada and Alice Lee to help her manage. She occupied herself fussing with furnishings and cutting flowers, and she smoked cigarettes. Mother smoked more and more as she got older, but she never inhaled.

Any discussion of Patrick was confined to statistics. Each day his nurse would report his temperature, how much he had been able to eat, and so on. We avoided talking about how sad we all felt, for my parents would not hear a word that was tinged with pity. We still paid periodic visits to Patrick's room. We were, by this time, required to wear surgical masks, for his disease had become highly contagious. TB is always contagious, but it becomes more so as it progresses. We told Patrick we were wearing the masks so that he would not be exposed to our germs.

Patrick died on January 30. He had lapsed into a coma that morning, and the doctor told us there was nothing more that could be done. We were standing around his bed as his breathing became fainter and finally stopped. Mother and Dow-Dow each was holding one of his hands and saying to him, "You're just fine, Patrick. We're right here with you."

We walked down the long hall, numbed. Even though we had known for so long that Patrick would die, we were stunned to realize it had actually happened. We got to the living room, and there we let loose all the emotion that had been pent up inside us.

The next morning, the doorbell rang. Mother answered it, and it was Dos. He always checked in, and when he called last, from South America, Dow-Dow had told him that Patrick's death was imminent. "I just wanted to be with you," he said to Mother.

* * *

As when Baoth died, there were many letters of condolence, but the one the Murphys cherished the most was from Scott Fitzgerald in Tryon, North Carolina. "The telegram came today," he wrote on January 31, 1937, "and the whole afternoon was sad with thoughts of you and the past and the happy times we had once. Another link binding you to life is broken and with such insensate cruelty that it is hard to say which of the two blows was conceived with more malice. I can see the silence in which you hover now after this seven years of struggle and it would take words like Lincoln's in his letter to the mother who had lost four sons in the war to write you anything fitting at the moment. The sympathy you will get will be what you have had from each other already and for a long, long time you will be inconsolable. But I can see another generation growing up around Honoria and an eventual peace somewhere, an occasional port of call as we sail deathward. Fate can't have any more arrows in its quiver for you that will wound like these. Who was it said that it was astounding how the deepest of griefs can change in time to a sort of joy? The golden bowl is broken indeed but it *was* golden; nothing can ever take those boys away from you now."

Hemingway wrote, of course, but his letter was inexplicably lost. Alice Lee Myers, the friend who took care of details, sent an informative letter to Ernest in Key West on February 6. "Perhaps the reason for possessions," Alice Lee wrote, "is to give someone something to do when one can't grieve and remember. Sara and Gerald are courageous and resigned. In going over Patrick's possessions, they asked me to send you his gun racks and, for your boys, two engines that he loved. He had not played with them, so . . . they are quite safe. Sara also wished me to ask you if you would like the mounted heads that you sent him for your trophy room [The impala

and other trophies Ernest had sent Patrick had been hung in Patrick's room in Saranac Lake]. . . . Patrick loved seeing you so—the last work he did were a few little scratches that he made on his etching of you. . . . Sara sends you her love."

<p style="text-align:center">* * *</p>

Patrick was cremated in Troy, New York, on February 1, 1937, and we took his ashes to East Hampton for burial. And then, to compound my mother's grief, her sister, Olga Fish, became very ill in March 1937. She had had breast cancer and had refused to undergo a second mastectomy. Mother was determined, though she was in no shape to do so, to go to California, and Alice Lee volunteered to go with her. They took a coast-to-coast flight but got no farther than Cleveland, because Mother suffered a severe neck-muscle spasm. She was in acute pain and unable to turn her head, so she was taken off the plane and sent home. We were living in New York City again—in a penthouse in the Hotel New Weston at Fiftieth Street and Madison Avenue. I had become a day student at Spence in order to be near my parents.

Mother's muscle ailment was diagnosed as the result of nerve strain, and it responded to rest. When her sister took a turn for the worse in April, she did fly to California, this time alone. She was met at the airport in Monterey by a dear friend of Olga, Cecilia Vom Rath, who told Mother during the drive to Carmel that Olga had died that morning. Dow-Dow joined Mother for the funeral, but he had to return to New York alone due to business responsibilities.

"My heart was so heavy in leaving you," he wrote from his flight, as it approached Reno. He continued the letter on the leg between Reno and Salt Lake City: "How infinitely sad it all is—this going of Olga's. Why must people go—Baoth, Patrick, and she before their time, before they can enjoy fully the love of those who love them and those they love? Why must life be so sad—and hurting? I *hate* seeing you hurt as you are."

We went to Europe for the summer of 1937, sailing on the *Aquitania* on June 16. "Beyond staying a few days in Paris and then to London," Dow-Dow wrote Pauline Hemingway on the day before we landed, "we have no plans as yet. All the future is clear as jelly and almost as interesting. However, I persist in believing that . . . all will seem better in the deceptive light of Europe. Lights *ought* to be deceptive, and, by God, mine shall be. So let's all laugh a great deal . . . and see lots of friends."

<p style="text-align:center">* * *</p>

Gerald was not laughing very much when he returned from Europe on the *Ile de France* in early September. "Learn as much as you can . . . about what you should do to feel better," he wrote Sara, who had stayed in Paris, as had Honoria, for two more weeks. "I know that it doesn't seem important in the face of what's happened whether we take care of ourselves or not. The motive is lacking, I suppose. But as long as we *must* live, we might as well feel as well as we can. It probably helps to give others a better time. Somehow it may contribute to the aura that surrounds Baoth's and Patrick's memory. They'd want it."

Sara and Gerald had been in East Hampton in May 1938 when Gerald wrote to Hale Walker, the architect, and Harold Heller, the designer, who had become close friends by this time. Sara and Honoria were soon to return to Europe. "When we left the house this morning," Gerald wrote, "Sara and I went to the cemetery and visited the graves of Baoth and Patrick for the last time before she goes abroad. As you know better than almost any of her friends, she is—and always will be—hopelessly inconsolable. As time goes on, she feels her bereavement more and understands less why the two boys were taken away—both of them. We have both felt that our life was definitely stopped before it was finished and that nothing that we do further has much meaning except as it can possibly be of service to Honoria and our friends."

You must know that, without you, **nothing** *makes any sense.*
I am only half a person, and you are the other half.

Sara Murphy to Gerald Murphy
August 7, 1963

IV. Only Half a Person Without You

Sara Sherman Wiborg and Gerald Clery Murphy met at a party in East Hampton in the summer of 1904. Sara's father, Frank B. Wiborg, had been among the first summer residents of the exclusive Long Island resort, where he acquired a large amount of seaside property. Patrick Francis Murphy had chosen Southampton, some twenty miles nearer New York City, for his vacation home, but his son Gerald preferred the social atmosphere of East Hampton. The reason is suggested by an anonymous commentator in 1926, quoted in a fifty-year history of the Maidstone Club, who pictured South-ampton as being "ruled by the fading remnant of the once all-powerful New York society." East Hampton, meanwhile, was a "society based on a community of intellectual tastes rather than a feverish craving for display and excitement."

Sara and Gerald did not become romantically attached right away. For one reason, there was a wide disparity in age and educa-tional status. Sara, at twenty, had just graduated from the Spence School in Manhattan; Gerald, who was sixteen, was a student at Hotchkiss, a prep school in Connecticut. Gerald considered himself "a cousin of the Wiborg girls," and that was his role for almost eleven years. "Mrs. Wiborg abhorred the idea of any of her daugh-ters marrying," he later said. "The subject was taboo. They were her

life, and she didn't want the spell broken. So we never thought of marriage until we were twenty-six." Actually, Gerald was twenty-six, and Sara was thirty-one when they became engaged in February 1915, and it was over ten months later—on December 30, 1915—that they were married at the Wiborg residence in New York City.

* * *

I was born on December 19, 1917, and named Honoria Adeline Murphy. My middle name was for my maternal grandmother, who had died on January 2 of that year. She had been a Sherman, of the Ohio Shermans, although she was born in Des Moines, Iowa, in 1859. Her father, Major Hoyt Sherman, was the U.S. Army paymaster during the Civil War and later president of the Equitable Life Insurance Company of Iowa.

Hoyt Sherman, who was born in Lancaster, Ohio, in 1827, was the next to the youngest of eleven children. One of his brothers was William Tecumseh Sherman, the Union Army general. On a visit to New York in 1928, we stayed at the Savoy Plaza on Fifth Avenue, and from our hotel window we could see a statue of General Sherman on a horse led by a female figure symbolizing victory. *"C'est l'Oncle General et Tante Hoytie,"* my brothers and I would tell each other. Why Aunt Hoytie? It just seemed to fit her.

Another brother of my great-grandfather was John Sherman, a U.S. Senator for twenty-five years and the author of the Sherman Anti-Trust Act. He resigned from the Senate to serve in the cabinets of two Presidents, both fellow Ohioans: he was Secretary of the Treasury under Rutherford B. Hayes and Secretary of State under William McKinley. John Sherman's own bid for the presidential nomination, in 1888, was defeated at the Republican convention in Chicago.

Not so much is known about my mother's family on her father's side. Frank B. Wiborg was born in Cleveland in 1855, the son of Henry P. Wiborg, a Norwegian immigrant, and Susan Bestow. He was about twelve when his father, a deckhand, died of pneumonia after saving several lives in a riverboat accident. His mother remarried, but Frank Wiborg left home, unable to get along with his stepfather. He went to Cincinnati, where he peddled newspapers, though he managed to get a high school education. It was in Cincinnati that he teamed up with Lee A. Ault, a Canadian, who was employed by a lampblack manufacturing company. They founded the Ault & Wiborg Company, which was to become the largest manufacturer of printing ink in the world. In 1928, long after my grandfather had retired, Ault & Wiborg was merged with International Printing, Inc.

Patrick F. Murphy was born in Boston in 1858, the eldest of thirteen children. His grandmother, Honoria Roberts Murphy, had emigrated from Ireland in 1832. At seventeen, upon graduation from Boston Latin School, he joined the sales staff of the Mark Cross Company. By the time he had bought the company and had decided to move it to New York, he had married Anna Ryan, who also was born in 1858. She at first refused to make the move to New York. He went anyway, so she relented and joined him three weeks later.

Both my grandfathers, then, were self-made men. By the time they had brought their respective families to New York, at about the turn of the century, they had earned respectable positions in the business world. They had also made enough money to treat their children to the advantages of wealth—a private education, summers on Long Island, and other luxuries. For whatever differences of background there might have been, my parents' immediate upbringing was of a similar kind.

<p style="text-align:center">* * *</p>

The aura of mystery about the Murphys is explained to some extent by Gerald's tendency to tamper with the facts of his and Sara's life. There is the case in point of Calvin Tomkins writing in *Living Well Is the Best Revenge* that Honoria was "named for no one in either family," Murphy or Wiborg. The source of this information was Gerald, who must have known that she was named for an ancestor, her great-great-grandmother. He told Honoria the name had come from a romantic Irish novel. Why? It was, again, Gerald's way of doctoring reality, and perhaps he wanted to keep Honoria "confused." Gerald would have been the last person to pick the name of a child indiscriminately. He even wrote out a list of some seventy names to be considered for his children. They were not, by and large, of the everyday variety: Cormac, Aongus, Enda—science-fiction names, some of them. There is a Baoth on the list, and a Padraic, though no Patrick. No Honoria appears either, though there are two variations of it: Honor and Onora.

Why would Gerald have given his daughter such a lovely and unusual name and then let her find out for herself that it had been the name of a forebear, who had emigrated from Ireland? The answer seems to be that Gerald preferred not to accentuate his Irish heritage. There were other indications of this tendency: he changed his middle name from Cleary to Clery; and he chose hats and collars that he hoped would de-emphasize his "Irish moon face." It proba-

bly was another reason that he favored the company of people in East Hampton, who were largely Anglo-Saxon Protestant, while in Southampton, there was a heavy concentration of Irish-Catholic gentility. Gerald was reacting, no doubt, to anti-Irish discrimination, which still was prevalent around New York in the early 1900s. That he might have been victimized by it would also serve to explain, at least in part, why he was unalterably opposed to discrimination of any sort for the rest of his life.

If being Irish and being Catholic bothered Gerald, Sara was the one more disturbed by the difference of their ages, and this might account for a discrepancy with respect to the ages of Sara and her two sisters, Mary Hoyt and Olga. The entries in their mother's Bible, written by her with pen and ink, are clear: Sara, November 7, 1883; Mary Hoyt, January 28, 1887; and Olga, February 6, 1889. A *Sherman Genealogy,* published in 1920, however, lists Sara's birth date as November 7, 1886, Mary Hoyt's as January 28, 1888, and Olga's as February 6, 1890. For lack of other documentation, such as birth certificates, it must be speculated that a mother's entry in her Bible is sacred and more accurate than a genealogy. But for posterity, the genealogy version would prevail: the birth date on Sara's gravestone in the cemetery in East Hampton is November 7, 1886. Gerald, who designed both his and Sara's gravestones, would not have made a careless mistake. He took pains, as has been noted, to correct the date of birth on his stone from March 25 to March 26, 1888. He was willing to cooperate—in fact, it may have been his idea—in a three-year adjustment of Sara's age.

* * *

Grandfather Wiborg had moved his family east from Cincinnati, and while he had bought a house in New York City—at 40 Fifth Avenue—he and my grandmother and their three daughters spent most of their time over the years in East Hampton. My grandfather retired as an active executive of Ault & Wiborg in 1909, and he thereafter devoted his energies to his real estate interests and other activities in East Hampton. His principal property was an eighty-acre oceanfront tract on which Dunes, the Wiborg manor, and surrounding farm buildings were located. The Murphy family was also fashionably situated in both town and country: they had an apartment in Manhattan, at 120 East Sixty-fifth Street, and the estate in Southampton, which was called The Little Orchard.

For several years, with Gerald Murphy in school and Sara Wiborg travel-

ing, much of their communication was by mail. Gerald was still at Hotch-kiss when he received a postcard, dated May 18, 1907, from London. "Palatial domicile on opp side is where we expect to be for two months," Sara wrote. "Hoytie is in her element." The picture was of the Hyde Park, one of the many stylish hotels at which the Wiborg sisters stopped on yearly trips abroad with their mother.

* * *

There were those in East Hampton who considered Frank B. Wiborg high-handed and haughty. He was a member of the board of directors of the Maidstone Club when, in 1922, the clubhouse burned to the ground. A decision was made to rebuild the club on the dunes, beside the Wiborg estate on Egypt Lane. "The decision was not reached without a struggle," wrote Jeannette Edwards Rattray, an East Hampton historian, in 1941. "One of the older members says today, 'I would draw a curtain over that fight.' F. B. Wiborg voted *No* on the motion to build a dune clubhouse, and when he was over-ruled, he resigned as a director." He also planted a tall privet "spite hedge" between his property and the Maidstone Club.

On the other hand, according to his obituary in the *East Hampton Star*, Wiborg had been "an outstanding man in both village and summer colony life. . . . A member of the Maidstone Club, Devon Yacht Club, and East Hampton Riding Club, he played a prominent part in the social activities of East Hampton summer life." It was also noted in the obituary that Frank Wiborg, while he had died a man of great wealth, had not lost touch with working people. "He probably had more friends among the permanent residents of East Hampton than any other summer resident. . . . Edwin C. Halsey Post No. 700, American Legion, . . . regarded Mr. Wiborg as one of their most sincere friends. . . . Each summer Mr. Wiborg entertained the American Legion men at a garden party at his summer home on the dunes."

Following graduation from Hotchkiss in 1907, Gerald went to Phillips Academy in Andover, Massachusetts. The reason he gave was that his father, as a Bostonian, had hoped that the year at Andover would induce him to choose Harvard over Yale, although there was more to it. It appears that the extra year of prep school was a college-entrance requirement, and even after he had com-pleted it, admission to Yale, which remained Gerald's choice, was

not assured. In September 1908, when he was enrolled in Hargrove, a "cram" school in Fairfield, Connecticut, "Jerry" got a stern letter from "Sara W," who was in East Hampton. "This is a word of exhortation from a kind old aunt," she wrote. "I don't mean to nag you, but *do* work your hardest to get in this time, won't you. Your mother and Fred [Gerald's older brother had graduated from Yale in June 1908] have *absolute* faith that you will pass your exams, and if by chance you didn't, the disappointment would be too cruel. . . . So work all night and every Sunday, for heaven's sake, rather than miss out again." Sara's way of signing off was in the style of her lovely levity. "We have missed you greatly here, Fat Face," she wrote.

Gerald did enter Yale in the fall of 1908, and he ultimately did graduate with his class, 1912, although he continued to encounter academic difficulties. In the fall of 1909, Gerald's sophomore year, the dean notified his father that his performance was unsatisfactory. "No course will be accepted in which the mark for the year is below 200," the report read, and it listed Gerald's current standing: philosophy, 150; economics, 100; geology, 220; English, 215; rhetoric, 160. He was, therefore, flunking three courses and barely passing two others (the top grade was 400). "Come, brace up," wrote Patrick F. Murphy, who had never had the opportunity to go to college and whose own father was said to have been illiterate. "You can't afford to let this thing go *now*. It means *failure*. . . . This general warning is the last one I want to see. Affectionately, Papa." There were no more warnings. Gerald's grades improved, and his father was duly impressed: "I'm proud of you and your record," he wrote in February 1911, when Gerald was a junior.

* * *

On reflection years later, my father voiced disappointment with his experience at Yale. "Only in my senior year did I realize how dissatisfied I had been," he wrote in the 1950s, "and how little I had benefited from my courses. Success was the order of the day. . . . Sports were highly organized. The athlete was all-important. . . . There was a general tacit philistinism. . . . An interest in the arts was suspect." Consequently, in all the years of my memory, Dow-Dow avoided any contact with the university. There is an entry in a thirty-year history of his class, which reads, rather testily: "Gerald has proven adamant in refusing to supply any information for this book."

I do not believe my father was all that displeased with Yale while he was a student there or during the first few years following graduation. It appears, as a matter of fact, that he got a good bit of enjoyment out of his undergraduate years. He was the manager of the glee club and a member of the junior prom committee. In addition, he was elected to the DKE fraternity, and he was "tapped" for Skull and Bones, a secret society limited to fifteen members of each Yale graduating class. He was extremely pleased, I know, with the grandfather clock that was given to him and Mother as a wedding present by his fellow members of Skull and Bones.

* * *

Sara went with Gerald to the junior prom on January 17, 1911, and assuming that the names on her dance card are a reliable indication, their friends were from families of the socially elite: J. Biddle, A. Howe, R. Gardner, J. Spaulding, T. Townsend, R. Auchincloss, and A. Harriman (Averell Harriman, later ambassador to the Soviet Union and governor of New York), and, of course, G. Murphy. Gerald was a golfer in those days, and he played at the exclusive Piping Rock Club on the North Shore of Long Island as the guest of a college classmate. He also went to his Yale class reunion in June 1915, and then to an island owned by Skull and Bones in upper New York State, for a few days of camaraderie. It should be clear, therefore, that up to the time of his marriage to Sara, at least, Gerald was quite comfortable in the presence of his peers, even those of a society he would accuse of "pompousness," "leaden dullness," and "hopeless circumspection," as he did in his letter to Archibald MacLeish in January 1931.

The alienation occurred at some point between the Murphys' marriage in December 1915 and their departure for Europe in June 1921. Gerald's explanation of why is the best available—in fact, it is the only explanation, except for speculation by his friend Monty Woolley, that there had been a specific incident, involving Skull and Bones, which remained a well-kept secret. Gerald, in a letter written in 1962, ascribed the rift to his "strong disinclination to *belonging* or being identified with any group." He said he "was uncomfortable in any Association, Society, Company (even Mark Cross), Club (don't belong to one), or . . . 'Set.' It's not anti-social, but maybe *non-*social. . . . It's not as simple as being a loner, which I'm not." He believed this characteristic had been nurtured by Sara, who "is by instinct and nature independent and removed." He quoted a friend of Sara in early life, Diana Manners, who became Lady Diana

Cooper, the wife of the British statesman Alfred Duff Cooper. "I love Sara. She's a cat that goes her own way," Lady Diana had said.

Gerald, as he often tended to do, overstated the case, at least with respect to Yale. "Went to my first reunion," he wrote in 1962. "Nightmare!" He said he had never been back since, which was a slight inaccuracy. And he noted that his fiftieth was coming up in June with a single word: "Morbid!" He kept faith with his vow not to join a club, however, even the Maidstone—especially the Maidstone, in fact. In 1962 the Murphys were still spending summers on what remained of the Wiborg estate in East Hampton, three acres that adjoined the club property. They lived in what had been a garage and chauffeur's quarters, and they had a flagpole, which could be seen from the Maidstone Club next door. Gerald, of course, knew this, and he delighted in hoisting flags that might slightly annoy certain staid members of the club. He got particular pleasure out of flying the Soviet hammer and sickle.

In the summer of 1911, as Gerald's senior year at Yale was approaching, Patrick F. Murphy was beginning to regard him as a confidant. One reason was that relations between their father and Gerald's brother, Fred, had cooled. The elder Murphy confided in Gerald in a letter from the Mark Cross factory in Walsall, England, on August 18, 1911. "I am not disappointed in my work for Cross," he wrote. "What hurts is that Fred seems to value it so lightly." He had other troubles to share with Gerald, company troubles. "The dock strikes have left the question of export impossible," the elder Murphy wrote. "However, you know I can philosophize—no one should be unhappy unless he is a criminal." It must have been a disturbing philosophy for Gerald, who was plagued by the Black Service, as he called his periods of depression.

Patrick F. Murphy held strict attitudes about physical toughness, as well, and they indirectly caused his death at age seventy-three. Gerald explained in a letter in 1963 to John Dos Passos how his father had gone to Rochester, New York, in November 1931, to visit the photographic laboratories of George Eastman. "It was deep winter and bitterly cold," he wrote. "Father, who never wore underwear or overcoats and [wore] summerweight suits all year, went . . . from steaming laboratories to frigid rooms for storage of films. . . . He took the midnight sleeper, which was . . . suffocatingly hot and went to his office with a fever. Next day, pneumonia *et finis.*"

When he was approaching age seventy, in 1957, Gerald wrote to

his sister, Esther, of his feelings about their father, as well as their mother. "I begin to recall now what seemed to me Father's avoidance of close relationships, including family ones. It may explain my having so little living memory of him. . . . He was solitary and managed, though he had a wife and children, to lead a detached life. I was never sure what his philosophy was, except that I recall it to have been disillusioned, if not cynical. I am not sure what he stood for. . . . The fact that he was self-educated and self-made was certainly to his credit. I doubt if I could have managed . . . under the same circumstances." Gerald's description of his mother in 1957, twenty-five years after her death, was brutally frank: she was "devoted, possessive, ambitious, Calvinistic, superstitious, with a faulty sense of the truth. She was hypercritical and, as I recall it, [she] ultimately resigned from most of her friendships."

Esther K. Murphy was fated for an unhappy time of it in life, and Sara seemed to sense this, as she wrote Gerald in June 1915 of her concerns for his sister, who was ten years younger than Gerald. "Poor little Esther. . . . She seems so helpless to me, and rather pitifully alone." Tess, as her parents called Esther, was, however, the pride of the family—"a wonder," their father wrote Gerald in July 1909. "Never have I seen such a mind. Everyone who meets her stamps her as a genius. It has been remarkable: a continuous string of laurels." Gerald indicated in a letter to Sara in July 1913 that he shared the enthusiasm, having sent a poem Esther had written to several magazines. Although it was not published, he could report that several editors had "pronounced it 'mature genius,' etc. . . . The first line is conventional, but the second thought and the last one are quite remarkable. I feel each day that she will do something with her mind."

Monty Woolley, having met Esther at age fifteen at the senior Murphys' New York apartment, wrote to a friend that he had been "utterly demolished when she turned to me with a dissertation on the difference between Dostoevski and Turgenev." But Gerald, as Sara had, sensed that his sister would suffer the dissatisfaction of the failure to fulfill her potential. "Esther, I fear, is one of the most pathetic figures I know," Gerald wrote Sara in October 1915.

When Esther was in her twenties, living in Paris, she was regarded as *the* expert on Madame de Maintenon, the essayist and second wife of Louis XIV, and on Edith Wharton, the novelist. Wharton was one of the American expatriates in France and a friend of

Esther, who took Scott Fitzgerald to lunch one day at her farm outside Paris. Esther was horrified when Fitzgerald stopped for a drink at every café along the way, and then proceeded to turn the lunch into conversational mayhem. It was Esther's lifelong intention to write books about Madame de Maintenon and Edith Wharton, definitive works, for which she was eminently qualified, but not a word was ever published.

"Her real form of communication was monologue," wrote a eulogist, Simon Hodgson, in a lengthy piece in the *New Statesman* in February 1963, three months after Esther died. "She did look and sound peculiar, with her appalling French accent, her height, her mannish clothes, her authoritative face and utterance; but despite this, despite the rolling eye that often squinted painfully, despite the nicotine-stained fingers and her messiness, she had physical distinction. She held herself superbly. And she was formidable." There was, said Hodgson, "the solid weight of knowledge and reading behind each story."

Esther was first married to John Strachey, the British writer and socialist theoretician; they were later divorced but remained on good terms. Her second marriage, to Chester A. Arthur III, grandson of the twenty-first President, also ended in divorce, and not a very tidy one. She returned to Paris following the second world war and remained there, dabbling in literature and politics. "Esther resounded with the vitality of her generation and chosen friends," Hodgson, a regular contributor to the *New Statesman,* wrote. "Ardently, indeed professionally, a radical and a Democrat, she had an eighteenth-century scorn for humbug, and inherited from that age a willingness to go full-bloodedly after the aunt sallies that the present days of compromise and committees throw up so generously." Hodgson wrote in March 1963 to Gerald, who had commented gratefully on his piece in the *New Statesman,* to offer one last word of praise for Esther. "She remained quintessentially an *American* intellectual," he wrote.

Frederic T. Murphy, Gerald's brother, who was three years older, was decorated for gallantry just before the first world war ended in November 1918: he was awarded the Croix de Guerre and a divisional citation. He had been sent to France as a private, having been trained in the field artillery at Fort Myer, Virginia, and winning his field commission as a lieutenant within six months of enlistment.

Assigned as a liaison officer with French tank forces, he was cited for heroism for action in a battle that began September 26. He explained in a letter to his father what had occurred.

"I was given the job of reconnoitering a road running through a wood occupied by the Hun, which wood we hoped to take that morning. It was planned to convey two units of tanks over that road, if our barrage hadn't rendered it impassable or if the Hun hadn't planted tank mines thereon. I went over right after the infantry, found the road impassable, but succeeded in rehabilitating it with the aid of some engineers.

"The tanks got through and saved the infantry many casualties by destroying the machine gun nests. It was not a very hazardous undertaking, . . . though there were snipers and machine gunners in the wood. Every infantryman who went over the top that morning took more of a chance."

Fred's modest comments to his father reveal quite a bit about his nature, as does the story he told about an officers' mess orderly, who "insisted on accompanying me, and all along that road he persisted in placing himself between me and the Hun snipers. I finally had to order him to take the other side. He said he was my self-appointed 'bodyguard,' a frail lad who already had been twice wounded. . . . One day the Hun dropped five big shells right around our kitchen, but this lad continued serving us our luncheon as if he were a waiter on Fifth Avenue. Makes one think . . . whether all these notions about caste, family, etc., are going to be allowed to exist after the war. Even the aristocracy of wealth—I wonder what will happen to it."

*　　　*　　　*

My father and Fred had great respect for one another, but there was a distance between them. It was not a relaxed kinship, so I find it unlikely that they would have had a frank discussion about a subject as controversial as class distinctions. Dow-Dow detested snobbery, though, and he certainly would have concurred in questioning a caste system. From the way he and Mother were living in the 1920s, however, I am afraid Fred may have had them in mind when he talked of the "aristocracy of wealth."

Fred Murphy had a history of serious illness. In 1913, he had mastoiditis, an ear disease, which in my brother Baoth's case years later developed into spinal meningitis and death. Fred came close to dying, according to my father. He had two operations and suffered terribly. Two years later, after

an examination at the Mayo Clinic in Minnesota, Fred learned he had ulcers, and surgery was eventually required. It is remarkable enough that he was able to pass the Army physical exam, much less go into combat.

My father was in the Army, too. After training in Texas and Ohio, he became a lieutenant in a signal corps aviation section, though he did not go overseas. "I had a letter from Fred this morning," my mother wrote my father in February 1918. "He has heard nothing of the baby [Honoria] yet, or that he is godfather."

Fred worked for Mark Cross in London following the war, and in 1920 he married Noel Haskins, who was thirteen years younger than he and who had long been a friend of Esther. "Esther would read his war letters to me," Noel told me, to explain how she had got to know Fred. He did not stay with Mark Cross, and feelings between Fred and his father were never repaired, as the disagreement about the future of the company was never settled. "Maybe his father fired him," Noel said. "I paid no attention." She was eighty-four at the time we talked about this, living, as she had most of her life, in Orgeval, just outside Paris. She struck me as being quite bitter about my grandfather.

"When Fred was quite ill," she explained further, "his father wrote to him and said he was thinking of selling the Mark Cross Company, and he asked Fred to send back the shares of stock he had given him. Fred sent him all the shares, and then Fred died, so I didn't get a penny. Mr. Murphy gave me $500 a month for six months, and then he told me, 'I'm sorry, Noel, but I cannot pay you any more.' It was just like discharging a servant."

My aunt and uncle were living in Paris when we got there in 1921. I vaguely recall visiting the hospital where Fred lay ill in 1924. It was the old stomach trouble, which had been aggravated in the war. He died in May 1924 of a perforated intestine. As in the case of my brothers, he could have been saved by antibiotics. In October 1923, about six months before he died, Fred was accorded one final honor by the French, and Dow-Dow cabled their father: "Fred here made *Chevalier de la Légion d'Honneur* today. Love."

* * *

In addition to the cutoff of funds, a source of Noel Murphy's bitterness was "the misunderstanding" between Fred and his father, as she explained it in a letter to Fred's mother in February 1924. "I'll tell you exactly about Fred," she wrote. "He *seemed* better. . . . He kept his nerve up and went around very much as usual. But I was

worried, as I saw him continually losing weight and slowly more and more nervous and sleepless. He would awake in the night quite off his head. . . . This delirium would last sometimes an hour. In those periods, the trouble with his father seemed dominant. In Fred's weak condition, it was a blow to his pride and self-respect that he could not surmount. . . . [H]is thoughts grew more and more bitter. . . . It goes in a vicious circle—the pain brings the *délire* and vice versa. . . . The doctors . . . all agree that, overlooking the fact of who is to blame, . . . the mental unrest (caused by *the misunder-standing*) and the pains go hand in hand. . . . I don't care who is right —I only want Fred to get well."

Following Fred's death, Noel got to know Ernest Hemingway, though she claims she was "dumb, innocent, and Victorian." She had, nonetheless, inspired a minor character named Edna in *The Sun Also Rises*, and Hemingway kept in touch over the years. "I liked him," she told Honoria, "but he could be just impossible." Noel remained in France during the German occupation, and Hemingway called her after Paris had been liberated in 1944. He was there as a correspondent, and he had a room at the Ritz. "I bicycled into Paris," Noel recalled, "and he invited me to his room. There was a nightgown on the chair, and I asked whose it was. 'It's the kraut's,' he said. He was referring to Marlene Dietrich, and I told him it was indecent. 'Well, I can't sleep alone,' he said. He was a very sweet man, really, but you had to get beneath his false manliness. It had bothered him terribly when Zelda Fitzgerald said to him, 'Ernest, nobody is all that male.' Zelda just nailed it all down."

Noel is very frank, which was most apparent when she turned to the subject of Hoytie Wiborg. "Hoytie was so beautiful," she said, "and her father adored her. She was great fun to be with, if you weren't related to her, but she was terribly spoiled and always got her way. . . . She drank, drank, drank. 'Is she a virgin or not?' someone would ask. And someone else would answer, 'She can't be a virgin, because she passes out in taxis.' Hoytie always wanted to be invited to Bill Bullitt's, when he was the ambassador to France. Bullitt once gave a dinner party to which Hoytie was not invited, but she went anyway. It caused quite a scandal."

Mary Hoyt's service as a nurse in World War I was the subject of a newspaper report in New York in June 1918. It told how she

and another nurse, in a little town on the Marne River, had turned a convent into a temporary hospital and had cared for 600 wounded soldiers until a team of doctors arrived. "These women, used in civil life to gentler things, pointed here to one soldier, saying that he was about to die, to another saying that he would get well, and so on, always with a word of cheer for those who could hear and understand. Neither had had more than three hours' sleep in forty-eight hours." For her wartime service, Hoytie was awarded the French Legion of Honor.

Hoytie never married, though she had several suitors. "I ain't been married, but I ain't been neglected," she once said. One of her early beaux, she claimed, was Gerald Murphy, before he fell in love with Sara. There was much speculation as to why a woman as beautiful as Hoytie remained a maiden lady. She set her sights too high, some said, and others offered the thought that there was no place for a husband in her dashing life. The consensus was, however, that her arrogant airs turned prospective suitors away: in a word, she was impossible to get along with. There is, for what it is worth, one other factor that bore on Hoytie's spinsterhood, a psychological factor: she revered her father. This can be easily seen in her letters to him.

She had been at sea a week in March 1918, en route to France in waters menaced by German U-boats, when she wrote, "Dearest Father . . . I am so afraid that you had a terribly dreary time and did not want you to stay to see the boat sail, as I thought it would be too distressing for you. I was terribly low for two days, . . . it has been so dreadfully lonely, especially at night when the decks are so dark. . . . Don't think I wanted to leave, it was terribly hard for me, but I do think seriously I can be of real service over here." She wrote again, from Paris, on March 11, saying she was afraid he had been worried about the air raids. If she had intended to be reassuring, she failed. "The third night I was here was our first good one," she wrote. "We could not resist going out to watch it from the Place Vendôme. It was terrible to see the fighting in the sky, but not at all frightening. We ducked to cover when we saw the streaks of red spiralling down. . . . They were like millions of fire flies."

Hoytie tried in later life, without success, to write professionally. It was not for lack of latent talent, however, as her letters to her family about the war demonstrate. Hemingway, who knew Hoytie in Paris in the 1920s but who was not fond of her and

probably never read a word she wrote, would have admired her descriptive ability and her sense of dramatic detail, not to mention her courage.

On May 22, 1918, Hoytie wrote Sara Sherman, her cousin. "What a life I have been leading! This last fortnight caps the climax in excitement, as I have been working up on a front-line hospital. . . . The Germans are only ten kilometres away, and we hear the cannons day and night and have been bombed by Boche *avions* for ten nights running. Last night was a terrific affair, with 40 incendiary bombs dropped all around us. . . . It was a bright moonlight night and a wonderful sight, . . . the star shells and shrapnel bursting in the sky. . . . Then, crash-bang, a bomb would drop. . . . This raid lasted two hours. We hardly had got settled in our beds. We sleep in stone-floored barracks, eight in a room, no running water, sheets as partitions. . . . Suddenly, one of the cannons from the front got our range. . . . Bang, the shriek of shells, then crash as they landed, the whole barracks shaking. This lasted one hour. . . . I lay in my bed, calling out to the others, wondering what moment would be our last and who would pick up the pieces to send to Father. A dog began to howl out in an open field, which I thought a terrible omen."

On June 4, Hoytie wrote to her father, Sara, and Olga from the front. "The attack swept down on us from Rheims to Dorman twenty kilometres away, . . . Château-Thierry cutting us off from Paris on the other side. . . . Three American divisions are near and, with the French and English, have driven the Germans back across the Marne. The guns are bombing night and day, and the wounded simply pouring in by the hundreds. We have been turned into an evacuation . . . hospital, . . . those dying left on our hands, the others carted away in ambulances within 24 hours. They have died like flies—English, French, and now Americans."

Hoytie was in Paris for a Bastille Day celebration in which "our troops and the Stars and Stripes were given the place of honor among all the allies." She was not away from the front for long, however, as she told her father in a letter from Montmirail Marne on July 21. "The day following [Bastille Day], early Monday the 15th, the third German offensive since I have been over here began. I did not get word in time to catch the train but got back here by a Red Cross motor Tuesday. . . . Different towns we came through were being shelled, and poor old Montmirail was getting a German

300 every five minutes. . . . The wounded poured in. . . . In this little hospital and another connected with it, we had 2,000 men pass through in . . . six days. . . . They are brought in from the front lines, we dress their wounds, . . . wash them, and give them anti-tetanus, morphine, or stimulants, and they are shipped straight out again. . . . It's all a nightmare and has been going on like this all week. But it is simply extraordinary what you can stand and what you can forget. A little American from Scranton, Pennsylvania, was brought in on a stretcher. So cheerful and talkative, knowing how glad his mother would be that he had got through the fight safely. He had his leg crushed and went to the operating room for amputation. I sat with him all night before he went in and after he came out of ether, gave him stimulants and kept him going. At four thirty in the morning, I came down thinking he was all right and went to sleep on a mattress for two hours, leaving him in the doctor's charge. . . . When I went back again, his bed was empty. He had died of shock and had been already sent away for burial. I simply broke down."

<div align="center">* * *</div>

My parents' letters, beginning in 1913, indicate they were both becoming increasingly unhappy over extended periods of separation. "Wasn't it gloomy the night we sailed," Sara wrote Gerald from aboard the *Mauretania* on March 9, 1913. "I shall see your saddened face to my dying day."

On July 29, 1913, Gerald wrote to Sara, who was in Scotland. "You asked if there are still those in the land who have your name on their lips." He was obviously annoyed, but he had not lost his sense of humor. "No day passes but that I am stopped on the street by some friend of the Wiborg family, who demands news. For a month or so, I made bold on such occasions to appear very intelligent about your plans and answer with emphasis and assurance that you would return early in August. Those days are over. People no longer regard me as an authority but pass me with an air of superiority and suspicion, for they have heard from 'someone who saw the Wiborgs in London' that you are returning just in time to catch the December steamer for India. All your friends have developed a keen, resentful interest in your delayed return. . . . I indulge in long effusions on your various wonderful experiences in London. They smile forcedly and remark: 'Yes, but I should think they'd hate to leave that beautiful place in East Hampton. Think of all the string beans going to waste.' "

<div align="center">* * *</div>

Gerald had spent the Fourth of July in East Hampton with Sara's father. "I have never seen the place more beautiful," he wrote of Dunes to Sara. "The weather was gorgeous—clear, wine-like sun, the glaring beach, and the surf growling and whitening for miles along it. The trees have decided to live till a later day, and the lawn and hedges have overgrown all the gaps of which we were conscious last summer. All is green, green. The garden looks as if it had been there for a hundred and one years, and it is calling so prettily for you. . . . I have never seen so many healthy roses together. . . . But we must leave the garden. I visited the horses, . . . who were forming the loveliest groups in the pasture, where they have been running barefoot all spring. The vegetable garden and barn blend into what looks like a corner of a Kentucky estate."

<div align="center">* * *</div>

Sara was off again in December 1913, sailing for England on her way to India. "I do wish you could have come," she wrote Gerald on December 27 from an English country village. "We had a wild two days in London and didn't come here till Thursday A.M., as we wanted to have Xmas Eve with Father and Mother. They were asked too but couldn't come. Mother didn't feel up to it. . . . We leave here Monday A.M., and London Wednesday A.M. New Year in Paris, night train to Marseilles, and sail Friday A.M., 10 o'clock. We all are *much* more excited about India than ever before."

"My dear Jerry Berry," Sara wrote from Rome on March 20, 1914, on the return trip from India. She was angry. "What do you mean," she demanded, "by never writing . . . ? I shouldn't mind so much if I thought it was sheer neglect, but what we *fear* is that it's some theory being worked out. What have you all been doing, and what were your costumes like at the costume balls? Having been to the ends of the earth, we'd like some news."

Sara's ire subsided, as she proceeded to describe her trip. "India, of course, was the *wildest* success. . . . We are going back, year after next. You must come with us then. It is the one place I've *ever* been, which is more picturesque than I had expected." The war in Europe interfered with her plans, however, and my mother's next trip abroad was in 1921, with my father, my brothers, and me.

<div align="center">* * *</div>

Gerald wrote Sara in London on June 10, 1914—her return had been delayed until early August. "I hesitate to tell you how beautiful it is at East Hampton. Your father and I spent last weekend there.

Surely, the place has a spell. . . . It is all waiting, expectantly, for your arrival. I have decided that it is the most satisfactory spot in the world. . . . We went . . . on an expedition to Montauk Light. On Sunday, we started at eight, your father, and James and I, with saddle packs, water, etc., and there began . . . one of the greatest experiences I have ever had. Why go to the Canadian woods? Within two hours, we were riding thro' . . . rolling downs, thro' pigmy forests, with the sea sixty feet below booming on an infinity of beach! My brain reeled under it all—hill beyond hill of green, surrounded by sea. . . . We visited the lighthouse, . . . a feeble attempt of man to cope with the sea and its dangers. On our return journey, we stopped at the inn, . . . where we ate as if there was no God. Your father, at this juncture, was carried from his western saddle, returning home by train. He had ridden bravely thirty-six miles, not having done so for years, and enjoyed it immensely. We had such fun, and laughed like freebooters all the way. Surely, I am meant for that, instead of padded chairs. James and I reached home at seven o'clock, having been in the saddle ten hours. . . . It left me exhilarated.''

In the same letter, Gerald wrote a poetic lament to Sara's absence. ''In the garden, the pansies come first to greet her, but fade one by one, whimpering, 'She will not come.' She thinks tonight only of the flowers of cloth she wears, and we who would fain live on water in her presence but a while must die. Throughout the house, the clocks await in idle silence the better hour of her arrival. On the hearth, the dog dreams of her return, awakes, hears no sound, and sighs, 'She will not come.' The waves of the sea rush up on the beach at her imagined approach, but return inevitably to their waters, hissing, 'She will not come.' The balcony stands lonely in the corner, blind with boards upon whose dust the wind has traced the words: 'She will not come.' ''

Sara expressed her love for Gerald just as warmly, if not so poetically. ''The spirit is lacking without you,'' she wrote, while riding on a train to East Hampton in August 1914. ''I never dreamed I'd find someone whom the same things and words delight. We *say* this so often, but I am always *feeling* it afresh. . . . We will always be able to get the most ecstatic joy out of the simplest . . . things—the earth and all the elements are our friends. . . . You are in my inmost heart

and mind and soul—where I never thought I'd let anyone go. You don't quite know it yet, but you are. And to say I love you seems a small, ridiculously faint idea to give of the truth. We *are* each other."

Gerald did not quite know it yet: his insecurity was augmented by a suspicion—probably well founded, in view of the attitude of Sara's redoubtable mother—that an alienation would be the result of his intention to be Sara's husband, rather than the family friend he had been for so long. On January 2, 1915, he stated his concern bluntly to Sara. "I find myself more surprised than anything else," he wrote, "at your refusal to admit of the gradual but probably inevitable dissolution of a friendship, . . . which has existed between the Wiborgs and Gerald." On January 4, he was in a state of utter despair. "Understand me, Sal," he wrote, "my friendship with you people is probably one of the few *real* things that I've known. . . . You mustn't think that, like Hamlet, 'I unpack my heart with words,' for I seem to see quite clearly, and I feel for the first time in years a bitter, enforced freedom. Isn't the truth rough-handed? What a price we must pay for not facing it."

Gerald was emotionally revived, however, on January 19, 1915. "Salamander mine," he wrote. (Like Sara's "Jerry Berry" for him, the nicknames were abandoned not long after they married.) "Last night I found myself much detached in that gathering of cackling human geese, but it doesn't irk me now. I felt rather that I had something no one else in that crowded room had. I'm afraid I felt rather elevated. . . . Just wait till the clouds roll by, Sally. Soon I shall come to your ear with a pleasant tale."

February 11, 1915, was a fateful day—it was the day that Sara and Gerald were secretly betrothed. That evening, Sara went with her mother and sisters to Montreal for a week's jaunt, so Gerald, in his letters—he wrote her three that day—could speak at once of love and of longing. His display of agony would sound callow, even unseemly, at a distance, but perhaps it was permissible, given the occasion. "Somehow I feel today," he wrote at eleven in the morning, "what those have suffered who would rather die together than live apart. What a gloomy letter—and yet not so, for it is but one expression . . . of the truth I am surest of in life: that I could never give you up, and that I need you as much as I do the air I breathe."

Sara and Gerald had lunch together in New York that day, and he wrote again at three in the afternoon. "I have been with you for the last two hours—I dare not think how I am to miss you. . . . I am feeling too much just now to write more."

Gerald went on an outing of his own—to St. Andrew's, a golf club in Westchester County. Sara had sent him a gift, which he opened when he got there: it was a seal, made of lavender amethyst and set in flower-decorated gold, with the figure of a turtle engraved on it. Gerald wrote her at eleven that evening. "I have not known until this hour why I came here. It was to suffer as I have for these past hours, to suffer as I never knew a human being could. . . . Alone in my room an hour ago, I opened your letter. When I saw what it contained—the seal, which you had given me—I put it to my lips, as I would have put my lips to yours. Since then, my heart has bled, my body has been racked with pain, my face flooded with tears."

Ten days later, Gerald was at a mountain-lake resort in upper New York State. "The novelty of this place is almost gone," he wrote Sara, who had returned to New York City. "My day is spent in hatching plots to get off by myself. Yesterday we snow-shoed six-and-a-half miles for luncheon. The other eleven people drove back, but I plunged into the face of the setting sun alone, much to their amazement. For the first three miles, I walked down the center of a long lake about a mile wide; it was wild, and the feeling that the pines were the 'first growth' and had been there since the beginning of time affected me strangely. And I felt your presence. Somewhat a current of eternity . . . runs thro' our relation. . . . In the woods, later on, I was startled by seeing suddenly in a ravine fifty feet below me a fat young doe, with the most beautiful slate-blue coat and white fan tail. She was frozen with terror. I hurtled down upon her and kept pretty well abreast, as the snow was two-feet deep, and I was on shoes. Finally, she tried to cross a stream, and went through the ice. As I came up to her, she turned two melting brown eyes upon me. . . . I went back. She soon struggled out, and, as I went off, she stood there watching me. . . . I am sure she was crying."

Sara and Gerald were together again in New York City by the end of February, but Gerald wrote every day just the same. On the 26th, the subject was one that had become familiar: the need to escape the

family clutches. "How nice that we feel so definitely that we should live in a different place and manner from our . . . families! You do realize, I hope, what an adventure life will be—we've both lived too padded and policed an existence."

Sara was accustomed to having dogs around the house, and she had wondered if Gerald would approve. "I look forward so to having dogs," he wrote. "As a child I was badgered by people who hated dogs (especially the old nurse who so disliked me), and many a night, when I had run the blockade and was asleep with Pitz (a sensitive wire-haired fox terrier), he would be seized, taken downstairs, and locked in the cellar. One winter they made him stay in the yard all day and night thro' blizzards. I built him a house with a soapbox, and often I'd throw out towels and comforters to him. He'd drag them into his house and try to keep warm. He grew wilder each day, and in the spring one time I tried to pick up a dry bone for him to chase. He flew at me, and they sent him away the next day. I've been afraid to become attached to a dog since."

"Tomorrow morning," Gerald wrote on March 5, 1915, a Friday, "I shall 'ply my suit with your respected male parent' (isn't it put thus in Jane Austen?) and 'pray God he will look upon me with favour.' " His lighthearted tone was deceptive, however, for Gerald expected opposition from Sara's family—not from her father, who assented in the meeting the next day, but he expected her mother would be furious. "Remember," he said firmly to Sara in the March 5 letter, "that the realization by the unsympathetic of the fact that our marriage is irrevocable and inevitable will call forth much at first, . . . just as one fights in double desperation against obviously overwhelming opposition." Sara was frightened of her mother, unusually so for a woman of thirty-one. As she explained years later to Honoria, she stood at a bathroom door when her mother was in the tub and blurted, "I'm marrying Gerald." She then closed the door and ran off.

"I am the happiest man in the world today," Gerald wrote Sara on March 6. "I shall pray tonight—for one of the few times in my life—that the God who made me may help me be worthy enough."

There was no official announcement of the engagement, probably because Adeline Sherman Wiborg was stonewalling, in the hope that there would be no marriage, which in fact was postponed at

At Antibes, summer 1924: Baoth, paddling; Honoria; Patrick; and two of their pets.

*"The golden bowl is broken . . .
but it was golden . . ."*
Scott Fitzgerald to Sara and Gerald
January 31, 1937

• A gathering of the Sherman clan at the home of Major Hoyt Sherman, Des Moines, Iowa, late 1870s: John Sherman, who resigned his seat in the U.S. Senate in 1877 to become Secretary of the Treasury, is to the left of the pillar; William Tecumseh Sherman, the renowned Army general, is the second man to the right of the pillar; Hoyt Sherman, Sara's grandfather, is to the right of him; and her mother, Adeline Sherman, is seated on the second step down.

The Shermans hailed originally from Ohio, and when Adeline Sherman married Frank B. Wiborg, they settled in Cincinnati, where Wiborg was one of the founders of Ault & Wiborg, manufacturer of printing ink.

In 1909, at age fifty-four, Wiborg, a multi-millionaire, retired and moved his family to New York.

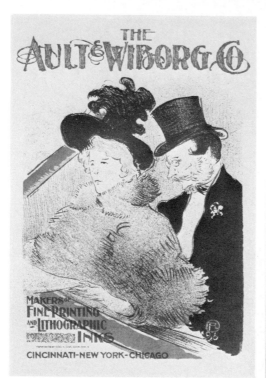

Ault & Wiborg poster by Toulouse-Lautrec.

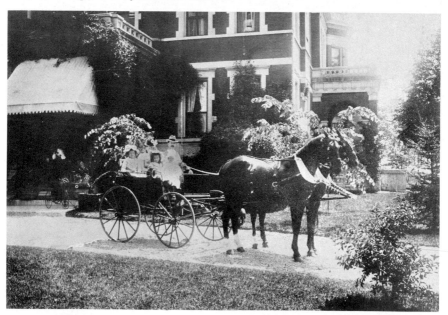

Frank Wiborg and daughters leave for a ride from their suburban Cincinnati mansion.

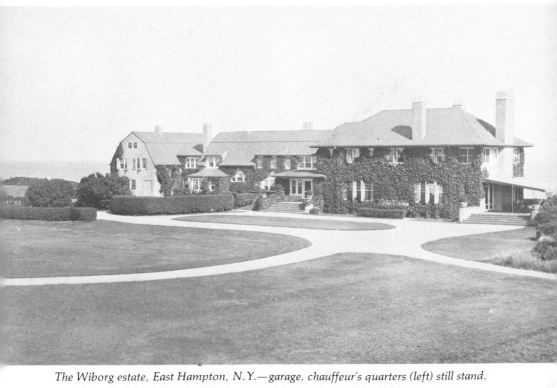

The Wiborg estate, East Hampton, N.Y.—garage, chauffeur's quarters (left) still stand.

Main room of the East Hampton "cottage," often the scene of weddings and parties.

India, 1914: Hoytie and Sara on one elephant, Olga and their parents on the other.

Hoytie, Sara, Olga with their father, 1890s.

• Growing up rich and beautiful was a privilege of the Wiborg girls. When they went abroad, as they did annually until the outbreak of World War I, they were widely admired and welcomed by royalty. Only Hoytie was all that impressed, however, at being presented at the Court of St. James, as they were in 1914.

• In 1963, Sara and Gerald were visiting Honoria's house near Washington when a young man asked about a portrait of Sara as a young woman. "Who's *that* morsel?" was the way he put it. Sara, who was eighty, was visibly flattered.

Sara at nineteen, a year before she met Gerald; the image of lovely young womanhood.

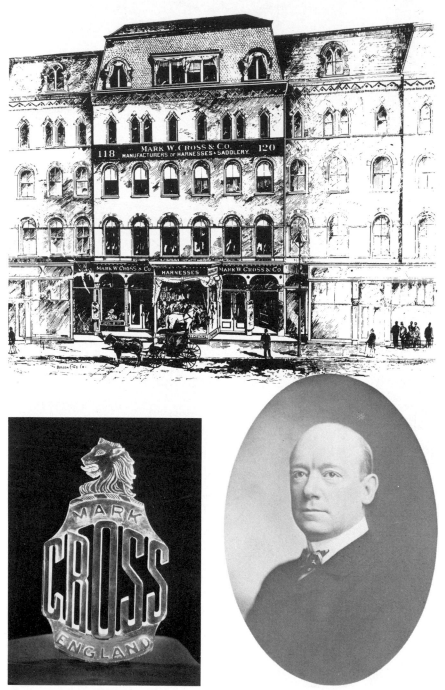

Lucite company emblem was Gerald's idea. *P. F. Murphy at the peak of his success.*

• Shortly after he purchased the company, P. F. Murphy changed its name from Mark W. Cross & Co. to Mark Cross, and he moved it, in 1892, from Boston to New York. For forty years, he ran it as a family business, and his refusal to expand caused a falling-out with his older son, Frederic.

Gerald worked for Mark Cross from the time of his graduation from Yale until he joined the Army in 1918, but he did not return after the war ended, setting his sights on Europe instead. After his father died, however, he was forced to return, and he served as president until his retirement twenty years later.

Fred, three years older, and Gerald.

Gerald in Yale portrait and in costume.

At her wedding, Sara was attended by her sisters, Hoytie (left) and Olga.

The newlyweds clowning at Coney Island. Right, Baoth won the Easter-egg hunt when F. B. Wiborg and P. F. Murphy visited Saint-Cloud in 1924. Vladimir Orloff is at far right.

• Soon after their marriage in 1915, Sara and Gerald began planning their "escape" to Europe. "...we have seen the shore ahead and will reach it," Gerald wrote Sara in 1919, "if there be no loss of command."

Uppermost in their minds, as they decided to become "foreign residents" of France, was pursuit of artistic fulfillment. But there was for both Sara and Gerald another reason: to be free of the influence of overbearing families. It was not, however, an estrangement, as indicated by the Easter celebration (below) with both grandfathers.

Honoria, three, at Croyde Bay in England.

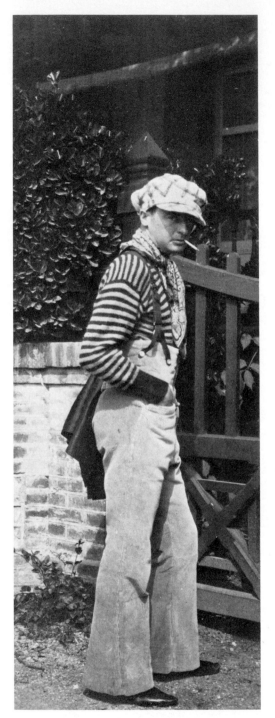

23 quai des Grands-Augustins.

• Remarkably, Gerald's career as a painter began the minute he arrived in Paris, and his work would be recognized fifty years later as "contemporary." He also conceived a ballet, *Within the Quota,* and he got his friend Cole Porter to do the score. It was produced in Paris in October 1923—set design and the costumes (below and right) by Gerald, assisted by Sara.

Gerald as an **apache**—*he relished role-playing.*

A view of the Seine from the window of the Murphys' top-floor apartment on the quai.

Backdrop for Within the Quota *was a parody of sensational journalism in America.*

Engine Room, *exhibited at the Salon des Indépendants, 1923—whereabouts unknown.*

• *Boatdeck,* 1923, also lost. "When Murphy brought the painting to the Grand Palais for installation," wrote William Rubin of the New York Museum of Modern Art, "its large size [18 by 12 feet] . . . caused considerable controversy. . . . 'If they think my picture is too big, I think the other pictures are too small,' [Murphy] dryly told the press."

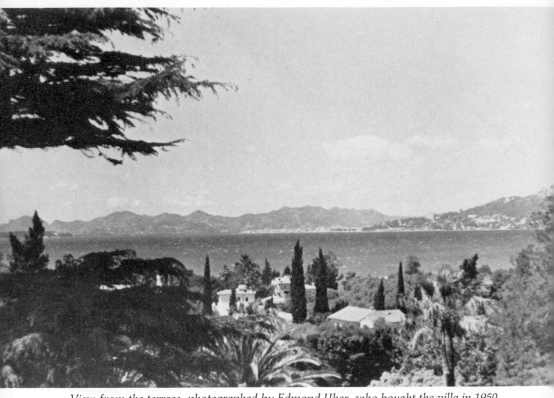

View from the terrace, photographed by Edmond Uher, who bought the villa in 1950.

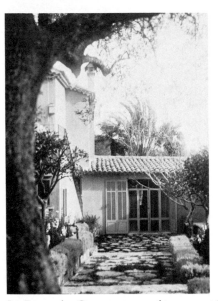

La Ferme des Orangers, one of two guest houses lent to friends.

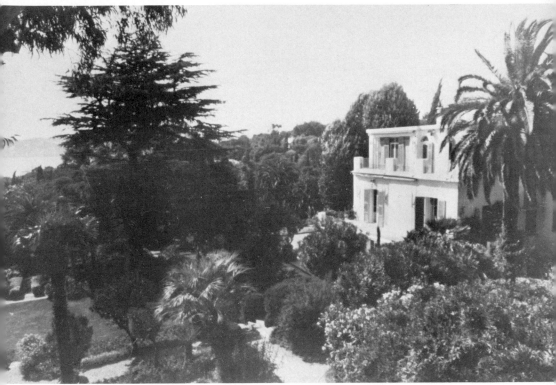

The villa proper, a stately stuccoed stone adaptation of Morrocan-style architecture.

• When the time came to sell the Villa America, Gerald—with his eye for detail—described the surrounding property. "...a terraced garden ...is made up of the finest examples of Mediterranean planting. ... These include pure white Arabian maples, desert holly, persimmon trees, many varieties of mimosa, eucalyptus, palms, genuine cedar of Lebanon, etc." There were also a "terraced vegetable garden" and a "fruit orchard of orange, lemon, and tangerine trees, ... olive trees, apricots, and nut trees."

Judy always found the dining room sun.

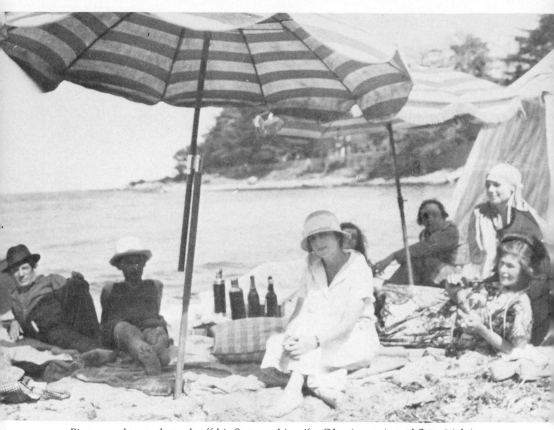

Picasso, who rarely took off his Stetson; his wife, Olga (center); and Sara (right).

Baoth, Patrick, and Honoria in their yellow Renault with "Mamzelle" Henriette Géron.

• Every day was a holiday during those summers at Antibes, and the daily ritual would begin with Gerald announcing: "All right, children, we're going to the beach."

For Honoria and her brothers, going to La Garoupe meant swimming, sunbathing naked, being rubbed with coco cream and bundled in towels by their nurse. For Sara and Gerald, it was lounging under big umbrellas, dry sherry and biscuits, and the pleasure of illustrious company, such as Rudolph Valentino, who came in 1925 (photo at right).

Dottie Parker and Bob Benchley, regulars on the Riviera, with Honoria and Gerald.

• "My father often said," Honoria writes, "that he was his happiest as a painter." However, only six of Gerald's fourteen or more works were recovered, for he had lost interest in what he had accomplished.

Gerald did his best work—understandably—in the latter part of his brief career, when he was able to work in the quiet surroundings of his studio at the Villa America. His masterpiece, *Wasp and Pear* (below), is dated 1929, the year he decided he would never paint again.

Razor, *first exhibited in 1925, won the praise of Gerald's friend Picasso.*

Wasp and Pear, *donated by Archibald MacLeish to the Museum of Modern Art.*

Watch, 1925, marked Murphy as a "precisionist," in the expert view of William Rubin.

Murphy exhibition, Dallas Museum of Fine Arts, 1974—Bibliothèque and Watch.

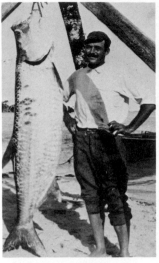

Ernest Hemingway

John Dos Passos

Katy Dos Passos

Archibald MacLeish at his Uphill Farm, Conway, Mass.

• Friends, Honoria recalls, were the "vital sustenance" of her parents' existence. Yet, when faced, in 1959, with the prospect of an article about their having been at the center of the expatriate artistic colony in France, Sara demurred. "...we ourselves did nothing notable except enjoy ourselves," she wrote John Dos Passos with characteristic modesty. "And now, at this late date, it would seem like loathsome name-dropping."

She was wrong and knew it. The bonds were genuine, most having been secured before the friends became famous.

Alexander Woollcott

Sara Murphy, Fernand Léger, Ada MacLeish

Mrs. Patrick Campbell

Ellen and Philip Barry (above), the Fitzgeralds (below).

Monty Woolley

Robert Benchley and Marc Connelly share a match.

En route to California on "The Chief." *Baoth and Patrick in Beverly Hills.*

• "I have put off talking about the Murphys," Dorothy Parker said in a letter from Montana-Vermala, Switzerland, to Robert Benchley. She told how Gerald (left) was obsessed with curing Patrick (above) of his TB. "Ah, why in hell did this have to happen to them?"

The Murphys had come, in October 1929, to the Palace Hotel, their own "magic mountain," as such a sanitorium was called in Thomas Mann's celebrated novel, published two years earlier. It was the beginning of a long and losing battle.

It was snowing in May 1930, when the Murphys moved to their chalet, La Bruyère.

nt Mame, Baoth, Sara, at the bar the Murphys remodeled and named "Harry's."

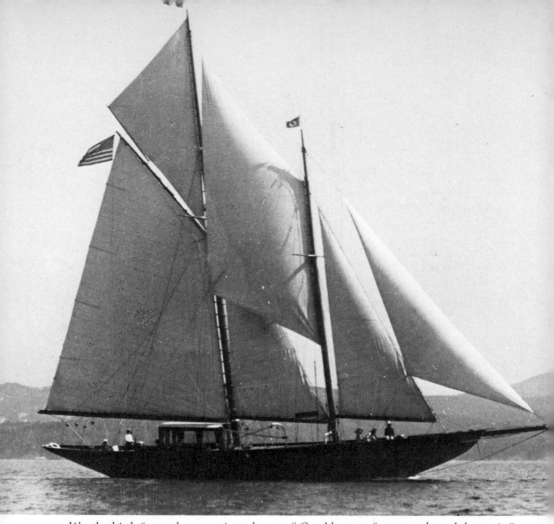

Weatherbird, *"a regular sea-going schooner,"* Gerald wrote, *"very steady and domestic."*

Cruising in 1934: Vladimir and Patrick. . .

And Sara, resting on deck.

• The decision to build the *Weatherbird* was made in 1930 by Sara, who helped supervise her design—"nice and deep with head-room below," as Gerald described the schooner in a letter to Archie MacLeish. She was named for a Louis Armstrong jazz tune, a record of which was sealed in her keel.

After Baoth and Patrick died, Sara refused to go to Antibes, but she did go on summer cruises on the *Weatherbird*. Her last one—with Honoria and two friends—ended in mid-August 1939, a matter of days before Britain and France declared war on Nazi Germany.

Phil Barry, owner Gerald, and Dick Myers.

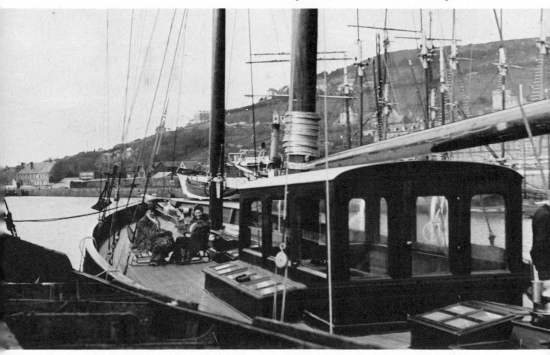

Sara and Gerald went to Fécamp, Normandy, for commissioning of the **Weatherbird.**

September 1932: Sara and Gerald with Hemingway at the L Bar T Ranch in Montana.

Baoth: always robust and full of cheer.

• "You will not have lucky journey," the telegram from Hoytie read, "for what you have done in breaking father's plans for us. All his reproaches will be with you." It was June 1934, and the Murphys were sailing for Europe.

If not a curse, Hoytie's words were surely prophetic. In September 1934, Patrick, who had been recovering from TB, had a relapse. While he lingered until early 1937, Baoth died suddenly of spinal meningitis in March 1935.

To Gerald, as he wrote Scott Fitzgerald in December 1935, it was an attack on "our only vulnerable spot—the children. How ugly and blasting it can be."

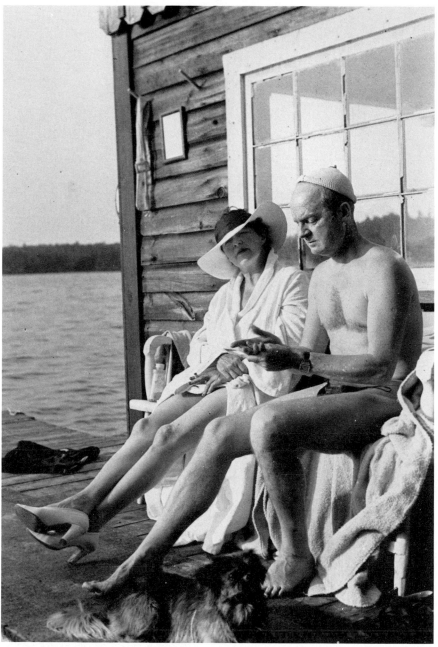

Sara and Gerald at Camp Adeline, Saranac Lake, N. Y., 1936: Patrick's last summer.

Fanny Myers Brennan, a best friend.

Alice Lee Myers, with Gerald.

• Fine houses were the pride of the Murphys' later life—from Swan Cove (above), a renovated farmhouse on the Wiborg property in East Hampton, to Cheer Hall (bottom right), a Revolutionary relic in Snedens Landing, New York. These residences and the apartments in Manhattan gave the misleading appearance of great wealth.

Sara in East Hampton, 1940s.

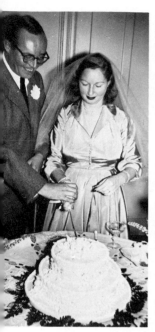
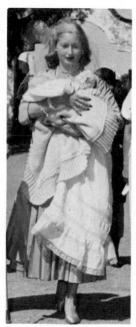
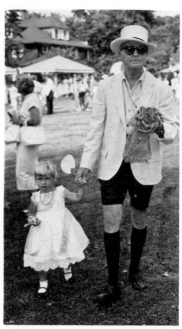

The Donnelly wedding; John's christening; Gerald with Laura at the East Hampton fair.

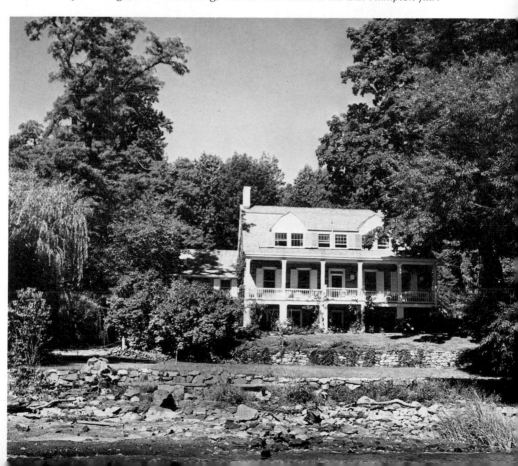

● "But I can see another generation growing up around Honoria and an occasional peace somewhere," Scott Fitzgerald wrote after Patrick died. Indeed, Honoria fulfilled Fitzgerald's promise with the births of Laura, John, and Sherman. "How different a dawn," Gerald wrote Sara when Sherman was born in 1953. "Two boys went out from our family, and now two other boys have come into it."

least once by Sara. There were two reasons for her doubts, and they both were addressed in a letter to Sara from her cousin Sara Sherman Mitchell. "I can't see that age makes any difference at all," she wrote. However, she did not as easily dismiss the second problem: "Sara, the Catholic part is hard at first, terribly hard, but one's point of view changes a lot after you're married, and it all seems to smooth out." Sara Mitchell was speaking from experience, for she had been married for five years to Ledyard Mitchell, also a Catholic. Sara Wiborg did work it out, though not in the way her cousin apparently had intended to mean. The three Murphy children would all be baptized in the Roman Catholic church, but Sara defiantly would not permit them to be brought up in the Catholic faith. Gerald, an agnostic at the time, supported her on the issue of religion. *"You* are *my* religion," he wrote Sara on April 22, 1915.

In June, Olga Wiborg announced she intended to marry Sidney Fish. "Mother was told this morning," Sara wrote Gerald on June 7, "and behaved much the same as before," meaning as she had when told of Sara's plans. "She wept and said, 'What do I know of this boy?' (She doesn't say that to you.) And when Olga says, 'Think how *long* we've all been together—much longer than most families,' Mother's answer always is, 'It hasn't been long enough for me.' "

As their October wedding date drew near, Sara and Gerald attended to practical matters, such as furnishing the house at 50 West Eleventh Street, which was a wedding present from Patrick Francis Murphy. "The measurements of the upstairs sitting room I have sent under separate cover," Gerald wrote Sara on July 27. "I gave the order for two yew-wood chairs. . . . I really think you'll like them. . . . Shall we ever be able to get away from mahogany furniture entirely? I wonder if you think it's as gloomy as I do." Gerald, of course, enjoyed nothing more than furnishing a house, and he enjoyed nothing less than the financial concerns, which were being imposed on him by both Sara's and his parents.

"Your father has phoned that he would like to see me at dinner," Gerald wrote in the same July 27 letter. "From his voice I feel that he's going to refuse me your hand until I'm earning $20,000 a year." That would have been an unheard-of salary for a young businessman in 1915, and Gerald, who was earning about $3,000, was being overly pessimistic. The next day he reported to Sara what had

actually transpired at the dinner. "I talked openly to your father," he wrote, "and explained that 50 West 11th is ours with close to $3,000 yearly, adding that unless you had been fortunately . . . enough placed to bring something, we could hardly have ventured. I said also that I was willing only that you should contribute as much as I, one half of which sum should go toward your dresses, etc. So, you see, the fact that you're to have $3,600 instead of $6,000 doesn't figure. . . . So don't worry."

There were those who did worry, however, as Gerald indicated in a letter to Sara on August 26. "Last night—in fact throughout the day—I had some 'hours of facts' with the family. . . . It seems that I have been a great disappointment to Father—in a worldly way. He says that my vision of life is unsound and warped and that I have failed to grasp the fundamental duty in life, i.e. self-support and financial independence. He fears for my future and that of anyone I'm responsible for, because he feels that were I sent out tomorrow to earn my own living, I could do little. He blames himself somewhat for having supplied me 'the crutches on which I walk,' namely money, which I do not earn. He has decided that a continuance of this would so unfit me for life or any reversal, that I should know it now. He is shocked that my project of marrying has not awakened my sense of responsibility, and he thinks that I am jeopardizing your future. . . . Most of what they say is true, so I'm telling you everything. Though I am able to admit it all, it does not dishearten me. . . . I told Father that though I loved the things that money bought, I would never be willing to slave for it. He said then that I did not deserve to be married."

On September 15, 1915, Sara wrote Gerald of her decision to postpone the wedding to December 30. "I thought about it all night," she said, "and I still think I am right about putting things off, . . . though Lord knows what a wrench it is. . . . I am not considering your father or my own family in this. It, I am afraid, would never have occurred to me on their account alone. It is because I honestly think it is best for *you.* I want you to feel at peace . . . with your work." She was beginning to sound like "Sara W," who in 1908 exhorted "Fat Face" to study hard for his Yale entrance exams. "Until you are working up to the hilt and doing your best," she continued, "your conscience . . . will always be

gnawing at you. . . . I mean you would always be . . . unhappy over your daily occupation, if you felt you were not putting yourself into it."

"I will be brutally busy these coming weeks," Gerald replied on September 27. It was perhaps the last entirely practical decision that Sara or Gerald ever made.

*You see now we have all come to the part of our lives when we start to
lose people of our own age. Baoth was our own age. Very few people ever
really are alive and those that are never die,
no matter if they are gone. No one you love is ever dead.*

Ernest Hemingway to Sara and Gerald Murphy
March 19, 1935

V. No One You Love Is Ever Dead

They were so alike and yet so unalike, the Murphys. "We com-
plemented each other so fully, that everything we did ran full cir-
cle," Gerald once wrote, which really was recognition of their dispa-
rateness. It was most evident in their approach to friendship: Gerald
cherished and would have settled for the affection of a few very best
friends—MacLeish, Dos Passos, Fitzgerald; Sara depended on the
company of many, and she had many friends, as Archie MacLeish
told Honoria after she died, but "never a favorite one."

In their letters, the Murphys reflected the difference: Gerald's
were brooding, penetrating, soul-searching, and he tried to let loose
his emotions; Sara's were newsy and wonderfully descriptive, but
only on rare occasions, as when she scolded Scott Fitzgerald, did she
openly reveal the turn of her mind. Any display of emotion was
usually by inference, as with the time she informed Ernest Heming-
way he had hurt her feelings by calling her snooty. She was not
snooty, though she chose her friends carefully; having chosen them,
she became addicted to their attention.

Her letter to the Hemingways at the L Bar T ranch on July 29,
1936, was at once an expression of the worst and the best of times:
an admission of loneliness, on the one hand—as exhibited in her
pleas and hopes that the Hemingways and others would come to

Saranac—and an account of high-spirited togetherness, on the other. Sara and Gerald had driven that summer from Saranac Lake to visit the MacLeishes in Conway, Massachusetts. "We danced with Archie and Ada on their 20th anniversary—in their barn," she wrote Ernest and Pauline. "It was a midsummer night and the greatest fun. They had a country orchestra with a man who called out directions. . . . We did all the Virginia reels, . . . amid general disorder and drinking. We were all in sort of invented peasant costume. . . . Ada made a picture I shall never forget—blue overalls with a flying veil and wreath." Sara and Gerald had also visited the Dos Passoses. "At last we got to Provincetown . . . and simply loved it," she wrote the Hemingways. "Their house is lovely, just my favorite kind of house."

All in all, it was a busy summer, the summer of 1936. By late July, when Sara wrote the Hemingways at the ranch, she and Gerald had seen Ellen and Phil Barry on Cape Cod, and a trip to the Gaspé Peninsula with John and Katy Dos Passos was planned. Sara also had word of Dorothy Parker. "Dottie and Alan Campbell are East," she wrote the Hemingways. Campbell, an actor and writer, had been married to Dorothy Parker in 1933. "They have bought, we hear, a stone house in Pennsylvania. They are coming up to stay over Sunday with Don and Bee [Stewart], who have bought a house . . . quite near here. I hope they will come here to stay too. I really love Dottie." Thinking of Dorothy Parker permitted Sara to get in a dig at a part of the world she detested, with reason, remembering what had happened in California in 1929. "So you see," she wrote, "there is quite a migration away from the stucco of Hollywood. Not for good, I suspect, but encouraging even as a tendency. . . . Our beloved Mr. Benchley is still in that hellhole, I hope making a LOT of dollars."

<center>* * *</center>

Friendship was lifeblood, no less, for Mother, who was absolutely devoted to people who had earned her esteem. She was, in keeping with her devotion, meticulous about remembering birthdays, which she recorded in a tattered date book: July 21, Ernest Hemingway; July 22, Pauline Pfeiffer Hemingway; July 24, Zelda Fitzgerald; August 22, Dorothy Parker; September 15, Robert Benchley; September 24, F. Scott Fitzgerald; November 8, Hadley Richardson Hemingway; and so on.

"In all the years I've known her," my father wrote Archie MacLeish on

June 11, 1956, "I've remarked that Sara, once she has told herself that a person is her friend, never is even tempted to depart for an instant from her apparent acceptance and understanding of incidents, which another person might consider unfriendly. Not out of blind loyalty this, but due rather to a kind of humane wisdom."

This is not to say that my mother, when she believed a bond had been breached, would simply let it pass. I am reminded of the letter she sent to Scott Fitzgerald in June 1926, after he had behaved so badly at the party she and Dow-Dow had given to celebrate Ernest Hemingway's return from Spain. It was a stern dressing-down. She was responding to Scott's having called my father "silly and rude" for walking out of the nightclub in anger.

This was the letter in which Mother expressed her discomfort at being subjected to Scott's "analysis, subanalysis, and criticism," which she found "on the whole unfriendly." The purpose of Scott's scrutiny, she soon realized, was to gather material for characterizations in his writing, which in my parents' case appeared in *Tender Is the Night.* Mother resented being used in such a way. No matter how fond she was of Scott—and her affection for both Scott and Zelda was very genuine—she believed that her privacy had been violated.

I too was a subject of Scott's analytical approach. I was only eight in the summer of 1926, but I well remember him as a man, very handsome in a delicate way, who would stare at me and ask penetrating questions. Why, he insisted on knowing, did I like the color red. Because my dress is red, or because I like the pink and red flowers in the garden, I would reply in my struggling way. I later became aware, as Mother had, that Scott had studied me for the purpose of fictional character depictions. The little girl in *Babylon Revisited* is probably more Scottie Fitzgerald than I, but it is not insignificant that he named her Honoria.

The impression I got as a child was that my parents felt mostly concern for the Fitzgeralds, and possibly some exasperation over their antics. They were pretty annoyed with Scott, I know, for throwing prized Venetian champagne glasses over the wall of our terrace. My father simply told Scott he was not welcome at the Villa America for a while. But Mother and Dow-Dow adored the Fitzgeralds, and I was never aware of any real anger on the part of either of them.

When I think of Zelda Fitzgerald in those summers at Antibes, I see a strikingly beautiful woman—blonde and soft and tanned by the sun. She usually dressed in pink and wore a peony in her hair or pinned to her dress. I was also aware of something tragic about Zelda. In 1924, when we and

the Fitzgeralds were staying at the Hôtel du Cap, she took a large dose of sleeping pills one night and nearly died. I was told later about the incident by my parents, who were, with good reason, very worried.

We were living in Switzerland in 1930 when Scott notified my mother and father of Zelda's first breakdown. They were terribly worried about Patrick, and now this. Dow-Dow was the one who fretted the most. He blamed Zelda's illness on her obsession with becoming a prima ballerina. He had seen the trouble coming, he would say, without fully realizing it. One evening—in the summer of 1926, I believe—my mother and father had gone with the Fitzgeralds to the nightclub in Juan-les-Pins. Without warning, Zelda gave a very unusual performance. She climbed up on the top of a table and danced alone—a slow pirouette, then another. Everyone was watching, Dow-Dow said, because it was so beautiful, but Zelda seemed oblivious to the attention.

My parents were both disturbed about Scott's drinking, but my father's concern was more noticeable. I recall one incident most clearly. In 1931, he and Scott went together from Switzerland to visit Baoth at school in Germany, and Dow-Dow came home very depressed. It seems that Scott had disappeared periodically from their compartment on the train, and each time he returned, he was in a condition decidedly more altered by alcohol. Finally, my father went to the washroom, and he found a dirty public cup next to the basin. Scott, who was carrying a flask of gin, was chasing the gin with water from that cup.

In August 1931, the Fitzgeralds came to Bad Aussee, in Austria, where we were renting a house for the summer. It was great fun playing with Scottie, who was bright, cute, and full of inventive ideas. She was four years younger than I, but she liked to orchestrate our games. She liked to assign the various roles in little plays that we did.

Zelda, who was thought to be well enough to leave the clinic at Prangins, Switzerland, looked pale and drawn—so different from her tanned prettiness of the days at Antibes. She and Scott left abruptly one morning, however, leaving Scottie and her nurse behind. I asked but was not told why they had gone or where. I learned later that Zelda had become very upset during the night and had threatened to kill herself, so Scott had taken her back to Prangins.

I saw little of Scott and Zelda in the later 1930s, but I did keep up with Scottie. When she was going to Vassar, she would come to visit us at Swan Cove in East Hampton. We would sit at the end of the dock, dangling our feet in the pond, and talk. I was amazed by Scottie's sophistication and admired her for it.

Zelda came with Scottie to visit Mother and me at our apartment in New York in 1946—in October, I believe. She was dressed very severely in a black suit, and her hair, cut in bangs, was much darker than I remember it having been. It was not a happy reunion, for Zelda was strangely remote. The conversation was strained, and when Mother mentioned events of the twenties, such as evenings at the nightclub in Juan-les-Pins, Zelda would only say, "I don't remember much about that anymore." And, in response to reminders about old friends, such as the Hemingways, she would respond, vaguely, "Oh, they were lovely people."

So, I prefer to remember Zelda Fitzgerald for an eloquent letter she wrote to my parents after Scott died in 1940. "Your devoted remembrance of Scott means so much to me," she said, referring to a letter she had received from them. "He cared deeply for his friends and always had plans for better happinesses and more auspicious rendezvous. . . .

"Those tragically ecstatic years when the pockets of the world were filled with pleasant surprises and people still thought of life in terms of their right to a good time are now about to wane. . . . Scott, as exponent of the school of bitter necessities that followed the last world war, gave the era a tempo and a plot from which it might dramatize itself . . . with as good a grace as might be salvaged. . . .

"I grieve for his brilliant talent, . . . his devotion to those . . . he felt were contributing to the aesthetic and spiritual purposes of life—and for his generous and vibrant soul. . . .

"That he won't be there to arrange nice things and tell us what to do is grievous to envisage. Though we have not been much together of recent years, he was as comprehensive and intelligent and gratifying a friend as I could ever have found, and he loved you dearly."

* * *

Long after Zelda Fitzgerald had also died—tragically, in a hospital fire in North Carolina in 1948—the Murphys reminisced at length about the Fitzgeralds, although Honoria was not listening. She was busy raising a family in the 1950s and '60s, when Sara and Gerald were talking with Calvin Tomkins, who was doing a profile of them for *The New Yorker*, and with Nancy Milford, who was writing a biography of Zelda. *Zelda* was published in 1970, and Milford inscribed a copy for Sara with the words: "For Sara Murphy, who with your husband, Gerald [Gerald had died in 1964], talked to me until I began to understand why Scott and Zelda had treasured your friendship so deeply."

Gerald told Milford of an evening in the summer of 1925, when the Murphys and the Fitzgeralds had dinner at a mountain inn near Nice. Isadora Duncan, the noted dancer, was at a nearby table. "Scott didn't know who she was," Gerald related, "so I told him. He immediately went to her table and sat at her feet. She ran her fingers through his hair and called him her centurion." Zelda had been watching, not saying a word; then she suddenly got up and plunged down a dark stairwell. "I was sure she was dead," Gerald recalled. When Zelda reappeared, Sara ran to her and wiped the blood from her knees.

Gerald also elaborated on Zelda's tabletop dance at the nightclub in Juan-les-Pins. "I remember it was perfect music for her to dance to, and soon the Frenchmen, who were . . . gathered about the archways leading to the small dance area near our table, gaped at her—they expected to see something spectacular. Well, it was spectacular, but not at all in the way they had expected it to be. She was dancing for herself; she didn't look left or right, or catch anyone's eyes. She looked at no one, not once, not even at Scott. I saw a mass of lace ruffles as she whirled—I'll never forget it."

Gerald described Zelda's beauty in both sets of interviews. "She was beautiful, in an unusual way," he told Tomkins. "She had a very powerful hawk-like expression, penetrating eyes, beautiful features." But her beauty "was not legitimate at all," he explained to Milford, by which he must have meant it was not ordinary. "It was all in her eyes. They were strange eyes, brooding but not sad, severe, almost masculine in their directness. She possessed an astounding gaze, . . . perfectly level and head-on. If she looked like anything, it was an American Indian."

"But Zelda could be spooky," Sara added. "She seemed sometimes to be lying in ambush, waiting for you with those Indian eyes of hers."

* * *

The most important reason my mother was so fond of Ernest Hemingway—so totally loyal when others regarded him as pompous and insulting —is that she found him to be a great source of strength. "You are a stimulus and an ideal," she wrote him in September 1935, after Baoth had died and Patrick lay desperately ill.

As for my father, he certainly shared Mother's admiration for Ernest, but his enthusiasm was based more on artistic respect than on personal affec-

tion. He had, for one thing, strong reservations about Ernest's inclination to court danger, as he had done on the visit to Pamplona in the summer of 1926, forcing Dow-Dow to join him in the bullring. Ernest, my father believed, was preoccupied with death. I realize this is common knowledge among literature students, but it was put to me as a child in a way I will never forget. Ernest's father died when I was ten—he committed suicide in November 1928. My parents were naturally sympathetic, but Dow-Dow often wondered out loud why Ernest talked about it so much.

Another way I was able to sense a lack of congeniality between my father and Ernest was that Dow-Dow was unable to go along with the "tough-guy" lingo, as Archie MacLeish and John Dos Passos did. When Archie and Dos got together with Ernest, they easily adopted his rather rough way of talking. They did not swear or utter obscenities: it was more a vernacular, consisting of short, punchy sentences and single-syllable words. It lacked the refinement that usually distinguished the conversations of Archie and Dos and my father.

Also, Archie and Dos enjoyed chatting with Ernest about fishing and hunting, subjects that did not interest Dow-Dow. I could not help but suspect, therefore, that he felt a little left out.

My first memories of Ernest—in 1925, when I was seven—are in keeping with the tough-guy image. He was a big man, with broad shoulders, and he had a habit of dancing about the room, thumbing his nose and punching the air with his fists. I was told he was shadowboxing. He also talked in an unusual way, the words seeming to come from the side of his mouth.

Quite often he bore the marks of injuries. A nasty gash on his forehead had been caused, I was told by Dow-Dow, by glass falling from a shattered skylight in the Hemingways' flat. He also had a bandaged knee. He seemed to be a healthy, active man otherwise—possibly too active, which would explain the accidents.

It is true that while my father respected Ernest as an artist, they got along less well as the years passed. "You'd like him, he's tough," is how Dow-Dow would quote Ernest's praise of someone, and I could tell from the tone of my father's voice that he did not approve of measuring men by their toughness. He also said that Ernest could be insulting, as he once was of him when he said, "You Irish know things you have never earned the right to know."

I suppose it is inevitable that there would be questions about a romance between my mother and Ernest. It is true that Mother often expressed great admiration for his strength and warmth. "You know, Honoria," she would

say, "he is a wonderfully warm man." I would submit, however, that my mother was a very correct, old-fashioned woman, who disapproved of flirtations among married people.

In the 1930s, Mother made several trips alone to visit Ernest in Key West and Havana. During this period, as well, Ernest wrote her letters, some of them passionate.

"Will write you again and very soon," Ernest wrote on December 8, 1935. "With very much love, much love and love also with love." He did write again, on February 11, 1936, and said: "I had a gigantic dream about you about ten days ago and woke up determined to write you a long letter . . . and tell you how highly I thought of you."

On December 27, 1939, Ernest wrote Mother from Sun Valley, Idaho: "Cut the last part of this letter off and burn it and forget what it says." He was referring to a previous passage in which he had complained about the breakup of his marriage to Pauline. "Am always unjust," Ernest said. "But have to talk to someone sometime. Much love always from your old friend who will be your good and old friend as long as he lives and afterwards, good kind beautiful lovely Sara."

But the point is that Mother adored *both* Ernest and Pauline. When they were divorced in 1940, no one was more upset than she.

Ernest Hemingway was a father figure to me, which is a considerable statement, since I regarded Dow-Dow as the be-all and end-all. Ernest, however, had a way of imposing himself: he was domineering, though never in an annoying way; he was a fine storyteller; and he was a patient teacher and counselor. He adored children and treated them in a way that may seem inconsistent with some other, if you will, crusty aspects of his temperament. He expressed his fondness to the children of friends, and I was privileged to be one of them.

Ernest always called me "daughter," and even though Bumby Hemingway once told me that his father addressed a lot of women that way, I believe he liked me very much. Perhaps I was the next thing to a daughter, since he had only sons. After my parents had died, I discovered a letter, which had been sent in February 1949 by John Dos Passos in Havana. He quoted a note from Ernest, who then was married to Mary Welsh. "Tell Sara Mary and I lost baby in Casper, Wyoming. If you are going to lose anything, Casper is the place. Sara wrote lovely letter about maybe we could have a daughter and never answered. Tell her am glad she had a daughter and will have to do for all of us. Tell her also that I love her very much."

My father always said there should be no favorite friends, but from among the American writers my parents met in France, there were two whose friendship was the most enduring: Archibald MacLeish and John Dos Passos.

Archie and Dow-Dow had a spiritual bond. When we were in Antibes, they loved going off, with Vladimir, on sailing trips. They once went bicycling through the wine country of Burgundy, just the two of them. They were very excited when they got back, because one day they had been in the cellar of a winery when, as Archie explained, "We suddenly heard the voices of angels." The winery turned out to be in a monastery and they were hearing the choir at practice.

The Archie I remember in those days was serious-looking, but he had a twinkle in his eye. His voice was gentle, almost caressing, and it had an up-lilt, which he used to punctuate his carefully chosen words. He had pet names for people, and mine was "M'noria," a contraction of "My Honoria." He was gentle and affectionate, as was his wife, Ada, who had a very cozy presence, as Dow-Dow liked to say. Mother had her own way of describing her: "Ada looks as though she just came out of a bandbox," which was an allusion to her pretty, feminine clothes. She wore a delicious jasmine perfume, and she had tiny fingers, which were meticulously manicured. We called her "Ada of the flying fingers," because she was always knitting. She also played the piano and sang beautifully.

There is a letter to my father, written by Archie in October 1946, which I treasure, for I find it to be such a beautiful statement of friendship. "It suddenly came over me today," he wrote from the farm in Conway, Massachusetts, "I don't know why today more than any other day except that there is a warm rainy autumn wind like the presence of memory driving the leaves down and the summer visibly with them—it suddenly came over me that I haven't seen you since the summer was first full and the elms full and green, as you said, like bunches of young parsley and the maples green and full and round and the grass under it all like time's reflection of eternity, which is surely blue in itself but green in the earth's reflection because green is brief. But 'came over me' is wrong, for it was like a blow. I count on your being in the world and not only in *the* world but in mine. So I write this letter to tell you and to say that I miss you. Quite simply and truly that."

Dos was just as close to my mother as he was to my father. I remember him at Antibes as a tall, rather shy man, who spoke hesitantly but with authority. My father once said that Dos was the one person he knew who had some knowledge about everything. Mother admired him as an adven-

turer with inexhaustible energy, and she once told me that he had walked clear across Spain. He married Katy in 1929—her full name was Katherine Smith, and she had been introduced to Dos by the Hemingways. Katy and Dos were with us on the *Weatherbird* cruise in the summer of 1933. Katy was delicate, and at times she found it difficult to keep up with Dos, but she had a fine sense of humor about it. She died in an automobile accident in September 1947. Two years later Dos married Elizabeth Holdridge.

As their friends and loved ones died over the years, Dos was careful to send a note to Mother. After Pauline Hemingway died in 1951, he wrote: "I'm very sorry. I was very fond of her. I wouldn't know what to say to old Hem. I imagine he'll feel pretty badly about it." Dos was on another trip to Spain when Ernest himself died ten years later. "Until I read of his poor death," he wrote Mother, "I didn't realize how fond I'd been of the old Monster."

<p style="text-align:center">* * *</p>

There were many, many friends over the long span of the Murphys' marriage. Not all were literary people, although the common denominator seemed to be a sharing of some sort of artistic interest. Alice Lee and Dick Myers were as close as anyone to Sara and Gerald and were the parents of Honoria's best friend, Fanny Myers. Alice Lee's artistry was in her taste for fine pieces of this or that—clothing, furnishings, and the like—a taste so refined that Gerald sent her on buying tours of Europe for Mark Cross. Dick Myers, for much of his life, was a buyer and seller of French wines, a connoisseur, but he was also a musician—an accomplished pianist and a composer.

There is, of course, a certain amount of artistry in friendship itself, which entails an ability to say or do something nice at a time when it counts. The Myerses and the Murphys understood the artistry of friendship. So did Robert Benchley, who, from out in Hollywood where he was writing film scripts, missed Sara and Gerald a lot, though he did not write often, as he admitted on July 1, 1937. "It is the strangest feeling, this writing a letter," he said. "I haven't written one for years. I guess I really wanted to write this one." He told how he was reconciling differences with Dorothy Parker, who was also in California, with her husband Alan Campbell. "It seems that one night just before I left New York I assailed Dottie in '21' on some labor issue and, in the course of my tirade, I told her not to make those ingenue eyes at me as she was no longer

ingenue. . . . Dottie didn't mind my views on labor activities, but the 'ingenue' line . . . cut her to the quick, and, during the month that they have been out here, they have refused to answer the telephone, although I have tried six or seven times. Finally, last Saturday, I paid a personal call at their hotel and left a note. . . . Mysterious underground forces have been at work since then, and tonight I am asked to dinner at the Wells Roots's [Wells Root, like Benchley, was a film script writer], and, I understand, am to be seated at the same table with the Campbells." He closed with a joke only Sara and Gerald would have understood, for it contained references to a school Honoria had attended, and to one of her favorite pastimes: "It almost seems as if I were back at Rosemary Hall, and I am sure that we will all end up making fudge in Alan's room."

In his letter to Archibald MacLeish in June 1956, in which Gerald Murphy noted that Sara never wavered in her friendships, he said that he was not "thus endowed," and he insisted that MacLeish had been wrong in his belief "that my instinct in that uncertain realm of human relationships is truer than yours." Gerald still had his pride, his *"amour propre* raising its head," to contend with. "Worse than the general feeling of lowered consequence . . . is the loss of confidence in one's ability to safeguard the precious friendship. This is pretty close to loss of confidence in oneself." He was quick to point out, though, that his regard for Archie was not in question. "I have no heart of oak," he wrote, "but I cannot see life—either past or future—without in it an enduring affection for you and Ada."

When Murphy wrote these words, Scott Fitzgerald had been dead for over fifteen years, time enough to enable him to look back with detachment. He had thought a lot about *Tender Is the Night,* he wrote Calvin Tomkins in October 1961, and he recalled telling Fitzgerald how "the book seemed . . . to take a change of direction and personnel half-way through." This was, Gerald knew, Hemingway's major objection, as Ernest had said to Scott in a letter in May 1934. "It started off with that marvelous description of Sara and Gerald," Ernest wrote. "Then you started fooling with them, making them come from things they didn't come from, changing them into other people, and you can't do that Scott. If you take real people and write about them you cannot give them other parents than they have. . . . You can take you or me or Zelda or Pauline or Hadley or Sara

or Gerald, but you have to keep them the same and you can only make them do what they would do. . . . Invention is the finest thing, but you cannot invent anything that would not happen." Fitzgerald had an answer to this sort of criticism, which Murphy related to Tomkins. "He said," Murphy wrote, " 'Gerald, the book was *inspired* by Sara and you and the way I feel about you both and the way you live. . . . The last part of it is Zelda and me, because you and Sara are the same people as Zelda and me.' "

Gerald still was not satisfied, when he reread the novel in 1961, with Fitzgerald's "method of shifting in and out of Zelda and Sara and himself and me. Certainly, Scott and I are not much alike, as Irish as we may be." He had, in fact, continued to be amazed at the suggestion of a similarity of life-styles. "When you think about it," he wrote, "we never shared with him our most passionate interests. They didn't appeal to him, not even the simplest of them: bathing, sunning, cruising, enjoyment of interesting food and wine in a redolent garden to a nightingale accompaniment. The arts we never touched on with him. . . . He was fascinated by the way we lived, but he really didn't understand it at all." Sara, late in life, remained adamant about *Tender Is the Night*. "The book is so *shallow,*" she wrote Tomkins. "I'd rather hoped that when someone's dead you wouldn't be irritated by them anymore. . . . I can't help wishing we were in some other book."

As for Fitzgerald's legendary bad behavior, Murphy maintained to Tomkins that he "never got drunk in our house, because he knew we didn't care for it." Perhaps, but Scott acted inexcusably at times, drunk or sober, as he did at a dinner party at the Villa America in the summer of 1926. One of the other guests, a writer and musician, was, according to Gerald, "an attractive and intelligent man, who was also openly homosexual. We invited him, . . . because he was charming and interested in the same things we were. . . . Scott, who had an ugly streak, . . . came up to him and asked, 'Are you a homosexual?' The man said, 'Yes.' Archie MacLeish, who overheard, called Scott aside. . . . Archie took him to the *bastide* and told Scott he wouldn't stand for his wrecking our evening that way; and then proceeded to knock him cold. Archie never liked Scott."

MacLeish told Tomkins a different version of the incident, which occurred the same evening that Scott threw champagne glasses over the terrace wall. Archie said he did admonish Scott, whereupon Fitzgerald took a swing at him.

When Fitzgerald was writing, he changed radically, Murphy wrote Tomkins in 1962. "He became cold, aloof, virtually inaccessible to family and friends. He drank no liquor and shut himself up daily for weeks on end." In his nonwriting periods, he had one work habit that was quite disturbing, to Sara especially. "Oddly enough," Gerald wrote, "it is only now that I begin to recall fully how much he peered at and catechized us." His constant questioning was considered by the Murphys to be intrusive and irritating, having to do with such private matters as their income and their sex life. Finally, Sara said to him one evening, "Scott, you just think if you ask enough questions you'll know about people. But you don't know anything about people." Aware that her remark had infuriated Scott, Sara offered to repeat it. "Scott," she said with even greater emphasis, "you don't know anything at all about people."

Fitzgerald was, however, an excellent observer, and he skillfully wrote fictional adaptations of events in the Murphys' life. A description of a psychiatric clinic in Lausanne, which appears in *Tender Is the Night,* was based on an account he heard from Gerald on a visit to Montana-Vermala in 1931. "I told him of having gone to Basel, to a disciple of Jung," Gerald wrote in a letter to Calvin Tomkins, referring to the occasion when, in deep depression over learning of Patrick's TB, he had sought psychiatric help. "You went and lived in a hotel, completely unidentified, and went out by trolley . . . every day at a fixed time, and waited in the garden so that you never saw anyone else coming out."

While Sara and Gerald could say, looking back, that they had had little in common with the Fitzgeralds, there is no denying their deep feeling for Scott and Zelda during their days on the Riviera. "There *really* was a great sound of tearing heard in the land as your train pulled out that day," Gerald wrote Scott and Zelda in September 1925. "Sara and I rode back together saying things about you both to each other, which only partly expressed what we felt separately. Ultimately, I suppose, one must judge the degree of one's love for a person by the hush and the emptiness that descends upon the day, after the departure. We heard the tearing because it was there, and because we weren't able to talk about how much we do love you two. . . . Suffice it to say that whenever we knew that we were going to see you that evening or that you were coming to dinner in the garden we were happy, and showed it to each other. We were happy whenever we were with you. My God, how *rare* it is. How rare."

Sara also wrote warm letters to the Fitzgeralds, such as one in June 1927, when Scott and Zelda were in the United States, having rented a house in Wilmington, Delaware. "We wonder very often how you both are," she wrote from Antibes, "and affection wells up in our hearts—believe it or not as you may, Scott especially, who considers us a lot of old scrap granite or something." Sara's letters were intended to keep friends abreast of what had been happening. "We've had a grand quiet spring here, . . . following a hectic five months in the U.S., counting crossings, and a dash through central Europe with the MacLeishes. But we never got to Russia as planned, as by the time we got visas the theaters were closed and the snow had started to melt, not to mention the opening of the season for executions.

"People have now started to crowd onto our beach, discouragingly undeterred by our natural wish to have it alone. However, by means of teaching the children to throw wet sand . . . and by bringing several disagreeable barking dogs, . . . we manage to keep open space for sunbaths.

"We miss you and the MacLeishes dreadfully. Gerald sends his best love, and so do the children. . . . Don't forget us, because we don't you—and won't ever. . . . In fact, we think about you both much more than you know."

Still, Sara was often impatient with Scott, as she indicated when she wrote him in 1934, the year *Tender Is the Night* was published. Zelda had suffered another breakdown, her third, and Scott, while on a trip to seek medical advice, had stopped to see the Murphys, who were living at 1 Beekman Place in Manhattan. "We were sorry not to see you again," Sara wrote, "but it seemed, under the circumstances, better not to. Please don't think that Zelda's condition is not very near to our hearts, . . . and that all your misfortunes are not, in part, ours too. But at times it seems best, for the very sake of our affection for you, not to let your manners (let us call it) throw it off its equilibrium, even momentarily. We have no doubt about the loyalty of your affections (and we hope you haven't of ours), but consideration for other people's feelings . . . is completely left out of your makeup. I have always told you you haven't the faintest idea what anybody else but yourself is like. . . . You don't even know what Zelda and Scottie are like, in spite of your love for them. It seemed to us the other night that all you thought and felt about them was in terms of *yourself.* The same holds good of your feelings

for your friends. . . . Why, for instance, *should* you trample on other people's feelings, becoming someone else (uninvited), instead of the Scott we know, love and admire, unless from the greatest egotism, a sureness that you are *righter* than anyone else? I called it manners, but it is more serious—it is that you are only thinking of yourself.

"Forgive me if you can, but you must try to learn, for your own good, . . . some distrust for your behavior." She signed it, "Your infuriating but devoted and rather wise old friend." Fitzgerald was duly chastised, and his next letter to Sara, at least of those she saved, was one he wrote on August 15, 1935, having heard from Gerald of the extent of her suffering and her need for "nourishment—from adults, from those who are fond of her." (Scott had written right after Baoth died, but his letter was later misplaced.)

"Today a letter from Gerald," Scott wrote, "telling me this and that about the awful organ music around us." The nourishment he offered was in the form of an explanation of his literary approach and how it applied to their friendship. "In my theory, utterly apposite [*sic*] to Ernest's, . . . it takes half a dozen people to make a synthesis strong enough to create a fiction character. . . . I used you again and again in *Tender.* . . . I tried to evoke not *you* but the effect that you produce on men. . . . And someday in spite of all the affectionate skepticism you felt toward the brash young man you met on the Riviera eleven years ago, you'll let me have my little corner of you where I know you better than anybody—yes, even better than Gerald. And if it should perhaps be your left ear . . . on June evenings on Thursday from 11:00 to 11:15 here's what I'd say.

"That not one thing you've done is for nothing. . . . You are part of our times, part of the history of our race. The people whose lives you've touched directly or indirectly have reacted to the corporate bundle of atoms that's you in a *good* way. *I have seen you again at a time of confusion take the hard course almost blindly because long after your powers of ratiocination were exhausted you clung to the idea of dauntless courage.*"

Sara may have been flattered, but she no doubt realized Fitzgerald was being as egotistical as ever, for he regarded himself in much the same way he did his fictional characters. "There never was a good biography of a good novelist," he wrote in his *Notebooks,* published in 1978. "There couldn't be. He is too many people if he's any good."

Scott wrote again in the spring of 1936. He had published in the February, March, and April issues of *Esquire* three self-revealing

essays—"The Crack-Up," "Handle With Care," and "Pasting It Together." "If you read the little trilogy I wrote," he said to Sara, "you know I went through a sort of 'dark night of the soul' last autumn." In a note the year before, Sara had asked anxiously of Zelda, and Scott said he was moving her to a sanitarium in Asheville, North Carolina: "For what she has suffered there is never a sober night that I do not pay a stark tribute of an hour to in the darkness."

Sara's reply was warm and friendly, yet argumentative: "I did indeed read your trilogy in *Esquire,* and I think you must feel better for it, as it seemed to . . . get something off your chest, if not much . . . for anybody else. . . . I never realized . . . to what *extent* you thought you could run things and control your life by just wanting to. . . . Do you *really* mean . . . you honestly thought 'life was something you dominated if you were any good'?" She was quoting from "The Crack-Up." "Well if you thought *that,* . . . I give up. I can't fight you on paper, but there are several very loose stones in your basement, rocking the house. . . . Oh how wrong you are, Scott, about so many things. . . . I remember once your saying to me—you and Dotty [*sic*] were talking about your disappointments, and you turned to me and said: 'I don't suppose you have ever known despair.' I remember it so well, as I was furious and thought, 'My God, the man thinks no one knows despair who isn't a writer and can describe it.' This is my feeling about your articles."

As her sympathies turned to Zelda, however, Sara's approach softened. "You have been cheated (as we all have been in one way or another)," she wrote, "but to have Zelda's wisdom taken away, which would have meant *everything* to you, is crueller even than death. She would have felt all the right things through the bad times —and found the words to help. . . . You have had a *horrible* time— worse than any of us, I think."

In 1938, Fitzgerald was working as a script writer in Hollywood and living with Sheilah Graham, a Hollywood columnist. When Graham came to New York, Scott asked if Sara and Gerald would invite her by. She came to the apartment at the New Weston, Honoria remembers, and drank only cocoa. "I realize now that it was a bad time to ask anything," Scott wrote Gerald on March 11, 1938, referring to the fact that it had only been a little over a year since Patrick's death. "You were awfully damn kind, . . . and as a

friend you have never failed me." In September 1939, Scott reported by telegram to Gerald that he had been ill "and confined to bed for five months." He was by this time "up and working but completely cleaned out financially," and he asked for $360, which Gerald sent. When he had not heard another word by April 1940, Gerald wrote anxiously and a bit impatiently. "Sara long ago convinced Celtic me that it's kinder (and more honest) to *tell* friends when you feel they've been a little unfriendly. So I thought I'd write you. . . . You must *know* how long we've been fond of you and for how many reasons." The feeling *was* reciprocated: in May 1940, Scott said in a letter to his editor, Maxwell Perkins, "You (and one other man, Gerald Murphy) have been a friend through every dark time."

Scott replied promptly to Gerald's April letter, and he seemed to be feeling better. "Honey—and that goes for Sara too," he began. "I have written a dozen people who mean nothing to me—writing you I was saving for good news. I suppose pride was concerned— in that personally and publicly dreary month of September last, about everything went to pieces all at once and it was a long uphill pull.

"To summarize, I don't have to tell you anything about the awful lapses and sudden reverses and apparent cures and thorough poisoning effect of lung trouble. . . . With it went a psychic depression over the finances and the effect on Scottie and Zelda. There was many a day that the fact that you and Sara did help me at a desperate moment . . . seemed the only pleasant thing that had happened in a world where I felt prematurely passed by and forgotten. . . . There seem to be the givers and the takers and that doesn't change. So, you were never out of my mind.

"In the land of the living again I function rather well. My great dreams about this place are shattered and I have written half a novel and a score of satiric pieces that are appearing in the current *Esquire.* . . . After having to turn down a bunch of well-paid jobs while I was ill there was a period when no one seemed to want me for duck soup. Then, a month ago, a producer asked me to do a piece of my own for a small sum ($2,000) and a share in the profits. The piece is 'Babylon Revisited,' an old and not bad *Post* story of which the child heroine was named Honoria! I'm keeping the name.

"Zelda is home since this week Tuesday—at her mother's in Montgomery. She has a poor pitiful life, reading the Bible in the old-fashioned manner, walking tight-lipped and correct through a

world she can no longer understand, playing with the pieces of old things, as if a man a thousand years hence tried to reconstruct our civilization from a baroque cornice, a figurine from a Trojan column, an aeroplane wing, and a page of Petrarch, all picked up in a Roman forum. Part of her mind is washed clean and she is no one I ever knew (this is all from letters and observations of over a year ago—I haven't been East since spring). So now you're up to date on me and I won't be so long again. I might say by way of counter reproach that there's no word of any of *you* in your letter. It is sad about Pauline. [He was referring to the Hemingway divorce.] Writing you today has brought back so much and I could weep very easily."

"It was good to hear from you," Gerald wrote Scott on August 26, 1940, "but I do not like to feel that you *consider* yourself ill. I can't believe you *are*. Don't think me without heart, but just as you, so have I, seen much illness around me. Your account of your condition for some reason recalled to me my own surprise the day you came to see us in New York wearing rubbers—which you removed and remembered to put on again when you left. It seemed unlike my idea of you. It still is. . . . I'm glad Zelda has been well enough to be home. There's probably some unrecognizable comfort for her in it—like Ernest's feeling of being sick as a child and being put to bed by his mother."

Scott wrote again in September 1940. "Anyhow you can see from the letterhead [20th Century-Fox Film Corporation], I am now in official health. I find, after a long time out here, that one develops new attitudes. It is, for example, such a slack *soft* place. . . . Except for the stage-struck young girls, people come here for negative reasons. . . . Everywhere there is, after a moment, corruption or indifference. The heroes are the great corruptionists or the supremely indifferent—by whom I mean the spoiled writers, [Ben] Hecht, Nunnally Johnson, Dottie [Parker], Dash Hammett, etc.

"I have a novel pretty well on the road. I think it will baffle and in some ways irritate what readers I have left. But it is as detached from me as Gatsby was, in intent anyhow. The new Armageddon [he was referring to the war in Europe], far from making everything unimportant, gives me a certain lust for life again. . . . The gloom of all causes does not affect it—I feel a certain rebirth of kinetic impulses—however misdirected.

"Zelda dozes—her letters are clear enough—she doesn't want to leave Montgomery for a year, or so she says. Scottie continues at

Vassar—she is nicer now than she has been since she was a little girl. I haven't seen her for a year but she writes long letters and I feel closer to her than I have since she was little.

"I *would* like to have some days with you and Sara. I hear distant thunder about Ernest and Archie and their doings but about you I know not a tenth of what I want to know."

Gerald wrote back on October 3: "Your letter was such a pleasure to receive. . . . We share in retrospect your feelings about Hollywood. We stood alone in a community made of tight little sets all of whom distrusted each other. Their insecurity and fear of . . . disfavor was depressing. With a veneer of cosmopolitanism they are hopelessly provincial and dread any risk. . . . Sara joins me in love to you—and Honoria too. You are one of the people of whom we are very fond. We think of you much."

On December 21, 1940, Scott Fitzgerald died of a heart attack. Years later, Gerald dug out a letter that he had written to Sara when he and Scott were traveling together in Switzerland in 1931. "Scott was quiet and speculative today at Lausanne," Gerald had written. "He talked thoughtfully and with a kind of tenderness of all of us, caressing his thoughts as they came. He looked straight ahead of him and upward, . . . as if expecting a vision of some kind. As I listened to him, I had the sense of coming on undiscovered gold and wanting to . . . mark the spot, so that I might come back to it someday."

Gerald Murphy was but mildly offended by Scott Fitzgerald's occasional thoughtless slights, but with Ernest Hemingway he found his *"amour propre* raising its head," as he had put it in his letter to Archie MacLeish. "He took to us immediately," Murphy wrote Calvin Tomkins, "though he obviously liked Sara more." It was partly that Ernest preferred the company of women, but Gerald suspected there was more to it. "Hemingway had a reservation about me," he explained. "I think it stemmed from an incident soon after our first meeting. . . . He was talking about homosexuals, kidding, as people did when there weren't so many, or at least they weren't so in evidence. He was extremely sensitive to the question of who was one and who wasn't, and he once said casually, 'I don't mind a fairy like so and so, do you?' For some reason, I said, 'No,' even though I had never met the man. I have no idea why I said it, except that Ernest had an ability to make it easier to agree with him

than to not. He was . . . an enveloping personality, so physically huge and forceful, and he overstated everything and talked so rapidly and so graphically and so well that you just found yourself agreeing with him. Anyway, instead of saying I did not know the man, I agreed with Ernest, and he gave me a funny look. I wondered later if he had laid a trap for me."

Hemingway's preoccupation with masculinity made Murphy uneasy. "He was obsessed with courage and with toughness," Gerald told Tomkins. "In Pamplona that time, I was wearing a darkish cap pulled down over one eye, and he said approvingly, 'That's just right. You look tough.' " There is other evidence that Murphy and Hemingway did not hit it off so well. When Gerald explained to Zelda Fitzgerald's biographer, Nancy Milford, that Zelda had called Ernest "bogus," he added the thought, "Of course, who knows how right she may prove to be?"

Gerald was always in awe of Ernest's talent, but he tended to remarks that Hemingway, a man of thin skin, might have regarded as insulting. "It's a great title, *The Sun Also Rises,*" Gerald commented in a letter to Hadley Hemingway in March 1926. "Someday he'll write, *Yet the Sea Is Not Full,* or its equivalent." Gerald was also prone to preachiness, which he no doubt believed was justified by the fact that he was over eleven years older than Hemingway, and by his willingness to provide financial assistance, in addition to artistic support, from time to time. A good example is the letter Gerald sent in September 1926 to the Paris studio he had lent Ernest, announcing he had put $400 in Hemingway's bank account. Gerald then addressed himself to Ernest's marital problems.

"There is one phase of your situation which disquiets me, and that is the danger that you may temporize: first, because Hadley's tempo is a slower . . . one than yours and . . . you may accept it out of deference to her; second, because of a difficulty in settling the practical phases of it all—Hadley's comfort, Bumby's. Should either of these things deter you from acting cleanly and sharply, I should consider it a dangerous betrayal of your nature. . . . As you read this, for Christ's sake, don't think of me as some impertinent pup, but I'll go down (in your estimation, if necessary) fighting just to state my belief and godalmighty valuation of that thing in you, which life might trick you into deserting. There's a side of you too sensitive not to be jangled by the hunk that life has thrown in your lap." In a postscript, Gerald advised that he was going in January "to . . .

Germany or somewhere to work. Sara was almost hurt to learn that I had been wanting to and had not suggested it to her. I believe in it for many reasons. Husbands and wives should take steps to keep each other fresh."

The Murphy-to-Hemingway letters continued sporadically through the twenties, although Ernest either did not respond or else Gerald destroyed what replies he did receive. In March 1927, Gerald voiced approval of Ernest's forthcoming marriage to Pauline: "Best to 'P the Pifer.' She looks finely. Is a good chicken. And I'd like to see her get along." Then, in May: "Sara and I are getting to Paris Wednesday. If you are about and this reaches you and the sun doesn't get in your eyes, come around to the quai [the Murphy apartment at 23 quai des Grands-Augustins]. We shall be very much alone and wearing red moustaches. . . . We've forgotten how to talk to people without barking."

In June, Gerald sent a postcard: "Harpo Marx wants to go to Pamplona." Harpo, of the Marx Brothers comedy team, was a regular on the Riviera and a good friend of the Murphys. Gerald's postcard was indication that he and Sara were telling their other American friends of their memorable trip to Spain the summer before.

On June 18, 1927, Gerald wrote to Hemingway in Paris: "Dear Oiness: It was good to have news of you both. It would be nice to have a chance to talk about almost everything with you both. Often it gives you a sense of covering ground, when you have a little talk. . . . Not that there's anything to be settled, God knows, but as Sadie says: 'I don't want to see those people; they tire me because I can't say anything that I think in front of them.' Ultimately you like people who leave you free to say what you think. . . . You do both know that we'd love to have you come to us if ever you just suddenly feel like it. You could have our room. That's what we do now when we have people, and go to the *bastide* ourselves. The *Cap* isn't at all bad, because we don't know anyone except Phil and Ellen Barry, who are at Cannes and they're grand. . . . I'm working all the time and feel that I've knocked one or two things on the nose. Before I die I'm going to do one picture which will be hitched to the universe."

"I think I have discovered something about Ernest," Gerald confided by letter to Archie MacLeish from the L Bar T Ranch in

Montana in September 1932. "He is never difficult with people he does not like, the people he does not take seriously. He has crossed swords with Sara and Ada, with you and Dorothy, . . . with Dos. But he will never do it with me; there has been no real issue with . . . Scott, whom he no longer respects. For in spite of his love for approval there is the sanctum to which he has admitted a few. . . . I find him more mellowed, amenable and far more charitable . . . than before, more patient also. But the line has been drawn very definitely between the people he admits to his life and those he does not. I have never felt for a moment a claim to his affection and do not receive it, and rightly—we are of opposing worlds. Sara does and receives it unstinted."

Gerald remarked to Archie on the one Hemingway quality he always cherished, Ernest's kindness toward children, specifically the three young Murphys. "The children adore it here," he wrote. "Baoth is just off the reservation, and Honoria is fast becoming a horse. It's paradise for them, and Ernest has been an angel about arranging their lives." As for Patrick, who had not been able to come to the ranch owing to his illness, Gerald later wrote Calvin Tomkins that he was especially favored by Ernest: "There was the strongest bond between them, despite . . . a generation between their ages."

Murphy was quite aware that he and Hemingway had little in common. Gerald did not fish or hunt, for he found the killing of a creature repugnant, though he did enjoy eating well-prepared game. "The lakes and streams are stiff with trout," he wrote Archie from the ranch, "and one drools in anticipation of the evening meal after a long ride, and one is disappointed. . . . Ernest is going to Cody to meet a friend from Key West, and they have been given the run of a preserve containing five hundred pheasant. If they do not taste good, I shall not say so, but I shall be a very saddened person."

Gerald much preferred attending a good play or a ballet performance to going with Ernest to a bullfight or a boxing match. Sara also appreciated the arts, but she endeared herself to Ernest by her enthusiasm for his sort of sporting pleasure. She would go deep-sea fishing with him in the roughest weather, earning the nickname "Seagoing Sadie," and, while living in Saranac Lake, she took up bobsledding. She also enjoyed going to prize fights. Honoria once went with her mother and Ernest to a championship bout in New

York, and she was horrified by the brutality of boxing. "Don't complain," Sara said sternly. "We are Ernest's guests. Besides, it's only a sport."

"Dearest Sara," Ernest wrote from Key West on April 27, 1934. "I love you very much Madam, not like in Scott's Christmas tree ornament novels but the way it is on boats, where Scott would be seasick." That was the Hemingway Sara admired—brash but affectionate. "Don't let's go so long without . . . seeing each other again," he went on. "We really do something against the world when around together and the world is always trying to do all these things to us . . . when we are apart."

By the mid-thirties, other friends of the Murphys were finding Hemingway difficult to abide. "Do you remember how irascible and truculent he was?" asked Katy Dos Passos in a letter to Sara in December 1934. Katy and Dos were Key West neighbors of the Hemingways, and she was able to report that he had mellowed and was "just a big cage of canaries," indicating that Ernest's bad temper was periodic. "Am good friends with Dos," Ernest had written Sara in April. "Stopped being mean. We are going to Havana together next week." Sara never acknowledged having noticed Ernest "being mean." When she called him the *"gros patron,"* or "big boss," as she often did, she did so out of reverence and to return the affection.

Was Gerald jealous? There is no evidence that he was, and the observations of other close friends support Honoria's contention that he had no reason to be. "Both Scott Fitzgerald and Ernest Hemingway revered your mother," Ellen Barry, Philip Barry's widow, told Honoria in 1981, when asked to comment on speculation that Sara had, at one time or another, been romantically involved with them. "But there was no romance in either case," Ellen Barry said. "I say this because I know Sara was quite austere about such things. There was a remoteness about her, which is one reason Scott and Ernest were so fascinated by her." She was also, Ellen Barry insisted, a devoted wife. "Sara and Gerald had an identity as a couple," she said. "We always thought of them as a couple, even though they were very different as individuals."

Lillian Hellman, the playwright, who met the Murphys in Paris in the summer of 1937, offered another reason for believing that Ernest's attentions to Sara were innocent. Hemingway, she said, was always devoted, and therefore faithful, to one woman, a wife, or an

intended wife. "He once came to my hotel room in Paris," she recalled, "and he made me sit up all night, reading the manuscript of *To Have and Have Not.* As he was getting into the elevator to leave, finally, he said to me: 'Lillian, I'm sorry I cannot sleep with you.' I was quite flattered at first, thinking that he was honoring my attitude. But then he said, at which point I got quite angry, 'Lillian, I'm sorry I can't sleep with you, but I'm in love with another woman.'"

The tragedy of her sons' dying young brought Sara and Ernest together more than anything else. Gerald worried about her constantly and tried in every way possible to make amends for what life had done to her, which included encouraging her to seek solace from the company of friends, even though he preferred to turn inward and take comfort from solitude. The friends, of course, were Ada and Archie, Katy and Dos, Pauline and Ernest—perhaps especially Ernest, and she heard from him often.

On July 10, 1935, he wrote from Bimini, having just learned she had taken Patrick to Saranac Lake. "You would love this place, Sara. . . . Patrick would love this place. You can catch snappers, tarpon, and twenty-five kinds of small fish right from the dock. . . . There is no sickness on the island, and the average age of people in the country [the Bahamas] is eighty-five. . . . It is under the British flag. . . . We have celebrated the Queen's birthday, . . . the Prince of Wales's birthday, the Fourth of July, and will celebrate the Fourteenth of July, getting drunk on all of these. We miss you on these occasions as well as all the rest of the time and send you *much* love and hope to see you soon."

The Hemingways were back in Key West on September 11, 1935, when Sara wrote to ask how they had fared in a recent hurricane. "We imagined Ernest *would* be in—or go into—the thick of things, and how awful it must have been! Won't it take quite a time to get over the horror of it all? I noticed by the map how much of the storm was over the very route you rushed me over that February last night that seems so many eons ago, now—yet it seems like yesterday too." She was alluding to the night less than seven months earlier when she had hurried from Florida to Boston to be at Baoth's bedside.

Ernest apparently had anticipated Sara's concern, for he wrote the very next day, presumably before receiving her letter. She was right about his having been "in the thick of things," as he had gone up

to Lower Matecumbe Key, which had been hit directly by the storm: "Things were too bad to write about. . . . It was as bad as the war." Ernest had, however, done a piece for the magazine *The New Masses,* which "should be out this week," and which told "what it was like on the keys when we got up there as a relief expedition." He asked how Sara was and answered the question himself with a somber assessment: "This has been a hell of a year or maybe it is just that they are always as bad but your numbers only come up on the wheel all in one season. I've gotten the feeling that maybe I am bad luck and that I should not have to do with people. The last thing was finding three hundred men drowned at . . . Lower Matecumbe, where you and Ada and I landed that night when you were going up to Miami to get the plane."

Sara responded promptly, on September 18, enclosing a small sum of money, which Ernest, at the peak of his writing career, probably did not need. "Just by a curious coincidence," she explained, "some of my mother's estate has just this month been settled up (she died eighteen years ago), and so I have some cash. . . . Before it is reinvested, will you . . . do me the greatest compliment one friend can do another and take some. . . . We have plenty—we don't need it. We have no boy to put through school. . . . It is cheaper to live at Saranac. Gerald has a good salary. Our friends are the dearest things we have (after the daughter, and she is fixed up), and you know where you come on the list of friends. . . . I swear I would take it from you if I needed it. It is just a short cut, if you really want to start your book. . . . I know you can make the money, but why wait?"

Sara expressed anxiety over Ernest's despair. "And please don't say that again," she implored, "about being bad luck. It isn't true. It's a lie. When have you been anything but good to people? I have been thinking that perhaps I was a jinx for my family—or, worse still, that I was negligent in not seeing that they were ill in time, or how ill they were. But we must not any of us think those thoughts, because that is destructive. . . . I won't if you won't."

Ernest would not be the one to tell Sara that she had *over*protected her children and that her germ phobia might have been a factor in the boys' illnesses. It was such a cruel thought that few friends or relatives would even mention it behind Sara's back, much less to her face. Noel Murphy, Sara's sister-in-law, was an exception. "I told your parents all that overprotection . . . was ridiculous," Noel told

Honoria in 1981. "I told Sara, that's the way you catch germs, and Fred tried his best to tell Gerald." From Hemingway, Sara only sought—and received—sympathy and encouragement, and she offered him the same. "You are a stimulus and an ideal for your friends, that is what you are," she wrote Ernest in September 1935. "You are something living in a dead or dying world, to hold to. You are generous and warm-hearted and you *know* more than anyone I can think of. Am I being fulsome? Because I could go on for such a long time."

When she wrote the letter in September, Sara probably had no idea how destructive Ernest's thoughts had become. "Along before Christmas I had gotten as gloomy as a bastard," he wrote on February 11, 1936. "Thought was facing impotence, inability to write, insomnia and was going to blow my lousy head off." He said he then realized it was because he "was overworking and not getting exercise," so he "started going out in the stream and fishing again and in no time was swell."

During the period of his depression—on December 8, 1935—Hemingway had written Sara a wry commentary on his psychological musings, though in the context of Ernest's suicidal bent, it reads as though it was a rare Hemingway attempt at black humor. "Seem, at this late age," he wrote, "to be made up of two people. One can stay out all night, drink like a fish, and sleep anywhere provided not alone, and keep a moderately even disposition. Other has to work like a sonofabitch, has a puritan conscience about work and everything that interferes and has to get to bed by at least ten o'clock. Only place these rival skyzophreniacs [*sic*] agree is do not like to sleep alone. Schyzo number two or the Moneyproducer, rather than He Who Gets Slopped, . . . also likes to read in bed and would kick Miriam Hopkins [the actress] out if she objected."

Ernest wrote again from Key West on February 27, 1936, responding to a note in which Sara had remembered being in Florida the year before when Baoth became ill. "Poor Sara," he wrote. "I'm sorry you had such a bad time. These are the bad times. It is sort of like the retreat from Moscow and Scott is gone the first week. . . . But we might as well fight the best goddamned rear guard action in history, and God knows you have been fighting it."

Hemingway detailed for Sara a fistfight he had had with Wallace Stevens, the poet. "Nice Mr. Stevens," he wrote. "This year he came again and first I knew it my . . . sister Ura was coming into the house

crying because she had been at a cocktail party at which Mr. Stevens had . . . [told] her forcefully what a sap I was, no man, etc. So I said, . . . 'All right, . . . we've had enough of Mr. Stevens.' So headed out into the rainy past twilight and met Mr. Stevens, who was just issuing from the door having just said, I learned later, 'By God, I wish I had that Hemingway here now. I'd knock him out with a single punch.' So who should show up but poor old Papa and Mr. Stevens swung that same fabled punch but fortunately missed and I knocked all of him down several times. . . . Only trouble was . . . I still had my glasses on. . . . After I took them off Mr. Stevens hit me flush on the jaw with his Sunday punch. . . . And this is very funny. Broke his hand in two places. Didn't harm my jaw at all and so put him down again."

Stevens asked Hemingway the next day to tell no one about the fight, and Ernest, who actually admired Stevens as a poet, for the most part complied. "But you must not tell this to anybody," he cautioned Sara. "Not even Ada, . . . and the official story is that Mr. Stevens fell down a stairs." Ernest could not, however, resist one final boast. "You can tell Patrick. It might amuse him. Tell Patrick for statistics sake Mr. Stevens is 6 feet 2 weighs 225 lbs." He neglected to mention that Stevens was twenty years older, overweight, and inexperienced at boxing.

When she wrote to Ernest on May 21, 1936, following her visit to Havana, Sara was feeling better. "Oh, Ernest," she wrote, "what wonderful places you live in and what a good life you have made for yourself and Pauline, and what a lot of people you have made love you dearly. . . . A more generous and warming and understanding friend doesn't exist."

In July 1937, Hemingway, MacLeish, and Dos Passos completed a film they had made for the purpose of raising funds for the Loyalist cause in Spain. "Ernest . . . took the film to Hollywood and showed it and raised $15,000 for ambulances," Ada MacLeish reported in a letter mailed July 23 to Sara and Gerald, who were traveling in Europe. "It was also shown at the White House, and the President was much interested and asked why they hadn't put more propaganda in it." Ada said that she and Archie had gone to New York for the first showing of the film, *The Spanish Earth,* and it "really is a fine thing." There had, however, been a disturbing clash of temperaments. "Ernest succeeded in making everything as diffi-

cult as possible," Ada wrote, "with insults for one and all. Archie has all my admiration for the way he has taken the whole thing over (Dos can't do a thing because of Ernest's attitude)." Ada said that Archie "has kept a decent relationship with Ernest because of the film," but that, once it had been sold, he would resign from a company he and Ernest and Dos had formed, Contemporary Historians. "I wish to state in writing," Ada declared, "the MacLeish family . . . will find it entirely convenient to stay out of Pappy's way for all time."

It was not a feud in the sense that there had been a specific disagreement, apparently—it was just that Hemingway, as he got older and more unreasonable, was harder and harder for most people, Sara being an exception, to suffer. When Ernest previewed the Spanish war film in Hollywood in July 1937, there was a party at Dorothy Parker's house, which Fitzgerald reluctantly attended. "This was the last time Fitzgerald saw Hemingway," Scott's biographer, Matthew J. Bruccoli, wrote, "and there is no record that they talked." The next day Fitzgerald sent Hemingway a telegram: "The picture was beyond praise and so was your attitude." Carlos Baker, Hemingway's biographer, explained that Fitzgerald elaborated on his reaction to Hemingway's "attitude" in a letter to Maxwell Perkins, Fitzgerald and Hemingway's editor at Scribners, as having had "something religious about it." Ernest, according to Baker quoting Scott, "was keyed up to a kind of 'nervous tensity' that sent him into and out of Hollywood 'like a whirlwind.'" Bruccoli found evidence, though, that Scott's praise was mixed with envy and self-pity. In his *Notebooks,* Fitzgerald wrote: "I talk with the authority of failure—Ernest with the authority of success."

Sara was obviously aware of the bad feeling toward Ernest, but she refused to be fazed by it. She wrote from Paris on September 20, 1937, to Valencia, on the Spanish Mediterranean coast, from where Ernest was covering the civil war. "I can't tell you how glad I was to get your wire this A.M. and know everything is all right," she wrote. On the same day, Sara and Dorothy Parker sent Hemingway a package containing, among other delicacies, *poulet roti à la gelée, jambon à la gelée, truite saumonée,* and *tripe à la mode de Caen.*

Gerald, on the other hand, was quite concerned about Ernest's moody behavior, which he had learned about from Archie and Dos. He was returning home from Europe on the *Ile de France* in September 1937, when he wrote to "Sal and Daughter," who had stayed

behind in Paris. "I've been thinking a lot about Ernest," he wrote. "He dreads life becoming soft for him (or anyone he likes), and if it threatens to, he takes it in hand. The Crusades would have given him a chance. Today he must make his own. Never being in his field (as Dos and Archie . . . are), he has never done anything violent to me, and tho' I have been terribly critical and think that at times he has been pretty nearly a cheap sport, I find it easy to revive my affection for him."

Was Murphy showing an ambivalence, considering how he had disclaimed any fondness for Hemingway in the letter to MacLeish five years earlier? Or was he speaking more kindly about Ernest for Sara's sake? Probably a little of both. "Don't worry about what I'll say about him to Archie and Dos," Gerald continued. "It seems to me an impertinence to try to negotiate an understanding. . . . Possibly it will all right itself."

Murphy considered Hemingway "critical and unforgiving," but he still admired—and was awed by—his artistic power. "Ernest will have given his life *one* thing," he wrote in the letter to Sara and Honoria in Paris, "and that is scale. The lives of some of us will seem, I suppose by comparison, piddling. . . . For me, he has the violence and excess of genius."

* * *

I was not aware of any rancor toward Ernest in those days. In fact, some of my most pleasant memories of the Hemingways are of the times I saw them in 1938 and 1939. I ran into Ernest in the fall of 1938 in Paris, where I was living and studying the history of French theater. We had drinks in the bar of the Crillon Hotel, and I asked him how he liked the way I had done my hair in a bun. He grumped, though not so it offended me, "Too many hairpins, daughter." I immediately removed the thirty hairpins. "I have seen Ernest twice," I wrote my parents, who were back in New York. "What a wonderful man he is—so sweet."

In February 1939, Mother and I went to Key West, where we rented a house Ernest had found for us. I spent just about every day sitting by the Hemingways' pool, although I was afraid to swim at first, because Ernest kept a large pet turtle in the pool. He convinced me, eventually, that there was nothing to fear. He cautioned me, however, against swimming in the ocean. "There are barracuda, daughter," he said. "They are very dangerous." In the evenings we went bowling, and Ernest was amused at my wearing high-heeled shoes.

I remember one day in particular, when Mother and I went to lunch at the Hemingways' lovely house. The impressions are still vivid: heavy tropical foliage and trees that leaned over the pool; large pieces of Mexican furniture made of dark wood, placed sparingly on colored tile floors; white walls with a portrait of Ernest in the living room and many photographs of him here and there.

Pauline greeted us at the door, and Ernest came down a while later. He was finishing a chapter of a book—*For Whom the Bell Tolls,* I believe—and he said he needed a drink. Pauline then served a beautiful lunch—cheese soufflé in individual crocks, green peppers stuffed with cream cheese and tomato sauce and served hot (Mother called them "peppers Pauline"), crisp French-fried potatoes, salad, and key lime pie.

After lunch, Ernest and I had a talk by the pool. It was a serious talk, and I felt as though he was trying to get into my head, but it was different than with the headmistress of Rosemary Hall, in that I wanted him to. He asked which of his writings I had read, and I said I did not read very much. He then said very solemnly, "Daughter, there is one you must read. It is a story called, 'The Short Happy Life of Francis Macomber.' " It was his favorite short story, and it is my favorite, too.

* * *

The Murphys did not hear from Hemingway as often in the late 1930s, although his occasional letters to Sara were warm and intimate. During the period that he was breaking up with Pauline, who remained in Key West, Ernest lived in Cuba, first at the Hotel Ambos Mundos and later at the Finca Vigia in San Francisco de Paula. The Finca had been picked out by Martha Gelhorn, a magazine writer and aspiring novelist from St. Louis, whom Ernest had met while she was on vacation in Key West in 1936. Martha Gelhorn would become the third Mrs. Hemingway.

Ernest had completed 243 pages of *For Whom the Bell Tolls* when he wrote to Sara in Paris on June 13, 1939. The beginning of the letter was a parody of his own recognizable narrative style. "Dearest Sara: How are you and goes everything and all of it? Here it is blowing a huge storm, close to a hurricane, and the royal palms are bent over in it and the branches clashing all out in one direction and the mangoes are scattering down and trees are going down in the gusts and it's been raining two days and two nights with me in bed with a bad head and chest cold." He had been finding a little time to fish and to go to the jai-alai matches, but his writing had preoccupied

him. "I work and work until I am too dead to think or write or anything and am happy doing it because that is what I am meant to do. But when I finish I will certainly like to raise hell."

Pauline was on a trip with her sister, Jinny Pfeiffer, and although she had sent, as Ernest said, "a fine letter . . . when they got to N.Y.," it was clear that the marriage was finished. Ernest was obviously lonely, which might explain a longing that was expressed to Sara without restraint: "I never could thank you for how loyal and lovely and also beautiful and attractive and lovely you have been always ever since always. I hope you are having a good time, dearest Sara. Give my love to Honoria and much love to you. I wish we were killing this lovely afternoon together. It is a beautiful storm."

Ernest wrote to Sara again six months later—on December 27, 1939. He told her of a Christmas he had spent with his Patrick, who had come to Havana from Key West. "Weren't you my Sara to write," he wrote, obviously lonely and dejected. "Do you know it was the only Christmas greeting or present or anything of any kind I had?" But, he assured her, "Patrick . . . and I had a fine Christmas, with great wheelbarrow loads of suckling pig being trundled by the old Ambos Mundos and everybody happy and jolly and I had that orchestra play, 'No Hubo Barrera en El Mundo' for you." He had nearly completed *For Whom the Bell Tolls,* which was published in 1940, and he was pleased with it. "Must finish this book," he wrote. "With a little luck and with a little less being slugged over the head . . . it can be the best one that I have written."

The remark about "being slugged over the head" was directed at Pauline and the collapse of their marriage, and he showed some bitterness. "I hope you didn't get the impression," he wrote Sara, "that I was away for Christmas . . . of my own free will. I think it was sort of a frame-up designed to get me to commit suicide. One can get gloomy if absolutely alone on one of those festive occasions and I think usual procedure is to kick people out of their homes the day *after* Christmas." But he said he had "refused to get gloomy or drunk or suicidal. Just got jolly the way we used to get jolly when things were too bloody bad to be born." Hemingway's play on words was no doubt intended.

By December 1940, Ernest had married Martha Gelhorn. They had come to New York, but he had not called the Murphys, and Ernest explained why in a letter to Sara. "New York was a mad-

house," he explained, "but in any kind of madhouse I would find plenty of room to go and see you and Gerald but I felt sort of strange about the honeymoon business . . . and the rush of people anxious to shift their allegiance from Pauline to Martha had me sort of disgusted too. So I didn't go see Ruth Allen [the wife of Jay Allen, a foreign correspondent who had been with Hemingway in Spain and who, in 1940, was covering the war in France] nor you nor other oldest friends (I have no closer friends than you) because it seemed sort of vulgar. . . . I mean I didn't want to strain your loyalties, altho [*sic*] I always marry good wives, as you know."

Ernest need not have worried about straining the Murphys' loyalties: they were saddened by the divorce and remained close friends of Pauline. In September 1939, Gerald had written to Scott Fitzgerald of a trip to Florida, on which he and Sara had seen Pauline. "She seems to me forlorn," he wrote. "I guess women who really love have always been."

Ernest was excited about the success of *For Whom the Bell Tolls,* and he said so, immodestly, in his December 1940 letter to Sara. "Wasn't it a hell of a book? It is just about three times as good a book as I can write so am in no particular hurry to write another. . . . Was explaining to Patrick that every time I sell hundred thousand copies I forgive some son of a bitch and when sell one million would forgive Max Eastman [whose review of *Death in the Afternoon* in 1933 had enraged Hemingway, who believed his manhood had been questioned]. But Patrick said, 'No, Papa, I prefer that we leave it as it is.' " There was a closing note about Scott Fitzgerald, who had just died. "I feel as you do about Scott," Ernest wrote. "Poor Scott. Yes, Scottie is the one to help now. No one could ever help Scott but you and Gerald did more than anyone."

There was a newsy letter to Sara on August 14, 1941, in which Ernest talked of a trip to China with Martha, of a wine-drinking escapade in Idaho with Dorothy Parker and Alan Campbell, and of a visit with MacLeish, who had gone to Washington to become the Librarian of Congress. "Archie was fine," Ernest reported. "I made all up with him because what are people doing nursing old rows at our age? I don't think we ought to be nursing anything. It isn't dignified. But certainly not old rows." That there had been a row would explain the "distant thunder about Ernest and Archie," which Fitzgerald mentioned in a letter to Murphy in September 1940.

The last of the "Dearest Sara" letters was dated May 5, 1945, and sent from Havana. At least it is the last one Sara saved. It would be quite understandable, recognizing the personal tone of some of Ernest's letters and his inclination to embarrassing candor, if some were destroyed. By 1945, Ernest had broken up with Martha Gelhorn: ". . . it's hard to say exactly where," he wrote. "But I need a wife in bed and not just in even the most widely circulated magazines."

Male chauvinism was not a widely recognized problem in 1945, but Hemingway epitomized it, nonetheless. "Been in love with a girl named Mary Welsh since last June," he wrote in the letter to Sara on May 5, 1945. "She wants to quit work and have children and look after me and I need that plenty. . . . Also she is the only woman besides you who really loves a boat and the water." He had news of his three sons: Bumby had been wounded and captured in the war but was safe and well; Patrick had had a tuberculosis scare due to a defective x-ray plate, which had caused Ernest to think a lot "about you and our other wonderful Patrick"; and Gregory, or Gigi, was "husky, funny, very good shot and athlete, good company."

Ernest told of his experiences in the war—of how, as a correspondent for *Collier's*, he had covered the action in France through the liberation of Paris in August 1944. "Then in July of last year," he wrote in May 1945, "went with an Infantry Division for the St. Lo breakthrough and stayed with them, or up ahead with the French Maquis . . . through Normandy, up to Argentan and then Chartres, Epernon, Rambouillet, Toussus le Noble, Buc, Porte Clamart, Bas Meudon, Porte de St. Cloud, Auteuil, Hotel Majestic, the Etoile and on down the Concorde and into the Vendome. We liberated the Travellers Club and the Ritz and I kept a room at the Ritz from then on to come back to from the front. Michel, George the Chasseur, all the barmen are fine. . . . Coldest and snowiest winter I ever saw in Europe and terrible fighting, Sara, all winter long. I came back when I knew we had the German army broken. Was fairly badly beaten up with three concussions and hadn't seen the kids for a year and Drs. said ought to take three months complete rest, . . . so thought would go to the showers instead of waiting for the pulling up of the goal posts."

Of particular interest to Sara and Gerald was word of their good friend Picasso, whom Ernest had seen in Paris. "His stuff painted

while the krauts were there is very good. . . . I call Welsh my pocket Rubens and he was going to paint her but we didn't have time." Ernest and Mary Welsh were married on March 14, 1946, in Havana.

While there apparently were no more letters from Ernest, the Murphys did hear about him from Dos and Archie. "The old Monster . . . had his weight down and seemed in splendid fettle," Dos wrote from Havana in September 1948. He had been to a send-off for Ernest, who was sailing for Europe. "The trouble with the party," he said, "was . . . the fact that the steamer, which was Polish, kept forgetting to leave. First it was 10:30, then 12 noon, and then when I had to tear myself away to go about my business, 4 P.M. The good old Monster kept ordering up more giggle water."

"Did Sadie hear of Ernest's death before she heard of his undeath?" Archie asked in a letter to Gerald in early February 1954. He was referring to a well-publicized airplane crash in Africa, which Ernest and Mary had survived with cuts and bruises, though there were some anxious moments when the news agencies reported them missing. "Our phone was ringing as we walked in," Archie wrote, "and it wasn't till the next day that we knew it wasn't true. I must say I suspected it wasn't. He's immortal."

In the fall of 1960, *Life* published "The Dangerous Summer," Hemingway's account of a *mano a mano,* a series of bullfights in Spain by two accomplished matadors, Luis Miguel Domínguin and Antonio Ordóñez. Gerald found the piece "stunning," and it reminded him of the trip with Ernest to Pamplona in the summer of 1926, which he described in a letter to Calvin Tomkins. "Our rooms at the Hotel Quintana were opposite the rooms of Villalta and Niño de la Palma [two matadors of the day—Niño de la Palma was the father of Antonio Ordóñez] along a narrow corridor. Their doors were always open, and as we passed we could not help but see them lying long, flat, and thin in their white cots (bed facing away from the door) with their hands folded on the counterpane, a sheaf of gladioli beside them and a picture of their Saint on the wall. . . . One of the *cuadrilla* was always sitting on a low stool at the door on guard. One day, a bull's horn had pierced Villalta's jacket without touching him. His *cuadrillero* was mending it. As we passed we stopped. He showed us the clean round hole through the heavy

material encrusted with pure gold metal bullion. As I took the jacket in my hand I was startled by the weight of it."

On May 24, 1961, Sara wrote to Ernest at the Mayo Clinic in Rochester, Minnesota. She had read reports of his various ailments —kidney trouble, hypertension, the usual penalties of high living —but she was having none of it. "It isn't in character for you to be ill," she wrote. "I want to picture you, as always, as a burly bearded young man, with a gun or on a boat. Just a line, please. I always remember old times with the *greatest* pleasure and that you were helpful to me at a time when I certainly needed it. We hope sometime to meet Mary too. Affectionately, your *very* old friend, Sara."

Sara did not hear from Ernest. On July 2, 1961, he took a favorite pigeon-shooting shotgun from the rack in the basement of his home in Ketchum, Idaho, and shot himself. "Sara is repairing slowly, but it's been a wretched business," Gerald said in a note to Calvin Tomkins on July 10. "Ernest's death affected her deeply. We've been dreading it for some time. She had written him . . . assuring him that his illness would pass, that it was unlike him to be ill. Apparently he decided he wouldn't wait to find out. He always warned us he would terminate any such situation. Possibly one has the right. I don't know. But what happens to the 'grace under pressure?' Gary Cooper, his great friend, apparently had another kind of courage."

In two more years, Gerald would learn that he would die of cancer, as had Gary Cooper, the actor, whose kind of courage Gerald really admired.

A reason—perhaps *the* reason—that memories of Sara and Gerald have endured is found in the letters to and from their friends. Repeatedly, as one reads the letters, certain themes appear—generosity, steadfastness—serving to explain why the Murphys were held in such esteem by the Fitzgeralds, the Hemingways, the MacLeishes, the Dos Passoses, and so on. And there is this important point about the letters: they represent a form of artistry, which all but disappeared with the Murphys' generation.

If any one of the Murphys' friends exemplified the art of letter writing, it was Katy Dos Passos, who wrote faithfully to "Mrs. Puss" or "the Pussers" over the eighteen years that she knew Sara and Gerald. Katy was witty, even a bit caustic, when it seemed

appropriate; she was a fount of news; and her stories were vividly descriptive.

"The big fishermen work over catching the big fish like Russians on a subway," she wrote in June 1935 from Bimini, where she and Dos were vacationing with the Hemingways. "They've got it all charted and organized and they're all out for records, and madly jealous of each other. The fish are huge—a thousand-pound tuna, eight hundred-pound sharks, six hundred-pound marlin. We had the tuna on the line for eight hours. Ernest finally brought him up alive and almost landed him, when five sharks rushed at him at once. They come like express trains and hit the fish like a planing mill—shearing off twenty-five and thirty pounds at a bite. Ernest shoots them with a machine gun, but it won't stop them. . . . I was really aghast, but it's very exciting."

Katy had written for magazines and had co-authored two books, and her social and political commentary was incisive and candid, but, above all, she was warm and admiring. "Oh, Mrs. Puss, I do miss you so," she wrote in July 1935. "I suppose you know you are my ideal." She was writing from Cape Cod, where she and Dos were spending the summer. "We have the most absurd neighbors here, by the way. They are pansies—not the bohemian intellectual or even theatrical kind, but purely homekeeping and domestic. . . . They spend all day in household tasks, and all day long they keep up a little tattle and chatter about their doings. 'Now, where did you put those rags, Jim?' 'Dickie, did you sweep the rugs?' "

By November 1937, the Dos Passoses (Gerald was ever tempted to refer to them in the plural as the Doi Passoi) had abandoned Key West and were living all year on the Cape, having bought a house in Provincetown. "Things are very quiet here—tranquil would be the literary word," Katy wrote. "A neighbor was robbed of $400 yesterday, but the criminal just took the money and walked up and down the back shore where he was instantly apprehended. He apologized and said he just wanted to see how it felt to have $400 on him—cash. So nothing was done."

The tranquillity ended abruptly over Christmas 1938. "It started out very beautiful," as Katy described it, "with candlelight and wreaths and eggnog parties and music and everybody kissing, . . . and then on Christmas Day at a goodwill gathering . . . a man and wife fight broke out. Bud, a young writer from the West, struck his wife Sally, and then Eben knocked Bud down and they fought

like wildcats in the kitchen till reconciled. . . . They all had a loving cup together, but as soon as he drank it Eben knocked Bud down again. . . . And then for no reason at all a quiet man who hadn't said a word all evening rushed over and struck his wife. The whole party rose up in disorder, and now Sally is suing for divorce, and there are black eyes and broken friendships all over town."

Katy was seriously distressed by the news from Europe—of the Munich Pact, in particular. "Aren't the papers awful?" she wrote. "They simply blow up in your hands. . . . World events, war, politics, elections . . . Hitler, Stalin, Republicans, Democrats, . . . whither are we drifting? You can't enjoy drifting if you try to find out whither. Think I will let Archie find out whither—I know it's somewhere in the stacks of the Congressional Library."

MacLeish had gone to work for the Roosevelt administration in October 1939, first as the Librarian of Congress, later as Assistant Secretary of State. "Archie is now working nights," Katy wrote Sara from Washington, where she and Dos were visiting in March 1940. "He appeared before the Senate and *wowed* them, Ada said. I'm sure he did. . . . Archie for President! Ada admits he wants to be a Senator. He'd make a lovely Senator." In December 1944, Katy had more to say about Archie's career in Washington. "Think of Mr. MacLeish in the pilot house of the Ship of State. 'Tis an elevation for any man to find himself in a situation to influence and even somewhat control the destinies of his country—how much more so for one whose patriotism must be so enlarged as to consider the world as his country and regard in all his undertakings the total advantage of mankind. Oh dear, I feel quite elevated when I think of our MacLeish."

That same December, Dos was in the Pacific as a correspondent, and Katy was alone in Provincetown when she wrote to Sara. "Darling it is Christmas and I cannot help but feel a rather queer and forbidding Yule with personal and world conditions what they are. I cannot help but notice that Dos is not here, that the war is almost too awful to endure, that minor catastrophes like the bulkhead caving in seem to accumulate. Heavens, what a letter for Christmas morning. . . . Dos writes that he is having a most exciting time, that Honolulu is madly beautiful, that he is seeing all sorts of people, that everything is jammed and crowded beyond belief, that he is crazy about our armed forces, that he is going into what they call the 'forward areas' soon."

She admitted in March she was worried about Dos. "I worry subconsciously as I will not allow myself to worry in the open. But yesterday I had a cable saying he would be home soon. He has left the Philippines and his last letter from a strange island seemed to indicate New Guinea. He has had a really hair-raising time and several close shaves. While flying over the burning city of Manila, . . . a Jap shell . . . crashed through the right motor of the plane. If there had been any enemy planes in the sky, he wrote, they would have been a sitting duck." In April, however, she got word that Dos was coming home. "He said he would telephone me from San Francisco."

Nearly all of Sara and Gerald's friends were ten or more years younger than they, which was so because they chose it to be—they enjoyed the company of younger people. By the 1940s, however, the generation of friends was nearing the mid-century mark, and, as people do in more mature age, Katy Dos Passos became retrospective in her letters. In August 1945, she wrote Sara that she had read "The Crack-Up" by Scott Fitzgerald. She said she had been "held by it in a trance of personal fascination and sadness, with a sense of Time and of the Past blowing through the book, like a night wind from the marsh, sweet and deathly. . . . The strange thing . . . is," she had concluded, "that this Past, which is so close and really ours, seems already as far distant as the Parthenon—not quite that far perhaps, but it seems very long ago."

In March 1947, Katy told Sara of a visit to Key West. She had seen Pauline Hemingway, who had become a decorator. "She does nightclubs, . . . has bought a house in . . . town for her shop, and seems very busy." Divided loyalty in the aftermath of the Hemingway divorce had been difficult for Katy, who had come to know Pauline well as a neighbor in Key West in the 1930s. At the same time, she had been a close friend of Ernest as a youth during summers in upper Michigan, and even though she was almost six years older than he, there is evidence that they were briefly engaged at one time. Townsend Ludington, John Dos Passos's biographer, wrote that Katy once confided as much to a friend, "although one suspects Katy of slightly flippant storytelling."

Katy and Dos went to London in August 1947, as Dos had an assignment from *Life* to do an article on the British economy. His political attitude had swung from left to right over the years, which

undoubtedly affected his grim assessment of Labor Party rule. "Britain's Dim Dictatorship," his piece in *Life* was titled. "The dark side is inside," Katy wrote, having first praised the British people. "Sara, there's nothing to eat but flour and tea." She had visited the Mark Cross factory at Walsall and had found it "a most energetic . . . setup in the distracted and, I fear, collapsing economy of this island." Katy advised they were departing England August 21 on the *Queen Mary*. "Send a great deal of love," she said.

The envelope, postmarked Southampton, England, 20 August 1947, and addressed to Mr. and Mrs. Gerald Murphy, 131 East 66th Street, New York City, was marked by Sara in pencil, "last letter." Katy and Dos, with Dos at the wheel, were driving from Province-town to Old Lyme, Connecticut, late in the afternoon of September 12, heading west into a blinding sun. Just outside Wareham, Massachusetts, they hit a truck, parked on the side of the highway. Katy died instantly; Dos was injured severely.

A friend of Dos and Katy, who had gone to the scene from Provincetown, placed a call to the Murphy apartment in Manhattan the next morning. Gerald took it and then announced to Sara and Honoria, "We have lost our Katy. They fear Dos will lose an eye." He was scheduled to leave in two hours on a European buying trip for Mark Cross. "Dow-Dow hated to leave," Honoria recalls, "but he had no choice." Gerald, who was making his first transatlantic flight, wrote to Sara right after taking off and mailed the letter from Gander, Newfoundland.

"We're veering over Connecticut," he wrote, "and Montauk goes out to sea. . . . Over Boston now, and I think of dear Dos lying there below, and of the anguish in his mind when he wakes, the anguish that he cannot be spared." Sara, he knew, was on her way to Boston, to see Dos at Massachusetts General Hospital. "Write me how they say he is in mind," he wrote. "Where *can* he put this nightmare? Where can he go that Katy will not be? I keep wondering what he'll do. Stand it, I guess." Sara wrote Gerald in London about Katy's funeral in Truro, on Cape Cod, and about her visit with Dos. "He cried, and the tears flowed from his one good eye," she had told Honoria.

Dos coped with Katy's death by getting back to work. *Life* had commissioned him to do another piece, and to obtain material he went to Coon Rapids, Iowa. "It's wonderful here," he wrote Sara on

November 5, 1947. "Nobody talks about anything but corn and hogs and oats and fertilizers, and it's a liberal education on the art of farming." He also found comfort in the Murphys' friendship, Sara's especially: "warm, cozy, humorously concerned with people," Dos wrote of her in a memoir, *The Best Times,* "with a great knack for the arrangement of furniture or food—if you were a friend of hers you never lacked just the right cushion in your chair before you sat down on it."

"You see now we have all come to the part of our lives when we start to lose people of our own age," Ernest Hemingway said in the letter to Sara and Gerald after Baoth died. "We must live it, now, a day at a time and be very careful not to hurt each other." Ada MacLeish put it another way in a letter to Sara and Gerald following the sudden death of Philip Barry. "It's so easy to be casual about our oldest friends," she wrote on December 8, 1949. "Then the lightning strikes, and one realizes how valuable was the relationship we have lost—and to think more seriously and thankfully of the ones that remain." But it was Archie MacLeish who addressed mortality the most eloquently and the most optimistically.

"Featureless horizon, yes," Archie wrote in September 1963, responding to a note from Gerald, who had said his therapy following an operation for cancer was gazing out over the ocean in East Hampton. "That is precisely what one sees from the uninhabited bare hills old men climb to, though only you would think of the just word. But the point is—or at least I think the point is—the horizon, not the featurelessness. When one expects to go on 'forever,' as one does in one's youth or even in middle age, horizons are merely limits, not yet ends. It is when one first sees the horizon as an end that one first begins to *see.* And it is then that the featurelessness, which one would not have noticed, or would have taken for granted before, becomes the feature. Ends are the hardest thing in the world to see —and precisely because they aren't *things,* they are the end of things. And yet they are wonderful. What would life be without them? Or art—imagine a work of art without ends: it would be worse than a novel by Thomas Wolfe. So . . . this featureless sky is as far as it is possible to be from negation. It is affirmation. It says the world is possible to man because to man there are horizons, there are beginnings and ends, there are things known and things unknown. Frost said (I don't believe he thought so) that the world was God's

joke on him. Meaning, I suppose, that because we die, because everything dies, vanishes, blows away, our lives are nonsense and our works worse. But it isn't true. Because if we didn't die there would be no works—no works of art certainly, the only ones that count. There would be no painter's line to include and exclude and so create. Death is the perspective of every great picture ever painted and the underbeat of ripe men who can sit as you do and look at a featureless sky above an endless sea that does, nevertheless, and at that point, *end.* I like to think of you there looking. . . . We have time to think of all this, you and I—much time— summers and winters. And time, I hope, trust, and pray to talk about it. Because *now* there is so much to talk about. No richer gift to any of us than a glimpse of death, . . . even to one who has had to live with death as much as you, or one whose glimpse was as brief as mine. Think of you? You would not believe how much or with what love. We will see each other soon. Meantime a great hug to that darling ever young Sadie."

In *A Moveable Feast,* an account of the Paris years written during a period of illness and depression and published posthumously in 1964, Ernest Hemingway had unkind words for some of his old friends. "The rich came led by the pilot fish," he wrote, describing his introduction to the Murphys by Dos Passos. " 'No, Hem, don't be silly and don't be difficult,' " he quoted Dos as having said beforehand. " 'I like them truly. Both of them I swear it. You'll like him (using his baby-talk nickname) when you know him. I like them both truly.' Under the charm of these rich," Hemingway wrote, "I was as trusting and as stupid as a bird dog . . . or a trained pig in a circus."

In notes to his 1969 biography of Hemingway, Carlos Baker printed a longer explanation of Hemingway's resentment, which had been deleted from the manuscript of *A Moveable Feast.* ". . . the rich," Ernest had written, "never did anything for their own ends. They collected people then as some collect pictures and others breed horses and they backed me in every ruthless and evil decision that I made. . . . It wasn't that the decisions were wrong although they all turned out badly. . . . I had hated these rich because they had backed me and encouraged me when I was doing wrong." He was referring to the loans of money and a place to live and to the words of encouragement from Gerald and Sara in the fall of 1926, when

his marriage to Hadley was breaking up, and he was preparing to marry Pauline. "But how could they know it was wrong and had to turn out badly when they had never known all the circumstances? It was not their fault. It was only their fault for coming into other people's lives. They were bad luck for people but they were worse luck to themselves and they lived to have all of their bad luck finally; to the very worst end that all bad luck could go."

Gerald read *A Moveable Feast,* and he revealed his reaction in a letter to Archie MacLeish on May 30, 1964. "I am *contre coeur* in Ernest's book," he wrote. "What a strange kind of bitterness—or rather accusitoriness. Aren't the rich (whoever they are) rather poor prey? What shocking ethics! How well-written, of course!"

<p style="text-align: center;">* * *</p>

I don't believe Ernest ever really thought harshly about my mother or my father. The ugly words he had for "these rich" were written late in his life, when he was very ill. I certainly never saw evidence of any resentment, and I have a letter from Gregory Hemingway, who is a physician practicing in Montana, in which he explains that unfortunate passage in *A Moveable Feast.* "My mother and father loved your parents and they always thought of them as a unit, 'the Murphys,' not Gerald or Sara," Gigi wrote in 1981. "Anything derogatory my father may have written about Gerald probably stemmed from two causes: 1) Gerald was a writer's dream to caricature; and 2) my father had a terribly powerful remorseful conscience. It would give him no rest when he made a mistake so he constantly had to find scapegoats for his mistakes. But to me he always spoke of them both, 'the Murphys,' lovingly."

VI. How Different a Dawn

The Murphys went to Carlsbad, Czechoslovakia, in the summer of 1937 for rest and recuperation at a resort renowned for its mineral waters. Gerald's concern for Sara's physical and mental well-being had developed into a preoccupation—justifiably, as she was in fragile health, and despondent—and he did not want her to be left alone for even a day. Honoria was in Salzburg, Austria, when Gerald wrote to her on August 13, in anticipation of her joining them. "I must leave here on the 18th," he said, "to go to Vienna for two days. It is the day you will be coming here—so Mother will not be alone for the night." He was pleased, on the whole, with the way Sara was responding to the cure. "In spite of a little resistance at first," Gerald wrote Honoria, "the doctors and I have got her pretty well in hand, and she is now a fanatical cure-girl. We get up at seven, drink at a fountain half a mile away. . . . A rest, then . . . exercises in the gymnasium for all parts of the body, . . . then massage, electric treatments, steam or mud baths and rest, then luncheon. Delicious food, . . . no alcohol," though he did say they were allowed two small glasses of red wine at night.

Sara, in a letter to Honoria on August 9, sounded a bit sardonic, but she too was enjoying the regimen at the Park Hotel Pupp, as the spa was called. "Well here we are taking the cure in the most

'pompier' style," she wrote. "I am being very good and doing as I am told, and I'm only kicking and screaming a very little. . . . Puppy loves it." Puppy, a Pekinese, had been given to Sara by Gerald shortly after Baoth's death, and he was a constant companion. "Such a surprising number of old wounds were opened," Gerald wrote John and Katy Dos Passos after Puppy died in 1940. "He was the last tie to the boys." Puppy was buried on the grounds of the Murphy place in East Hampton.

* * *

The year 1937 was the year of my graduation from the Spence School. It was also the year I turned twenty—in December. But unlike most people of that age, I was not shaking loose my family ties. If anything, with Patrick's death that January, which made me realize that while no longer a child I was an only child, I was drawn closer than ever to my parents. Mother especially, I recognized, needed comfort. That is why I had decided to become a day student at Spence and live with her and Dow-Dow at the apartment in New York City.

I, as well as my parents, spent that summer in Europe. I first went to Salzburg and to Budapest with Alice Lee Myers, who was conducting a tour for a group of young women, which included her daughter and my great friend, Fanny Myers, as well as Scottie Fitzgerald and a few others. I then joined my parents in Czechoslovakia, and from there we went to Paris.

* * *

In early September 1937, Gerald returned to New York to attend to business, leaving Sara and Honoria in Paris. It troubled him to do so, even though they were to follow in just two weeks. "Dearest Sal: I'm going to miss you both so much," he wrote on the way to catch the boat. He sailed on September 4 on the *Ile de France* and wrote a *journal de bord*, addressed to "Dearest Sal and Daughter." It was a detailed day-by-day account of the voyage, full of small talk and gossip, for the most part, though it was the letter in which he offered his discerning assessment of Hemingway: "For me he has the violence and excess of genius." He also expressed his serious doubts about the future.

"For the first time," he wrote, "I feel that I do not know what is ahead of me in America. There's a strange impermanence . . . [there], and all through the world. . . . I'd like once to be long enough in a place to see hay around the house taken in, fruit and vegetables

grow and pumpkins and apples ripen, not to speak of flowers." He envied his friend, Fernand Léger, who was living in his native Normandy. "The Légers enjoy the *ferme* so—he originates all his pictures there now, as he told us." Gerald ended the letter with a note to Honoria: "Make Mother rest sometime during the day. Love to you both. I land today and hate facing it without you two."

Gerald's mood had not improved by the time he wrote Sara and Honoria from New York on September 14. "One wonders why one has come back. Americans all seem such . . . immature human beings. They know nothing and want mainly money. . . . Just now they are very critical of the European mess and most unsympathetic to it." Gerald had been to East Hampton for the wedding of a daughter of Sara's cousin, Sara Mitchell. The ceremony was at Dunes, the Wiborg mansion, which Ledyard and Sara Mitchell were renting from the Murphys for the summer.

Another residence was being readied for the Murphys on the property in East Hampton, and it would be named Swan Cove. An old dairy barn had been moved to the edge of Hook Pond, next door to the summer house they had occupied since 1932, which had been named for the pond. Hale Walker and Harold Heller were doing the renovation, as they had with the Villa America and with Hook Pond. "There are seven windows in the living room," Gerald wrote Sara, describing the new place. "It seems impossible at this stage to tell you where the lace curtains should go, or when things will be finished. They say early October."

* * *

I spent the winter of 1937–38 living with Mother and Dow-Dow, still in the penthouse at the New Weston, and it was then that I got actively involved in the theater. I joined a group of players, the French Theatre of New York, and I had a couple of small parts. I believed it might be the beginning of a career.

Stella Campbell was living in New York then—at the Hotel Sevillia on Fifty-eighth Street. She had given up on her movie career. "I'm through being a jackanapes in Hollywood," she had written Mother in January 1937. I took acting lessons from Aunt Stella, and she introduced me to John Gielgud when he came to New York to appear in *Hamlet*. It was Gielgud who told me, many years later, that Stella had died a pauper, in 1940, while living in Pau, near Biarritz, in the south of France.

I was shocked, though I had known Aunt Stella was hard-pressed finan-

cially. She had hoped to support herself late in life by writing a book based on her correspondence with George Bernard Shaw. "Bernard Shaw has sent six registered envelopes," she wrote me in 1937, "with all my letters . . . from 1901! Now that I have his letters and my own it will be much easier, or at least it should be, to make a book." Her hopes were dashed, however, when she was unable to obtain Shaw's permission to publish his letters at that time. She came to my father for advice, but there was nothing he could do.

*　　*　　*

Stella Campbell had been working for some time on a book about her long affair with Shaw. In May 1932, as she was about to visit the Murphys in Antibes, she wrote to "Dear Joey," as she called Shaw: "My aim will be, as you say, to write 'something vital and artistically true,' but not too elaborate, . . . but if your criticisms are too devastating, I must burn the whole thing on the funeral pyre at the Ferme des Orangers [the Murphys' small farm, at which Stella was staying]. Shaw's criticisms were not "too devastating," but he insisted that his letters not be published until both he and his wife, Charlotte, were dead. Stella stipulated in her will that when the letters were made available to her heirs they be published in full. In 1952, two years after Shaw's death, the correspondence, edited by the theater critic of *Illustrated London News,* was published. The proceeds, according to Shaw's will, were to be "used for the secondary education of Mrs. Campbell's great-grandchildren."

"Stella was penniless after the debacle in Hollywood ('My dear, all they got me out there for was to play drunken duchesses!'),'' Gerald wrote Calvin Tomkins in 1962, "and we contrived to set her up in a small hotel. . . . We sent her the rental money each month. . . . She was living, with her white Pekinese, 'Moonbeam,' surrounded by a sea of Irish-lace pillows. They [she and Moonbeam] subsisted, literally, on slivers of white meat of chicken. The management, who adored her and knew of our friendship, confided to us reluctantly one day that she was in arrears in her rent. I appealed to Stella on the basis that we were just able to manage to help her and that it worried us now to learn that we could no longer have the comfort of knowing that at least she was assured of shelter. Her expression was one of tragic innocent wonderment. . . . 'I sent the money to my dear brother. He's older than I am, and luckless.' I asked if she thought that was fair. 'I don't

really know,' she replied, 'but I've always felt that money was for those who needed it.' "

* * *

Mother and I sailed for Europe on May 22, 1938—Mother noted the date in a log she had started keeping—on the maiden trip of the *New Amsterdam,* and Dow-Dow joined us in Paris on June 6. Paris was a constant whirl—lunches at Laurent and Maxim's, dinners at the Ritz and the Café de la Paix. And there was a Stravinsky concert or a Molière play or an opera or a ballet almost every night.

The Dos Passoses arrived in Paris on the Fourth of July, and the five of us took a train to Rome on July 7. Then, on July 10, we took a train to Naples, where we were met by Vladimir Orloff, who was still the captain of our boat, the *Weatherbird.* We went on a cruise down the coast of Italy to Sicily, with a side trip to the ancient city of Pompeii.

It was a pleasant cruise. The port towns we visited, such as Amalfi, had a stage-set beauty about them, with houses of many muted colors nestled on the hillsides. There were also some sights that held me fascinated, for they related to my reading of history and the classics. The visit to Pompeii was unforgettable, and when we passed through the strait of Messina, we all went on deck and talked and thought about Scylla and Charybdis and the mariners of mythology.

Certain aspects of the cruise were decidedly unpleasant, however. There was in Italy a distinct spirit of nationalism, which was demonstrated in rather frightening ways, one of which was posters near the docks that proclaimed: THE SEA IS OURS. We also were taunted a bit, as we pulled into a port. "Hollywood, Hollywood," people chanted.

When we were in Amalfi, the Duke and Duchess of Windsor were also there. I remember wondering, as their yacht moved into the harbor, what the former British monarch was doing in fascist Italy in 1938. Much later, when I read charges that Edward VIII had been sympathetic to the Axis powers following his abdication, it made more sense to me.

Most disturbing about the cruise in 1938 was the occurrence of illness on board and how it affected Mother, who was acutely sensitive to the slightest sniffle, with obvious justification. She, for all of Dow-Dow's worries about her, stayed relatively healthy, suffering only one brief stomach disorder, "a case of the grumps," as she called it in her log, which she treated with a medicine prescribed by Vladimir—lactic acid in water. But I was often seasick, and Dos and Katy and I were all plagued by "the grumps" or a cold or a bit of fever.

Dow-Dow was the one who suffered the most. "Gerald very uncomfortable," Mother wrote in her log on July 23. "Slept most of the day." He had a severe throat infection, and it made him very morose. The infection, though it cleared, may even have contributed to his decision to leave the cruise early. "G has decided to leave tonight—business in Florence and elsewhere," Mother wrote on August 9, when we were in Messina. Dos and Katy had departed four days earlier.

Mother and I got back to Naples on August 18, exhausted. "Bed early," she wrote in her log. We caught the express train for Paris, though I got off in Florence to visit a friend from my days at Spence, Jane Faust, the daughter of the American writer whose pseudonym was Max Brand. Mother got to Paris August 21, and Dow-Dow called her from Prague to say he would arrive the next day. Mother's log entry for August 24 records my return to Paris: "G met Honoria at train." She also noted that Fanny Myers and Scottie Fitzgerald were with me when I got to the hotel. They had been traveling with Fanny's mother, Alice Lee, and we rendezvoused in Paris.

My parents sailed on September 3 on the *Paris,* and I stayed on for a few months of study and fun. "We had a lovely, restful crossing," Dow-Dow wrote on September 14. "Motored to Swan Cove, which is a paradise of flowers, trees, . . . a bower of tropical plants. . . . Mother is scratching about in her trunks and loving cooking in the kitchen." The letter warmed me. My parents were slowly coming back from the bottom.

<p style="text-align:center">* * *</p>

After he left the *Weatherbird* cruise, Gerald had gone on a buying trip, and from Florence he sent Sara some thoughts about the family business. "The M. C. Co. seems to be taking on national proportions," he wrote, "and the experts think the future important. As much as I hate to sacrifice a week (this one), . . . I feel I am right to keep *in* the situation while I'm in it. There's something in it for Honoria, I think, and doubtless about all I am capable of giving her." Gerald was also keeping an eye on the international situation. He had gone to London in late August 1938, and he sent Sara, still in Paris, a London *Times* article about unrest in Czechoslovakia, along with an account of the sixth annual celebration of the Third Reich, which had been held in Stuttgart, Germany. The *Times* articles were dated August 30, 1938, less than a month before the signing of the Munich Pact, in which Britain and France agreed to the partition of Czechoslovakia, in order to appease Hitler.

There was more immediate disaster at home. On September 21, 1938, the worst storm of the century struck the northeastern United States, and Long Island felt its full force. The aftermath of the hurricane was described in the *East Hampton Star* the following day: "The sun rose this morning on the saddest sight East Hampton has ever seen. It seemed at first that hardly a tree was left on Main Street. Business places were crushed in; fine old houses had roofs crumbled by toppling elms. A dead calm reigned. . . ." Sara and Gerald, who had been staying at Swan Cove, left for New York City just hours before the hurricane hit. They were well-advised to do so. "The water from the ocean," according to the *East Hampton Star,* "overran banks and sluiced through roadways, joining in with Lily Pond, Hook Pond. . . ."

"I just talked with Gerald," Dick Myers wrote his daughter, Fanny, in Paris on September 22, "who told me that the terrific hurricane had completely ruined their house in East Hampton. The roof was blown off, the doors and windows were blown away, the terrace . . . was blown clear across Hook Pond and the garden and trees utterly destroyed."

*　　　*　　　*

Fanny Myers and I were lodged in Paris at Madame Catelot's, a *pension,* which was a boarding house where courses in language and literature were taught. It was rather strict, with rules about such things as when we had to be in bed at night. Fanny got kicked out, because she called the *concierge* a cow for locking her out one night.

I was also taking a course in French theater, which had been arranged by Léger, and my teacher was Mme. Darius Milhaud, the wife of the composer. Stella Campbell had come to Paris by now. I would go to see her at the Hotel Brighton, where she lived, and when I left for home in December, I asked Fanny to go see her now and then.

*　　　*　　　*

"The only thing I didn't like, angel," Dick Myers wrote Fanny in February 1939, "was your seeing Stella. I know all about her, and she is a very vicious old lady with a poisonous character. She can't do you any good, and she was so horrid in Hollywood that even that den of iniquity kicked her out." Fanny felt sorry for Stella and saw her often, despite her father's admonition. She even arranged for a momentous event—the one time each year that Stella Campbell got her hair washed. "She had the most beautiful hair," Fanny recalled.

"There was a touch of gray, but it was still mostly black, even though she was well into her seventies. The reason she only needed a hairwash once a year was that she brushed it for hours every day." Dick Myers was right on one point, though—Stella could be vicious. "She scolded me once, and I got very upset," Fanny said, "but then she sent me a series of letters to apologize for making me cry."

* * *

There was a war scare in September 1938, just before the signing of the Munich Pact, and our parents—Fanny's and mine—were frantic. "All watching developments carefully," their cable read. "Hold yourselves in readiness." It sounded like Dow-Dow, and I could tell they wanted us to leave Paris, which was threatened with bombing. We got in touch with a friend of Ernest Hemingway named Pierre Robillard, who worked for the Guaranty Trust of New York, the bank my parents used. He arranged for Fanny and me to go to La Baule, on the coast of Brittany.

The first question Mother asked me in her letter of October 11, 1938, was about the "trek to La Baule" and about my impressions of the "almost war." She actually was leading up to a scolding, which I deserved. "We sailed five weeks ago last Saturday," she wrote, "and so far have had two letters, so you couldn't have written weekly, as you promised. . . . Naughty." I loved my parents dearly and worried about them every day, as I knew they did about me. There were, however, many distractions in France. It was, after all, the country of my childhood: I was fluent in the language, I loved the customs, and I had many French friends. I was just dying to stay on through the winter, but I realized—even though they said they would understand—that they wanted me home for Christmas. "We miss you DREADFULLY," Mother wrote.

Mother's letters were always breezy and upbeat, but I could sense she was striving a bit to sound content, as she told, among other things, about spending weekends in East Hampton. "The weather has been so lovely since the hurricane," she wrote in October. "We could so have enjoyed the garden, . . . if it hadn't been destroyed. And Hale and Harold had worked so hard, making it lovely." Swan Cove, she said, had been tidied up: "All the mud and fish and broken things have been cleared up, . . . so that it looks neat at least." The village, however, was another matter. "It is a shocking sight to see rows of enormous elms lying on their sides, some across houses. How the mighty are fallen, one thinks." I can now see so much meaning in that statement of Mother's. She received letters, dated October 21, 1938, from the Committee for the Restoration of East Hamp-

ton to thank her for two donations of $100 in the memory of Baoth and Patrick, which were to be used to replace two mighty, but fallen, elm trees.

Mother and Dow-Dow still were going to East Hampton on weekends. They had been there for what would have been Patrick's eighteenth birthday, October 18, to put "lots of flowers" on his grave. "The huge cypress . . . we have had so long on our plot in the cemetery," she reported sadly, "broke to pieces in the hurricane. So we must plant something else." They would be going to Swan Cove again the coming weekend, she wrote on November 2, and staying through Monday, her birthday, and Tuesday, election day. "Alice Lee and Jinny and Pauline are coming down," she said, "so we shall probably open champagne."

Mother also wrote about a renovation of the New Weston penthouse, saying, "the place looks so much nicer than last year, with the larger entrance hall. We knocked out that big coat closet, and with a big mirror at the back it looks enormous. . . . Lots of plants, bright colors and candles do the trick."

<p style="text-align:center">* * *</p>

It is clear that Sara and Gerald were emphasizing the "living well" theme of their tortured existence, and they were slowly recovering —nourished, as Gerald liked to say, by the cultural experiences they steadily sought. More important still was the encouragement they received from friends, many friends, and although this dependence on company would end in time, even Gerald, the seeker of solitude, was hardly ever by himself. As Sara had told Honoria they would, they had a little birthday party for her at Swan Cove on November 7, and they had another in Manhattan two nights later. "I'm having some people in in the evening for a cake for Mother at the penthouse," Gerald wrote Honoria. His motif for the design of the event was health, with the cake in the shape and color of a telegram, wishing her well. "Then there's one tall candle in the form of a thermometer," he wrote. "Kind of crazy, anyway." Sara herself described the party in a letter to Honoria, stressing the gaiety, though her enthusiasm seemed strained. "The Barrys came, and Ada, and Hale, and Léger [who was visiting New York], . . . also Pauline and Jinny Pfeiffer. . . . " There had been, she said, about fourteen guests in all. "We had sort of a buffet dinner, with an enormous turkey and lots of champagne, and everyone was very gay and danced to Gerald's Capehart [his phonograph]. We missed you, and everyone asked about you."

* * *

Mother and Dow-Dow kept me abreast of their artistic activities, the theater in particular. The actor Eric Portman, whom they had met in London following a Shakespeare performance by going backstage and introducing themselves, was in New York, rehearsing for an opening. "He had dinner with us tonight," Mother wrote, "and is very excited about everything." She also mentioned having told Marc Connelly, whose famous play was *Green Pastures,* that I was interested in a stage career. Connelly immediately offered to give me a role in a play he had written, provided I could be in New York within a month. "We said we feared that wasn't possible," Mother wrote.

Dow-Dow wrote on October 17, enclosing a clipping about Jean Gabin, the fine French film actor. A Cole Porter musical had flopped, my father reported, as had the Eric Portman play, but *"Oscar Wilde* with the English company is remarkable." He also told me that a novel, *War in Heaven,* by Philip Barry had been dedicated to Patrick: "To Patrick Francis Murphy II. There was in him something that was fierce and imperishable." The novel was adapted by Phil Barry as a play, *Here Come the Clowns,* which was produced on Broadway in December 1938.

The refurbishing of Swan Cove and "the reconstruction of the penthouse" had, my father advised, tired my mother. "I've had to clamp down on her. . . . She's being very obedient." Finally, Dow-Dow showed his inclination to be overly generous in indulging my interest in the theater. "Mother asks how much money you have," he wrote. "Please count up and tell us, and we'll judge if it's best to send you more. Please go to everything . . . in the good theaters. If you could see the rotten-cotten plays we go to so hopefully every night, you'd obey a nagging male parent."

* * *

Against her will, but with her parents' wishes in mind, Honoria sailed for home on the *Paris* on December 7, 1938. She knew, as the surviving child, that her well-being was dominant in her parents' minds. She was ten days away from being twenty-one years old, yet they doted on her and pampered her as most parents would a teenager who had left home for the first time. "Mother insists on a single room, outside," Gerald wrote a month or so before she was to sail. "You can decide if you want a bath or not. Now don't try to shift to tourist. The *Paris* is the most reasonable of the French boats, and the pleasantest, I feel. Your passage should cost about two hundred twenty-five dollars. . . . The rest of the money you

should have in dollars for tips. About five or six to your stewardess and the same to the table steward. The head dining salon steward gets five too, if he does anything for you. . . . Ask for a table alone at first, and you can join other people, if you want to, the next day. If you need more francs before leaving Paris, cable us, and I'll send them right over. . . . Don't hesitate to cable if you need advice." For her part, Sara was concerned about Honoria's diet. "Hope you are managing to get enough to eat," she wrote in mid-November. "You DO still get the milk, don't you."

<p style="text-align:center">*　　*　　*</p>

In January 1939, I was given an audition by Orson Welles for a small part in a New York production of Shakespeare's *Henry IV*, and, while I did not get the part, that was the high point of my theatrical career. I wanted to please my father, whose interest in the theater went beyond attendance at openings. He even did the historic research for the Richard Rodgers folk ballet *Ghost Town*, which was produced in 1939.

I was inspired by the influence of some very talented people. It was in 1939 that Philip Barry's wonderful play, *The Philadelphia Story*, with Katharine Hepburn, opened on Broadway. The following year, I had a part in another Barry play, *Liberty Jones*, which opened for a brief run on Broadway in February 1941. I was let go, however, for not being an accomplished ballet dancer.

Mother had a gall bladder operation in March 1939, and in April she and I went to Key West to visit the Hemingways. On May 25, we sailed for France again, aboard the *Champlain*. Dow-Dow did not come with us. He had his hands full running Mark Cross, and he was worried more than ever about family finances. But he was determined not to arouse my mother's concern. "Don't worry, not important," he wrote her in Paris on June 7. "Why do you persist," he asked, "in going to cheap small hotels? I don't think it pays. . . . Try a good one, on the right bank if necessary. Don't scrimp. You'll end by hating Paris."

I had brought my car over on the boat. It was a new green Chevrolet coupe, which I called "Heathcliff," because I was crazy about Laurence Olivier, who had recently appeared in the film *Wuthering Heights*. On June 4, two days after arriving in Paris, we drove to the cemetery at St. Germain-en-Laye, outside Paris, to place flowers on the grave of Dow-Dow's brother, Fred, and we went to visit his widow, Noel, on the little farm in Orgeval, which she had bought in 1926, two years after Fred died.

Fanny Myers had remained in Paris through the winter and had met us at Le Havre. She had been invited by an American student at Oxford, Lloyd Bowers, to the commencement ball, and she had accepted with the stipulation that he find an attractive Englishman for me. Fanny liked to tease me by saying that I had a passion for anything English, especially English men. Lloyd did arrange for my escort, although he wasn't English. He was a Canadian Rhodes Scholar named Alan Jarvis. I was too excited to quibble.

Mother had bought her clothes for years at Nicole Groult, which, while not a *grande maison,* was a very fine Paris couturier. She had always dealt with the head saleswoman, Madame Hélène Mermet, who had become a good friend. Mother took Fanny and me to Madame Hélène to outfit us for the ball, and she bought us the most beautiful organdy evening dresses.

We left Paris—Fanny and I, with Mother along as chaperone—in my car on June 15, a Thursday. We caught the boat from Calais to Dover and arrived in London about 8:30 P.M. The next evening we went to a play that Eric Portman was in and had supper with him after the performance. We arrived at Oxford on June 18, a Sunday, in time for lunch at Lloyd Bowers's rooms at University College.

With the beginning of the festivities on Monday, complications developed. Fanny had taken one look at Alan Jarvis and had decided he was much more attractive than Lloyd Bowers. Lloyd, in turn, had taken a shine to me, and at one point he made a pass and bit me by mistake. There was a lot of drinking going on, as we went from party to party, and we never did get to the ball. Fanny and I had gotten all dressed up, but our dates were so drunk that they decided to go to bed, having locked us in their sitting room. We were rescued just before dawn by their valet, and we trudged back to our hotel, looking quite bedraggled.

Mother thought it was terribly funny. She liked Lloyd and Alan, and when they arrived later that morning, looking red-eyed and sheepish, she invited them to come to London with us. Mother enjoyed having young people around, young men in particular, which, remembering my brothers, was easy for me to understand. Fanny and I were quite cool to Lloyd and Alan at first, but it all worked out. We went to London and had a wonderful time. We saw several plays, including a John Gielgud performance of *Hamlet* and Noel Coward's *Design for Living.* "Honoria wanted to see Rex Harrison," Mother noted in her log, "—perfectly awful." We also went to the ballet and to art galleries.

On July 2, we left London by car and arrived in Paris about nine in the evening. Mother had invited our friends from Oxford to join us on a

four-week cruise to Corsica on the *Weatherbird*. Alan Jarvis was otherwise committed, but Lloyd Bowers, an avid sailor, accepted on the spot and said he would meet us in Monaco.

<div align="center">* * *</div>

"Your letter from London about the Oxford adventure has now been read to a roaring public," Gerald wrote Sara on July 7, 1939. "I'm saving it until I see Dos and Katy and the MacLeishes." His comment was a light aside in a serious letter in which Gerald was forced, much as it was against his nature, to advise Sara of financial difficulties. "I was feeling so flush," he wrote, "and suddenly Amory wrote me a warning letter about our withdrawals of capital." He was referring to Copley Amory, Jr., of Loomis-Sayles, the investment firm, and it was further evidence that the Murphy wealth was an exaggeration. "We're down to $201,000 on account of drawing out $84,000. . . . It was the hurricane that cost us. . . . I'm only telling you because Amory wants us to know. You see, we carry an awful lot of insurance. It's the best way to protect Honoria." Finally, he assured her that their real estate was secure, "in spite of the necessary repairs to Swan Cove and . . . Hook Pond and the Big House." He had, however, decided upon one money-saving device in connection with the East Hampton properties: he had terminated the middleman services of Hale Walker and Harold Heller, "as they add ten per cent to all labor and material . . . as their fee. All charge accounts are now in my name. . . . I realize now how much pleasure I've been deprived of in not doing the things myself."

Gerald was more concerned about international developments, as they might affect Sara's trip, but he was cautiously optimistic for the time being. "It looks as if England has Adolf scared," he wrote to Sara on July 11, 1939. "People coming here from Europe feel that he is afraid to launch his blitzkrieg now. Let's hope so. At least you'll get your cruise in. Corsica should be lovely." But, for the longer run, his pessimism prevailed. "I'm glad you're motoring down through France," he said. "One has the feeling that one may not see France for a long time." He enclosed clippings about Archie MacLeish, whose appointment as the Librarian of Congress had been announced, and Gerald had reservations about it. "He must know (and he alone) what he is doing. I am only haunted by his indecision. . . . It's a life job from which no traveller returns. Possibly he belongs to the state and not to poetry. . . . Everyone agrees about its being a brilliant gesture on Roosevelt's part."

Gerald was not always kind in his comments about friends, especially if he felt they had slighted him. He had heard that Pauline Hemingway and her sister, Jinny Pfeiffer, were nearby—"up the coast somewhere," he said to Sara. "After all, I was pretty damn kind to those two boys of Pauline's," he wrote. "You'd think she'd take some pains to get in touch. Never even a word about the dog's fate," a reference to a puppy that Gerald had given to Patrick Hemingway. "The hell with them."

Having heard from Sara that she had had dinner in Paris with Léger, who had brought his mistress along, Gerald let his bitterness get the better of him. "Sorry about Jeanne," who was Léger's wife, he wrote, "and sorrier that you can't see Fernand without the Belgian cat. She's such a bore. The years one passes with the mistresses of artists, the price of bohemianism." He did, however, have a pleasant thought to offer with regard to Dorothy Parker and Alan Campbell, who were arriving in Paris in late June, and who had "sighed with envy when I mentioned your cruise to Corsica. Why not install the young on the deck and invite them as your adult life? You deserve it." Sara had dinner with Dottie and Alan on July 3 at Pierre in Paris, but either she did not invite them on the *Weatherbird* cruise, or, if she did, they did not accept.

* * *

Fanny, Mother, and I arrived in Monaco late in the afternoon of July 12 and were greeted by Vladimir and his crew and by Lloyd Bowers. We lived aboard the *Weatherbird,* but we remained in port for about a week. Mother had some business to attend to. She needed, most importantly, to obtain a certificate to send some Villa America furniture, which had been in storage, to the United States. Also, we were plagued by bad weather. In her log, Mother recorded a *mistral* on July 17. On July 18, she wrote, "Should have left for Corsica, but still *grosse mer.*"

Although Antibes was only forty-five minutes from Monte Carlo, Mother declined to go there, for the memories of the twenties would have been too much for her to bear. But Fanny and I, along with Lloyd and a friend of his, did drive up the coast one evening in Lloyd's friend's sports car. We went to the nightclub at Juan-les-Pins, the one that my parents had gone to so often in the 1920s and had taken Fanny and me to in 1934. It evoked so many memories of the good old days that I decided I had to have a fleeting look at my childhood home. We drove to Antibes and passed by the Villa America, but it was a dark night, so we did not get a very good look at the deserted buildings.

It was early in the morning when we got back to Monte Carlo, and Mother was waiting on the deck of the *Weatherbird.* Her face was ashen with worry, and I broke into tears. Vladimir was furious. "Your mother has been through hell," he said. The entry in Mother's log for that day was simple and direct: "Girls and young man out till 6 A.M."

We sailed from Port Monaco at 6:30 on the morning of July 19. It was a beautiful day, though the seas were a little rough. "Honoria not well," Mother wrote in her log. "She slept most of the day." We arrived the following day at Calvi, "a very dirty and picturesque town." We found a nightclub there and went in the evening to drink champagne and listen to guitar music. We left Calvi on July 22.

On July 23, we encountered more heavy weather, which Mother described. "Called at 7 by V, who said must leave, port untenable. Got outside and found huge seas—great difficulty passing point. A rather terrible day, almost everyone ill, including cook and steward, so nothing to eat. Boat a shambles. H never got up at all. Arrived Ajaccio about 6:30. All had drinks and cheese sandwiches. Dined later in Café Sofferino as boat picked up. Bed, as all dead tired."

From Ajaccio we went to Propriano, Campomora, Bonifacio, Porto-Vecchio, and Bastia. It was as we sailed from Bastia, which is on the northeast corner of Corsica, to the island of Elba that we had a near disaster. It was "rather rough," as Mother wrote in her log.

"Cook and steward sick again. Gin and bitters," which was her favorite drink at sea, as she believed it settled the stomach. "P.M.: Wonderful run along the coast of Elba, in lee of island. High wind, no motor, thirteen knots. Italian officials came out and told us we must either leave or go to Portoferraio. . . . Just finishing dinner, in sight of Portoferraio, when we hit hard aground. Three sickening jolts, which threw everything over on table. Thought we were on rocks. Bow up high. All terrified for boat. V in state. Then began grueling work, hauling on two anchors to pull her off. Tried also to accentuate list to port by boom, staysail, and filling youyou [a dinghy] with water. Finally, little by little after two hours of frightful work, she slid off. Tug had arrived, wishing to tow, and boatful of Italian officials. They were fairly nice—took all of our papers for visas, and we went slowly into Portoferraio. . . . All to bed, exhausted, after drink."

* * *

"We were frightened for a reason that goes beyond the threat of the boat sinking," Fanny Myers explained. "We knew there was a threat of imminent war, and we could hear the hum of the factories,

the war plants, on the Italian island of Elba. We also knew that Sara had been told to keep her eyes open, and we wondered—with some degree of alarm—if the Italians would accuse us of espionage."

"We are really having a nice trip in spite of some bad weather," Sara wrote Dick Myers, Fanny's father, from Bonifacio on July 30, 1939. "This is an indescribable port—a flat cliff approached with misgiving, and suddenly one sees that one can . . . creep through the high rocks of the port. Tonight I have a gay cocktail on deck, . . . and the girls, with Lloyd, who has worn very well, have gone out to explore the town. I don't feel so energetic, so stay here to write my letters. . . . The girls laugh inordinately. Lloyd is nice with them—there is much teasing and pushing, like young animals. I look on life as an old Chinese woman, who only needs sun and a cocktail to be as happy as a blade of grass." Sara obviously enjoyed the presence of a young man on board. "The girls are both enjoying themselves," she wrote in the letter to Myers. "They look and act superb, and Lloyd is the necessary foil. . . . If he were two, he would be love. As he is *one,* he is a brother—to tease, to argue with, to pull hair, . . . and he makes things generally sane."

<div align="center">* * *</div>

Portoferraio was not a pretty place. "Belching factories (coal and iron mines)," Mother wrote. But, the next day, we rode a horse-drawn cab to see Napoleon's house, and we toured the countryside. "Very cultivated, mostly grapes and corn, so different from Corsica," she noted. The trip back, via Bastia, Ile Rousse, and Calvi was relatively uneventful. Lloyd Bowers left us in Bastia, to catch a boat for America on August 16. At Ile Rousse, we went to a hotel, "the only good one in Corsica," Mother wrote, to take baths and wash our clothes. We arrived at Port Monaco at about 2:30 on the afternoon of August 15, and, a week later, we said good-bye to Vladimir. It was the last I ever saw of him.

Dick Myers met us at the dock in Monte Carlo, and he told Mother that we must get to Paris quickly—and out of Europe—because there was about to be a war. Dick took the train back to Paris, and Mother and Fanny and I drove up in my Chevrolet. In each town we passed through, we could hear radios blaring the news of imminent war.

<div align="center">* * *</div>

It was uncharacteristic of Gerald to write as seldom as he did that summer, and Sara recorded her disappointment in her log when she did not find a letter from him at Ile Rousse. She did get a letter from

John Dos Passos: postmarked in New York on July 24 and addressed to Sara in Paris, it had been forwarded, first to Bonifacio, then to Porto-Vecchio, and finally to Monaco. Dos Passos had written from East Hampton, where he was a guest at Swan Cove. "Gerald looks well—he's out pruning fruit trees, and in a moment we are going bathing. Love to Honoria—my that was a funny letter about England." He was referring to Sara's account of the commencement ball at Oxford and of Lloyd Bowers making a pass at Honoria. Dos showed some concern for "our Sadie," in light of the European crisis. "Frankly," he wrote, "there are going to be a lot of people very much delighted when you get home to these shores."

Sara did hear from Gerald when she got to Paris—in a letter written on July 26 and addressed to her at the Guaranty Trust, he indicated slight confusion over her itinerary. "I'm not sure where this will reach you," he wrote. As Dos had, Gerald alluded to war clouds. "I hope [the cruise] is turning out well," he said. "What luck that we had the boat for you to do it, as the Continent doesn't sound too attractive. Now the English have sold China down the river to the Japanese! There seems to be no principle left."

Gerald was also worried about the future of Mark Cross, as he explained in a letter dated August 2. "People begin to talk of an upturn, . . . though there has been no sign of it with us." A decision about the company would have to be made the following year, he said—by March 1, when loans from him, from his sister, Esther, and from Robert W. Goelet, the financier, who owned fifty percent, came due. "We shall have to make a deal of some sort," he wrote. "Esther and I are determined to hold out for a fair price, but if he refuses, there will be nothing to do but liquidate the company." A deal was made, and following Goelet's death in 1943, Gerald was able to pay off the debt to his heirs for $25,000.

On a visit to the MacLeish farm in Conway, Massachusetts, Gerald had enjoyed a reunion with Archie and Ada and Dos and Katy. "I started from New York with a jeroboam of champagne wrapped in red, white, and blue. . . . We toasted the new Librarian of Congress, and he seemed touched. . . . The President apparently adores Archie. I can see why." There was another letter from Gerald, dated August 15, in which he responded to Sara's report of rough weather. "That sounds like the wickedest sea they've had on the *Weatherbird*," he wrote, obviously forgetting the boat's maiden cruise, on which Vladimir was repeatedly driven into port by a hurricane, as he was coming up the Spanish coast from Gibraltar.

Sara had written about Honoria, Fanny, and Lloyd Bowers acting like young animals, as she had described them to Dick Myers, and Gerald responded. "It's nice," he said, "that all human relationships aboard were so smooth. . . . Bowers sounds nice. When you think of it, Honoria has never known well any simple youth filled with animal spirits." While it was a compliment to Bowers, Gerald was perhaps expressing chagrin over the way he and Sara had sheltered Honoria and had deprived her of youthful associations—with boys, specifically. He could also be very strict with her. "You're wearing too much lipstick, daughter," Fanny Myers remembered Gerald saying to Honoria once, when they were living in Saranac Lake. He then took a Kleenex tissue and placed it on Honoria's mouth, and he kissed her squarely on the lips, effectively removing the makeup.

In his letter of August 15, 1939, Gerald also had news of the Hemingways. "Pauline hopes to see you in Paris before she returns," he wrote. By this time, though it is not clear if Gerald or Sara knew, the Hemingways had agreed to separate, and Ernest was not with Pauline in Paris. He was in Montana in September, at the L Bar T Ranch, and Pauline joined him there when she returned from Europe; but Ernest then went on to Idaho with Martha Gelhorn, whom he intended to marry and with whom he had been living in Havana. "The Jay Allens called," Gerald reported—Allen was Hemingway's friend and fellow newspaper correspondent from Spanish civil war days. "I invited them over for Saturday and Sunday, as I was alone. Although somewhat out of place in a rural setting, I think they enjoyed it. . . . She's sweet, and he's nice, but a bit hipped on the male virility angle, which is a tacit boast, I always feel."

* * *

"Army being called out," Mother wrote in her log on August 24, 1939, the day we arrived in Paris. And the next day, she noted, "Not very good news about international situation." Paris was the scene of general mobilization during the day, and the city was blacked out at night. "Very *angoissante,*" Mother wrote on September 1. "Terrible depression everywhere. Bank gloomy." The only bright note in her entry for that day was the lunch she and I had at Maxim's with Fernand Léger.

There was a letter to Mother from Aunt Hoytie, which had been sent to the Guaranty Trust. "At this critical moment," she wrote, "I think all else should be forgotten and forgiven." She offered her apartment as a place to stay in the event of war. "I think it is one of the safest places." Mother had no interest in a reconciliation with Hoytie, and she did not

answer the letter. There was, however, a confrontation, which occurred on the day the war started. "British at war, 11 A.M.," Mother noted in her log. "French at war, 5 P.M." We had dinner that night—Mother, Dick Myers, and I—at Maxim's. "First person I saw—Hoytie," Mother wrote. "End dinner, came and gave us advice in strangled voice. Very gloomy."

As I remember the incident, and I do remember it well, Dick Myers said to Mother as we were having coffee, "Sara, Hoytie is coming over here." Mother said simply, "That's all right." Neither Mother nor Aunt Hoytie even tried to be polite—they did not even say hello to each other. Hoytie just blurted, in her shrill way: "Sara, I'm not going to say anything to you except, for the sake of your child and yourself, you should get out of Paris. I happen to know they are going to bomb tomorrow night." Mother thanked her stiffly, and Hoytie walked away.

The Germans did not bomb Paris the next day, but we realized it was time to leave. "For heaven's sake, get Honoria home," Aunt Noel pleaded in a note to Mother. On September 4, we applied for bookings on the *George Washington*, which was sailing from Le Havre on the ninth, and that night we drove the short distance to Orsay, where we stayed with Hélène Mermet of Nicole Groult, and her husband, Claude, a professional chef.

"In bed all day with terrific cold," Mother wrote in her log on September 5. "Honoria has one too. . . . Dick and Fanny into Paris to see about passage, which he got. Mme. Hélène taking such good care of us—am very grateful to her." On September 8, we drove to Le Havre in my car, which had U.S.A. painted in big white letters on its roof. "Honoria took her car to dock at 9 A.M.," Mother wrote. "All stood on dock among crowd of passengers until 1. . . . Didn't sail. All waiting. Puppy in kennel."

September 10 was a Sunday. Mother's log entry was succinct, but it told the story. "All day in port," she wrote. "Airplanes around us. *Alerte* this A.M., 5 A.M. Four in cabin. Very stuffy. All coughing. Sailed about 7 P.M." The next morning, we arrived in Southampton, England. "Took on more passengers," Mother wrote. "Now over two thousand. Left Southampton late, about 5:30. Watched mines laid across mouth of harbor, after we were through in angry sunset."

* * *

The 1940s were a period of emotional recovery for Sara and Gerald, though it was gradual and subject to setbacks, especially for Sara. She had lost interest in the way she dressed, choosing to wear simple black suits or dresses, and when Gerald bought her a mink coat for her birthday one year, she quietly asked him to return it.

Gerald was different—he continued to be fastidious about his appearance, "even when he was raking leaves," as Fanny Myers told it. There was a period, following the deaths of the boys, when he wore only black suits and white shirts, but then he got into browns —his favorite color—and, eventually, "some color slipped in," according to Fanny. Gerald, as an artist, was very conscious of color. "It's not too late for Patrick's yellow and the thought that goes with it," he wrote on the card that went with some roses he gave to Sara.

It was also a period of economic adjustment, the 1940s—not a retrenchment exactly, for that would have been counter to the Murphy style. Trips to Europe had to be abandoned, for the duration of the war, but winter vacations were taken with regularity, at least by Sara. She was in Sarasota, Florida, in the spring of 1941, when Gerald spelled out a bit of the bad news. "A warning from Amory," he wrote. "I guess we've got to give up any idea of financing a side-trip. It would mount up. I'll make a list of our *permanent* expenses: rent, electricity, telephone, wages, insurance, etc., and then we can cut down on our withdrawals from your fund." This, however, was more lip service than an actual determination to economize. Extravagance—a willingness to spend whatever it cost to enjoy life, drawing on capital when necessary—continued to be a Murphy hallmark. *"Anyone,"* as Gerald was fond of saying, "can live on his income," meaning it took ingenuity to go beyond one's means, the sort of flippant remark that no doubt distressed the conservative Bostonian Copley Amory, Jr.

The greatest drain on the Loomis-Sayles account was related to real estate—not the property Sara had inherited, for its value would ultimately enable the Murphys to stay afloat—but the places in which they lived. Sara and Gerald, who rarely called a house a home, literally collected habitats. Having just spent a pretty penny on its "reconstruction," they abandoned the penthouse at the New Weston in October 1939, and took an apartment at 25 West Fifty-fourth Street in New York. The following year, they moved again —to 131 East Sixty-sixth—and in 1949, having purchased Cheer Hall, a Dutch colonial relic requiring much renovation, they moved to Snedens Landing, New York, thirty miles north of Manhattan, on the west side of the Hudson River. All the while, of course, there were the houses in East Hampton: Sara and Gerald were still summering and winter-weekending at Swan Cove in the early forties, although its maintenance—in addition to that of Hook Pond and

Dunes—was a financial burden they would not be able to bear for very much longer.

There is another point about Sara and Gerald's spending habits that deserves mention: their life demanded upkeep and support, which required servants. "The solution is not in doing without the servants," Gerald wrote Sara in Paris on August 8, 1939. "I think we *should* have service." He did, however, have a suggestion: "You might discuss with Vladimir whether money could be saved by putting the boat up . . . for the winter. Something has got to be done."

Something was done—the *Weatherbird* was sold, for Vladimir found a buyer in 1941, a Swiss count, who paid 850,000 francs ($19,400 in American dollars) for the boat and retained Vladimir as her captain. The transaction, which was voided temporarily by the U.S. Maritime Commission for a Shipping Act violation, had actually been Orloff's decision, not Murphy's. "I don't know his experience of the last years," Gerald said of Vladimir in a letter to Archibald MacLeish in February 1945, "except that he felt it essential to sell the *Weatherbird,* as he was to be put in concentration camp by the Germans, as being a Russian. He was later released and built himself a stone hut outside of Ramatuelle, a hill town above St. Tropez. . . . The boat he sold to a Swiss resident of Geneva and Paris named Gerard de Loriol. The whereabouts and amount of money we knew nothing, although he assures us it's safe. I instructed him to withdraw from it periodically wages for himself, Joseph [Revello], the gardener, and family. De Loriol . . . is apparently a *louche* character. . . . I was . . . interviewed concerning him by the FBI last year."

There had been allegations, though not any proof, that De Loriol had dealt in contraband, which would explain the FBI investigation. Murphy met him for the first and only time when he was on a buying trip in Europe in the spring of 1950. "Sal dear," he wrote from Paris. "Vova left last night for St. Tropez. He had brought De Loriol for a drink before luncheon. He proves to be the *most charming* person. Apparently he was disapproved of by his very rich father as being a playboy and decided he'd go to the Gold Coast, where he made a fortune in ivory. He's tall, dark, with an open plain face. Enormous vitality. Loves to laugh. Loves danger, adventure, travel, exploration. . . . He and E. Hemingway should know each other."

When the war in Europe ended in May 1945, Fanny Myers was transferred from London to Paris, as was her boss, Francis (Hank) Brennan, who would later become her husband. Fanny and Hank both worked for the U.S. Information Service, which had been the Office of War Information until the German surrender. They were planning to go on leave in the south of France in August, and Fanny wrote Gerald Murphy to ask if she could do anything for him in Antibes. Gerald replied simply that he would like her to get in touch with Vladimir Orloff. She arranged a meeting for 2:30 on the afternoon of August 16 at the Villa America, as Fanny noted in her diary. She still did not know the purpose of her mission, as she reminisced with Vladimir in the garden of the villa.

"He talked about the *Weatherbird,*" Fanny recalled, "and told how she had been damaged by bombings and since repaired. He was anxious for us to come to Monte Carlo to see the boat." Monaco was off limits to American military personnel, which included Hank and Fanny, who carried simulated Army ranks—Hank was a "colonel," and Fanny was a "lieutenant." But they were not in uniform so decided to make the forty-five minute drive anyway, and Vladimir served champagne.

Fanny and Hank were getting ready to leave when Vladimir finally began to reveal what it was they had come for: he said he had a parcel to give them. "I realized," Fanny said, "that we were to take something to Gerald, who knew we were awaiting orders to come home." The parcel was hidden in an apartment Vladimir had rented in Antibes for storing furniture from the Villa America. "It was dark when we parked in front of the apartment, and Vladimir was gone so long that we began to worry. When he did return, he explained that he had hidden the parcel behind a stone in a wall, and he had had a hard time remembering which stone.

"He handed me a tin Balkan Sobranie box, the fifty-cigarette size. It contained neatly stacked gold coins, which counted out to be worth about $15,000. It was payment by Gerard de Loriol for the *Weatherbird.* Vladimir then told me whom I should go to in Paris to have the gold exchanged for dollars."

If Fanny had any misgivings about her errand, they were overcome by her devotion to Sara and Gerald. They were her second parents, just as Honoria is her second sister, and when Baoth and Patrick died, it was as if she had lost *her* brothers. (Fanny's own

brother, Richard H. Myers, or Dicky, was killed in Canada in 1943 while on a Royal Air Force training flight.) Fanny's affection for Sara and Gerald was in response to many qualities, not the least of which was their generosity. The Myerses were not well-to-do, so the Murphys—as they had with Scott Fitzgerald, Ernest Hemingway, John Dos Passos, and others—assisted them in several ways. "Dicky goes back to school tomorrow," Fanny's father wrote her in April 1939, "and Mummy is driving him back in our new Chevrolet (which Gerald and Sara helped us buy, the dears)."

"They were always extraordinarily generous," Fanny said of Sara and Gerald. "They gave lavish presents—not just Christmas presents or on birthdays, but often out of the blue." When Fanny and Hank arrived in New York from France in September 1945, there was a gala coming-home party at the Murphys' apartment, and the Brennans' wedding present was a sizeable check.

Gerald's generosity extended beyond support of impecunious close friends to taking up the cause of the victims of discrimination or red-baiting or any other indignity. One day in April 1936, he had taken Honoria and Fanny to Carnegie Hall for a concert, and he recognized Josephine Baker, the black entertainer, who was having difficulty at the box office. Gerald knew Miss Baker only by sight, but he walked up to her and said: "Please, will you go in with my daughter and her friend." He gave her his front-row ticket, bought another for himself in the back of the hall, and then escorted the three women to their seats. "She sat between Honoria and me," Fanny recalls, "and she seemed to be very grateful." Gerald was right—they did practice racial discrimination in New York in the mid-thirties. "Black people," Fanny remembers, "still were required to sit at the back on buses."

When Lillian Hellman came to Gerald in 1951 in need of bail money for her friend Dashiell Hammett, the writer and political activist, he promptly lent her $10,000, because he believed that Hammett and others like him were the "rather poor prey," as he would phrase it, of the anti-Communist zealots. Similarly, when Paul Draper, the dancer, was persecuted for his liberal leanings, Gerald, who had known Draper's mother quite well, gave Draper a ringing character reference. "Gerald Murphy always was a champion of victims," Draper said.

Gerald Murphy was a liberal Democrat, a staunch supporter of Franklin D. Roosevelt, although his doubts about the democratic system were such that he took a course in 1937 and 1938 in Marxism and socialism at the New School for Social Research in Manhattan. He did his best, as well, to identify with the dissatisfaction of politically alienated friends, such as Donald Ogden Stewart and Dorothy Parker. "It was a strange crew we were," he wrote Sara in Europe in July 1939. "Dorothy had asked me for luncheon, . . . and I found we were to meet Don and his wife and one of the editors of *New Masses.* . . . The talk was violent and technical."

Gerald was an unlikely revolutionary, however, much as he realized there would be a price to pay in terms of old friendships. He and Sara saw little in later life of Don Stewart, who, having lost his American passport, became an exile in London. As for Dorothy Parker, there was an even sadder parting of the ways, because she had been such a close friend. "To be anti-Communist is to be anti-Dottie, apparently," Gerald wrote Sara in 1953. "Too bad!"

Gerald was essentially a patriot, and he had been inspired by a visit with the MacLeishes in Washington in April 1943. "The pleasure at seeing you," he wrote Ada and Archie, "in what is the asylum you both deserve—that gracious house and garden, the evening with high diplomacy in the Jamesian atmosphere, . . . the becoming dinner party and the rarefied delight of listening to the play of such minds."

Gerald envied MacLeish for his appointment to a high government post, and his own role as a retail merchandiser was proving no more suitable to him. "Weeks ago," he wrote MacLeish soon after war was declared in Europe, "I started a losing fight to get the Fifth Avenue merchants to devote their windows for one poor week to displays of their own choosing calculated to stop the passer-by in his tracks and make him *think* about what he stands to lose *right now.* They all begged off, but I learned that their real reason was that they would not risk offending *their* clients, whose sentiments might be opposed to intervention. Can you beat it?"

Murphy regarded the Mark Cross Company as "this monument to the nonessential," as he put it in a letter to Archie MacLeish in February 1943. He said he was actively seeking an alternative career —in the government, perhaps—and he put the question to Archie: "Toward what kind of service do you think it would be best for me to direct myself? Granted my age (55 this coming March), am I fitted

for anything in which I could be of value? Physically, I'm in pretty good condition, although Sara and I do notice that we recently have been pretty much slowed up due to the wallop that the bumpy period of Baoth's and Patrick's illnesses took out of us." As best can be known, it was just a whim—no more was ever said about Gerald's going to work for the government.

<p style="text-align:center">* * *</p>

I do not believe that my father was all that negative about his years with Mark Cross. There was much that he enjoyed about running the company —planning the window displays is a good example. When the other stores declined to adopt his patriotic theme in the early forties, he went ahead on his own. He filled his windows with graphic presentations of quotations of the founding fathers—George Washington, Samuel Adams, Patrick Henry, Daniel Webster, Thomas Paine, Benjamin Franklin. He later wrote Archie that "some of the comments of the people were downright heart-breaking."

My mother, meanwhile, was a volunteer at the Wood Memorial Day Nursery on One hundred eighteenth Street, in Harlem. The nursery, of which she was president in 1947 and 1948, took care of about thirty youngsters, ages two to five. I went one day to watch her at work. When I walked in, she was leading the children in a nursery song. It affected me so that I had to leave for a moment, because I did not want her to see me cry.

Mother brought two of the children from the nursery to East Hampton on weekends. They were brothers named Charley and Toopie. She even tried to adopt them, for she believed they were being mistreated at home, but their guardian, a grandmother, would not allow it. It was awfully touching—wrenching might be a better way to describe it—to watch her being a mother of sons again.

I had given up my acting career, though I had not lost my interest in the theater. I wrote a radio script about the German U-boat menace—I had gotten the idea during a weekend in East Hampton, where we were required to observe blackouts at night—and it was produced in 1942 as part of a government-sponsored series, *The Treasury Star Parade.* Fredric March had been scheduled to narrate it. He was appearing on Broadway in *The Skin of Our Teeth,* by Thornton Wilder. However, the night before the radio show was to be aired—on December 22, 1942—Tallulah Bankhead, his co-star, accidentally poked March in the eye with her finger, and he was replaced by another actor, Martin Gabel.

In the late 1940s, I worked as a receptionist for Theatre, Inc., a production company. Theatre, Inc. brought to New York great plays from Europe, such as Sophocles's *Oedipus,* with Laurence Olivier, Shaw's *Pygmalion,* with Gertrude Lawrence, and Chekhov's *Uncle Vanya. Oedipus* and *Uncle Vanya* were part of the repertory of the Old Vic Theatre Company, which appeared in New York for the first time under the auspices of Theatre, Inc.

Dos came to stay with us often when we lived at 131 East Sixty-sixth, occupying a room my father had named "the inside cabin," because it was in the rear and looked out on the back of another apartment house. Dos had a habit of just showing up in town and asking by phone, "Is the inside cabin available?"

My father was a master at orchestrating evenings. David Pickman, the son of my parents' friends in Boston, Hester and Edward Pickman, came to dinner one night, and he did not recognize the balding man seated across the table. "David," my father said, "you have read *U.S.A.,* have you not?" and David knew, without undue embarrassment, that he was having dinner with the eminent author John Dos Passos.

Mother and Dow-Dow had been out of touch with Cole Porter for some time, but they got together again in the 1940s. Cole and his wife, Linda, would have us to dinner at the Waldorf-Astoria, where they had adjoining suites. They were lavish dinners, which always preceded a ballet or a play. This was after Cole had lost the use of his legs in a fall from a horse. When we were ready to go to the theater, two men would come in and carry Cole to his wheelchair and take him to the elevator.

I sent Cole, in 1946, a synopsis of a musical I was writing, and he sent me a thoughtful, if somewhat discouraging, reply. "Unluckily I was not a born critic," he wrote, "but this is my opinion: it seems to me that you have a very good basis for a ballet but not for a musical comedy. I do not believe there is enough story for a musical comedy, as you have no suspense whatever. Even though most people do not realize it, no musical comedy is a success unless its book has a solid story with suspense."

There were also, in the forties, occasional Sunday lunches at Lillian Hellman's farm in Westchester County. Mother always praised Lillian's cooking—her Indian pudding, especially, and a dish she called "liver Lillian." Lillian tells a marvelous story, however, which leaves you with quite a different impression.

My parents had gone to visit for a weekend at her farm. "I had cooked skunk cabbage for lunch," Lillian explained, "and Gerald came down in the afternoon and said that Sara was upstairs dying. I said, 'Oh my God, what can we do?' Gerald said, 'Let's drive down to the drug store and ask

what to do for a woman who has been poisoned by a playwright.' That's exactly what we did, and Gerald said to the druggist: 'I don't like to mention Miss Hellman's name, but she has poisoned my wife. Could you recommend anything?' He did, and Sara recovered."

*　　*　　*

As the Murphys managed, however slowly, to restore the beauty of their life, the last thing they needed was a confrontation with Sara's sister and nemesis, Mary Hoyt Wiborg, who filed a civil suit against them in the New York Supreme Court in 1942. "I wish there were something I could do to help you and Gerald through this miserable, beastly business," Archie MacLeish said in a letter to Sara in February 1944. "What a really dreadful woman she is!" On the other hand, it was perhaps just as well that the simmering dispute over the property in East Hampton be settled, which it was, in Sara's favor. Why did Hoytie wait ten years to go to court? The answer would be contained in the decision of the judge, and it would be used against Hoytie.

There was a long and acrimonious trial in the spring of 1944 in Riverhead, New York, the seat of Suffolk County. Hoytie testified that, according to the terms of the 1932 verbal agreement, the money she had received from Sara was a loan on which she had agreed to pay annual interest of five percent, and that she had hoped to repay the loan within two years. She admitted, however, that none of the interest or principal had ever been paid. Sara testified, in rebuttal, that her sister had asked her to buy the property for $25,000, which she did, paying $22,500 and retaining $2,500 for back taxes and other outstanding bills. She emphatically declared that nothing had been said about a loan.

The court, in rendering a verdict, determined there were four outstanding features of the case. First, in several instances, it was the veracity of the defendant (Sara) versus that of the plaintiff (Hoytie) that was at issue, and in each one, the court believed the defendant's testimony and rejected the plaintiff's. Second, it was a fact that, in August 1932, when the plaintiff deeded her property to the defendant, she feared the consequences of her unsuccessful real estate venture. She therefore sought to convert her property into cash quickly, because she knew that as real estate it was available to creditors who had obtained a judgment against her. Third, the plaintiff had studiously delayed bringing the suit until the attorney

who had represented her in the real estate transaction (Nicholas E. Betjeman) had died, and until it was safe for her, owing to the ten-year statute of limitations, to hold real estate in her own name. (She filed the suit ten years, almost to the day, from the date of the disputed transaction with her sister.) Fourth, no evidence was offered by the plaintiff to show why the defendant would be willing to lend her money.

The court also commented on the price Sara had paid Hoytie for the property. It noted that the plaintiff had offered expert testimony to show a disparity between the purchase price and the real value, while experts retained by the defendant had testified that the purchase price and the real value were in balance. All of the experts had agreed, however, that there was little demand for the property at the time of the sale, because it was "specialty property," meaning it was resort property, for which there was not much of a market during the Depression. In the court's view, in fact, Hoytie could not have sold the property to anyone during the Depression, except her sister, who had bought it primarily for a personal reason, which was to keep it in the family. Finally, the court cited a sentimental reason for Sara's purchase: Frank B. Wiborg, who had laid out the plots for his three daughters and had built the house on the property, had died in 1930.

In summary, the court ruled that the conversation on the dock on July 16, 1932, had been testified to accurately and truthfully by Sara; Sara had bought Hoytie's property for a valuable consideration; and there had been no qualifying oral agreement, as Hoytie had claimed. Hoytie had sold the property, said the judge, "to quickly denude herself of possessions which her judgment creditors could reach in satisfying the judgments, which she knew in July, 1932, were in the making." By interfering with her creditors' right to collect on their judgments, she had "sought to and did hinder, delay, and defraud them." She was now seeking, he added, "the aid of a court of equity to enforce a transaction, which, if it ever existed, was conceived in fraud and bad faith on her part." As for Sara, the judge decided, she had not been "informed of plaintiff's motives," and she had "innocently participated in the transaction."

"Finally the deplorable suit . . . has finished its course," Gerald wrote Sara's aunt, Helen Griffith of Philadelphia, "with a 100 percent exoneration of Sara as to every single charge brought against

her." That the Murphys were not alone in rejoicing was indicated by the gossip columnist of the *New York Journal-American,* Cholly Knickerbocker: "Practically all the fashionables down East Hampton way, cognizant of the bitter feud existing for years between Mary Hoyt Wiborg and her sister, Mrs. Gerald C. Murphy, and the lawsuit brought by 'Hoytie' against Mrs. Murphy, are expressing frank pleasure in the fact that by a decision just handed down in the Supreme Court, Hoytie has lost her case, and Sara has been completely exonerated."

Old friends of Sara and Gerald were also elated. "Huzzah!" Ada MacLeish wrote in June 1944. "I am so relieved that you are now beyond the reach of such a prodigious monstress. You have really been forced to put in a whole year of misery entirely due to that unscrupulous, egocentric woman." The court decision, however, failed to restrain Hoytie from pursuing the case further. "Hoytie, the bitch, is suing Sara again," Dick Myers wrote his daughter, Fanny, in 1945. The suit never came to trial, but Sara was taken to court by the heirs of Hoytie's creditor, Oscar M. Manrara, for an award of the unsatisfied judgment against Hoytie. That suit was dismissed, however, as the statute of limitations had expired.

With no further legal options, Hoytie tried another tactic: she got relatives to put pressure on Sara. "Is there not some way you could restore to her some of her property?" asked Cecilia Reber, a cousin, in a well-meaning letter, which nevertheless infuriated Sara. "There is much more that I could say," she wrote "Cecil," "but I feel that it is futile." Actually, Sara had drafted a long reply to Cecilia Reber, and while she then thought better of sending it, she kept it—four legal-size pages written in longhand. Excerpts provide an insight into her feelings about the protracted feud.

"Don't think I am not sorry and dismayed," Sara wrote, "to see Hoytie's life, which started with every advantage and promise, so wasted and unenviable now. . . . It is difficult, however, for me to believe in Hoytie's poverty in the face of her having received two sizeable sums: one from my grandfather's estate, in 1935 or '36, and one from Aunt Mame's. Both [came to her] several years after the sale of her property to me, for which she received . . . a fair price. . . . To get the cash, I had to sell stocks in a falling market. . . . I was the only one willing to buy it, which I did for the sake of my parents' memory, and also for our children, not knowing then what was in store for us. I could ill afford it. The house was frame stucco,

not good materials by the sea. It was old, parts of it very old, and rapidly disintegrating. . . . The taxes were enormous, not to mention upkeep and insurance. . . . It cost $500 to open each year. . . . Hoytie and her creditors have sued separately. . . . The litigations were most painful and cost $5,200.

"We feel that Honoria's future . . . has been affected, and we have always regretted that Hoytie never saw fit to buy back the old place, . . . especially after she came into my grandfather's money."

Finally, in the letter to Cecilia Reber, Sara let loose her emotions —about the meaning of the property in East Hampton and much more. "Our sons . . . are buried at East Hampton," she wrote, "and Honoria loves the place, so whatever is left will be willed to her. I am a strong believer in helping the younger generation. . . . If Hoytie . . . is really in want, we shall know it. At the moment, I feel that our own daughter needs help more. . . . I can forgive, and have, the scarring experiences and money losses, . . . but I will not countenance the slanderous accusations Hoytie has thrown at me and my family all these years. . . . Her friends would do well to tell her to stop and turn her eyes toward her own faults, for once. I'm sorry."

"Hoytie Wiborg is in Washington driving everybody mad trying to get a job," Dick Myers wrote Fanny in January 1945, "and people are hiding and locking their doors and refusing to answer their telephones. . . . Bob Lovett says we ought to send her to Germany as a secret weapon." Robert A. Lovett, a New York investment banker and a friend of Sara and Gerald, was Assistant Secretary of War for Air at the time.

Hoytie had returned to the United States when Paris was occupied by the Germans and her apartment was commandeered for an SS officer and his actress girlfriend. Hoytie would eventually return and live in France for the rest of her life, but there was an interim, after Paris was liberated, during which she rented the apartment at 13 quai de Conti to Charles and Lael Wertenbaker. There were several advantages to living in that apartment. "It was magnificent," Fanny Myers Brennan remembers, "with high ceilings and large windows overlooking the Seine and a dining room spacious enough to seat twelve people." Best of all, though, the Wertenbakers were treated to the services of Hoytie's superb cook, a formidable Bretonne named Marie Leleizour.

Wertenbaker was chief of European war correspondents for *Time-Life*. In June 1945, a month after the war in Europe ended, Allen Grover, a senior assistant to Henry R. Luce, the editor-in-chief of *Time-Life,* was paying a visit to the bureau in Paris. Grover and the Wertenbakers decided to give a dinner party at 13 quai de Conti for an old friend, Louise Macy Hopkins. Louise Macy, or "Louie," had, before the war, been in charge of the *Harper's Bazaar* office in Paris, and she had recently married Harry Hopkins, President Roosevelt's long-time confidant. Hopkins had remained a White House assistant when Roosevelt died earlier in the year, and he was, in June 1945, in the Soviet Union, conferring with Stalin. Louie was on her way to join him, and the purpose of the *Time-Life* dinner was to pry from her some secrets about her husband's trip to Moscow.

Fanny Myers and Hank Brennan were among the guests, and Fanny remembers that Marie, the cook, outdid herself—cold lobster, caviar, tournedos, and a dessert of cake, cream, and spun sugar, molded in the shape of a ship in full sail. It was all bought on the black market, amounting to a $2,000 item on Grover's expense account. "There was wine, of course," said Fanny, "lots of it—the best red, the best white, as well as champagne." What was learned from Louie about her husband's meeting with Stalin? "She probably knew little about it anyway," Fanny said, "but everyone, especially Louie, was so squiffy [drunk] that not a bit of information was forthcoming."

Sara and Gerald had started selling the East Hampton property in 1938, well before the dispute over it with Hoytie was resolved in court. At the time, an acre in East Hampton was worth only $3,000, as against $150,000 or more following the real estate boom of the 1970s. But the Murphys, who had no way of predicting the boom, were hard-pressed for cash: by 1950 or so, when the per-acre price was $5,000, they had placed on the market Sara's entire holding, save the three lots they had reserved for themselves, which the Donnellys inherited.

"Dune Meadows—ideal sites for attractive country residences," it said in the brochure circulated by Previews Incorporated, a real estate clearing house. "The property adjoins the Maidstone Club with an excellent 18-hole golf course, salt-water pool, and beach cabanas." In 1941, Dunes, which Gerald had come to call "the big bad house," had been torn down, in order to save over $1,200 in

annual taxes and the cost of its maintenance; and in the mid-forties, the old farm buildings, which had been renovated—Hook Pond and Swan Cove—were sold for about $50,000 apiece.

Sara and Gerald did retain a summer residence in East Hampton, however. When the big house was demolished, the garage and chauffeur's quarters were left standing. A bedroom, bathrooms, and a terrace were added, a growth of old ivy was stripped away, and the stucco exterior was painted pink. The cottage was named Dune Flat but is often called "the pink house."

In 1950, another house—the only one Sara and Gerald ever had constructed, rather than renovated—was built on a lot adjacent to Dune Flat. It was called La Petite Hute (The Little Hut) and was, by Murphy standards, modest, though there was nothing very tiny about the living room, which had a cathedral ceiling and a commanding picture-window view of the Atlantic. There was but one spacious bedroom, which Sara occupied. As Honoria explained, "My father wanted to live a monklike existence," and, indeed, Gerald's quarters originally were about the size of a monastic cell. Sara decided, however, that Gerald was overdoing it, and she talked him into adding another bedroom to the house.

It was also in 1950 that the Villa America was sold—for $27,000 to Edmond Uher, a Swiss electronics engineer and well-known manufacturer of tape recorders. Sara and Gerald had not been to the villa since the boys died, and Sara had no intention of ever going there. Gerald had felt the same when he arrived in Paris in June 1950, while in Europe on a Mark Cross trip. He was due to go to Monte Carlo, "to sort out our Villa America goods," he wrote on June 12 to Ellen Barry, who was at her place in Cannes, and he promised to pay her a visit. Phil Barry had recently died, and Gerald reasoned that Ellen would understand his reluctance to return to the villa. "I can see how difficult it must be," he wrote "to return to places where one recalls . . . enjoyment. I still see Patrick at his little garden. . . . I cannot go back."

Gerald did go back, though, for Vladimir Orloff advised that the sorting of possessions could not be accomplished in Monte Carlo, where only some of them were stored. "V says I'll have to do the *triàge* [sorting] at the villa," Gerald wrote Sara on June 29. It was not, after all, the depressing experience Gerald expected. "Immediately one is caught up in the compelling beauty of it," he wrote Sara on June 30, 1950, "that shining transparent sea, the high healthy palms.

. . . The stillness and peace and the air are stirred constantly by the sea. I had come with misgivings, prepared to be saddened, but no! The villa is untended in appearance, but the garden, no! The palms, the large conifer, the linden, the eucalyptus (like a tower) have now eclipsed the view of the water, so that it's a secret garden."

In September 1947, it was announced that Mark Cross would be merged with the Drake America Corporation, a transaction that Gerald had initiated with bankers in London. "The mixture of the social . . . and business is new to me," he wrote Sara from London that same month. "I've never mixed the two before. . . . I'm being sized up, which is uncomfortable, as I've never worked for anyone else." The amount paid for the company, apparently, was very little. "It was ridiculous," Noel Murphy told Honoria in 1981. "It was something like $80,000." But Gerald had reason to be desperate: he was nearing age sixty; and his hopeful expectations for the company —which he had expressed in a letter to Sara in 1938—had diminished. "What future form the M. C. Co. will take," he wrote Sara, "I'm not quite sure. There's bound to be a change of some kind. However, the change was essential to save anything out of it."

Gerald remained with the company as its president, drawing his $35,000 salary, but it was not a successful arrangement for him, and he stepped down in 1955. "I had a sense of sleepwalking for twenty years," he later told Calvin Tomkins, "following Father's ghost. If you have any sort of creative sense, this leaves little room for it."

The 1947 trip to London on Mark Cross business was the occasion of Gerald's first transatlantic flight, the one he made on the day after Katy Dos Passos died. It was also his first trip abroad after the war, and it affected him deeply. "Had occasion to drive into the old city today," he wrote Sara, "and I got a sense of what they've been through. What shocks you is that suddenly—in some remote and now quiet and peaceful square—a house is missing. . . . You wonder where the people are who were living in it."

Sara went to Nassau in January 1949—she went with Honoria, to recover from a painful case of rheumatoid arthritis. Gerald remained in New York, living still at the apartment at 131 East Sixty-sixth Street. Cheer Hall in Snedens Landing had been purchased, and moving day was imminent. "Let me know what you think we

should put into Snedens in the way of an investment," Gerald wrote Sara on January 6. "After your last withdrawal, there's $18,500 in the 'special.' I have another ten in my savings account." He was, however, sounding cautious about plans to restore Cheer Hall. "We have not as yet launched," he wrote, "on any real Versailles-on-the-Hudson." January 14 was John Dos Passos's birthday, and Dos wrote to Sara the next day. "Gerald in some way managed to get seats to *Kiss Me Kate,* and we roared and clapped all evening. It's definitely one of Cole Porter's better products. The only thing we missed was the presence of Mrs. Puss." And Gerald wrote her on the 16th. "I had decided my gift to Dos would be an old-fashioned theatre party. . . . Squab . . . preceded by a wise choice of Theresa's clam broth, piping hot Brussels sprouts, new potatoes, iced shredded pineapple, and a cake for Dos, one candle. . . . Champagne very cold."

Cheer Hall was soon transformed into a residence of special Sara-and-Gerald quality. "It gives me such satisfaction to think of you in that lovely place," Ada MacLeish wrote on December 8, 1949—"sunrise and moonrise over that noble river . . . and the ground full of growing things. There has always been Murphy magic in your houses, but I think Snedens is the star on the very top of the tree."

<center>* * *</center>

I had my own apartment in New York in the spring of 1950—at 25 West Fifty-fourth Street, the same apartment house my parents had lived in briefly in 1940. I was at loose ends, since Theatre, Inc. had stopped producing plays, so I decided to make a trip to California in July.

While visiting in Carmel, I went to a dinner party one evening. I was introduced to a gentleman on crutches named William M. Donnelly, whom everyone called Captain or Willie. I learned that he had been wounded in the war—in Germany in March 1945—by a land mine, and that he operated a skeet and trap club in Pebble Beach.

Bill Donnelly and I were together the entire evening—I never left his side. We talked a lot about religion. He told me he was a Catholic, and I said I had been baptized a Catholic, but, except for one year at a parochial boarding school, I had never practiced the faith He had obviously learned a little bit about my background, for he knew that my parents had been acquainted with Scott Fitzgerald and Ernest Hemingway. I never liked to talk about the celebrated friends on first meeting someone, for it seemed

like name-dropping—I agreed with Mother on that score. I simply said that I had spent most of my childhood in France.

I would have to say that Bill Donnelly and I fell in love immediately—I with him and he with me. He invited me to lunch the day after the dinner party, and we were inseparable thereafter. I had planned to stay in California for three weeks or a month, but I remained until September, when Bill and I drove east together to be married. I had written my parents, and they were very pleased with the news, especially by my telling them of his bravery and his wonderful sense of humor.

We were married on November 14, 1950, in a chapel of St. Patrick's Cathedral in New York, and there was a reception at Fanny and Hank Brennan's Manhattan apartment. I had decided to become a full-fledged Catholic and to bring up my children in the church. That did not please my parents much, I must say, but they acknowledged that it was a decision for me to make. They realized it was what I wanted to do, and that was that.

Our first child, a son, was born in Carmel on June 20, 1951. He was named John Charles Baoth Donnelly. "DAUGHTER!!!" Dow-Dow wrote from Snedens Landing—my parents had just returned from a trip to Europe. "This is the day after you called us to tell us quite calmly . . . that you had had a little baby boy. It would have told you everything we feel . . . to have seen Mother . . . running from room to room into the kitchen out on the porch, exclaiming to Theresa [the cook], to the Lowndes [Lloyd and Marion, neighbors] and to the dogs that you'd had a baby and that she was a grandmother. . . . I could never have realized what it really meant to her and what a great deal it makes up to her in this life. When she had quieted down, . . . she said to me, 'Isn't it strange how life goes on?' I asked her what she meant, and she said, 'My mother had me. I had Honoria, and now Honoria has her child.' I think it answers for her the question as to why the boys' lives were stopped off for no reason. You have really brought her something, which no one else *could.*"

Mother came to California for the birth of our second child, William Sherman Donnelly, who was born on June 10, 1953. The minute I heard he was a boy, I thought to myself, my goodness, we may have replaced what was lost. I remembered what Scott Fitzgerald had written following Patrick's death about "another generation growing up around Honoria."

I talked with Bill about it, but not with Mother. The loss of her sons was not something she was able to discuss, but I could tell how she felt about our sons from the joy on her face when she was with them. With the birth

of our third child, a daughter named Laura Sara Donnelly, born on September 27, 1954, I realized the Donnelly family was a replica of the Murphy family. The pleasure of fulfilling Scott Fitzgerald's prophecy could be felt without being mentioned.

* * *

"How different a dawn than the one we saw in a hospital eighteen years ago," Gerald wrote Sara following the birth of the Donnellys' second son. "I guess that's how it is. Two boys went out from our family, and now two other boys have come into it."

At bottom it is all a question of the love of life, isn't it?

Archibald MacLeish to Gerald Murphy,
the inscription on a copy of *The Book
of Job,* sent to Murphy in early 1964

VII. The Love of Life

Archibald MacLeish, for all his wisdom, did not feel qualified to make a final appraisal of his friend Gerald Murphy as a painter, so he relied on the judgment of the master—Picasso. "It is now obvious," MacLeish said in a letter to Honoria in November 1980, "that Gerald was not only capable of living well but also of painting well—painting, indeed, far more than well—painting as well as Picasso *said* he could paint." It was as a painter that close friends preferred to remember Murphy, as John Dos Passos did when he wrote *The Best Times* in 1966. He described a walk along the Seine with Gerald and Fernand Léger in 1924—it was only the second time Dos Passos had met Murphy. "As we strolled along," he wrote, "Fernand kept pointing out shapes and colors. . . . Gerald's offhand comments would organize vistas of his own. Instead of the hackneyed and pastel-tinted Tuileries and bridges and barges, . . . we were walking through a freshly invented world. They picked out winches, the flukes of an anchor, coils of rope, the red funnel of a towboat, half a woman's face seen behind geraniums through the casement window of the cabin of a barge. . . . The banks of the Seine never looked banal again after that walk."

"I was alive those seven years that I was painting," Gerald wrote Calvin Tomkins in April 1964. He had recently turned down a request by the Corcoran Gallery of Art in Washington for an exhibition of his work. "Alas, I find myself unable to rise to all this and am temporizing," he said. "All of that is as if in a sealed chamber of the past and has become somehow unreal." It was one of Gerald's few recorded reflections on his period as a painter, and it was about as close as he ever came to explaining the real reason he quit, as opposed to some nonsense he would offer, when pressed, about being second-rate. *"Je n'en peut plus"* ("I cannot any longer"), he wrote Tomkins. *"Trop tard"* ("Too late").

"I said to Gerald," Lillian Hellman recalled in an interview in 1981, "I said, 'I don't like to ask this sort of question, because nobody has a right to, but why did you stop painting?' He said, 'Because I never believed I was any good.' I'm not sure I believe that answer, . . . but he was such a complicated man that he probably did convince himself that he wasn't as good as he wanted to be." Ada MacLeish urged Gerald to take up his brush again, writing him from Boston in February 1950 (Archie was by then Boylston Professor of Rhetoric and Oratory at Harvard): "I wish you might have the enthusiasm . . . your picture invariably evokes." She was referring to a painting Murphy had entitled *Watch,* which the MacLeishes had bought, though they later exchanged it for *Wasp and Pear.* "Perhaps before long," Ada continued, "you will get out your tools and start again. You should, Dow. Time has proven the increasing and lasting value of your painting." Gerald's response to Ada is not known, but it perhaps was similar to what he said to another friend in Boston, Hester Pickman: "I just haven't the facility."

Gerald was so thoroughly finished with his painting career when he abandoned it in 1929 that he rolled up his canvases and put them in storage, and he did not even bother to retrieve them when war was imminent in Europe. There were at least ten paintings, although William Rubin of the Museum of Modern Art in New York City, who did an extensive study of Murphy's work in preparation for the one-man show in 1974, estimated there were fourteen. Only six Murphy originals made it safely to the United States, however: *Wasp and Pear,* which later was given by the MacLeishes to the Modern Museum in New York; *Razor* and *Watch,* which Murphy donated to the Dallas Museum for Contemporary Arts; *Bibliothèque* and *Doves,* which belong to Honoria and William Donnelly; and *Cocktail,* which

hangs in the residence of Mrs. Philip Barry of Washington, D.C. Of those missing, four have been the subject of serious search: *Boatdeck*, which was stored in a warehouse of LeFebvre-Foinet, an art supply company in Paris; *Portrait*, which Murphy gave to Vladimir Orloff; and *Engine Room* and *Roulement à Billes*, which just disappeared, presumably from the storage vaults.

It was not until 1947 that Murphy made any effort to recover his works, and it was a near-failure. MacLeish, who was then an Assistant Secretary of State, was headed for a United Nations conference in Paris, so Murphy wrote to Vladimir Orloff in March to ask if he would ship the paintings to MacLeish at the U.S. Embassy. Archie did not receive them, but Gerald was unconcerned: when he wrote Vladimir again, in June, he was more worried about a jacket he had sent Vladimir, which was too small, than he was about his paintings; and it was due only to the persistence of Alice Lee and Dick Myers that they were found. Alice Lee and Fanny, Dick Myers wrote Gerald, had been in the south of France and had visited the Villa America, where they talked with Joseph Revello, the gardener. "He was greatly worried about your paintings," which he had helped pack and ship to Paris, Dick explained to Gerald, "and A. L. promised to find them. And she did. First she went to the Embassy and kicked up a rumpus and then went to UNESCO, and, by insistent demanding, she finally located them. They had arrived addressed to Archie, and whether they failed to give them to him or whether they arrived too late—at any rate, they were there." Myers brought them back to the U.S.

In 1960, Gerald first realized his paintings were of value as the works of a recognized artist. "I've been discovered," he said at a family gathering. *"What* does one wear?" Only then did the search for the missing works—which was continued by Honoria and Bill Donnelly after Gerald's death—begin in earnest. The proprietors of LeFebvre-Foinet staunchly maintained that they knew nothing of the whereabouts of *Boatdeck*, which would have been difficult to lose, since it measured eighteen by twelve feet. In April 1964, less than five months before he died, Gerald, now determined, wrote Douglas McAgy, the director of the Dallas Museum for Contemporary Arts, that he had recently asked Vladimir "whether he could find the *Boatdeck*, which was left in storage in Montparnasse." He also asked him if he still had *Portrait*.

Of all the missing paintings, *Portrait* posed the most baffling mystery, and its disappearance has raised questions about the honesty

of Vladimir Orloff. One explanation given by Vladimir was that the painting had been burned when his small cabin near St. Tropez was destroyed in the war, but it turned out that the cabin had not been damaged and had been sold by Orloff in 1955. Gerald was obviously torn by conflicting sentiments about the man who had assisted him in his painting and had been the captain of his three boats. When they saw each other for the first time in twelve years—in June 1950 —it was an emotional reunion at the airport in Paris. "There was Vova," Gerald wrote Sara, "looking so much the same! His face handsomely lined with weather, his figure as always, and impeccably neat."

That was 1950: in 1964, Gerald wrote Calvin Tomkins that he could not understand Vladimir's behavior. "Well, there's nothing more to be done," he wrote. "The *Boatdeck* I can understand, but the *Portrait* I gave to Vladimir as a souvenir of his years with us. He seemed to prize it so at the time." Gerald then offered an insight, not fully explained, about Vladimir, who was to die at sea, washed overboard, in 1967. "However," Gerald wrote, "his life . . . has been marked with one tragedy after another, and of a genuine Tolstoian kind."

*　　　*　　　*

My father often said—and he meant it sincerely—that he was his happiest as a painter. I well remember how he, with Vladimir at his side, would march off to his studio at the Villa America. He would spend hours there, absorbed in his work and content with the result. "My last things are a moving mass of looseness and liberation for me," he wrote John Dos Passos in August 1928.

My father also enjoyed so much the company of the French artists. "Léger has been here for three weeks," he wrote Dos from the Villa America. "It's always great to back up once a year and take on a load of him. He's very exciting on the subject of *surrealiste* direction." It was Picasso whom Dow-Dow admired the most, though, for reasons that must be obvious. Picasso also was a delightful person, with a splendid sense of humor. "He was constantly upsetting your serious observation," my father wrote Calvin Tomkins in 1964, "by a contradictory outlandish (often Rabelaisian) comment. . . . At P's apartment, I was admiring a *complete* abstract on which he was working. He said: 'It started out as a portrait of my uncle.' "

One of my father's favorite Picasso stories was the subject of a wonderful note to me. "Years ago at Antibes," Dow-Dow wrote, "you three

children did some drawings for Picasso. . . . You did a cow, starting at one horn, and without lifting your pencil from the paper did the entire outline of his body, stopping at the other horn." Small wonder he was confused as to the gender of the animal, since I had endowed the "cow" with long horns. I had also neglected to connect the horns, and Dow-Dow started to tell me the drawing was not complete. But Picasso stopped him, saying he liked what I had done. *"Faut pas qu'on y touche!"* ("Must not touch it!") he said.

I would disagree with those who have maintained that my father's paintings were precursors of pop art. He did not approve of pop art, for he deemed it affected. Pop art is flashy and bold, and the designs are not as meticulously drawn as those of my father. I think of Dow-Dow as a precisionist, a painter with an eye for precise detail. As William Rubin of the Museum of Modern Art said, he was a cerebral painter. That he might have influenced pop art, I cannot dispute, but that is not the painting he did.

A question so often asked is: Why did my father abandon his painting? His own explanation, said in his self-deprecating way, was that there already were too many second-rate painters in the world. Well, he was not second-rate, and I doubt that he really believed he was.

I find it significant that Dow-Dow stopped painting when Patrick first became ill, and his inability to take it up again, I believe, was an emotional reaction to the deaths of my brothers. Later in life, quite a bit later, he was at peace with himself, and he directed his talent to designs of beauty around the house—his rose garden, for example. But he was never the same, as Mother was not, after the boys died, and that is why he did not paint. As Archie MacLeish explained it to me, "He did something very Irish. He turned on himself."

* * *

Gerald did not altogether depart from the artistic scene—he stopped painting, but his contributions to other forms of art were significant. "It was Gerald Murphy . . . who first interested me in doing this score," Richard Rodgers wrote in his autobiography, *Musical Stages,* published in 1975. The famed writer of musical plays was explaining *Ghost Town,* a Western ballet, which was produced on Broadway in 1939. "At that time," Rodgers wrote, "the Ballet Russe specialized in the classics or in new works by European choreographers and composers, and Gerald was anxious to see the Paris-based company expand its repertory by adding ballets that

would be completely American in theme and choreography. . . . We brought in a lot of characters, including Jenny Lind and Algernon Swinburne, and I'm afraid it was too cluttered and involved for its own good. But it was given a sumptuous production, . . . and it did serve its purpose of introducing a native American work into the repertory. Years later the Ballet Russe would do far better with other Western ballets, . . . but at least *Ghost Town* was the one that started the trend."

Douglas McAgy did as much as anyone to bring about the belated recognition of Murphy as an artist. In May 1960, in an exhibition entitled *American Genius in Review,* five Murphy paintings were shown at the museum, and Gerald donated two of them, *Watch* and *Razor,* to the permanent collection. "I like so much," he wrote McAgy in October 1960, "the feeling of their finding such happy asylum after their years of confinement in a dark attic. . . . I had never been able to submerge entirely in my consciousness their existence. It is good to think of them now as observed—and alive."

The reviews of the Dallas showing were approving, and the Dallas *Times-Herald* quoted Gerald, who summed up his artistic versus his business career. "I wonder," he said, "how many aspiring American artists have been claimed by the harmful belief that if a business is your 'inheritance' that it is heresy not to give up all in favor of it. I hope not too many. We need real American artists." McAgy, in an article published in 1963 in *Art in America,* analyzed the Murphy approach to art. "Painting from notes and memory in solitude," McAgy wrote, "Murphy needed to get his vision clearly in mind before acting on it. He worked in carefully considered stages, never moving to a canvas without a maquette to start with. He stretched the finest 'airplane' linen on plyboard, meticulously enlarging the sketch to scale in pencil before applying a brush. The process gave him time, but in the end the act was the thing. In producing *Cocktail,* derived from his father's bar accessories when 'as a boy I was apparently impressed by the assembly of the various objects which were usually standing in evident juxtaposition,' he spent four months to complete the detail of the picture on the inside cover of a cigar box."

Murphy indicated in his advice to others that he was a thoughtful painter, a cerebral painter, as William Rubin said in 1974. "Was interested in your playing with color in the abstract," he wrote Ellen

Barry in May 1963. He explained that Natalia Goncharova of the Russian ballet had taught him reversely: form first and color applied to the forms later. "Try it," he suggested. "Take a small canvas and divide it into forms, . . . which don't resemble any real object. Apply your color to each form separately. You'll find that strong forms need the striking, stronger colors. It's excellent discipline and teaches you respect for certain shapes and certain colors."

* * *

"This is a business letter, but don't be alarmed," my father wrote me in September 1962. He explained that, inasmuch as he was no longer earning a salary, he and Mother had decided to live on the principal of their joint funds. "The withdrawals, of course, became substantial," he continued. "The income from our funds has been $6,700 annually. Our withdrawals have been totalling $23,000. . . . You can see from this that our funds cannot last indefinitely." There was a final recourse, which my parents had to face the following year—the selling of Cheer Hall, their house in Snedens Landing. "I thought it best to be frank with you," Dow-Dow said, "as there has not been any general confidential information between us. . . . People have always thought us richer than we are because we spent freely."

* * *

Publication of *Living Well Is the Best Revenge* in *The New Yorker* in July 1962 did little to destroy the legend of Murphy wealth, and neither did Sara and Gerald's style of life, which was still quite splendid. About the only concession they made to having reached well into their seventies was to do most of their entertaining during the day —at lunch—but, oh, what lunches! "Last week we had guests for lunch three days," Sara wrote Honoria from Snedens Landing in March 1963. "Wednesday evening we went to dine with Cole [Porter, at his Waldorf-Astoria suite]." She did admit it had been a trying week, but she was sounding happier than she had since the days in France, and she proudly enclosed the menu for lunch the previous Friday, for which Gerald had hired a professional chef: cocktails, *paté et bisquits, poisson, selle d'agneau, pommes de terre Paillasson, purée de petits pois, brioche avec fraises en sirop, crème Chantilly, fromage brie, café,* and "lots of *vins et liqueurs.*"

Sara's letter was dated March 26, 1963, and she noted the cards and flowers Gerald had received from the Donnellys. "He insists that today is really his birthday," she wrote. "He claims his mother

changed it to the 25th on account of its being the day of some saint, whose name I don't remember. So we end by sort of celebrating the two days."

The house in Snedens Landing was sold in April 1963. "We have regrets, of course," Sara wrote Betty and John Dos Passos, "but it has been a little too much for the past year—slippery road, remoteness, little or no help, etc. We have always believed it good to leave a place before it leaves you." There was time for a few more memorable events at Cheer Hall, however, as the Murphys had until November to vacate and to screen, as Gerald put it in a letter in July to Archie and Ada MacLeish, "the accumulated possessions of 48 mortal years of marriage." At Easter, there was a party for which Gerald made a garland of flowers for Laura Donnelly to wear in her hair, which reminded Honoria of similar parties when she was a young girl in Antibes. Bill and Peg MacLeish, Archie and Ada's son and daughter-in-law, had brought their two daughters to the party, and Bill wrote Sara and Gerald, his godparents, "We are returned home far happier for having spent this fine day with you. The daughters are peeking and munching and comparing their loot."

In October 1975, Peg MacLeish wrote Honoria about that Easter party. It was shortly after Sara had died, but her letter was more a tribute to Gerald. "I know," she said, "that what Dow did that Easter in his garden in Snedens was so magical and enchanting that never again will . . . I sit in a beautiful garden without thinking of him. . . . An artist can do this with his painting, a poet with his poem —that capturing of the essence of a moment—but, somehow, Dow's special gift seems to have been in the very *doing* itself, so that the record is left not in any concrete form that can be examined by others, as a painting or a poem can be, but is simply held in the minds of those who were present at the moment of creation. . . . He certainly knew the value of 'the golden moment,' which he shared so willingly and joyously with others. That generosity of spirit that all their friends felt in both Sara and Gerald—how you must cherish that."

There was a farewell dinner at Cheer Hall on June 3, 1963, attended by Betty and John Dos Passos and their daughter, Lucy, who was Sara and Gerald's goddaughter, and by Lloyd and Marion Lowndes, close friends and neighbors of the Murphys in Snedens Landing and old friends of Dos Passos. The plan was for Sara and

Gerald to go to East Hampton for the summer and return in the fall to pack up their possessions. "Everything of value and use goes to Honoria for the house in McLean, Virginia," Gerald wrote Archie and Ada. East Hampton would be the Murphys' final home—a home at last, and they would even call it that—except in the coldest winter months, when they would go to a hotel in New York or Washington.

Laura Donnelly, in the summer of 1963, was soon to be nine, and when she was in high school six years later she wrote her impressions of her grandfather, who had since died. "As I remember Grandpa," Laura wrote, "one thing that stands out most in my mind is the manner in which he did even the smallest task. He was a perfectionist, a very meticulous person in every aspect. Every morning during the summers in East Hampton, I would trot over to his house just to watch him shave." (The Donnellys spent summers in Dune Flat, next door to La Petite Hute.) "Each time the routine was the same, but it was done like a miniature concert."

Gerald accompanied his morning routine for Laura with commentary. " 'Granddaughter,' he would say—he never called me anything else—'never brush your teeth with your eyes open. It's very vain.' He would then imitate in an exaggerated way a very vain fellow admiring himself as he brushed. That was the amusing side of Grandpa. I also sensed—or maybe I only realized it when I got older—that he had the ability to see beauty in the simplest thing and to turn the simplest thing into a thing of beauty for others."

John Donnelly, three years older than Laura—he was thirteen when Gerald died—perceived that his grandfather kept his distance a bit. "He was always an attentive, though somewhat brittle man," John said in a retrospective discussion in 1982, "who entertained his grandchildren with enthusiasm. But to my child's eye he at times betrayed a reticence. It has occurred to me that he had entertained his own sons in such a way, and he did not want to be caught again, unawares."

Among the hundreds of little notes that Gerald saved, there is one, written in his careful way of printing with a pencil, that records the ages of Baoth and Patrick, had they lived, in 1956—thirty-seven and thirty-six, respectively. And, in Sara's writing, there is a notation, "Dates of Murphy boys." A new generation, as Scott Fitzgerald had said it would, was growing up around Honoria, and that

was a source of comfort, but the scars were evident still. "You don't know how lucky you are," Gerald said to Honoria and Bill Donnelly in 1963, "to have two sons who are still alive."

In August 1963, Gerald learned he would have to undergo surgery for an intestinal tumor. "So, I have cancer," he would say after it had been confirmed, "but we'll not talk about it." He did write to friends, however. "I am worried more for Sara than anything else," he wrote Archie, but in September he was home from the hospital and able to report to the MacLeishes: "I seem to have mended to the doctors' satisfaction. . . . Ada, your calls and letters were such a comfort for Sara and warming for me to hear about from her. . . . Nothing brings as much comfort as *knowing* that you are in the thoughts of those you love."

Gerald had gone to the hospital in Southampton for his operation, and while he was there recovering, he received a heartwarming yet sad letter from Sara. She had returned to a theme of her letters to him shortly after they were married and he was off in the Army. "Here I am at home, without you," she wrote, "and it is no longer a home, just a place to live. You must know that, without you, *nothing* makes any sense. I am only half a person, and you are the other half. It is *so,* however I may try, and always will be. Please, please get well soon and come back to me."

<p style="text-align:center">* * *</p>

Mother and Dow-Dow spent the winter of 1963–64 in Washington, at the Fairfax Hotel, and it was wonderful having them nearby. Scottie Fitzgerald—she was Scottie Lanahan then, married to Jack Lanahan, a Washington lawyer—gave them a party in February, and Betty Beale, a society columnist, wrote about it in the *Washington Star.* She quoted my father as having said "it was a wonderful thing to reach the irresponsible age of seventy, only it came too late in life." I was reminded of the time I first saw Dow-Dow wear reading glasses—in the forties, at lunch in New York one day—and I had remarked on it. "I know," he said. "I'm getting old, and I like the feeling."

<p style="text-align:center">* * *</p>

Age did not really overtake Gerald until he was well past seventy. He had been a long-distance swimmer all his life, and in the late years in East Hampton, he would worry Sara no end by going out beyond the breakers in that treacherous surf and do a mile or two

up and down along the beach. When his grandsons, John and Sherman Donnelly, were old enough, they would go with him, but one summer—Sherman remembers it was in 1962—Gerald admitted he was up to it no longer. "Grandfather simply said," Sherman recalls, " 'I am too old for this.' It was sad to realize he would not be out there with us again, coaxing us."

"This is a strange place to be," Gerald wrote Calvin Tomkins from Washington on January 31, 1964, a little over two months after the assassination of President Kennedy. "One still feels the Presence. . . . Certainly to be President is a heroic-scale job. . . . Of all the things said in that awful latter November, I felt that Lord Alex Douglas Hume's utterance was the greatest tribute. We were told that he was in the country near London, and that when word came to him, personally, that the President was dead, . . . the radio station went silent until the Queen was advised and Hume could get to the broadcasting station. Unfortunately, during that stricken hour, nothing was taped, so only an American reporter heard and remembered part of what Hume said extemporaneously: 'At this time, when the heart and mind is stopped, let there be no oratory. . . . My last memory of that remarkable man is of walking with him in the rose garden . . . outside the White House. . . . As I looked at him and listened to the passionate dedication with which he spoke of the one thing for which he yearned, I said to myself, looking always at him, "If we are ever to have peace, it will come with and because of a young man such as this. It will come from the young." ' "

* * *

"Don't think for a moment that Mother had been even mentioning that she hadn't heard from you," my father wrote in late April 1964. They had just returned to East Hampton, and, typically, Dow-Dow was worried about Mother. "On the contrary," he continued, "she kept saying, 'I *must* write Honoria.' I was really anxious that she hear from you as, since her memory has begun to fail, there has come with it, naturally, a kind of confusion of mind. . . . For instance, she will repeat the same question to me several times a day, and my reassurances do not seem to comfort her. 'Do you think Honoria is satisfied with the way her house looks?' or 'Do you think she's short of money with all those new expenses?' All this is natural, since she loves you more than anyone in her life. How many times a day she says: 'Isn't Honoria lovely? I love so being with her.' "

Aunt Hoytie, still in Paris, had recently died, and Dow-Dow reported that the news had disturbed Mother, "not because she mourned her but because she realized that her own sister had been the only enemy she had ever had. . . . It is a tragedy. . . . All these memories have been awakened again in her mind. I hope they fade away soon."

The cancer returned in the summer of 1964, and Dow-Dow expected he would die soon, though he never admitted it. His only complaint was stated in a wistful wish that he could have gotten to know old age better. His greatest concerns were for others, Mother in particular.

I was in East Hampton as much as possible that summer, and one day, when he was quite ill, Dow-Dow insisted on taking some roses to the Brooks, Gina and Alec Brook, friends who lived in North Haven, beyond Sag Harbor on the north side of Long Island. When we returned and had reached the front door of the cottage, Dow-Dow suddenly felt very faint. As I reached out to help, he looked at me and said, "Don't tell your mother."

<p style="text-align:center">* * *</p>

Gerald was still in Washington when he received from Archie MacLeish, in the spring of 1964, a printed copy of *The Book of Job,* an address Archie had given at the First Church of Christ, Farmington, Connecticut, on May 8, 1955. "Love creates," MacLeish had said. "Love creates even God, for how else have we come to know Him, any of us, but through love?" And there was an inscription to "Dear Dow," which read: "At bottom it is all a question of the love of life, isn't it?" Gerald wrote back from East Hampton. "How clear and how sustained your message about Job, about love! It has the clarion-quality of a trumpet-call, of something declarative, something that has been *said.* The very conception of eternity, infinite space, birth, death, love . . . has always, I must admit, left me awe-struck, and possibly intimidated. My conception of God was hopelessly disfigured . . . by a rigorous institutional Catholic training, beginning at a convent at seven years. At fifteen, at Hotchkiss, I rebelled and chose 'chapel,' rather than go to the village Roman Catholic church. Sara's and my 'mixed marriage,' as it was called by the church, was a nightmare of bigotry. . . . But today the sight of a priest or a nun affects me. I doubt if one recovers. . . . So your *Job* was like drinking from a pure source. I wish it were not so late. I bless you for sending it. I heard every note of your clarion-call."

Gerald presented his questions about old age to Archie in a letter on May 30, 1964. "Has anyone, anywhere, written of the nature of *la vieillesse?*" he asked. "We have been told so little of how it comes in the night or when one is off one's guard. I wish I had known."

Archie replied on July 4. "Camus says," he wrote, " 'To a conscious man old age and what it portends is not a surprise.' You have always been a conscious man: there is no higher praise." Archie added a postscript to the note. "Camus also says, apropos of your remark that we are not taught preparation for old age: 'There was in Athens a temple dedicated to old age. Children were taken there.' "

"The Camus was just what I had hoped to hear," Gerald wrote Archie on July 9, 1964. He reported on his illness and told of his reliance on the wisdom of another poet he admired, Gerard Manley Hopkins. "Apparently it is to be a matter of protracted and only partial adjustment. So I am cultivating GMH's 'Patience exquisite, that plumes to Peace thereafter,' and trying to envisage an existence (?) of amiable and regulated debility. I had so wanted to greet and know old age."

* * *

The last letter from Archie MacLeish was postmarked September 29. Dow-Dow was so weak that I had to read it to him. "When I got back from Chicago yesterday," Archie reported, "I found a letter from Alfred Barr, the Director of Acquisitions at the Museum of Modern Art, asking me to tell you that the Museum of Modern Art is proud to have a work by you in its permanent collection. He is referring to the *Wasp and Pear.* When you told me a few weeks ago about the loss of the picture Vladimir had, I wrote the museum telling them that . . . I should like to give the painting to the museum. They accepted at once and with the greatest eagerness, and Alfred now sends this word to you by me. I don't need to tell you how happy I am that the picture is to go where it belongs and where it will long represent your great work."

Dow-Dow smiled faintly after I had finished reading. He was terribly weak but able to say, "How wonderful."

My father died on October 17, 1964, and he died a Catholic. My husband, Bill, had mentioned that a priest at St. Philomena's in East Hampton had been a chaplain in World War II. "Get me the Army man," Dow-Dow had asked a couple of days before the end, and the priest came to perform last rites. Dow-Dow knew that Mother and I were in deep grief, and his

concern showed in the expression on his face. But he only said, "Smelling salts for the ladies."

There is no need to describe my mother's sense of loss, since she herself said it best when she wrote that she was only half a person without him. "Dearest Girl," she wrote me shortly after Dow-Dow died, "a little gift for you. . . . I know it isn't enough for the party dress, but perhaps for a scarf, or a bag. . . . This cheque is from Gerald, and we'll both wish he was at your party. He did love a good party!! Much much love from us both."

Archie MacLeish wrote to "Darling Sadie" in December 1964. "I am proud," he said, "to be asked to think of something for Gerald's stone. I thought first I wanted something of Hopkins because Gerald loved him so. But I can find nothing that will fit the space: Hopkins needs room to build up those marvelous rhythms. So I am going to propose three words from *King Lear:* RIPENESS IS ALL. Many readers of Shakespeare think the phrase is Shakespeare's greatest: certainly his most searching. But that isn't my reason. My reason is that it is so like Gerald, who achieved the most complete maturity I have ever seen. Think about it."

Mother did, and she liked it, and "Ripeness is all" is the inscription on my father's gravestone in South End Cemetery in East Hampton. Dow-Dow had arranged for mother's gravestone before he died and had had it inscribed with a line by the Elizabethan poet Thomas Campion: "And she made all of light."

Other friends wrote Mother, of course. "You overcame your sorrow to help all of us," Ada MacLeish wrote of the funeral in East Hampton, and Dos wrote, "Now we must rally round our dear Sara." Dorothy Parker said simply, in a telegram, "Dear Sara, Dearest Sara."

<div style="text-align:center">* * *</div>

Sara continued going to East Hampton in the summer, living in the little cottage, La Petite Hute, which was no longer very small. Sara had added one bedroom for Gerald when he became ill—"Mother can't stand my room as is," Gerald wrote Honoria in September 1963 —and another one after he died. By altering the appearance of the house, she reasoned, it would be less a reminder of Gerald and of her missing his being there. In winter, Sara lived at the Volney Hotel in Manhattan. Dorothy Parker also had an apartment at the Volney, and each of them was convinced that she was responsible for the well-being of the other: Sara would fret over Dottie's poor appetite, and Dottie was often disapproving of the women taking care of Sara, her "keepers," as Sara called them. In 1974, Sara's health had deteri-

orated, and she moved to the Donnelly residence in McLean, Virginia. She died of pneumonia on October 9, 1975.

Archie MacLeish wrote to Honoria in October 1973 that he intended to propose to the Museum of Modern Art in New York a "cluster of small one-man shows of artists, among them Murphy, who worked outside the dominant currents of their day but produced consistently good work." The Murphy show opened in April 1974, and it set in motion a resurgence of interest in Gerald's work.

"Murphy paintings repeat earlier triumph," the headline read in the newsletter of the Dallas Museum of Fine Arts, which had merged with the Dallas Museum for Contemporary Arts, the scene of Gerald's first American showing, in 1960. The newsletter announced that on August 28, 1974, a Murphy exhibition had opened and it "has been a nostalgic return for those Dallasites who recall the exciting 'American Genius in Review' exhibition." Exhibition followed exhibition: *Doves* was included in "Avant-Garde Painting in America, 1910–25" at the Delaware Art Museum in April and May 1975; *Watch* was called "one of the masterpieces of the exhibition" in a review in the October 1977 *Art News* of "Modern American Painting, 1910–1940" at the Houston Museum of Fine Arts; and *Razor* was featured in an article in the *Illustrated London News* of November 1977 about an exhibition in London of American painting and photography between 1908 and 1935.

"The exhibition of Murphy's work leaves one with a sense of loss," art critic Jan Butterfield wrote in *American Art Review* of the one-man show at the Museum of Modern Art in New York. "The fact remains that we have only six works by which to judge him. . . . Murphy was a good painter. . . . Whether he would, in time, have become a great painter is speculation. . . . The qualities which combine to make a great painter are very particular, yet always somewhat undefinable. One senses intuitively that Murphy had those qualities. While there is awkwardness in some works, this is offset by brilliance in others. Murphy sprang full-blown, relatively late for a painter, and received accolades both from the artistic giants of his time and from the critical press. If Murphy had continued to paint for his full span of years and with the strength and brilliance evidenced in *Razor,* and continued the new involvements he began in *Wasp and Pear,* there is a strong possibility that he would now stand alongside American masters of that period such as

Sheeler and Demuth. If we can see the weaknesses now in retro-spect, it should be remembered that we look with the eyes of a different time—a time grown accustomed to the kind of work that was, for the twenties, a radical new way of painting."

* * *

This is the picture of my parents in later life that I treasure. At sunset in summer, they are sitting on a dove-gray wooden bench outside the front door of their cottage in East Hampton. They are sipping their evening cocktails, usually the "house drink"—a combination of fruit juices and gin over crushed ice with a sprig of mint picked from their own patch. The tray of hors d'oeuvres is tempting.

Their view is of the village, and though they have gazed at it on count-less evenings, they still enjoy it so—a flagpole, a church steeple bright white against the pink sky, clusters of full green trees. A bit of English countryside, my father would say.

The look of contentment on my parents' faces tells me they have found what Scott Fitzgerald called "an eventual peace somewhere, an occasional port of call as we sail deathward." The sunset reminded me of a favorite poetic passage of Mother's, a stanza from "For the Fallen" by Laurence Binyon:

> *They shall not grow old, as we that are*
> *left grow old;*
> *Age shall not weary them, nor the years*
> *condemn.*
> *At the going down of the sun and in*
> *the morning*
> *We will remember them.*

I realized—from watching Mother and Dow-Dow and thinking of the poem—what Ernest Hemingway meant when he wrote, "No one you love is ever dead."

A Chronology of Events

November 7, 1883: Sara Sherman Wiborg is born.

March 26, 1888: Gerald Cleary Murphy is born.

Summer 1904: Sara and Gerald meet for the first time.

June 1912: Gerald Murphy graduates from Yale and goes to work for the Mark Cross Company.

December 30, 1915: Sara and Gerald are married.

January 2, 1917: Adeline Sherman Wiborg, Sara's mother, dies.

December 19, 1917: Honoria Adeline Murphy is born.

November 1918: The first world war ends, as does Gerald Murphy's career as an Army officer.

May 13, 1919: Baoth Murphy is born.

September 1919: The Murphys move to Cambridge, Massachusetts, where Gerald enrolls as a graduate student of landscape architecture at Harvard.

Summer 1920: The Murphys spend the summer in Litchfield, Connecticut.

October 18, 1920: Patrick Francis Murphy II is born.

June 11, 1921: The Murphys sail for Europe on the S.S. *Cedric*.

August 1921: The Murphys spend the summer at Croyde Bay, Devonshire, England.

September 1921: to Paris and a residence at the Hôtel Beau-Site

October 1921: to rue Greuze, Paris

June 1922: to Houlgate on the coast of Normandy

October 1922: to Versailles, Hôtel des Reservoirs

July 1923: to Antibes, Hôtel du Cap

September 1923: return to Versailles

February 1924: to Antibes

April 1924: 3 rue Gounod, Saint-Cloud

May 1924: Frederic T. Murphy, Gerald's brother, dies.

June 1924: to Antibes, Hôtel du Cap

September 1924: return to Saint-Cloud

March 1925: to Antibes, Hôtel du Cap

Summer 1925: move to the Villa America, Antibes

1926: Baoth's name is legally changed to F. Baoth Wiborg.

October 1928: The Murphys sail for America on the S.S. *Saturnia* and travel by train to California, where they rent a house in Beverly Hills.

March 1929: depart California

May 1929: return to Antibes

October 1929: The Murphys move to Montana-Vermala, Switzerland, for treatment of Patrick's tuberculosis.

May 12, 1930: Frank B. Wiborg, Sara's father, dies.

Summer 1931: The Murphys spend the summer at Bad Aussee, Austria.

November 23, 1931: Patrick Francis Murphy, Gerald's father, dies.

January 1932: return to Antibes

April 25, 1932: Anna Ryan Murphy, Gerald's mother, dies.

July 1932: The Murphys return to America on the S.S. *Aquitania.*

June-September 1934: The Murphys spend the summer in Europe, at Antibes and cruising the Mediterranean.

December 19, 1934: Gerald becomes president of the Mark Cross Company.

March 17, 1935: F. Baoth Wiborg dies.

July 1935: Sara and Patrick go to Saranac Lake, New York, where they are joined occasionally by Gerald and Honoria.

January 30, 1937: Patrick Francis Murphy II dies.

February 1937: The Murphys take an apartment at the Hotel New Weston in Manhattan.

April 1937: Olga Fish, Sara's sister, dies.

June-September 1937: Europe

May-September 1938: Europe

May 1939: Sara and Honoria sail for Europe, returning in September.

October 1939: The Murphys move to an apartment at 25 West Fifty-fourth Street in New York City.

Mid-1940: The Murphys move to 131 East Sixty-sixth Street in New York City.

1941: Dunes, the Wiborg mansion in East Hampton, is torn down.

1942: *Weatherbird,* the Murphys' cruising schooner, is sold.

June 1944: A suit brought by Mary Hoyt Wiborg, Sara's sister, is settled in Sara's favor.

September 1947: The Mark Cross Company is merged with the Drake America Corporation.

1949: The Murphys move to Snedens Landing, New York.

September 1950: The Villa America is sold.

November 14, 1950: Honoria and William M. Donnelly are married.

June 20, 1951: John Charles Baoth Donnelly is born.

June 10, 1953: William Sherman Donnelly is born.

September 27, 1954: Laura Sara Donnelly is born.

December 1962: Esther Murphy, Gerald's sister, dies.

April 1964: Mary Hoyt Wiborg, Sara's sister, dies.

October 17, 1964: Gerald Murphy dies.

April 1974: Paintings of Gerald Murphy exhibited in a one-man show
at the Museum of Modern Art in New York City.

October 9, 1975: Sara Murphy dies.

and Marge Benchley, for correspondence of Nathaniel Benchley; Mrs. Miles Reber, for correspondence of Cecilia Reber; Nancy Milford, for correspondence of Nancy Milford.

For the photographs appearing between pages 142 and 143, the following are acknowledged:

Pages 1 through 7, William and Honoria Murphy Donnelly (Wm. and HMD) collection; page 8 top, Mark Cross Company; pages 8 bottom through 15, Wm. and HMD; pages 16 and 17 top, Edmond Uher; pages 16 and 17 bottom, Richard E. Myers (REM), now Frances Myers Brennan collection; pages 18 and 19, Wm. and HMD; page 20 top, Dallas Museum of Fine Arts; page 20 bottom, Museum of Modern Art; page 21 top, Dallas Museum of Fine Arts; page 21 bottom, Dallas Museum of Fine Arts; page 22 top left , Wm. and HMD; page 22 other photographs, REM; page 23 top left, REM; page 23 other photographs, Wm. and HMD, except for photograph of F. Scott and Zelda Fitzgerald, courtesy of Frances Scott Fitzgerald Smith; pages 24 through 26, Wm. and HMD; page 27 top, REM; page 27 bottom, Wm. and HMD; page 28, Wm. and HMD; page 29, REM; page 30 three top, REM; page 30 bottom right, Wm. and HMD; page 31 top farthest right, Bert and Richard Morgan; page 31 top other photographs, Wm. and HMD; page 31 bottom, L. F. Stockmeyer; page 32, Edward Rice.

Index